Colossal **DESIGN**

► ► ► 379 inspiring designs with the
stories behind the concepts

Colossa

DESIGN

By Clare Warmke

Designed by Lisa Buchanan

HOW
DESIGN
BOOKS

www.howdesign.com
HOW Design Books
Cincinnati, Ohio

ABOUT THE AUTHOR

Clare Warmke is the acquisitions editor for the HOW Design book line. At HOW, Clare has acquired and edited a wide variety of books, in addition to authoring the book Idea Revolution *and coauthoring* Powerful Page Design. *Clare lives with her husband, Bryan Rosser, her dog, Galen, and her two cats, Casper and Rogue, in Cincinnati, Ohio.*

Other fine HOW Design Books are available from your local bookstore, art supply store or direct from the publisher.

07 06 05 04 03 5 4 3 2 1

Library of Congress Cataloging-in-Publication Data

Warmke, Clare.
 Colossal design / by Clare Warmke.
 p. cm.
 ISBN 1-58180-444-X
 1. Commercial art--United States--History--20th century. 2. Graphic arts--United States--History--20th century. I. Title.

NC998.5.A1W37 2003
741.6'0973'0904--dc21 2003047770

Editor: Clare Warmke
Editorial Assistance: Eric Schwartzberg, Jenny Wohlfarth, Barbara Poe, Amy Schell
Designer: Lisa Buchanan
Production artist: Karla Baker
Photographer: Tim Grondin
Production Coordinator: Sara Dumford

DEDICATION

*For my mother, Priscilla Shaw, who always encouraged
me to tackle ridiculously oversized projects.*

ACKNOWLEDGMENTS

*I'm grateful to every designer who contributed to this
book and to the team of dedicated people who helped
with the details. Thanks to Eric Schwartzberg and Jenny
Wohlfarth for sorting content; Lisa Buchanan for the
design; Barbara Poe for organizing the paperwork; and
Amy Schell for helping in all other capacities. And, as usual,
a gusty "Thank you!" to the legion of in-house folks at
F&W Publications who get these books into your hands,
specifically Phil Sexton and Nicole Hoch. Yea, team!*

POSTERS

[SECTION ONE]

EDITORIAL DESIGNS

[SECTION TWO]

PAGE 134

[SECTION THREE]

CD &
MUSIC
GRAPHICS

BROCHURES
PAGE 164

[SECTION FOUR]

BUSINESS
COLLATERAL

[SECTION FIVE]

Annual Reports and Marketing Kits
Identity Systems
Self-Promotion Materials

PAGE 274

MAKE IT BIG

We could have called this book Big Ass Design, *but that title was already taken by a shoe sale event in Washington, D.C. (page 58). We could have called it* The All-You-Can-Eat Design Buffet, *but we thought the tasty Saffron Shores designs were tantalizing enough to get your mouth watering (page 106). We could have called it* The Mother of All Design Books, *since the pages are filled with work from big mamas of the design world, like Jill Howry (page 55), Ann Willoughby (page 73) and Deb Koch (page 351). Instead, we decided to call it exactly what it is—*Colossal Design. *It's a titanic, awe-inspiring collection of today's most monumental page designs, culled from the winners of HOW and I.D. magazines' graphics competitions, some HOW Design Book favorites, and plenty of new blood. It has everything.*

Don't think of this page design collection as fat—think of it as big boned. It has the kind of meat and muscle that will fuel your design inspirations for many projects to come. Five hefty sections—brochures, posters, CD/music graphics, editorial designs and business collateral—serve up nearly 400 inspiring solutions to client problems. And it doesn't scrimp on the side dishes either. Each design entrée includes in-depth captions that explain the concepts behind the work and the production details that made it possible. To add extra flavor, sprinkled throughout the book are quotes from designers that answer two main questions: What are your most staggering challenges in design work and how do you solve them, and what advice do you have for rookie designer who wants to make it big?

So make room on your lap and in your head. Colossal Design *is going to take up a lot of space.*

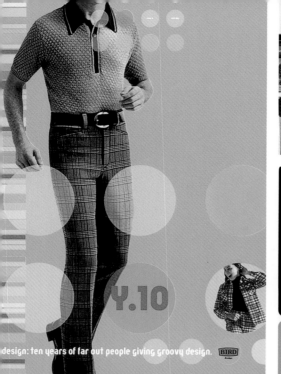

Y.10

design: ten years of far out people giving groovy design. BIRD

ll for entries. By January 11, 2002

the caribbean verse by verse

SCREENPRINTING
Branding Elements / Permanent Fixtures
Point of Purchase Display
High-End Presentation Materials

A
R T real

T

body

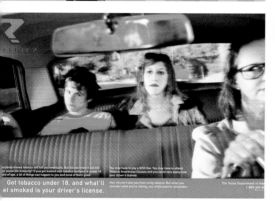

Got tobacco under 18, and what'll et smoked is your driver's license.

The Texas Department of In
1-800-345-8

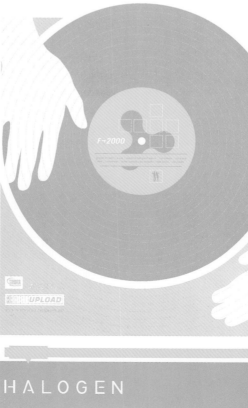

F→2000

UPLOAD

HALOGEN

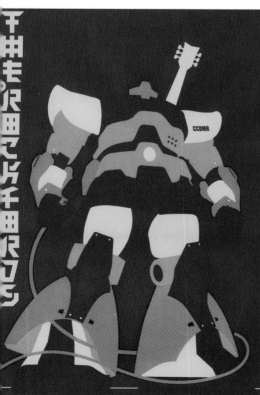

CCDMR

07:20:00 ◉ ◔ ▫ •
E ROCKFORDS WITH KIM VIRANT & GARTH REEVES
RESENTED BY THE CROCODILE CAFE

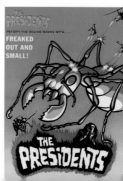

THE PRESIDENTS
PETRIFY THE SOUND WAVES WITH.....
FREAKED OUT AND SMALL!
THE PRESIDENTS

WE JUST SHO
YOU OUR
NOW
US

POSTERS

Like trimming on a tree or face paint on a clown, posters are
adornments that entertain and delight. In the graphic design
realm, they also communicate—giving information about an
event, a product, or the artist's political views. Posters can be big
and brash, or understated and subtle, and all encourage viewers
to interact with the poster's message and environment.

Posters are meant to be displayed, and in this section, you'll
find ninety varied poster designs to delight you. Think of it as a
tidy, compact grafitti wall for your bookshelf.

> Every shape or mark you make is an opportunity. Opportunities are questions. What do you want to say? Why?
> GEOFF MCFETRIDGE

BOYS AND GIRLS DRESSES

Champion # 91 of 300

MINIPOSTER PACKS ▶

[STUDIO] Champion Graphics
[DESIGNER] Geoff McFetridge
[PAPER] White, 80 lb. cover, acid free
[COLORS] 1, match
[SIZE] 8" × 10" (20 × 25cm)
[PRINT RUN] 300
[TYPE] Akzidenz Grotesk Stencil
[SPECIAL COST-CUTTING TECHNIQUE] hand stapling, folding, collating
[INSPIRATION/CONCEPT] Free Christian publications

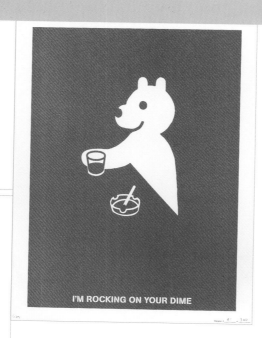

I'M ROCKING ON YOUR DIME

SAN FRANCISCO
2012

THE BRIDGE TO THE FUTURE
San Francisco · U.S. Bid City · 2012 Olympic Games

DESIGN: JENNIFER MORLA / MORLA DESIGN · PRINTING: H1TPRINT / DOME PRINTING · PAPER: SAPPI · 1:1:1 BASOC 2012.org

2012
SAN FRANCISCO

SAN FRANCISCO 2012: U.S. OLYMPIC BID CITY POSTER ▼

[STUDIO] Morla Design
[DESIGNERS] Jennifer Morla, Hizam Haron
[PHOTOGRAPHERS] Jock McDonald (portrait),
Photodisc
[CLIENT] San Francisco Bay Area Sports Organizing
Committee

[CLIENT'S PRODUCT/SERVICE] Promoting San
Francisco for the 2012 Olympics
[PAPER] Potlatch McCoy
[COLORS] 4, process
[SIZE] 18" × 24" (45 × 61cm)
[TYPE] Bell Gothic BT, Helvetica Black

"We created a contemporary version of the classic portrait poster, one that incorporated the optimism of
the Olympics with a bold, iconic portrait of an Asian-American swimmer," designer Jennifer Morla says.
"The radiating lines, bright color palette and posterized dot screens are a modern take on San Francisco
music posters from the sixties. Photographs of summer Olympic events peek through the background
pattern and communicate the vitality of the events and the diversity of the area."

13

BLUES IN THE BURG
POSTERS ▶

[STUDIO] Arnika
[ART DIRECTORS/DESIGNERS] Michael Ashley, Bill Lee
[CLIENT] Boys and Girls Clubs of America
[CLIENT'S PRODUCT/SERVICE] Blues festival fund-raiser
[COLORS] 4, process
[SIZE] 18" × 22" (46 × 56cm)
[PRINT RUN] 800
[COST PER UNIT] All donated
[TYPE] Block, Carpenter, Clarendon

"The blues are as American as apple pie, but they lack the awareness of other musical genres," art director Michael Ashley explains. "We wanted to educate the public by giving them a deeper understanding of what the blues are all about and show them how blues songs are made."

★ CREATE YOUR OWN BLUES SONG ★

Just fill in the words. Play by yourself or with friends!

Woke up this _____ , had to find my _____ .
　　　　　　　(time of day)　　　　　　　　　　　*(article of clothing)*
Woke up this _____ , had to find my _____ .
　　　　　　　(time of day)　　　　　　　　　　　*(article of clothing)*
My baby's gone and left me, skipped town with _____ .
　　　　　　　　　　　　　　　　　　　　　　(name of best friend)

I'm going to _____ them, bring her back home
　　　　　　　(verb)
I'm going to _____ them, bring her back home
　　　　　　　(verb)
Tell everyone in _____ , to feed _____ while I'm gone.
　　　　　　　　(name of town)　　　　　　*(name of pet)*

Now 1 and 1 is _____
　　　　　　　　(number between 1 and 10)
2 and 2 is _____
　　　　　　(number between 1 and 10)
She's done it _____ times, should've known she'd do it some more.
　　　　　　　(number between 1 and 10)

Now I feel so _____ , you hear me when I _____
　　　　　　　(emotion)　　　　　　　　　　　*(bodily sound)*
Now I feel so _____ , you hear me when I _____
　　　　　　　(emotion)　　　　　　　　　　　*(bodily sound)*
I've been so lonely for _____ , ever since you've been gone.
　　　　　　　　　　　(noun)

Oh _____ , don't you want to go.
　　(term of endearment)
Oh _____ , don't you want to go.
　　(term of endearment)
Come back home, home to sweet _____ .
　　　　　　　　　　　　　　　(name of Northern U.S. city)

Now all you need is the music. Find it Saturday, September 22nd at Uptown at Central Park, Fredericksburg, Virginia. Come see Roomful of Blues, Cephas & Wiggins, Big Jesse Yawn, Jailtones, Linwood Taylor, Archie Edwards, and Sheryl Warner and the Southside Homewreckers. It'll be much, much better.

BLUES IN THE 'BURG

"Where the blues never get old"

www.bgcfxbg.org • For more info call 540-785-6472 • Tickets available through www.TicketWeb.com • Benefits the Boys and Girls Club of Greater Washington, Fredericksburg Regional Branch.

The biggest challenge is always getting noticed, followed closely by being remembered. We always push for an execution built around a solid, compelling idea. The final question we always ask is, "Will somebody want to keep this piece?" That's the ultimate litmus test for the work.

MICHAEL ASHLEY

★ BLUES NAME STARTER KIT ★

Take one name from each column and voilá! Your very own blues name!

PHYSICAL INFIRMITY	FIRST NAME (OR FRUIT)	LAST NAME OF A PRESIDENT
Blind	Lemon	Jefferson
Little	Willie	Washington
Crippled	Banana	Fillmore
Bucktooth	Kiwi	Johnson
Short	Virgil	Clinton
Asthmatic	Peach	Bush
Skinny	Joe	Carter
Wet	Mango	Coolidge
Fat	Billy	Ford
Varicose	Strawberry	Hoover
Corn-toed	Enis	Polk
Arthritic	Jethro	Tyler
Sweaty	Tomato	Pierce
Peg-legged	Melon	Jackson
Stinky	Papa	Lincoln
Mangy	Pear	Hayes
Rickety	Sherman	Cleveland
Dehydrated	Johnny	Taft
Scabby	Lychee	Taylor
Bald	Cherry	Wilson
Deaf	Eustis	Nixon

Now all you need is the music. Find it Saturday, September 22nd at Uptown at Central Park, Fredericksburg, Virginia. Scabby Joe Coolidge won't be there, but Roomful of Blues, Cephas & Wiggins, Big Jesse Yawn, Jailtones, Linwood Taylor, Archie Edwards, and Sheryl Warner and the Southside Homewreckers will be.

BLUES IN THE 'BURG

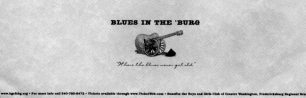

"Where the blues never get old"

www.bgrfxbg.org • For more info call 540-785-6472 • Tickets available through www.TicketWeb.com • Benefits the Boys and Girls Club of Greater Washington, Fredericksburg Regional Branch.

UNDERSTANDING THE VALUE OF ★ THE BLUES ★

A good blues fan always knows which ticket he/she deserves.
What're you worth?

$15 TICKET	$20 TICKET	VIP PASS
P R E R E Q U I S I T E S		
an Ex	two Ex's	your own legal department
dandruff	halitosis	scurvy
a dog that won't come	a dog that won't fetch	a dog that won't let go of your pants
two parking tickets	two speeding tickets	two years before you can drive
overdue library books	overdue movies	overdue taxes
a dead car battery	a flat tire	an Ex with your spare tire
corn (on your feet)	athlete's foot	twenty-seven toes
bad hair	mohawk	no hair
trick knee	trick back	trick bladder
early bird syndrome	high level of procrastination	a warrant for your arrest

Now you can make an informed decision, regardless of how pitiful you are. On Saturday, September 22nd at Uptown at Central Park, Fredericksburg, Virginia, you can see Roomful of Blues, Cephas & Wiggins, Big Jesse Yawn, Jailtones, Linwood Taylor, Archie Edwards, and Sheryl Warner and the Southside Homewreckers. Find out if you bought the right ticket.

BLUES IN THE 'BURG

"Where the blues never get old"

www.bgrfxbg.org • For more info call 540-785-6472 • Tickets available through www.TicketWeb.com • Benefits the Boys and Girls Club of Greater Washington, Fredericksburg Regional Branch.

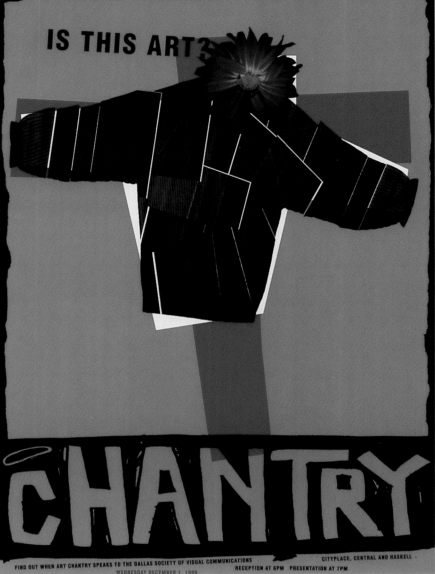

IS THIS ART? ▶

[STUDIO] Sibley Peteet Design, Dallas
[ART DIRECTOR/DESIGNER] Brent McMahan
[ILLUSTRATOR/PHOTOGRAPHER] Brent McMahan
[CLIENT] Dallas Society of Visual Communications
[PAPER] Consolidated-Frostbite Text
[COLORS] 4, process
[SIZE] 18" × 24" (46 × 61cm)
[PRINT RUN] 1500
[COST PER UNIT] Donated
[TYPE] Helvetica Neue, hand lettering
[SPECIAL TYPE TECHNIQUE] Hand drawn, photocopied

"This poster was for Art Chantry's speaking engagement in Dallas," says art director Brent McMahan. *"Many designers in town think Art is one of the most influential people in the business and many think he is just right over the top. Because of this polarization I played around with a Jesse Helms versus Art Chantry approach."*

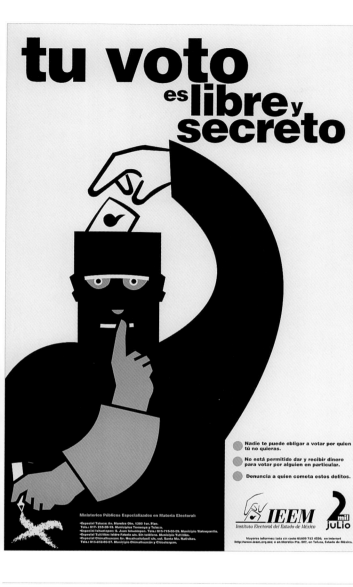

TU VOTO ES LIBRE Y SECRETO ◄

[STUDIO] La Maraca y El Tacón
[ART DIRECTOR/DESIGNER] Abraham Morales
[ILLUSTRATOR] Abraham Morales
[CLIENT] Instituto Electoral del Estado de México
[CLIENT'S PRODUCT/SERVICE] Institution watching the
 electoral process of Estado de México.
[COLORS] 2, offset
[SIZE] 36" × 24" (91 × 61cm)
[PRINT RUN] 5,000
[TYPE] Helvetica Black (title, advice), Freeway Black (addresses, web site, phone numbers)

"The institution wanted to promote an electoral culture into the Mexican population. I thought that the best way to transmit the concepts of democracy, free and secret vote, was through a clear and direct image," explains art director Abraham Morales. "The act of voting is shown by the human figure inserting the vote into its head, the next action is voting with the cross and finally the last idea of secret vote is present with the finger crossing lips. Three simple actions come together and are the key to make a powerful and clear image. Behind all the process of design was the feeling that democracy and voting are strong concepts in people's minds and hearts, and I'd like to believe that we are nurturing them in some way."

FABRIC OF FASHION ▼

[STUDIO] Pentagram Design
[ART DIRECTOR] Angus Hyland
[DESIGNER] Angus Hyland, Charlie Smith, Emily Wood
[PHOTOGRAPHER] Michael Danner
[CLIENT] Crafts Council
[CLIENT'S PRODUCT/SERVICE] The Crafts Council is the United Kingdom's national organization
 for the promotion of contemporary crafts.
[COLORS] 3, match
[SIZE] 40" × 60" (102 × 152cm)
[TYPE] Combination of hand sewn (stitched) and Checkout (designed by Julian Morey)
[SPECIAL TYPE TECHNIQUE] Hand-stitched headline
[SPECIAL PRODUCTION TECHNIQUE] Hand-separated colors
[INSPIRATION/CONCEPT] Weave and screen print (the two basic processes of
 textile design)

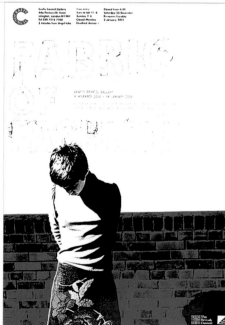

You have to define what you want to accomplish as a designer. Clients always want to get the most spectacular designs, but in some cases this approach does not make a good design because there is no concept—only a visual effect. So if you want to be a successful designer, you make what the clients want to get; if you want to be a good designer, think with your heart and participate in the projects that make you feel happy—although you may not make the big money.
ABRAHAM MORALES

17

CARIBBEAN VERSE BY VERSE POSTER ▶

[STUDIO] Fuszion Collaborative
[DESIGNER] John Foster
[ILLUSTRATOR] John Foster
[CLIENT] Endearing Records
[CLIENT'S PRODUCT/SERVICE] Record label
[PAPER] Finch Fine
[COLORS] 2, match
[SIZE] 11" × 17" (28 × 43cm)

[PRINT RUN] 1,000
[TYPE] Helvetica Neue, Trade Gothic
[SPECIAL TYPE TECHNIQUE] Type is laid out at a 90-degree angle and has variation in font and size in the same line of copy.
[SPECIAL PRODUCTION TECHNIQUE] Overprinting blacks

"This poster had to be large enough to grab your attention but small enough for record-store windows so the label could distribute them to merchandise outlets and clubs for appearances," designer John Foster says. "I really wanted viewers to garner some sort of feeling for the band's brainy, creative and slightly mopey brand of layered pop. I also wanted to play on the band's name by using the swirls of painterly blue. The music created by the band inspired me to search for some way to express the joys in the tiny details and perfectly timed open spaces in their songs."

the caribbean verse by verse ndr02

the caribbean verse by verse ndr023
© 2001 endearingrecords, p.o. box 69009, Winnipeg, Manitoba, Canada, r3p 2g9
endearing.com, www.endearing.com ▪ MADE IN CANADA

[STUDIO] BAD Studio
[ART DIRECTOR] Lyn Albers
[DESIGNER] Kevin Fitzgerald
[ILLUSTRATORS] Lyn Albers, Scott Banks, Lauren Caprarola, Kevin Fitzgerald, Suzanna Schott
[CLIENT] Innovations
[CLIENT'S PRODUCT/SERVICE] Modern Classic Furniture Retailer
[PAPER] Coated sign board
[COLORS] 2, match
[SIZE] 22" × 28" (56 × 71cm)
[PRINT RUN] 100
[COST PER UNIT] $6.25 each
[TYPE] Logo is a customized version of Bodoni; "Holiday Sale" is set in Vectora LH regular and light
[SPECIAL PRODUCTION TECHNIQUE] Elementary school style of cutting paper snowflakes
[SPECIAL COST-CUTTING TECHNIQUES] Silk-screening instead of offset; the use of just two colors

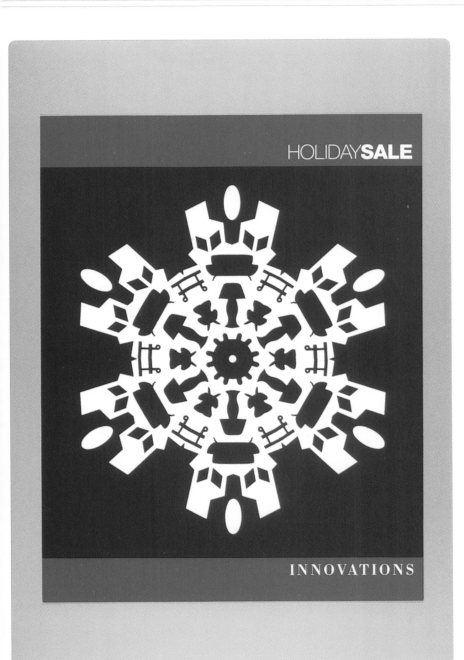

"The client needed a point-of-sale visual for the holiday season that would still convey the image of the brand," explain the design staff at BAD Studio. *"We used a snowflake motif because it conjures up images of ski chalets, sweaters, and hot chocolate by a roaring fireplace. Then we comprised the snowflake out of shapes of the product itself. We first made the shapes and rotated them around an axis in the computer, but they didn't look right. They were too antiseptic, too forced and they lacked emotion. So we just cut them out by hand with imperfections, scanned in the best one and traced over it for the final mechanical."*

Make certain each piece has a concept and communicates a message. Too many portfolios feature pretty pictures and the technique de jour. The real art of good page design is knowing how to utilize the appropriate tools to communicate the client's message effectively.

LYN ALBERS

NOLA AND THE COLA ◄

[STUDIO] Spencer Francey Peters
[ART DIRECTOR/DESIGNER] Barry Quinn
[ILLUSTRATOR] Jamie Bennett
[CLIENT] OpenCola
[COLORS] 4/1, process plus 1 special
[SIZE] 42" × 59" (107 × 150cm)
[PRINT RUN] 2,000
[TYPE] Helvetica Neue, New Clarendon
[SPECIAL COST-CUTTING TECHNIQUE] Cheap paper;
 use of a trade printer.

"We loved how graphic the illustration looked once it was printed that size; it reminded us of sixties pop art and European film posters," says art director Barry Quinn. *"We folded it down to be about the size of an LP record."*

SAGMEISTER POSTER ►

[STUDIO] Stoltze Design
[ART DIRECTOR] Clifford Stoltze
[DESIGNERS] Clifford Stoltze, Violet Shuraka,
 Brian Azer
[ILLUSTRATOR] Found illustrations
[CLIENT] AIGA (American Institute of Graphic Arts)
[CLIENT'S PRODUCT/SERVICE] Non-profit, graphic
 arts association
[SIZE] 24" × 36" (61 × 91cm)
[TYPE] FF Din (Sagmeister), Letter Gothic
 (informational text)
[SPECIAL COST-CUTTING TECHNIQUES] Using
 "found" illustrations

"This poster was designed to promote the talk 'How to Touch Someone's Heart with Design' by Stefan Sagmeister, a noted designer who specializes in CD packaging," says art director Clifford Stoltze. *"The poster puts the designer in the spotlight, moving him from his usual behind-the-scenes position of CD designer to the front of the CD booklet, suggesting a transformation from designer to rock star. The poster was designed in such a way that the over-printed version works as an interesting combination of both the front and back of the poster."*

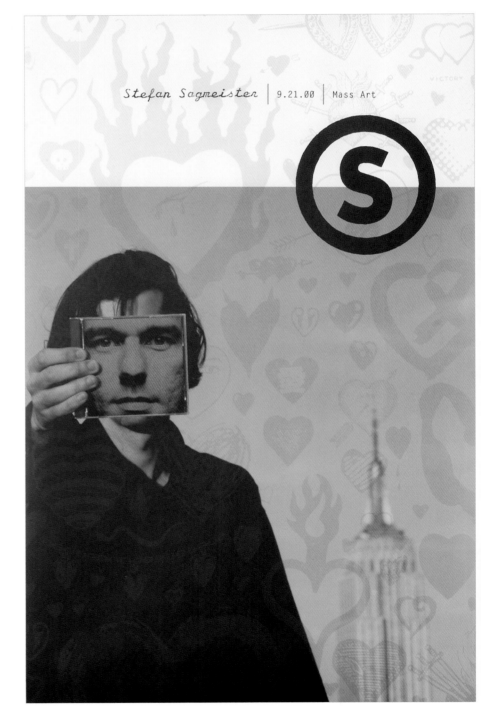

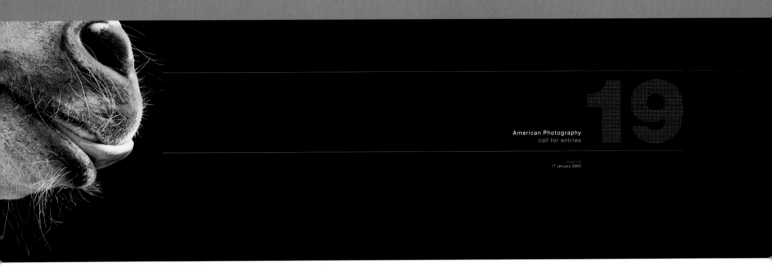

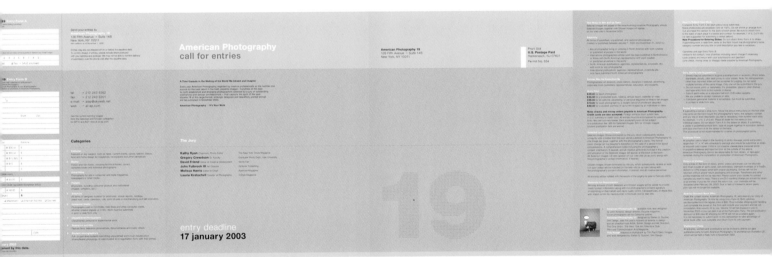

AMERICAN PHOTOGRAPHY 19 CALL FOR ENTRIES POSTER ▲

[STUDIO] 344 Design, LLC
[ART DIRECTOR/DESIGNER] Stefan G. Bucher
[PHOTOGRAPHER] Tim Flach/Getty Images
[CLIENT] Mark Heflin/Amilus Inc.
[CLIENT'S PRODUCT/SERVICE] Publisher of American Photography and American Illustration annuals
[PAPER] Montauk 100 lb.. glossy text with a gloss aqueous finish
[COLORS] 4, process plus one match
[SIZE] 38" × 11½" (97 × 29cm)
[PRINT RUN] 39,000
[COST PER UNIT] free, mailed in the US, Canada, UK, Germany and Japan
[TYPE] Custom-made 19 with Helvetica

"Photographers want to be in this book so bad, they can taste it," says art director Stefan Bucher.

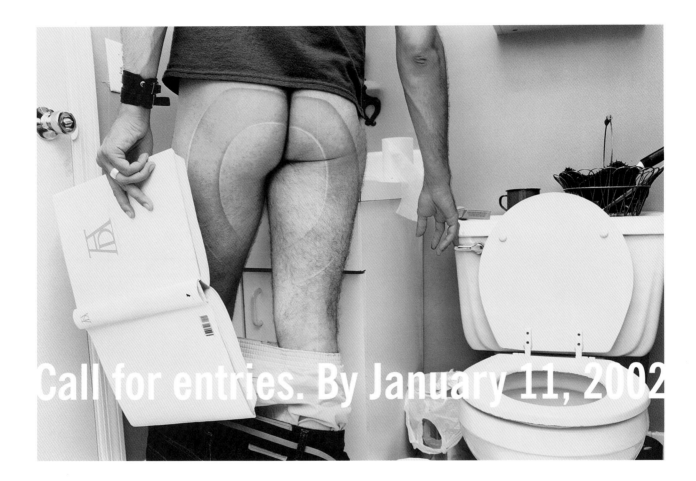

Call for entries. By January 11, 2002

ART DIRECTORS CLUB
CALL FOR ENTRIES ▲ ▶

[STUDIO] CPS
[ART DIRECTORS] Erik Vervroegen (sunburn and
microwave), Molly Sheahan and Soo Mean Chang
(toilet seat)
[COPYWRITER] Kerry Keenan
[PHOTOGRAPHER] Megan Maloy
[CLIENT] Art Directors Club

"We were inspired by the fact that the work one finds
in the Art Directors Club annual is so engrossing
you will ignore other things," says art director Soo
Mean Chang. "This campaign was mailed out as a
collateral piece. Five different posters were sent
out, and everyone received a different image from
the campaign. That made the work interesting and
attracted people's attention. The only way to see
the entire campaign would be to see which posters
your colleagues received."

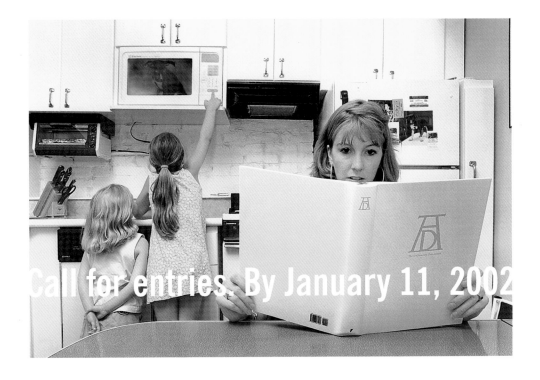

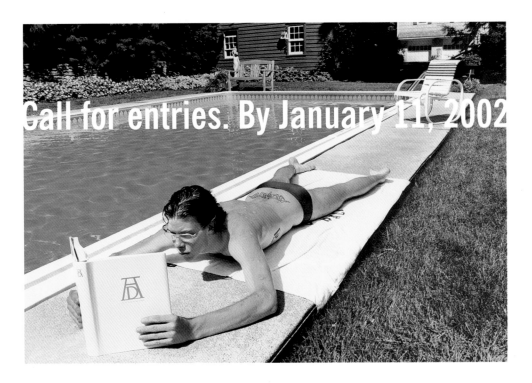

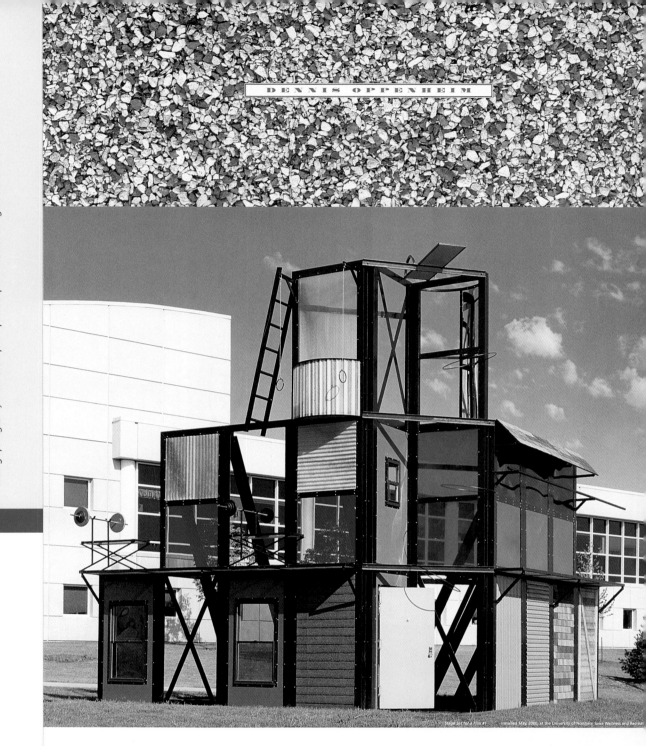

Stage Set for a Film #1 — Installed May 2000, at the University of Northern Iowa Wellness and Recreat[...]

DENNIS OPPENHEIM POSTER ▼

[STUDIO] Philip Fass
[ART DIRECTOR/DESIGNER] Philip Fass
[PHOTOGRAPHERS] Randy Van der Werf, Mark Johnson, Philip Fass
[CLIENT] University of Northern Iowa Gallery of Art
[CLIENT'S PRODUCT/SERVICE] Exhibition and education in the context of a university art department

[PAPER] 110 lb. Centura Text
[COLORS] 4, process
[SIZE] 35" × 22" (89 × 56cm)
[PRINT RUN] 4,000
[COST PER UNIT] Approximately $1
[TYPE] Madrone, Univers 55, Frutiger, Janson text

"The idea was to invite viewers to enter the work of the artist, thus the close-up of the doorknob," explains art director Philip Fass. "This thinking also prompted the placement and cropping of images on the front, giving the viewer three distances from which to experience the piece. The back had to stand on its own as a poster while containing an amount of text that usually would be presented in a small catalog, and it had to work effectively with the front as well. The green and white relate to the shingle colors used on the front, and the horizontal butting of images rhymes with the form of the sculpture that was being commemorated."

24

...ER IS PUBLISHED ON THE OCCASION OF THE SEPTEMBER 21, 2000 DEDICATION OF THE DENNIS OPPENHEIM SITE SCULPTURE STAGE SET FOR A FILM #1

on the campus of the University of Northern Iowa

AND THE OPENING of the exhibition Dennis Oppenheim: Twenty Years in the Public Eye

at the UNI Gallery of the Department of Art, September 11 – October 22, 2000.

EXHIBITION CO-CURATED BY Rachel Flint, UNI Gallery Director,

Mary Frisbee Johnson, Head, Department of Art; and Dennis Oppenheim.

FINANCIAL SUPPORT for this publication and the exhibition is provided by the FLORENCE HARTWIG UNI TRUST

© Copyright 2000 by the UNI Department of Art, UNI Gallery, Kamerick Art Building, University of Northern Iowa, Cedar Falls, IA 50614-0362, 319.273.3095

POSTER DESIGN by Philip Fass

FRONT PHOTOGRAPH: Rod VanderWerf

BACK PHOTOGRAPH of Stage Set for a Film #1: Mark Melhorn

PRINTER: Color FX, Waverly, Iowa

DENNIS OPPENHEIM TWENTY YEARS IN THE PUBLIC EYE

An exhibition of photographs and drawings of the public sculpture of Dennis Oppenheim

September 11 – October 22, 2000 Opening reception September 11 at 4 pm

University of Northern Iowa Gallery Department of Art Kamerick Art Building Main Floor Cedar Falls, IA 50614-0362 319.273.3095

Gallery Hours Monday through Thursday: 9:00 – 9:00 pm Friday: 9:00 – 5:00 pm Saturday and Sunday: 12 pm – 5 pm

SPECIAL EVENTS

"DENNIS OPPENHEIM: THEATRICALITY," A lecture by Dr. Craig Adcock, Professor of Art History, University of Iowa, Iowa City; September 20 at 7 pm in the Art Auditorium, Room 111, Kamerick Art Building.

A LECTURE BY DENNIS OPPENHEIM, the Dedication of Stage Set for a Film #1, and a Celebration of the 40th Anniversary of the Iowa Art in State Buildings Program on the UNI Campus.

September 11 at 2 pm in the Great Hall of the Gallagher-Bluedorn Performing Art Center

A RECEPTION WITH THE ARTIST at the exhibition "Dennis Oppenheim: Twenty Years in the Public Eye"

September 21 at 4 pm at the UNI Gallery, Kamerick Art Building

Student guides will be available to take visitors to the site of Stage Set for a Film #1. Lectures, exhibition, reception, and printed matter funded by the Florence Hartwig UNI Trust

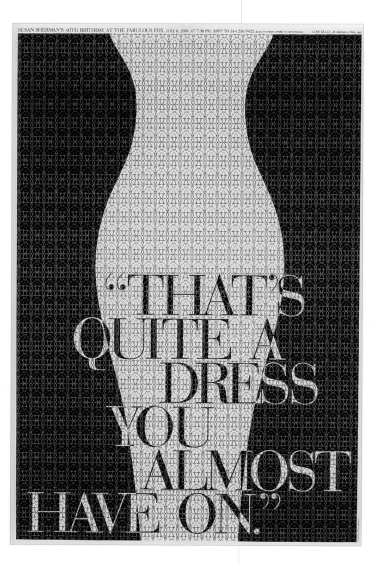

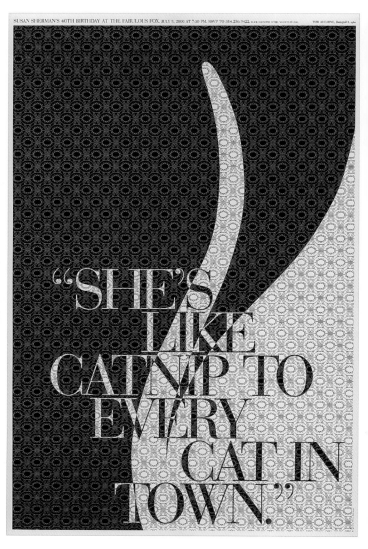

SUSAN SHERMAN 40TH
BIRTHDAY PARTY ▲ ▶

[STUDIO] Kuhlmann Leavitt, Inc.
[ART DIRECTOR] Deanna Kuhlmann-Leavitt
[DESIGNERS] Deanna Kuhlmann-Leavitt , Kathy Miller
[ILLUSTRATOR] Kathy Miller
[CLIENT] Susan Sherman
[PAPER] Monadnock Dulcet
[COLORS] 1, black
[SPECIAL PRODUCTION TECHNIQUES] Silk-screening
[SPECIAL FOLDS OR FEATURES] Rolled up in a tube
 and mailed

*"The historic Fox Theatre in St. Louis Grand Center Arts
District was built in 1929 at the height of the glam-
orous movie house era,"* says art director Deanna
Kuhlmann-Leavitt. *"Its storied past inspired the use of
memorable lines from cinema, ornate patterns and
the poster format."*

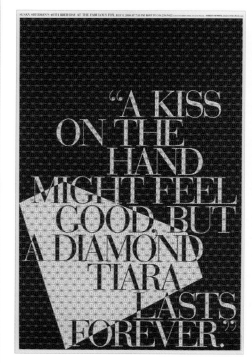

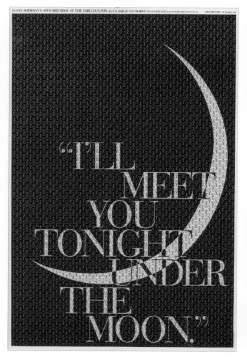

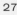

SUPER
·MEGA·
TELCO

*I work
seven days
a week!*

SUPER MEGA TELCO POSTER ▼

[STUDIO] Ralfinoe Creations
[ART DIRECTOR] Ralfinoe
[PHOTOGRAPHER] Ralfinoe
[CLIENT] Strangeland Productions
[CLIENT'S PRODUCT/SERVICE] Film Production Company
[PAPER] White poster stock

[COLORS] 2, process
[SIZE] 24" x 36" (61 x 91cm)
[PRINT RUN] 100
[TYPE] FF DIN (logo); Univers (body)
[SPECIAL PRODUCTION TECHNIQUE] Photocopied images
[SPECIAL COST CUTTING TECHNIQUE] Donated labor

"When asked to design the series of posters for the Independent Film Workers Unite, in which 'Super Mega Telco' is a propaganda backdrop, I wanted the design to be clean and simple," admits art director Ralfinoe. "At the same time, I wanted to arouse the viewers with wit and bring them back with curiosity and subtle humor, being that the film was poking fun at corporate culture."

A good designer is, in my mind, a good detective. There is no way to begin the case until all the pieces are analyzed, scrutinized and recognized. This means you must first understand who your client is, what the project is about and where is the direction of the piece is heading. Only then can a solid design solution be executed.

RALFINOE

[STUDIO] Fry Hammond Barr
[CREATIVE DIRECTOR] Tim Fisher
[DESIGNERS] Sean Brunson, John Logan
[COPYWRITER] John Logan
[PHOTOGRAPHER] John Bateman
[CLIENT] Valencia Community College
[COLORS] 1, match
[TYPE] Franklin Gothic

"This is a humorous way to show how the college can help one excel," says designer Sean Brunson.

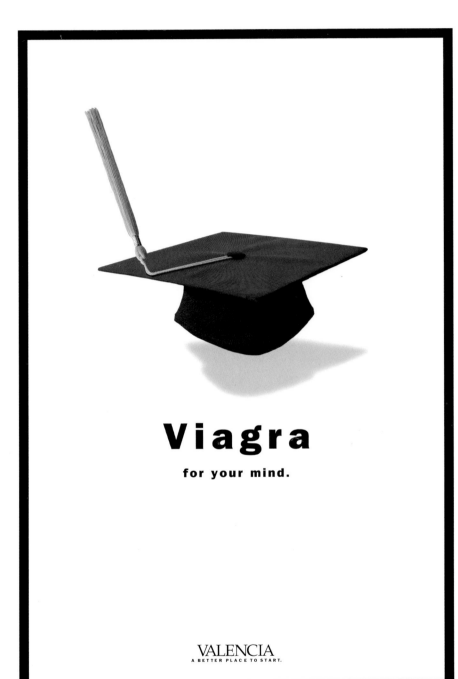

28

MASSIN: IN CONTINUO
POSTER ▲

[STUDIO] Mirko Ilic Corp.
[ART DIRECTOR] Mirko Ilic
[DESIGNERS] Mirko Ilic, Heath Hinegardner
[ILLUSTRATOR] Heath Hinegardner (diagrams)
[CLIENT] Futureflair
[PAPER] Scheufelen
[COLORS] 4, process
[TYPE] Frutiger, Champion

"The poster's subject, Robert Massin, designed La Cantatrice Chauve, which became his seminal work—and subsequently rare," says art director Mirko Ilic. "The poster reproduces every spread of this in miniature and includes diagrams on how to cut out and assemble your very own copy."

Maintaining the integrity of
a client's identity
while delivering
a message
through a relevant design
is our biggest challenge. We
strive to create a piece that is
unique in elements of design,
but if we are not held account-
able to the goals of the client,
we might hinder the piece
rather than benefit it.

RODNEY RICHARDSON

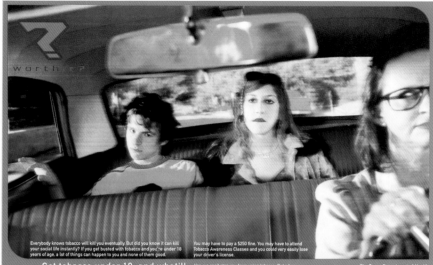

Everybody knows tobacco will kill you eventually. But did you know it can kill your social life instantly? If you get busted with tobacco and you're under 18 years of age, a lot of things can happen to you and none of them good.

You may have to pay a $250 fine. You may have to attend Tobacco Awareness Classes and you could very easily lose your driver's license.

Got tobacco under 18, and what'll get smoked is your driver's license.

Hey, we can't stop you from using tobacco. But when you consider what you're risking, you might want to reconsider.

The Texas Department of Health
1-800-345-8647

WORTH IT? POSTERS ▶

[STUDIO] Tuerff-Davis EnviroMedia Inc.
[ART DIRECTOR] Rodney Richardson/RARE Design
[DESIGNERS] Rodney Richardson, Jeremy Smith/
RARE Design
[PHOTOGRAPHER] Dennis Fagan (Austin, Texas)
[CLIENT] Texas Department of Health/Office of Tobacco
Prevention and Control
[CLIENT'S PRODUCT/SERVICE] Tobacco prevention
for teens
[PAPER] 105# white halopaque book
[COLORS] 4, process, plus one spot
[SIZE] 14" × 20¾" (36 × 53cm)
[PRINT RUN] 100,000 total; 30,000 of the "Smoked,"
70,000 of the "Ought to Be a Law"
[COST PER UNIT] $.20 (printing only)
[TYPE] DINSchrift: Mittleschrift (headline, body copy),
Serpentine (logotype)
[SPECIAL COST-CUTTING TECHNIQUE] Some royalty-free
imagery

"To a teen, every aspect of their life, every decision they
make is so intense, especially when it comes to their
social status," says art director Rodney Richardson.
"Even the small decisions, in their minds, can make or
break them—affect their level of cool. That's what we
wanted to appeal to—that idea that tobacco can ruin
your social life. Not just because of health reasons, not
because it's dirty, but because you could lose your inde-
pendence. There's really not anything more socially
traumatic to a teen than that."

The Texas Department of Health
1-800-345-8647

Because no matter what you read about the tobacco industry being put in its place, it will still find a way to target children. And children being children, tobacco is an easy sell.

But if you help enforce this law aimed at keeping minors from even buying tobacco, we've got a good chance of keeping them from using any kind of tobacco when they are most at risk to become long-term users. Or worse. Studies show that tobacco is often the gateway to using other, even more dangerous drugs.

So how about it, is it worth it to you?

Actually, there is. A new law designed to stop minors from purchasing and possessing tobacco products – SB55, and it's a law that needs you behind it.

There ought to be a law against it.

worthit?

30

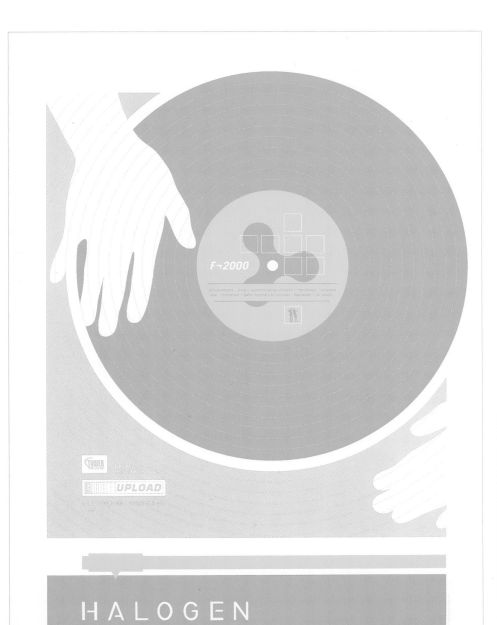

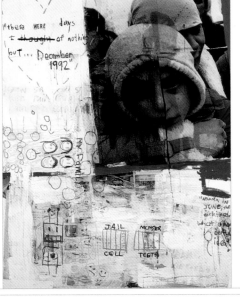

HALOGEN ▲

[STUDIO] BC Design
[ART DIRECTORS] David Bates, Mike Calkins
[DESIGNER] Pat Snavely
[ILLUSTRATOR] BC Design
[CLIENT] Nordstrom
[CLIENT'S PRODUCT/SERVICE] Retail clothing
[PAPER] Cougar opaque
[COLORS] 3, match
[PRINT RUN] 3,000
[COST PER UNIT] $1.50
[TYPE] Eurostyle, custom type

"This poster was created to announce a promotional compilation CD by the Nordstrom clothing line, Halogen. Bold color fields were used to illustrate a turntable and create impact, while referencing the environment of the club-oriented music on the disc. The area implied as the label of a record was then used to house specific information, such as the artists included," explain the artists from BC Design.

GRANDAD ▲

[STUDIO] Ryan Slone
[ART DIRECTOR/DESIGNER] Ryan Slone
[ILLUSTRATOR] Ryan Slone
[PAPER] Mixed media on canvas
[SIZE] 3' × 4' (90 × 120cm)

EVIL HAS A NAME POSTER ▼

[STUDIO] Louviere & Vanessa
[ART DIRECTOR/DESIGNER] Jeff Louviere
[ILLUSTRATOR] Jeff Louviere
[PHOTOGRAPHER] Vanessa Brown
[CLIENT] The American Dream
[CLIENT'S PRODUCT/SERVICE] Social complaining, activism
[PAPER] French Frostone
[COLORS] 1, match

[SIZE] 11" × 17" (28 × 43cm)
[PRINT RUN] 150
[COST PER UNIT] $.50
[TYPE] Rubbermaid and hand-manipulated type
[SPECIAL COST-CUTTING TECHNIQUES] Photography and illustrations were done in-house, and old-fashioned mechanicals were created to shoot the plate.

"The inspiration for this piece was all the citizens of New Orleans who have to deal with Louisiana politics in starting a business, permits, voting and taxes," says art director Jeff Louviere. "Dealing with City Hall is like pulling off a daring feat without a net, and this poster is a way to acknowledge that in a humorous way and act as a rallying cry. The French words at the top are the slogan for the French Revolution."

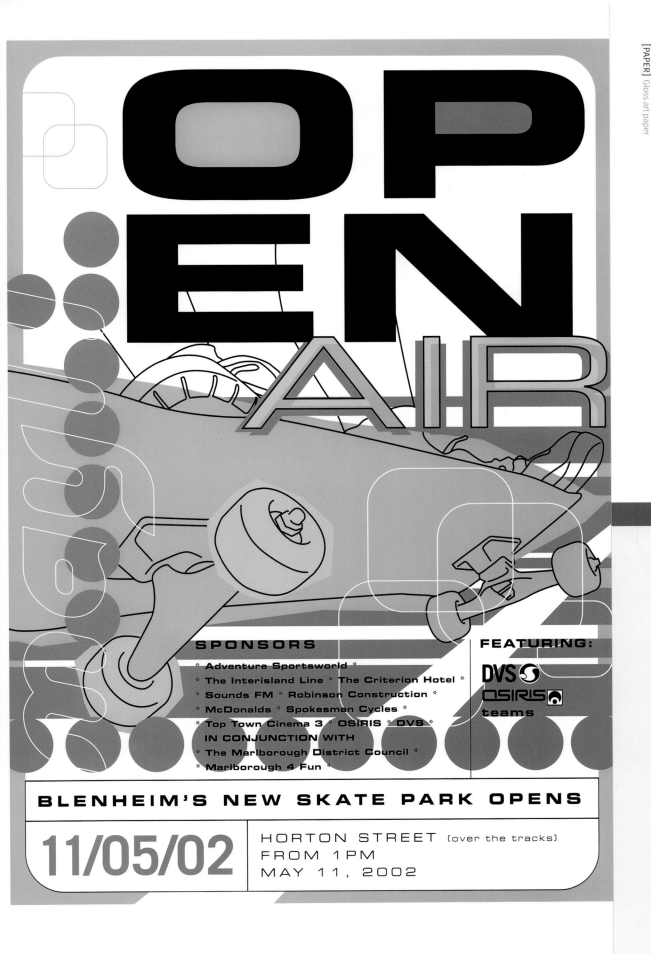

[STUDIO] Lloyds Graphic Design and Communication
[ART DIRECTOR/DESIGNER] Alexander Lloyd
[ILLUSTRATOR/PHOTOGRAPHER] Alexander Lloyd
[CLIENT] Local council
[CLIENT'S PRODUCT/SERVICE] Administering local
public services
[PAPER] Gloss art paper

[COLORS] 3, match
[PRINT RUN] 500
[TYPE] Eurostile Extended
[SPECIAL COST-CUTTING TECHNIQUE] The border illus-
tration was traced in Freehand over a digital photo of
the art director's nephew standing in a driveway.

"A new skate park facility was being officially opened and national pro skateboarders
were coming in for the event, so the poster had to reflect contemporary youth cul-
ture," says art director Alexander Lloyd.

33

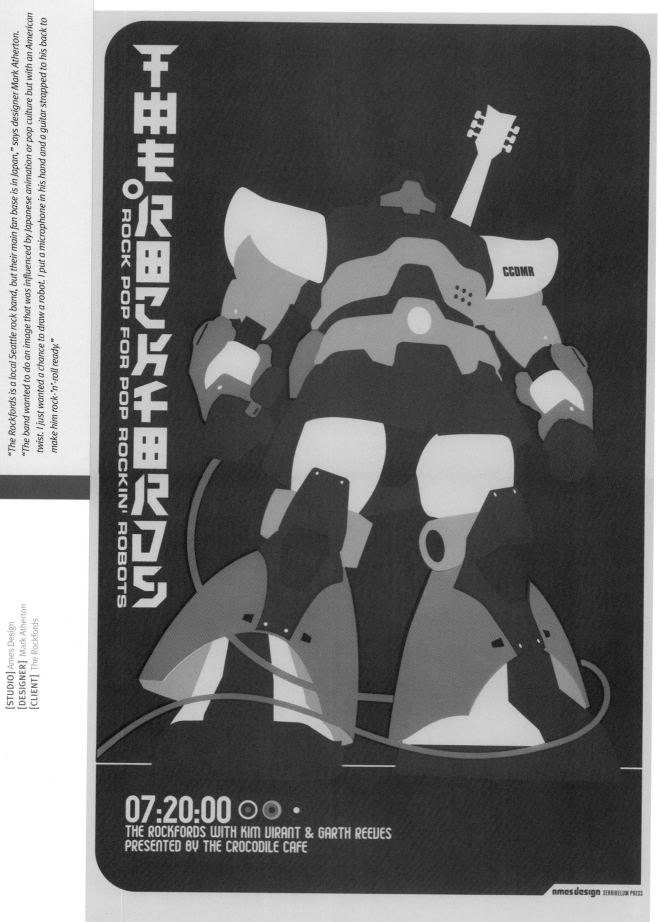

POP ROCKIN' ROBOT ▶

[STUDIO] Ames Design
[DESIGNER] Mark Atherton
[CLIENT] The Rockfords

"The Rockfords is a local Seattle rock band, but their main fan base is in Japan," says designer Mark Atherton. "The band wanted to do an image that was influenced by Japanese animation or pop culture but with an American twist. I just wanted a chance to draw a robot. I put a microphone in his hand and a guitar strapped to his back to make him rock-'n'-roll ready."

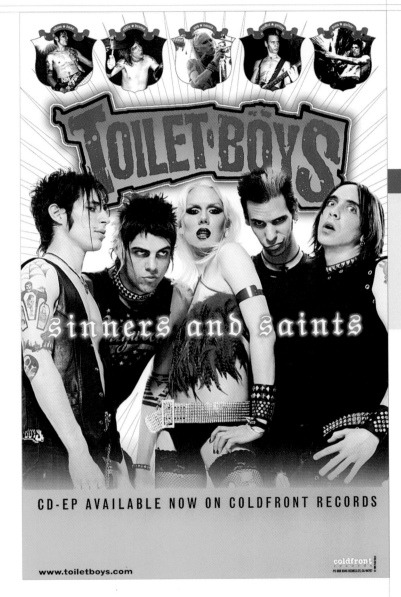

TOILET BOYS, SINNERS AND SAINTS ◄

[STUDIO] Edward ODowd Graphic Design
[ART DIRECTOR/DESIGNER] Edward ODowd
[PHOTOGRAPHER] Michael Halsband
[LOGO ILLUSTRATOR] Rocket/Monkey/Dome Productions
[CLIENT] Coldfront Records
[TYPE] Mathematical Pi, News Gothic
[COLORS] 4, process
[PRINT RUN] 3,000

"The record label was really insistent on showing that the group is hard-rocking and not just a bunch of 'pretty boys,'" says designer Edward ODowd. "I developed the 'regal' type crests across the top of the poster with sweaty, less flattering live photo insets to contrast with the clean studio photography that dominates most of the page. I feel the end result really gives a sense of what this band is about."

"IT IS BEAUTIFUL ...
THEN GONE" ▶

[STUDIO] Appetite Engineers
[ART DIRECTOR/DESIGNER] Martin Venezky
[ILLUSTRATOR/PHOTOGRAPHER] Martin Venezky
[CLIENT] Self
[COLORS] 2, match
[SIZE] 24" × 36" (61 × 91cm)
[PRINT RUN] 1,000
[TYPE] Found type
[SPECIAL TYPE TECHNIQUES] Handcrafted collage. Every
 letter and element was cut individually and hand placed.

*Designer Martin Venezky says that the inspiration of this
piece was the process of making and building. "In my
show at the San Francisco Museum of Modern Art, sever-
al of my collages are presented as original pasteups and
final printed pieces," he says. "I wanted to create an even
more elaborate one as a poster, and voilà!"*

Learn to love the process
itself, not just the result.
MARTIN VENEZKY

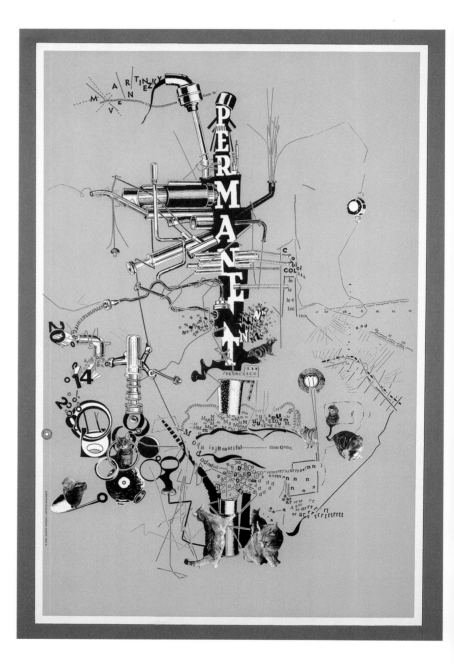

Before

After

curves

Over 2,400 locations worldwide. For more information visit curvesforwomen.com.

CURVES CAMERA
ADVERTISEMENT ▲

[STUDIO] CPS
[ART DIRECTORS] Erik Vervroegen, Soo Mean Chang
[COPYWRITER] Kerry Keenan
[PHOTOGRAPHER] Andy Spreitzer
[CLIENT] Curves International
[CLIENT'S PRODUCT/SERVICE] Weight-loss center

"The concept was to create an ad that would familiarize people with Curves diet center and get people interested in joining. We also wanted to do something different than all those typical weight-loss centers you see on the streets," explain art director Soo Mean Chang and copywriter Kerry Keenan. *"We redesigned the Curves logo to mimic the idea of losing weight. We created each letter of the word Curves to go from thick to thin, which conceptually worked well in the context of the ad."*

[STUDIO] Fry Hammond Barr
[CREATIVE DIRECTOR] Tim Fisher
[DESIGNER] Sean Brunson
[COPYWRITER] John Logan
[PHOTOGRAPHER] Ben Van Hook
[CLIENT] Valencia Community College
[COLORS] 4, process
[TYPE] Trixie

"The goal of the Lifemap program is to help students find their way through college. We wanted to use language they could relate to," designer Sean Brunson explains.

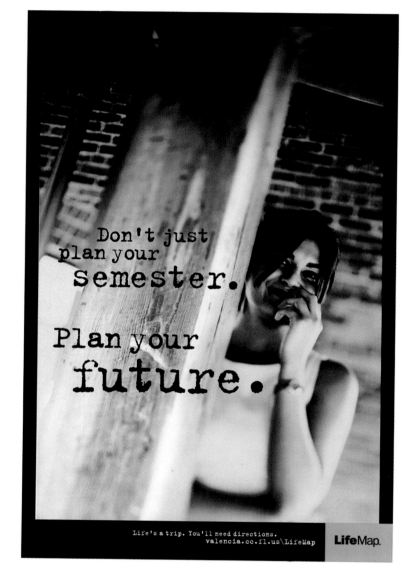

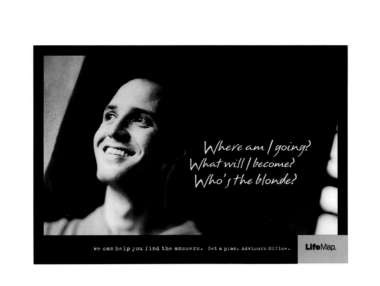

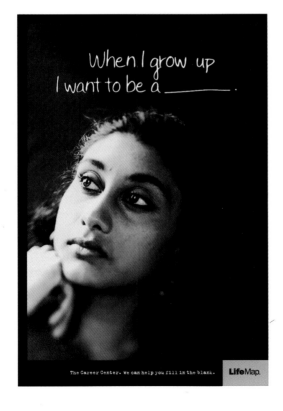

ART DIRECTORS CLUB POSTER ▶

[STUDIO] Platinum Design Inc.
[ART DIRECTOR/DESIGNER] Andrew Taray
[CLIENT] Art Directors Club of New York
[PAPER] Strathmore Elements 80 lb. text soft white
[COLORS] 3, match
[SIZE] 30" × 40" (76 × 102cm)
[TYPE] Champion
[INSPIRATION/CONCEPT] "The inspiration was paper—its old and new uses," Platinum Design's Mike Joyce explains.

DLD MILLENNIUM POSTER ▼

[STUDIO] Lemley Design Company
[ART DIRECTOR/DESIGNER] David Lemley
[CLIENT] David Lemley
[PAPER] Parchtone French 80#T
[COLORS] 5/1
[SIZE] 12" × 24" (30 × 61cm) (flat), 6" × 6" (15 × 15cm) (folded)
[PRINT RUN] 425
[TYPE] Franklin Gothic Family, Council, Times Roman, Senator

"The inspiration came from the realization that we would all awaken post new millennium and say, 'Hmmm, that was pretty neat. Now what's for breakfast?'" says art director David Lemley. "I wanted to share with my circle of influence the kinds of questions that float in my head. Although I consider the piece a success, many of the recipients asked questions like, 'Why did you send that out now?' and 'Wow, are you sure this is on-brand for the firm? My response is that a personal piece is intended to get you to ask questions of yourself."

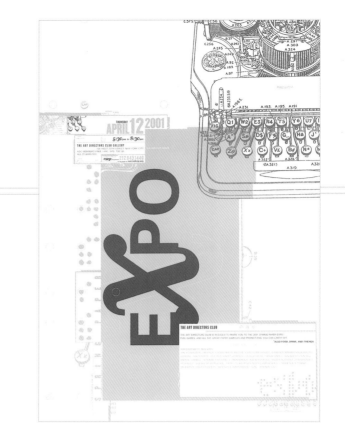

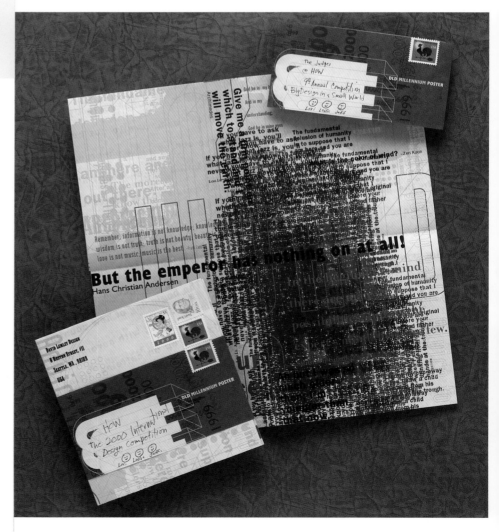

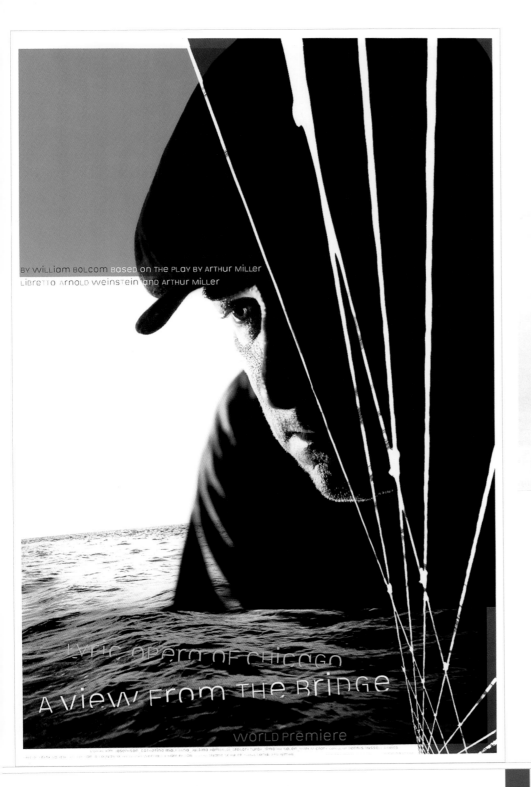

BY WiLLiam BOLCOM BaseD ON THE PLaY BY ARTHUR MiLLeR
LiBReTTO ARNOLD WeinsTein and ARTHUR MiLLeR

LYRIC OPERA OF CHICAGO
A VIEW FROM THE BRIDGE

WORLD PREMIERE

The most challenging aspect to any design is to be of the moment, not to retreat to nostalgia and solutions that have already been experienced. For when communication has been experienced, it shares its meaning with the past.
RICK VALICENTI

A VIEW FROM THE BRIDGE ▲

[STUDIO] Thirst and Thirstype.com
[ART DIRECTOR] Rick Valicenti
[DESIGNER] Thirst
[ILLUSTRATOR] Rick Valicenti
[PHOTOGRAPHERS] The Valicenti Bros.
[CLIENT] The Lyric Opera of Chicago
[CLIENT'S PRODUCT/SERVICE] Grand Opera
[PAPER] Gilbert Realm Smooth 80# Cover Natural
[COLORS] 4, process

[SIZE] 24" × 36" (61 × 91cm)
[PRINT RUN] 1,000
[TYPE] Barry Deck's Euneverse (available from Thirstype)
[SPECIAL PRODUCTION TECHNIQUE] The slight tint to the color helped add the illusion of a special color in the highlights. The entire image was printed 4-color process with a dense black substituting for process black.
[SPECIAL COST-CUTTING TECHNIQUE] "Our invoice displayed wages akin to a McDonald's employee."

Rick Valicenti lists the inspirations behind his design: "Arthur Miller's post-war play; the Italian Flag; the view from the bridge looks down to water turned to blood."

MAN...OR ASTROMAN? ▶

[STUDIO] Steven Cerio's Happy Homeland
[ART DIRECTOR] Dave Ewars
[DESIGNER] Steven Cerio
[ILLUSTRATOR] Steven Cerio

[CLIENT] Artrock
[TYPE] Hand-rendered
[COLORS] 8 flat, silkscreen
[PRINT RUN] 250

"My first good excuse to use a metallic Pantone ink," says designer Steve Cerio. "Type was all hand-drawn. Imagery takes a curtsy to cereal-box prize spots."

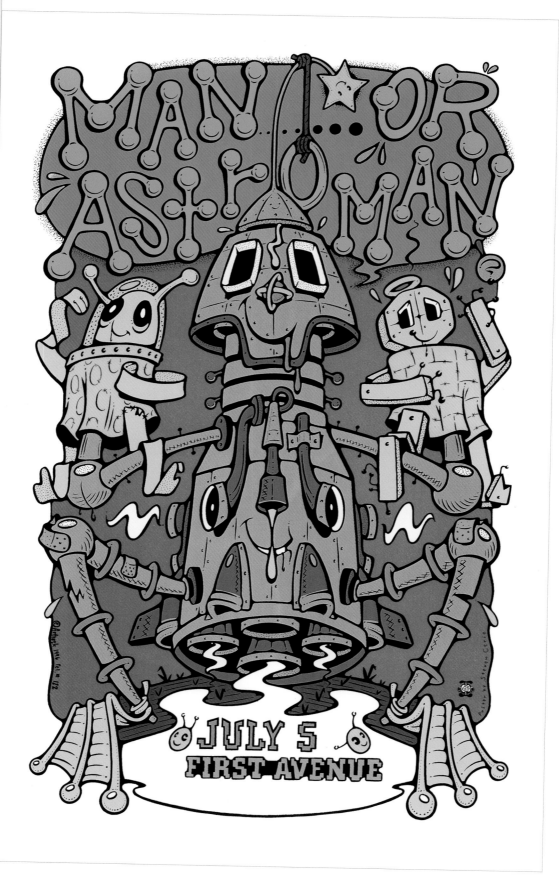

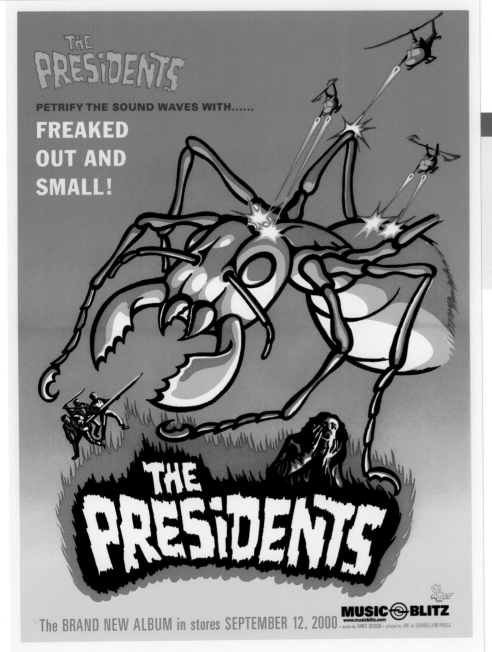

PRESIDENTS POSTER
"FREAKED OUT & SMALL" ◄

[STUDIO] Ames Design
[DESIGNER] Coby Schultz
[CLIENT] Music Blitz (Presidents)
[CLIENT'S PRODUCT/SERVICE] Online music promotion

"The title of the Presidents' new album, Freaked Out & Small, *was the inspiration for this piece," explains designer Coby Schultz. "There was no art direction, so where I could go was pretty wide open. I decided to take something small, an ant, and make it freaked out. B-movie posters from the 1950s and 1960s always made me laugh with how dramatic they were and always were better and more scary than the movies. I tried to re-create that drama and humor with this poster."*

STAR CANYON 5TH ANNIVERSARY FUND-RAISING POSTER ▶

[STUDIO] Group Baronet
[ART DIRECTOR] Meta Newhouse
[DESIGNER] Bronson Ma
[ILLUSTRATOR] Cathie Bleck
[CLIENT] AIDS Arms
[CLIENT'S PRODUCT/SERVICE] Public service
[PAPER] Conquerer Light Speck Dune 80 lb. cover
[COLORS] 4, match
[SIZE] 9¼" × 14¾" (24 × 38cm)
[PRINT RUN] 5,000
[TYPE] Ottomat, Latin Wide, Mesquite

"We wanted this piece to be fun yet inviting to reflect the personality of this upscale Dallas southwestern restaurant," designer Bronson Ma explains.

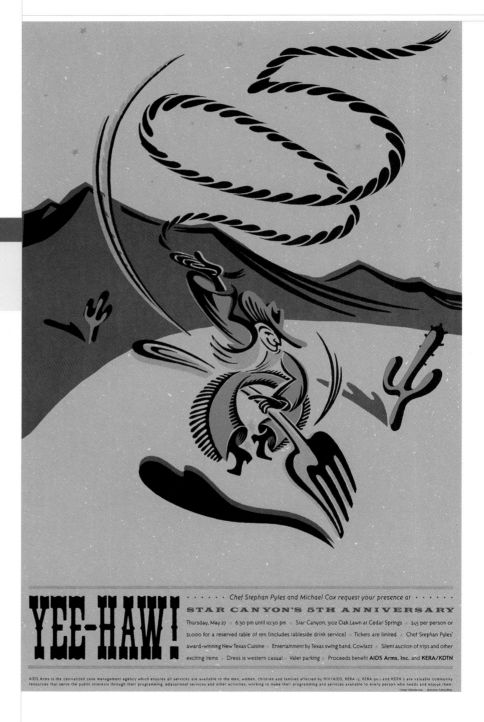

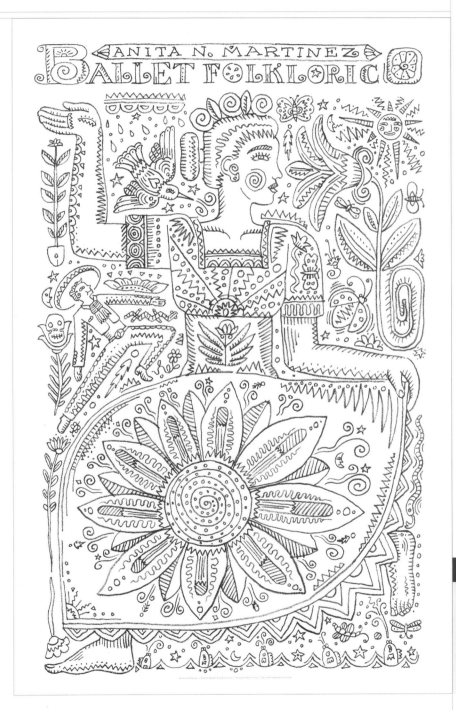

ANITA N. MARTINEZ BALLET FOLKLORICO POSTER ◄

[STUDIO] Dennard, Lacey & Associates
[ART DIRECTOR/DESIGNER] James Lacey
[ILLUSTRATOR] James Lacey
[CLIENT] Anita N. Martinez Ballet Folklorico
[CLIENT'S PRODUCT/SERVICE] Teaches Mexican and Latin culture through various forms of Latin folk dance
[PAPER] Gilbert Neutech PS
[COLORS] 1, match
[SIZE] 22" × 34" (56 × 86cm)
[COST PER UNIT] $1.50 each
[TYPE] hand-drawn
[SPECIAL PRODUCTION TECHNIQUES] "The original pencil drawing is only 4" × 5"," confesses art director James Lacey. "I scanned the drawing into the computer and enlarged it, giving the line some extra texture."
[SPECIAL COST-CUTTING TECHNIQUES] "One color worked for the concept and worked toward cost effectiveness," says Lacey, "and really helped sell the piece!"

Art Director Lacey says he drew inspiration from many aspects of the Folklorico's dance. "We visited the ANMBF studios and watched the costume makers and dancers in action. And in the spirit of teaching about Latin cultures, we made the poster interactive—a children's coloring poster."

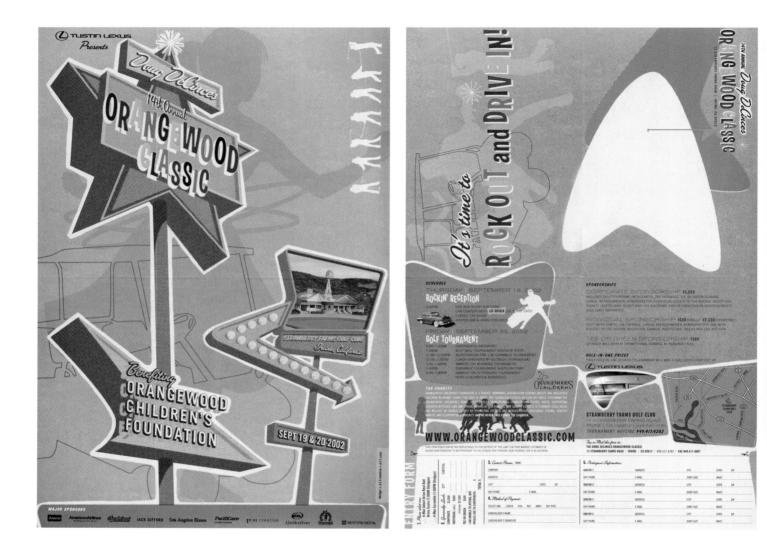

14TH ANNUAL DOUG DECINCES
ORANGEWOOD CLASSIC POSTER ▲

[STUDIO] p11creative
[ART DIRECTOR] Lance Huante
[DESIGNER] Alex Chao
[CLIENT] Orangewood Children's Foundation
[CLIENT'S PRODUCT/SERVICE] A nonprofit organization that helps abused and
 neglected children in Orange County, California
[PAPER] House 100 lb. text
[COLORS] 2, process
[SIZE] 17¾" × 13⅞" (45 × 35cm)
[PRINT RUN] 2,000
[COST PER UNIT] $.79
[TYPE] Las Vegas, Trade Gothic
[SPECIAL PRODUCTION TECHNIQUE] Halftone dots give the piece an offset, grainy look.

The concept was "aged retro," explains p11creative's Leigh White. "Because this event had a 1950s theme, we didn't want to make a cliché out of it. It would've been really easy to make a tribute to the Fonz, a black-and-white-checkered and poodle-skirt easy solution. Instead, we chose some silhouettes and space-age shapes that were more indicative of the decade. Some of the best layouts and type design are from the 1950s, so we wanted to create this piece as if it really had been produced in that era and looked like it had faded in a trunk somewhere for decades. It was more of an homage than a mere interpretation of a client-driven theme—which, incidentally, was a perfect match for the demographic that was targeted to receive this piece."

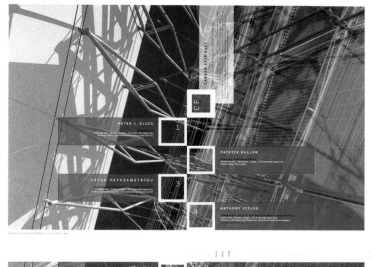

IIT POSTER SERIES ◄

[STUDIO] Thirst and Thirstype.com
[ART DIRECTOR] Rick Valicenti
[DESIGNERS] Rick Valicenti and Chester
[ILLUSTRATORS] Various
[PHOTOGRAPHERS] Various
[CLIENT] IIT School of Architecture
[CLIENT'S PRODUCT/SERVICE] Educational institution
[PAPER] Gilbert Realm 100#T
[COLORS] 4, process plus one match
[SIZE] 24" × 36" (61 × 91cm)
[PRINT RUN] 2,000
[TYPE] Gridnik, FF DIN
[SPECIAL TYPE TECHNIQUES] Simplicity and ease of access
[INSPIRATION/CONCEPT] Architecture as design and information.

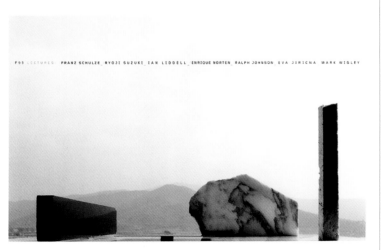

> The challenging thing about designing posters is posting them. You put a few up—they get ripped down. Sometimes, if you're lucky, a graffiti artist will add some nice things to it.
> FELIX SOCKWELL

PARSONS POSTERS ▶

[STUDIO] felixsockwell.com
[ART DIRECTOR] E. Kim
[DESIGNER] Felix Sockwell
[ILLUSTRATOR] Felix Sockwell
[CLIENT] Parsons
[CLIENT'S PRODUCT/SERVICE] Art education
[PAPER] Reeves BFK
[COLORS] 3, match
[SIZE] 30" × 40" (76 × 102cm)
[PRINT RUN] 95
[TYPE] Clarendon, Trade Gothic Bold Condensed 20, Azkidenz Grotesk
[SPECIAL PRODUCTION TECHNIQUE] Hand silk-screening
[INSPIRATION/CONCEPT] Art and design education

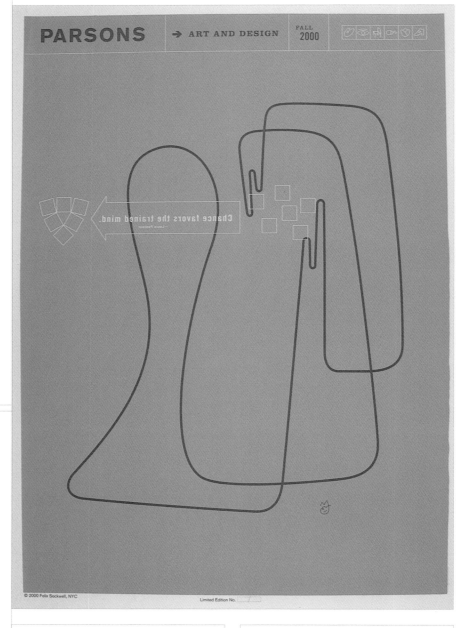

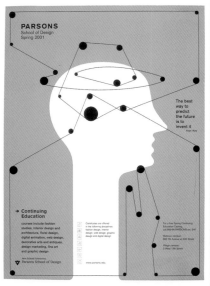

48

winston-salem symphony 2000/2001 season

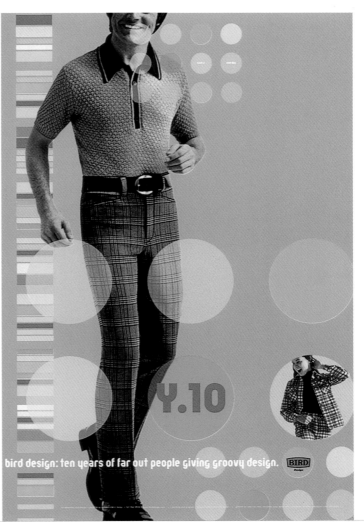

Y.10

bird design: ten years of far out people giving groovy design. BIRD Design

WINSTON-SALEM SYMPHONY ▲

[STUDIO] Henderson Bromstead Art Co.
[ART DIRECTOR] Hayes Henderson
[DESIGNER] Will Hackley
[ILLUSTRATOR] Will Hackley
[CLIENT] Winston-Salem Symphony
[PAPER] Neenah
[COLORS] 4, process
[SIZE] 19" × 36" (48 × 91cm)
[PRINT RUN] 8000
[COST PER UNIT] $0.40
[TYPE] Helvetica
[INSPIRATION/CONCEPT] Free-form, single-line drawings intended to be light and energetic

BIRD DESIGN POSTER ▲

[STUDIO] BIRD Design
[ART DIRECTOR/DESIGNER] Peter King Robbins
[PAPER] Fox River Starwhite Sirius 130# cover and 80# text
[SIZE] 18½" × 28" (47 × 71cm)
[TYPE] BayerArchiType/House Industries, Chalet
[SPECIAL COST-CUTTING TECHNIQUES] Involving vendors in the project both as partners in the promotion and/or as a credit

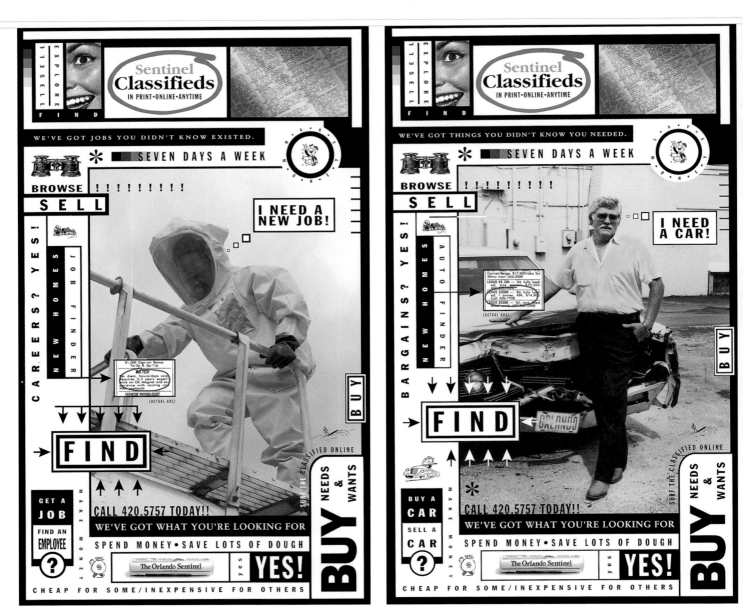

SENTINEL CLASSIFIED POSTER SERIES ▲

[STUDIO] Fry Hammond Barr
[ART DIRECTOR] Tim Fisher
[DESIGNER] Sean Brunson
[CLIENT] *The Orlando Sentinel*
[CLIENT'S PRODUCT/SERVICE] Newspaper
[COLORS] 1, match
[TYPE] Helvetica
[INSPIRATION/CONCEPT] "We wanted to show lots of stuff, like what you'd find in the classifieds," says designer Sean Brunson.

[STUDIO] Ames Design
[ART DIRECTOR/DESIGNER] Coby Schultz
[ILLUSTRATOR] Coby Schultz
[PRINTER] Joe Barilla

[CLIENT] Pearl Jam
[TYPE] Hand rendered
[COLORS] 3, flat, silkscreen
[PRINT RUN] 1,000

Art director Coby Schultz wanted to do another "as-nonrock-as-possible" poster. "Yield, the title of Pearl Jam's 1998 album, can take many forms," he says. "In this case, a farmer 'yields' a crop. Do they farm in Montreal or Toronto? Doubt it—did a tractor anyhow."

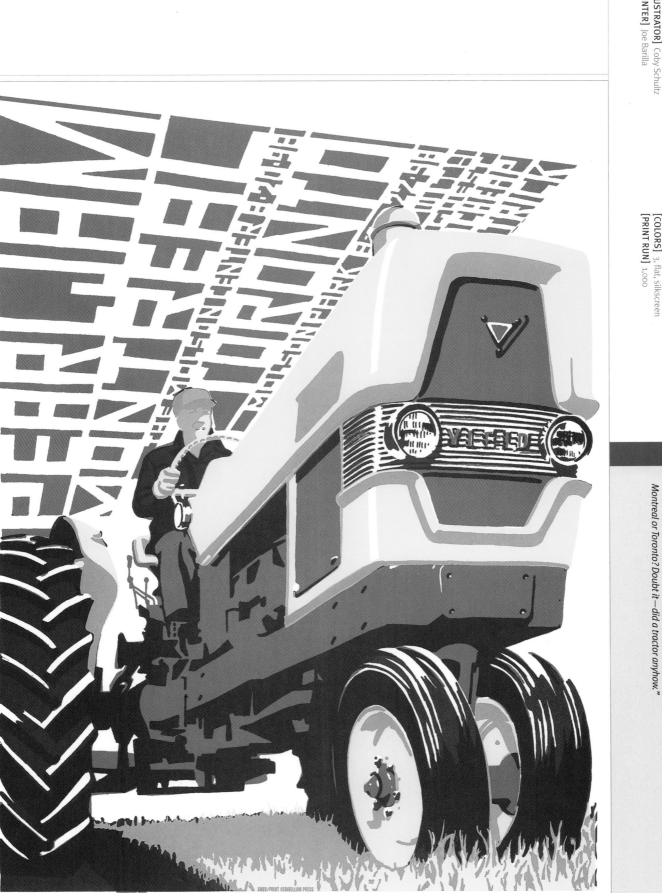

ART REAL POSTERS ▶

[STUDIO] Templin Brink Design
[ART DIRECTOR] Joel Templin
[DESIGNER] Brian Gunderson
[ILLUSTRATOR] Brian Gunderson
[CLIENT] Art Real
[CLIENT'S PRODUCT/SERVICE] Screenprinting
[PAPER] Sappi, Somerset Matte Cover 63 lb.
[COLORS] 4, match
[SIZE] 23" × 38" (58 × 96cm)

[PRINT RUN] 300 sets
[TYPE] Akzidenz Grotesk
[SPECIAL PRODUCTION TECHNIQUES] "The screen printing allowed us to really push the overprinting of colors, as well as the slight crustiness of illustration and typography."
[SPECIAL COST-CUTTING TECHNIQUES] "Since the piece was a promotion for Art Real, we dealt only with film and paper costs. The screen printing was free."

"We originally designed a set of promotional cards that then spawned the Art Real Posters. The original cards had no real design limitations, so we decided to push and play as hard as we could," says designer Brian Gunderson.

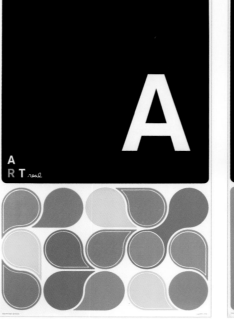

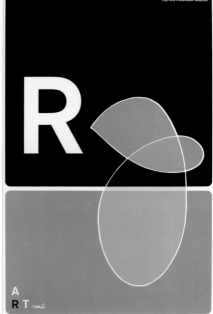

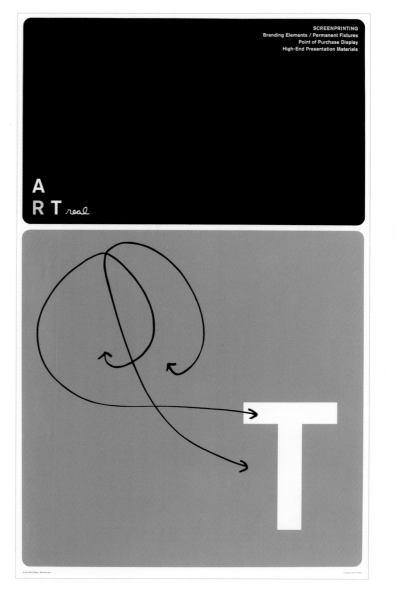

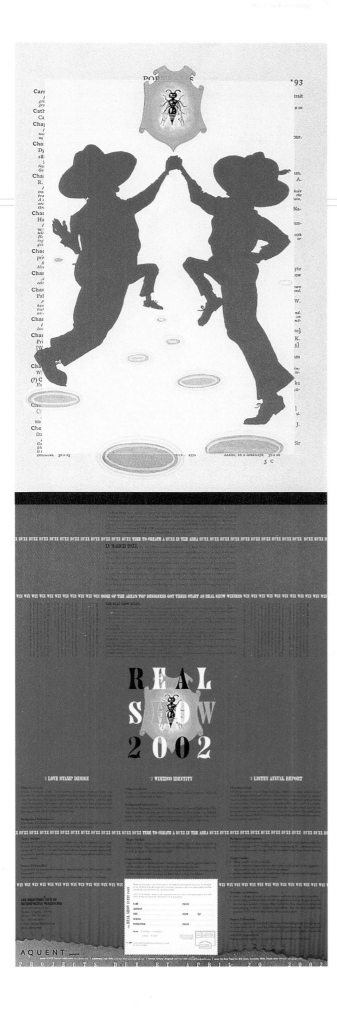

REAL SHOW CALL FOR ENTRIES POSTER ◄

[STUDIO] Fuszion Collaborative
[ART DIRECTOR/DESIGNER] John Foster
[ILLUSTRATOR] Leigh Wells
[CLIENT] Art Directors Club of Metropolitan Washington
[PAPER] Coronado Stipple
[COLORS] 4, process
[SIZE] 12" × 36" (30 × 91cm)
[PRINT RUN] 1,000
[COST PER UNIT] All donated
[TYPE] Juniper, Adobe Garamond, News Gothic
[SPECIAL TYPE TECHNIQUE] The copy is run at a variety of angles and rags, and the type size fluctuates in the same line of copy.
[SPECIAL PRODUCTION TECHNIQUE] Custom dyes for the folder pockets and a shorter bind-in registration form

"The Real Show is a student competition in which three 'real-world' projects that have been tackled by the area's top design firms are laid out as their original creative briefs for the students to create solutions," explains art director John Foster. *"Leigh Wells' brilliant illustration captures youth, yearning, accomplishment and achievement as well as the beginning of the career climb in a very sophisticated manner. The 'buzz' references in the copy were inspired by her inclusion of a bee in the imagery. I tried to let the great image be the focus while incorporating all the necessary copy."*

53

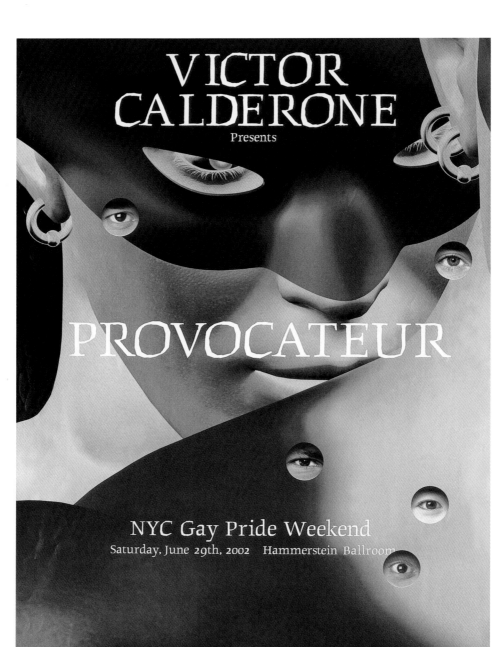

PROVOCATEUR POSTER ▲

[STUDIO] Mirko Ilic
[ART DIRECTOR] Mirko Ilic
[DESIGNERS] Mirko Ilic, Heath Hinegardner
[ILLUSTRATOR] Mirko Ilic, Lauren Denapoli (3D artist)
[CLIENT] Victor Calderone
[CLIENT'S PRODUCT/SERVICE] Music/dance event
[COLORS] Varies from 4-color to tri-tone metallics, match and process
[TYPE] Logotype Script produced in-house and hand-drawn scratchboard type

"For a New York gay-pride weekend event, the Provacateur theme needed a dark, voyeuristic look," art director Mirko Ilic explains.

"ONE" PROMOTIONAL POSTERS ◄

[STUDIO] Howry Design Associates
[ART DIRECTOR] Jill Howry
[DESIGNERS] Calvin Jung, Todd Richards, Ty Whittington, Clay Williams
[ILLUSTRATOR/PHOTOGRAPHERS] Calvin Jung, Todd Richards, Ty Whittington, Clay Williams and various others
[CLIENT] Fong & Fong Printers and Lithographers
[CLIENT'S PRODUCT/SERVICE] Prints and Lithographers
[PAPER] Yupo
[COLORS] 6 plus varnish
[SIZE] 11½" × 17½" (29 × 44cm)
[PRINT RUN] 5,000
[TYPE] Bembo, Helvetica, Helvetica Condensed, Letter Gothic, Little Dotties, Trade Gothic
[SPECIAL PRODUCTION TECHNIQUES] Printed using UV inks on a Heidelberg 6 Color UV press

"Fong & Fong, a Sacramento printing company, needed a new promotional piece to promote their experimental printing techniques and capabilities of printing on synthetic, translucent stocks," says designer Todd Richards. "The audience was the design community. We developed a concept featuring a layered packaging approach using a translucent stock. The four layers represented surface, body, mind and spirit. When combined, the layers created one being, thus the concept 'One.' The body idea was derived from translucent membrane quality of the stock and became a vehicle to build on the concept of peering into the soul. The four posters were housed in a blue plastic 'body bag' and sealed with a custom-printed adhesive label."

55

[STUDIO] Fry Hammond Barr
[CREATIVE DIRECTOR] Tim Fisher
[DESIGNER] Sean Brunson
[COPYWRITER] Tom Kane
[PHOTOGRAPHER] John Deeb
[CLIENT] Hard Rock Live
[CLIENT'S PRODUCT/SERVICE] Live music venue
[COLORS] 4, process
[SIZE] 24" × 30" (61 × 76cm)
[TYPE] Helvetica Black, Mason Alt., Bell Gothic

"We tried to promote the event by tapping into bands that are well known now but got their start at Hard Rock Live," designer Sean Brunson explains. *"We wanted the type to visually reflect the bands' styles—for example, Bell Gothic for Creed—and wanted the headlines to play off the bands' names and fame."*

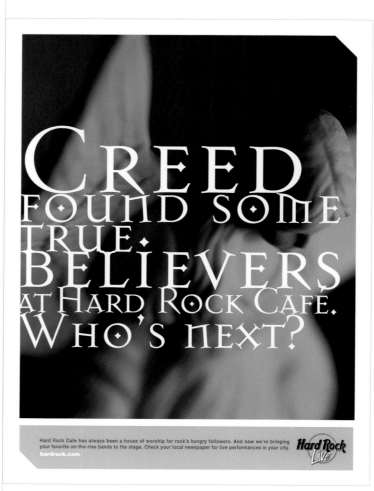

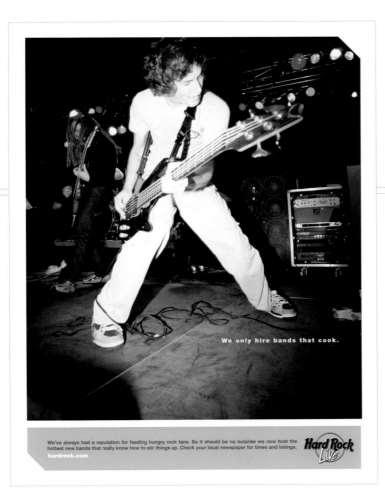

We only hire bands that cook.

We've always had a reputation for feeding hungry rock fans. So it should be no surprise we now host the hottest new bands that really know how to stir things up. Check your local newspaper for times and listings. hardrock.com

Hard Rock Live

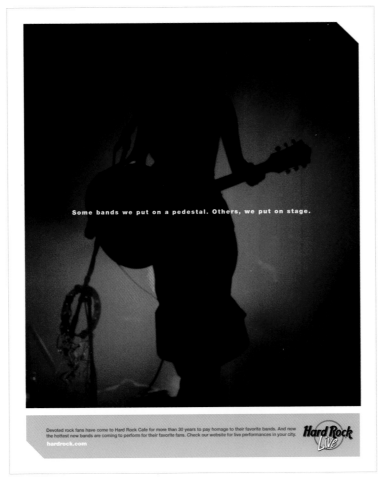

Some bands we put on a pedestal. Others, we put on stage.

Devoted rock fans have come to Hard Rock Cafe for more than 30 years to pay homage to their favorite bands. And now the hottest new bands are coming to perform for their favorite fans. Check our website for live performances in your city. hardrock.com

Hard Rock Live

BIG ASS SALE POSTERS ▶

[STUDIO] Fuszion Collaborative
[ART DIRECTOR/DESIGNER] John Foster
[CLIENT] Shake Your Booty
[CLIENT'S PRODUCT/SERVICE] Retail Shoes and Accessories

[TYPE] Trade Gothic, Puffin, Circus
[SPECIAL TYPE TECHNIQUES] Old-style book fonts that are roughed up and thrown all over the place, with modern fonts running at all angles; subtle craziness.

"Shake Your Booty's Bi-Annual Big Ass Sale is more than just a sale in the fashionable neighborhoods it sells its shoes in. It's an event!" exclaims art director John Foster. "The materials need to generate excitement in the young, funky trendsetters that shop there. They need to be simple, direct, action packed and sophisticated all at the same time. For this sale, I had an illustration that I had been waiting to use for a 'call out' type of piece. The rough style of that image drove the treatment for the rest of the components. By the way, photocopier textures are only passé when used poorly—just like any element that becomes 'trendy' design. I'm hoping to inspire a local comeback as these are hung all around town. Then I can move on to that 'minimal' look I've heard so much about."

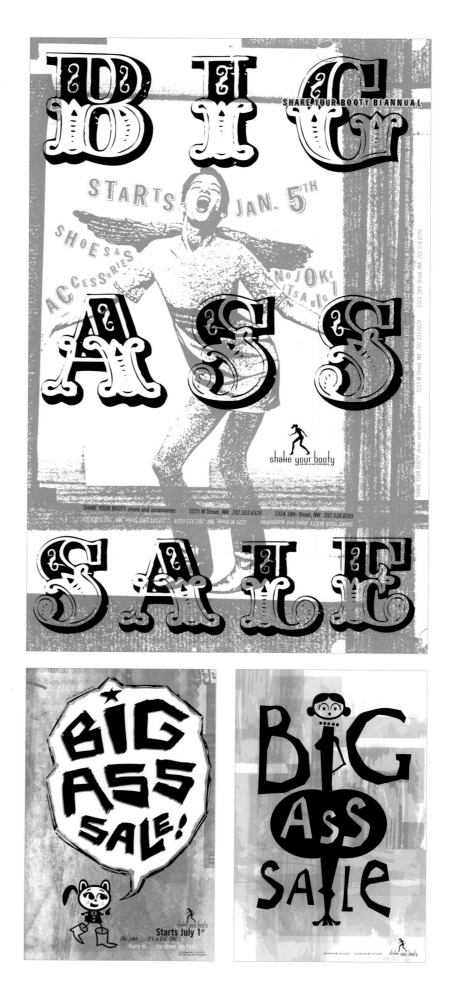

58

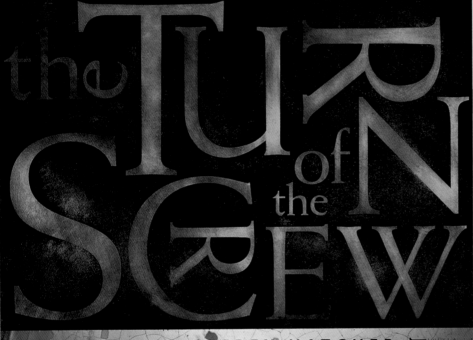
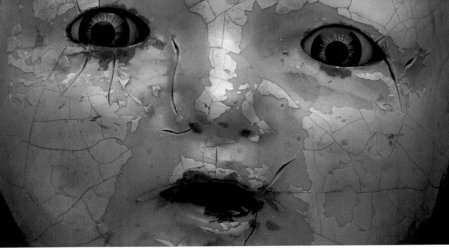

TURN OF THE
SCREW POSTER ◄

[STUDIO] Cyclone Design
[DESIGNERS] Traci Daberko, Dennis Clouse
[CLIENT] Intiman Theatre

"We wanted to visually prepare the audience for this chilling story of lust and possession," say the designers.
"The best way to express 'loss of innocence' was through this powerful image of a doll's face."

VIDEO WORLD ▲ ▶

[STUDIO] CPS
[ART DIRECTORS] Erik Vervroegen, Soo Mean Chang
[DESIGNER] Molly Sheahan
[COPYWRITER] Kerry Keenan
[PHOTOGRAPHER] Andy Spreitzer
[CLIENT] Video World
[CLIENT PRODUCT/SERVICE] New York video-rental
 store and dubbing services

"The concept was to show the breadth and depth of the selection available at Video World," says art director Soo Mean Chang. *"The poster's type is reminiscent of the type used to display the credits on movie posters."*

FROM PEARL HARBOR TO NOSFERATU. VIDEO WORLD

FROM CABARET TO JAWS. VIDEO WORLD

FROM THE BONE COLLECTOR TO BOOGIE NIGHTS. VIDEO WORLD

Focus first on designing functional, legible pieces. The fancy eye candy can only be applied after the basic usability of a piece is developed. Always favor function over form, even if it is a 51/49 percent mix.

RYAN DONAHUE

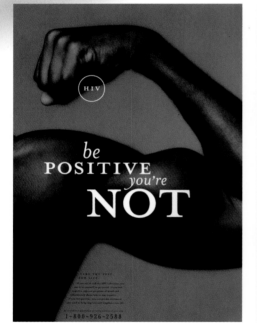
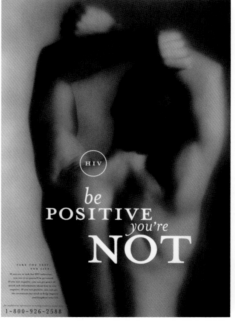
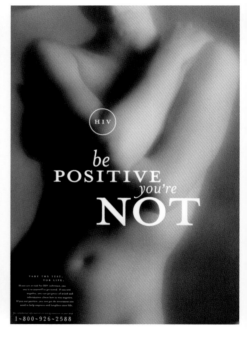

BE POSITIVE YOU'RE NOT ▶

[STUDIO] Oliver, Russell & Associates
[ART DIRECTOR] Ryan Donahue
[DESIGNER] Robert Barnes/Freelance
[CLIENT] Idaho AIDS Foundation
[CLIENT'S PRODUCT/SERVICE] HIV testing and awareness
[PAPER] 80# Sterling Ultra Gloss Cover
[COLORS] 4, process plus gloss aqueous coating
[SIZE] 10" × 14" (25 × 36cm)
[PRINT RUN] 4,000 (English), 1,000 (Spanish)
[COST PER UNIT] Approximately $.78 each
[TYPE] Mrs Eaves (Emigre)
[SPECIAL COST-CUTTING TECHNIQUE] Stock photography

"We wanted to create a piece that focuses on a healthy self-image and appeals to the viewer's sense of self-respect," explains art director Ryan Donohue. "The piece avoids any unnecessary reference to death or disease, as we felt it would cause the viewer to ignore the message. It is such a classic human condition to be uncomfortable thinking of one's own mortality."

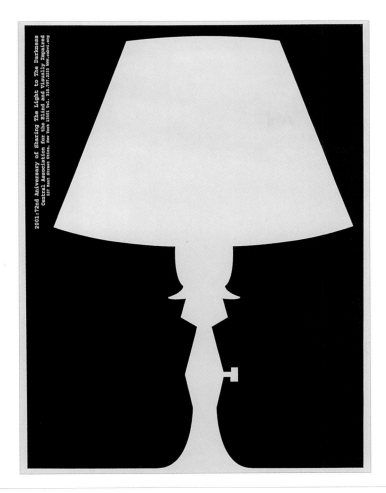

CENTRAL ASSOCIATION FOR THE BLIND AND VISUALLY IMPAIRED POSTER ◄

[DESIGNER] Permsak Suwannatat
[ILLUSTRATOR] Permsak Suwannatat
[CLIENT] Central Association for the Blind and Visually Impaired
[CLIENT'S PRODUCT/SERVICE] Not-for-profit organization
[PAPER] Card stock
[COLORS] 1
[SIZE] 16" × 22" (41 × 56cm)
[TYPE] Courier

"Seen as an art piece, this poster reflects the spirit and philosophy of the organization," explains independent designer Permsak Suwannatat.

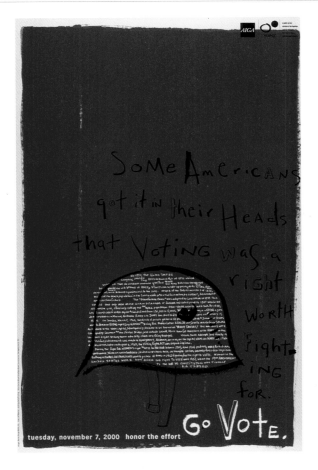

VOTE POSTER ◄

[STUDIO] Werner Design Werks, Inc.
[ART DIRECTOR] Sharon Werner
[DESIGNERS] Sharon Werner, Sarah Nelson
[ILLUSTRATOR] Sharon Werner
[COPYWRITER] Jeff Mueller/Floating Head
[PRINTER] Daily Printing, Minneapolis
[CLIENT] AIGA
[PAPER] Yupo
[COLORS] 4, match
[SIZE] 18" × 27" (46 × 69cm)
[TYPE] Helvetica, hand drawn
[SPECIAL PRODUCTION TECHNIQUES] Hand-drawn art, overprinting

"AIGA asked designers from the different chapters around the country to design a voting initiative poster," says art director Sharon Werner. *"We knew we wanted the design to be thought provoking and impactful and luckily for us, the copywriter, Jeff Mueller, came up with some really good concepts. All that was left was for us to make it look good. We researched voting rights statistics and added those to give the poster another level of meaning. The design we kept very simple and bold for maximum impact."*

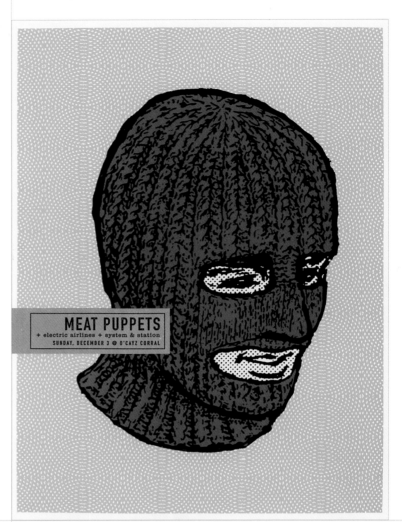

MEAT PUPPETS POSTER ▶

[STUDIO NAME] Planet Propaganda | Aesthetic Apparatus
[DESIGNER] Michael Byzewski / Planet Propaganda | Aesthetic Apparatus
[CLIENT] True Endeavors
[COLORS] 3, silk-screened

NINTENDO PARTY POSTER ▶

[STUDIO] Lemley Design Company
[ART DIRECTOR] David Lemley
[DESIGNERS] Lemley Design staff
[CLIENT] Nintendo
[CLIENT'S PRODUCT/SERVICE] Video game hardware manufacturing
[PAPER] French Parchtone
[COLORS] 6 match plus a three-press-pass blind emboss detail
[SIZE] 18" × 36" (46 × 91cm)
[PRINT RUN] 1,000
[TYPE] Hand lettering, Council

"Big Bad Voodoo Daddy was the surprise entertainment for the party at The Biltmore Hotel's Crystal Ballroom," explains art director David Lemley.

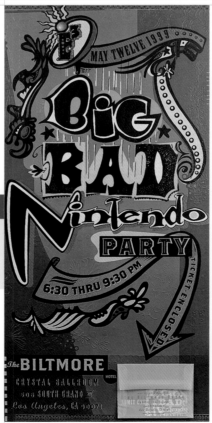

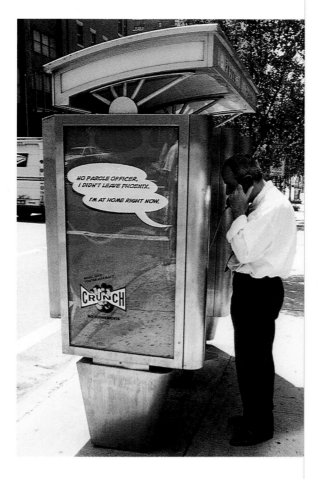

EAVESDROPPING CAMPAIGN ◄ ▼

[STUDIO] DiMassimo Brand Advertising
[CREATIVE DIRECTOR] Mark DiMassimo
[ASSOCIATE CREATIVE DIRECTORS] Julie Lamb Marsh, Phil Gable
[ART DIRECTOR] Sandra Scher
[COPYWRITER] Rob Berland
[CLIENT] Crunch Fitness
[CLIENT'S PRODUCT/ SERVICE] Gyms
[COLORS] 4, process
[SIZE] 26" × 50" (66 × 127cm)
[TYPE] Comic (headline and payoff); Franklin Gothic (tag line)

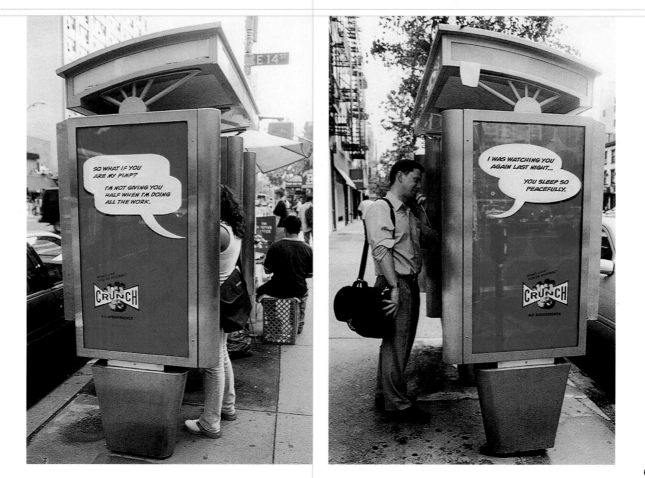

AIGA PORTFOLIO 1-ON-1
POSTER ▶

[STUDIO] Sussner Design Company
[DESIGNER] Derek Sussner
[COPYWRITER] Eddie Prentiss/Brainco
[CLIENT] AIGA Minnesota
[CLIENT'S PRODUCT/SERVICE] Portfolio One-On-One is an event for graphic design students.
[PAPER] 20# white bond copier paper
[SIZE] 22" × 31" (56 × 79cm)
[PRINT RUN] 100
[COST PER UNIT] $1.95
[TYPE] HelveticaNeue Bold Condensed (text); HelveticaNeue Condensed Oblique (AIGA description); hand-lettering (headline)
[SPECIAL PRODUCTION TECHNIQUES] Hand lettering, image enlarged on photocopier, Adobe Photoshop collage

Designer Derek Sussner says the inspiration was mail-order ads from 1950s and 1960s hunting magazines such as Sports Afield *and* Outdoor Life. *"These ads sold pets through the mail—dogs, quail, rabbits and 'live' seahorses—what other kind would you want to buy?—and my favorite, $15 squirrel monkeys. Monkeys are funny. They make people laugh. Plus, there's a sort of a trained-monkey-that-does-tricks-in-the-street-for-spare-change feeling that a student can relate to."*

Make sure you are having fun in a non-design hobby from time to time.

DEREK SUSSNER

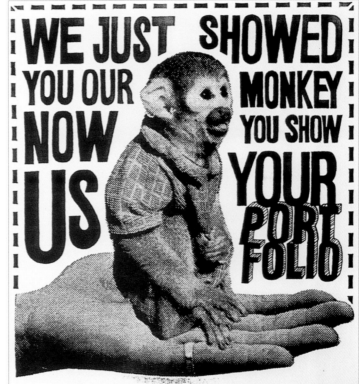

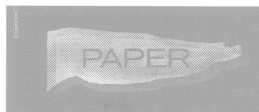

ART DIRECTORS CLUB POSTER ◄

[STUDIO] Platinum Design, Inc.
[ART DIRECTOR/DESIGNER] Kelly Hogg
[ILLUSTRATOR/PHOTOGRAPHER] Kelly Hogg
[CLIENT] Art Directors Club of New York
[PAPER] Scheufelen Job Parilux
[COLORS] 3, match
[SIZE] 20" × 30" (51 × 76cm)
[TYPE] Helvetica Extended, Bauer Bodoni Poster Italic

"The inspiration behind this poster is the game of rock, paper, scissors as a visual for the paper expo," Platinum Design's Vickie Peslak explains.

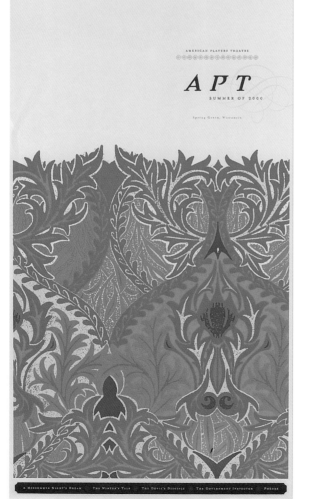

APT 2000 POSTER ◄

[STUDIO] Planet Propaganda
[CREATIVE DIRECTOR] Dana Lytle
[DESIGNER] Jennifer Katcha
[CLIENT] American Players Theatre
[CLIENT'S PRODUCT/SERVICE] Outdoor theater
[PAPER] Mohawk Tomohawk Crème White 80# Cover
[COLORS] 6
[SIZE] 20" × 36" (51 × 91cm)
[TYPE] Mrs Eaves, Alembic

PAD

The Guide to Ultra-Living
BY MATT MARANIAN

Photographs by Jack Gould
Illustrations by Susan Tudor

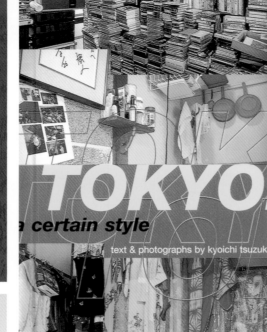

TOKYO
a certain style

text & photographs by kyoichi tsuzuki

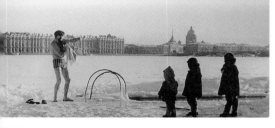

33
MOMENTS OF HAPPINESS
St. Petersburg Stories
INGO SCHULZE

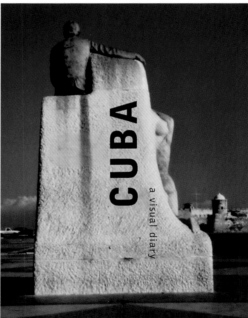

CUBA
a visual diary

photographs by Evan Dion

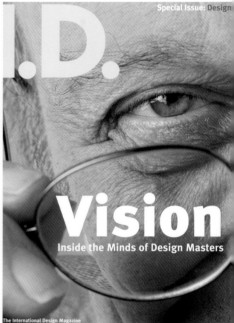

I.D.

Special Issue: Design

Vision
Inside the Minds of Design Masters

The International Design Magazine

PRAGMATISM

A READER

Edited and with an Introduction by
Louis Menand

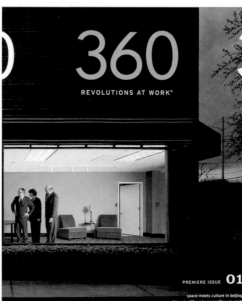

360
REVOLUTIONS AT WORK™

PREMIERE ISSUE 01

space meets culture in beijing
geof kern's different perspective on work
getting a look at the real whirled in michigan

EMERY REVES
THE ANATOMY OF PEA

EDITORIAL

*Now that book and magazine superstores are the norm, a con-
sumer can be face-to-cover with thousands of editorial products
in one afternoon of shopping. The design crowd, as we all know,
always judges a book by its cover—so the pressure editorial
designers put on themselves to create the package that pops is
immense.*

*Over 40 designers rose to the challenge in this section, offer-
ing book cover, interior and magazine pages that percolate to
the top of any Books-Я-Us superstore stock.*

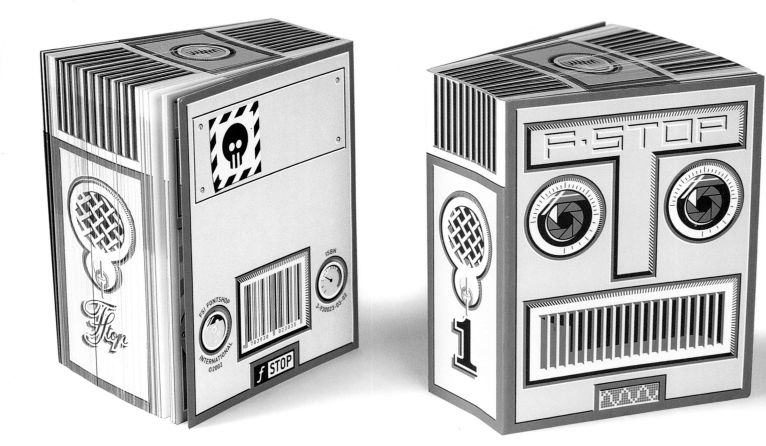

F-STOP ▲

[STUDIO] Sagmeister Inc.
[ART DIRECTOR] Stefan Sagmeister
[DESIGNER] Mathias Ernstberger
[ILLUSTRATOR] Mathias Ernstberger
[PHOTOGRAPHERS] Various
[CLIENT] Fontshop International
[PAPER] Matte coated
[COLORS] 4, process
[SIZE] 4¾" × 3¾" × 2 (12 × 9 × 5cm), 478 pages
[PRINT RUN] 10,000
[TYPE] FF DIN
[SPECIAL PRODUCTION TECHNIQUES] Tampon Print-
ing on all three edges

"F-Stop is the first book of a series featuring royalty-free photo collections photographed by well-known designers like David Carson and April Greiman," says designer Stefan Sagmeister. "Every book is a little fat object, a complete head, visible from all sides including the fore edge. The entire series will be composed of different heads, visualized in different illustrative and photographic styles and will hopefully make for a nice collection. The dividing pages always offer a view inside the head of F-Stop, just as our collection offer views inside the designers/photographers heads. The names of the designer/photographers are featured as running text along every spread."

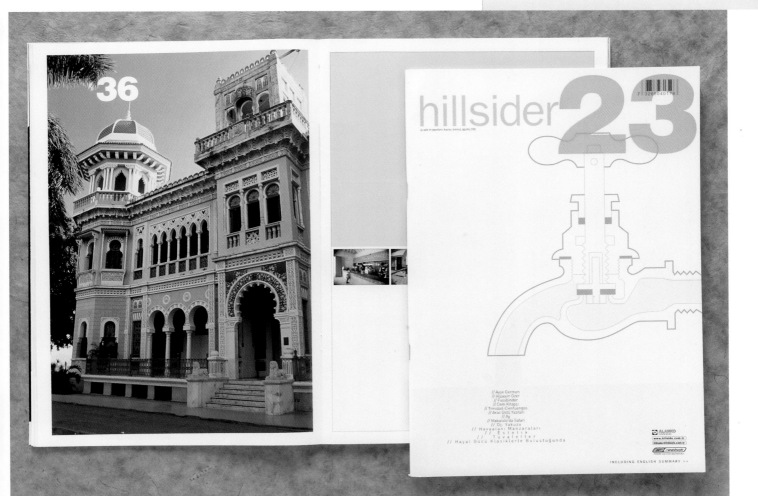

Don't approach design subjects and briefs with the first or most common ideas. One should consider how to handle it in a different manner or how to make it more impressive. When the ideas are applied in such a process, you look as if through someone else's eyes and think "What would I say if I had seen this?" This approach is the first step to having an envied, successful portfolio.

ALI GUREVIN

HILLSIDER 23 ▲

[STUDIO] Zebra Design Factory
[ART DIRECTOR/DESIGNER] Ali Gurevin
[ILLUSTRATOR] Asligul Akin
[PHOTOGRAPHERS] Senol Altun, Sarioz & Baran, Tolga Cebi, Devrim Yalcin, Duygu Arseven
[CLIENT] Hillside Clubs
[CLIENT'S PRODUCT/SERVICE] Tourism and entertainment group
[PAPER] Zanders 115 gr. (pages), Zanders 250.gr. uncoated (cover)
[COLORS] 4, process plus 2 match and lacquer (cover); 4, process uncoated (pages)
[SIZE] 9¾" × 13½" (25 × 35cm)
[PRINT RUN] 10.000
[COST PER UNIT] $1.56 (print cost)
[TYPE] FF DIN, light and bold (text), Trade Gothic, light and bold (headlines)

BEAUTIFUL AMERICAN ROSE GARDENS ▼

[STUDIO] Platinum Design, Inc.
[ART DIRECTOR] Victoria Stamm
[DESIGNER] Arya Vilay
[PHOTOGRAPHER] Richard Felber
[CLIENT] Clarkson Potter
[CLIENT PRODUCT/SERVICE] Book publishing company
[COLORS] 4, process
[TYPE] Mrs Eaves, Stone Sans
[SPECIAL PRODUCTION TECHNIQUE] Laminated covers
[SPECIAL COST-CUTTING TECHNIQUE] One-color line
 drawings at the end of the book are printed on
 uncoated stock.

*"The inspiration for this piece was the beauty and impact
of roses," Platinum Design's Vickie Peslak explains.*

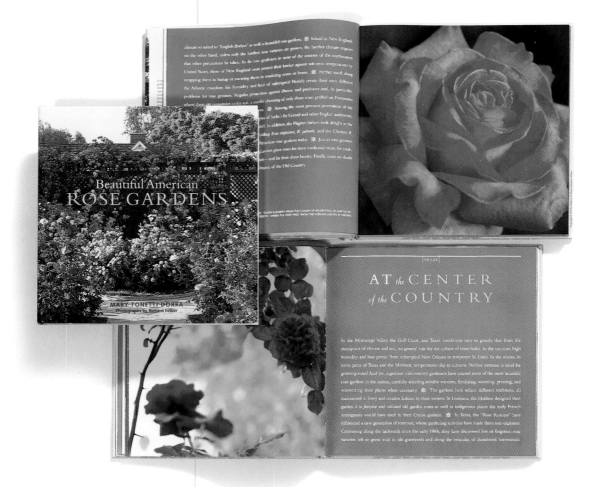

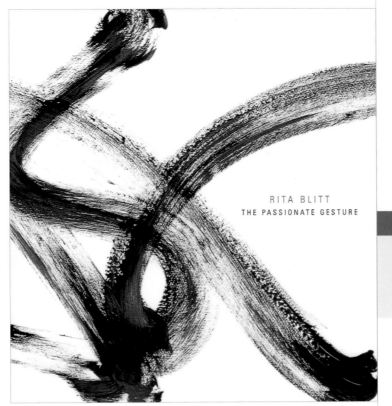

RITA BLITT
THE PASSIONATE GESTURE

RITA BLITT: THE PASSIONATE GESTURE ◄

[STUDIO] Willoughby Design Group
[ART DIRECTOR] Ann Willoughby
[DESIGNER] Deb Tagtalianidis
[ILLUSTRATOR] Rita Blitt
[CLIENT] Rita Blitt, painter and sculptor
[PAPER] 100 lb. Utopia One balanced white dull text (text
 and dust jacket); 80 lb. Confetti purple text (end sheets)
[COLORS] process
[SIZE] 7¾" × 8¼" (20 × 21cm)
[PRINT RUN] 5,000 first edition; 300 limited edition with
 sculpture
[COST PER UNIT] $49 retail
[TYPE] Goudy OldStyle, Zurich

"Like Rita's art, we designed The Passionate Gesture *to be a piece of artwork itself—beautiful, small in size and simply stated," say the designers of Willoughby Design Group.*

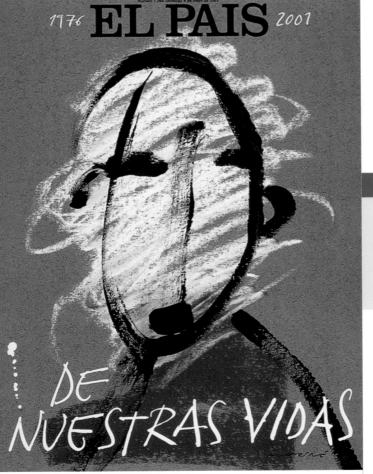

1976 **EL PAIS** 2001

DE NUESTRAS VIDAS

EL PAIS DE NUESTRAS VIDAS ◄

[STUDIO] OMB Diseño y Comunicación Visual/OMB Design and
 Visual Communication
[ART DIRECTOR/DESIGNER] Oscar Mariné Brandi
[ILLUSTRATOR] Oscar Mariné Brandi
[CLIENT] Diario El Pais
[CLIENT'S PRODUCT/SERVICE] El Pais 25th Anniversary
[PAPER] Offset
[COLORS] 4
[SIZE] 8" × 10½" (21 × 27 cm)
[TYPE] Hand-drawn
[SPECIAL TYPE TECHNIQUE] Direct painting

"The image represents an unknown reader of El Pais, *someone with his head full of information and who has been reading* El Pais *for the last 25 years.* El Pais, *the leading newspaper in Spanish political environment, inspired a step forward in the transition to democracy in Spain," says designer Oscar Mariné Brandi.*

POWERFUL PAGE DESIGN ▼

[STUDIO] F&W Publications
[ART DIRECTOR/DESIGNER] Lisa Buchanan
[CLIENT] HOW Design Books, an imprint of F&W Publications
[CLIENT PRODUCT/SERVICE] Magazine and book publishing

[COLORS] 4, process and match
[SIZE] 8½" × 11" (22 × 28cm)
[SPECIAL PRODUCTION/TYPE TECHNIQUES] The silver-printed, die-cut cover has a red gel filter that masks colored type.

"The inspiration for this book was the layering designers use every day in page-layout programs such as QuarkXPress, specifically the grid system," designer Lisa Buchanan says. "The entire concept of the book was based on a theme of 'revealing,' from the cover to the endpapers. The red transparency on the cover masks colored type on the title page, resulting in an optical illusion that hides warm-colored letters and makes cool-colored letters appear black. When the book is closed, the inside text shows only a partial reading of the subhead—'To design your vision'—but once you open the cover, you see colors that were hidden, and the full subtitle is revealed—'Top designers lay out their concepts to reveal their inspirations.' There's also a surprise encoded message on the back endpaper of the book."

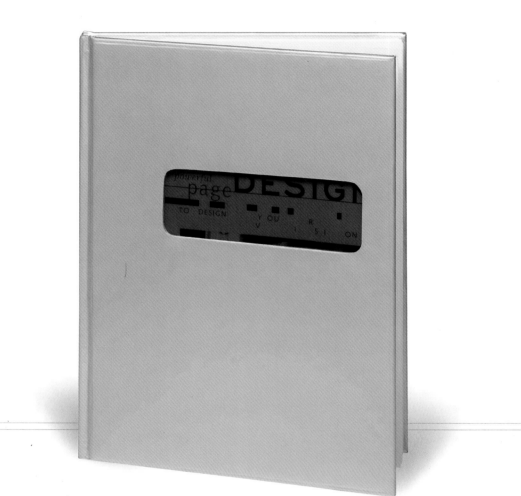

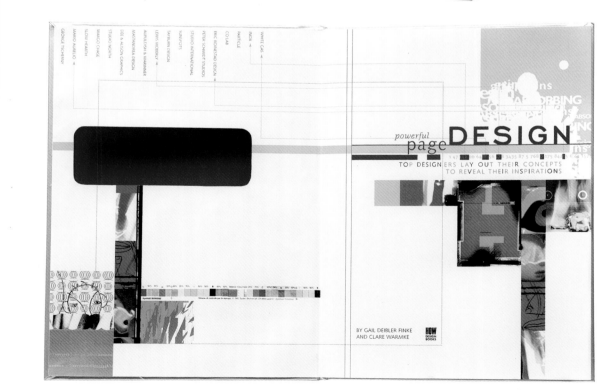

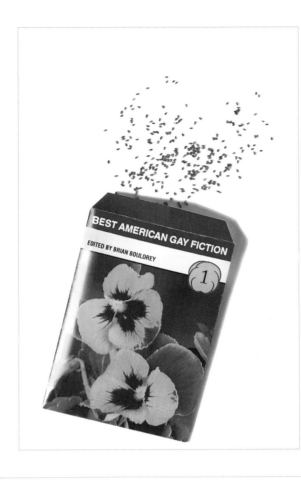

BEST AMERICAN GAY FICTION (SERIES) ◄ ▼

[STUDIO] Little Brown and Company
[ART DIRECTOR] Michael Ian Kaye
[DESIGNER] John Fulbrook III
[PHOTOGRAPHERS] Marc Tauss (Book 2); Dan Bibb (Books 1 and 3)
[CLIENT] Little Brown and Company
[COLORS] 4, process
[PRINT RUN] 10,000 per title
[TYPE] Helvetica, Odeon, Univers, Quorum

"I ran around town on these projects, gathering card decks, seeds, curly twigs, etc. It was great to be able to put a fag on the cover of a gay book—and to make use of such humorous props," says designer John Fulbrook III. "Michael, the art director, and I worked together closely to make these come to life, and I wish we could have continued, but my publisher no longer wanted the series. I guess fruitcake or fairies would have been next. I am glad people 'got it,' and even happier that the concept made it to press."

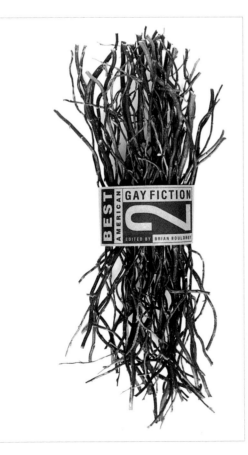

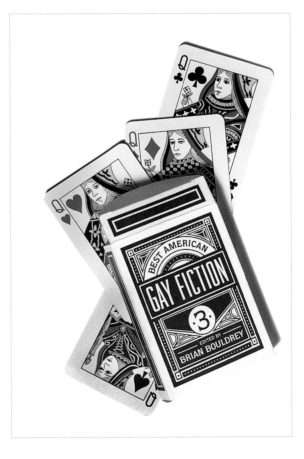

360 MAGAZINE ▶

[STUDIO] Grant Design Collaborative
[ART DIRECTOR/DESIGNER] Grant Design Collaborative
[ILLUSTRATORS] Ann Field, Giselle Potter, Paul Wearing and
 Anders Wenngren
[PHOTOGRAPHERS] Jerry Burns, Justin Guariglia, Geof Kern,
 Brian Miller, Mike Monahan, Maria Robledo and Sonny
 Williams
[CLIENT] Steelcase, Inc.
[CLIENT'S PRODUCT/SERVICE] Commercial furnishings
[PAPER] Uncoated
[SIZE] 9" × 11" (23 × 28cm)
[PRINT RUN] 125,000
[COST PER UNIT] Approximately $1.50
[TYPE] Interstate (text), Clarendon (headlines)
[SPECIAL TYPE TECHNIQUE] Combining several languages
 in the international case studies to give the publication a
 global feel
[SPECIAL FOLDS/FEATURES] Gatefold cover with perforat-
 ed "postcards from the edge" on the inside back cover.
 The "Intermission" photo essay appeared in the exact
 center of the publication to provide the reader with a
 visual rest from the text-driven case studies.

"Working within a functional context, Grant Design Collaborative created a content-driven publication supported by edgy but relevant visuals," say the designers. "We wanted to present the rich, educational content in a refreshingly provocative manner. 360 was designed primarily as an international, visual magazine which is supported by informative, concise and engaging case studies and project essays."

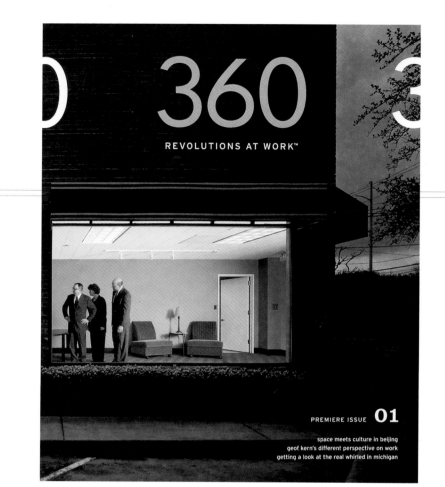

The ultimate challenge is always the same: how to utilize design as a strategic element in communicating the client's products or services in the most effective manner. Our process at Grant Design Collaborative is atypical. We attempt to remove layers of unnecessary visual elements in order to present the "essence" of a brand, product, mission or service.

BILL GRANT

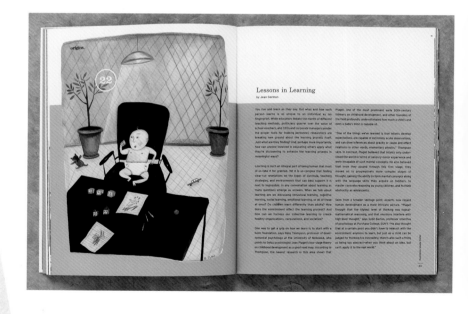

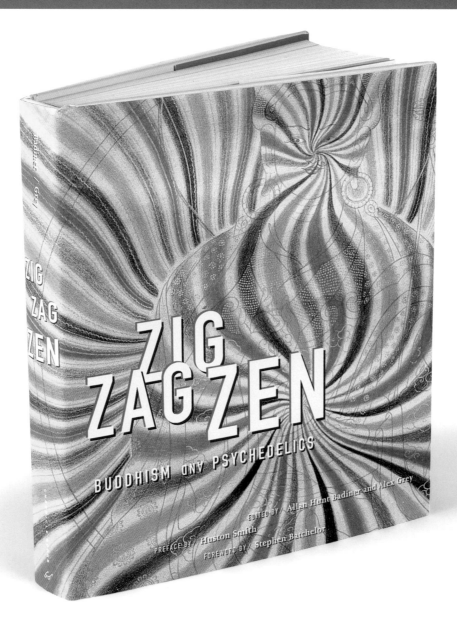

ZIG ZAG ZEN, BUDDHISM AND PSYCHEDELICS ▲

[STUDIO] Chronicle Books
[ART DIRECTOR/DESIGNER] Sara Schneider
[CLIENT] Chronicle Books
[CLIENT PRODUCT/SERVICE] Book publisher
[PAPER] 157 gsm Japanese matte art
[COLORS] 4, process
[SIZE] 7¾" × 9¼" (20 × 24cm)
[PRINT RUN] 7,500
[TYPE] FF DIN Engschrift, Joanna
[SPECIAL TYPE TECHNIQUE] The staggered, overlapping type and appearance of upside-down words further the concept that there's more than just one linear form of expression.

"Zig Zag Zen *is a book of essays and art pieces that explore the connection between psychedelic drugs and Buddhism,*" art director Sara Schneider says. *"The design draws from the content's prevalent themes to reinforce the anthology's recurring concepts. These concepts include the idea of an interconnectedness of all things, altered impressions leading to clarity and the development of multiple levels of being. The cover image appears to be a psychedelic swirl of color until you realize the chaos clearly organizes itself into the form of a Buddha."*

NEXT ATHLETE, FARM LIFE ▶

[STUDIO] ESPN, The Magazine
[DESIGN DIRECTOR] Peter Yates
[ART DIRECTOR/DESIGNER] Henry Lee
[ILLUSTRATORS] Henry Lee (Next Athlete Logo, Farm Life Logo)
[PHOTOGRAPHERS] Andrew Eccles, John Huet, Michael O'Brien
[CLIENT] ESPN, The Magazine
[CLIENT'S PRODUCT/SERVICE] Sports magazine
[PAPER] 36 lb., uncoated, Norset
[COLORS] 4, process
[SIZE] 10" × 12" (24 × 30cm)
[PRINT RUN] 1.5 million
[COST PER UNIT] $3.99 (newsstand price)
[TYPE] Trade Gothic, Lust Pure (Farm Life Story)

"We envisioned the Next logo being a hybrid of anti-trendy and high design," says design director Peter Yates. "The Gothic typeface successfully provides weighty, Old World contrast against the modern, erratic, ultrafine lines. The hectic speed-induced hairlines also reach out and grab the images, pulling them into the drama of the Next ideal. All of this results in a unified moment for the reader." Says art director Henry Lee, "The lighthearted Farm Life design, with its arrows, stars and lowercase type, reflects the energy and constant flow of these young athletes who are striving to step up into the major leagues. Together the photos also capture the essence of these young athletes in the midst of the shifting of players, situations, cities and the pure fun of the game."

We know our readers appreciate the visual feast the magazine provides their senses. Our job is to sustain their excitement from issue to issue and, thus, our challenge is to design a magazine that is constantly dynamic, progressive and unexpected—like the sports we cover.

PETER YATES

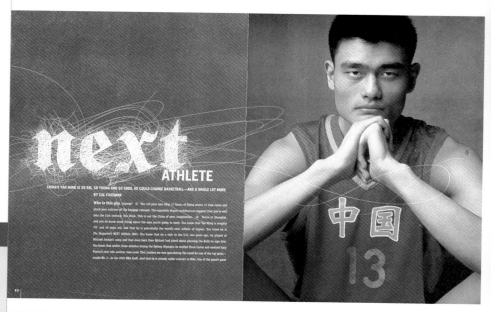

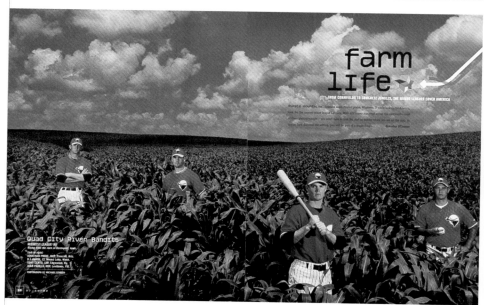

> Utilize typography, photography and illustration, pacing and scale to create dynamic pages.
>
> MIKE JOYCE

SPACE.COM ILLUSTRATED MAGAZINE LAYOUTS ▼

[STUDIO] Platinum Design Inc.
[ART DIRECTOR/DESIGNER] Mike Joyce
[CLIENT] Hearst Custom Publishing/Space.com
[CLIENT PRODUCT/SERVICE] Magazine
[COLORS] 4, process
[SIZE] 9" × 10⅞" (23 × 28cm)
[TYPE] Helvetica Bold, Eurostile, Flixel

"The inspiration for this design was outer space and NASA technology," art director Mike Joyce says. *"Our challenge was to create a visually interesting magazine in a saturated market."*

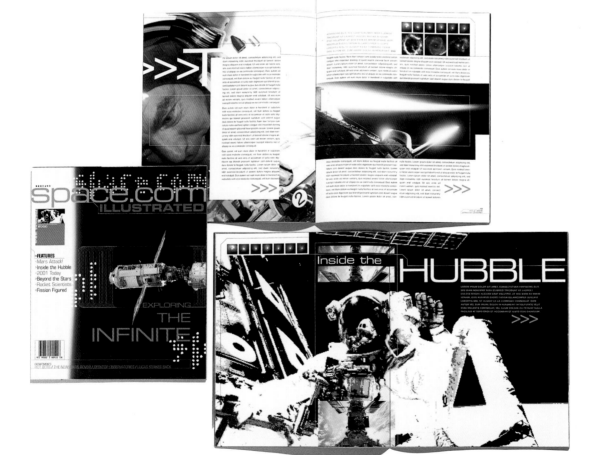

THE INVISIBLE ART ▶

[STUDIO] Chronicle Books
[ART DIRECTOR/DESIGNER] Azi Rad
[CLIENT] Chronicle Books
[CLIENT PRODUCT/SERVICE] Book publisher
[PAPER] 157 gsm matte art
[COLORS] 4, match and process (with metallic case)

[SIZE] 11¾" × 10" (30 × 25cm)
[PRINT RUN] 10,000
[TYPE] Goudy, ITC Goudy Sans, Bodoni Classic, Della Robbia, Truesdell, Kelmscott, FontleroyBrown, Filosofia, Dalliance, Linotype Decoration Pl

"I was impressed by the unbelievable labor and constantly evolving technique that goes into the creation of this long-lived and yet often hidden art form, and the design took on a mysteriously classical approach," art director Azi Rad says. "I took inspiration from silent film intertitles; my goal was to create a book that feels cinematic and legendary."

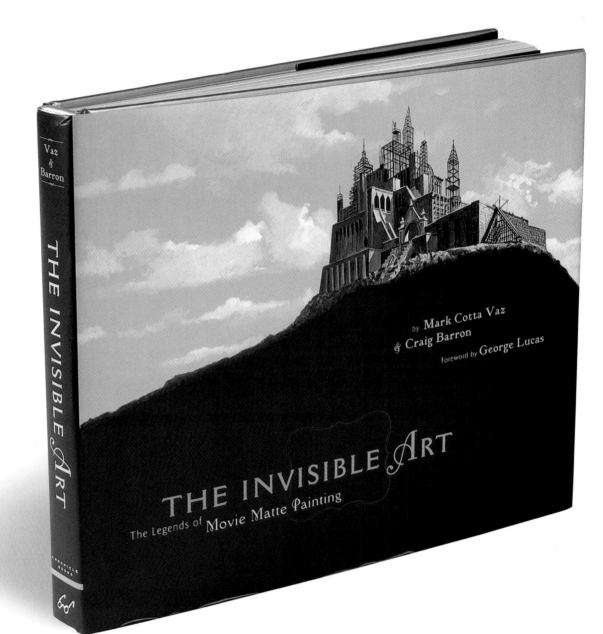

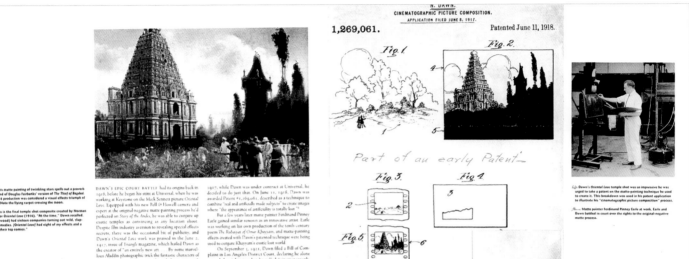

1,269,061.

Patented June 11, 1918.

Fig 1 *Fig. 2*

Part of an early Patent

Fig. 3 *Fig. 4*

Fig. 5

Inventor:
Norman Dawn,
by

Top: This matte painting of twinkling stars spells out a proverb at the end of Douglas Fairbanks' version of The Thief of Bagdad. This 1924 production was considered a visual effects triumph of its day. Note the flying carpet crossing the moon.

Above: This is the final temple shot composite created by Norman Dawn for Oriental Love (1916). "At the time," Dawn recalled, "[Hollywood] had sixteen companies turning out wild, slapstick comedies. [Oriental Love] had eight of my effects and a cast of their top comics."

Left: Dawn's Oriental Love temple shot was so impressive he was urged to take a patent on the matte-painting technique he used to create it. This breakdown was used in his patent application to illustrate his "cinematographic picture composition" process.

Above: Matte painter Ferdinand Pinney Earle at work. Earle and Dawn battled in court over the rights to the original-negative matte process.

DAWN'S EPIC COURT BATTLE had its origins back in 1916, before he began his stint at Universal, when he was working at Keystone on the Mack Sennett picture *Oriental Love*. Equipped with his new Bell & Howell camera and expert at the original-negative matte-painting process he'd perfected on *Stars of the Andes*, he was able to conjure up exotic temples as convincing as any location shoot. Despite film industry aversion to revealing special effects secrets, there was the occasional bit of publicity, and Dawn's *Oriental Love* work was praised in the June 2, 1917, issue of *Triangle* magazine, which hailed Dawn as the creator of "an entirely new art." By some marvelous Aladdin photographic trick the fantastic characters of *Oriental Love* seem to be moving through the most magnificent structures that could be conceived by man.

The work was praised by Sennett himself, who urged Dawn to get a patent on his matte-painting technique. In 1917, while Dawn was under contract at Universal, he decided to do just that. On June 11, 1918, Dawn was awarded Patent #1,269,061, described as a technique to combine "real and artificially made subjects" to create images where "the appearance of artificiality is totally lost."

But a few years later matte painter Ferdinand Pinney Earle gained similar renown as an innovative artist. Earle was working on his own production of the tenth-century poem *The Rubaiyat of Omar Khayyam*, and matte-painting effects created with Dawn's patented technique were being used to conjure Khayyam's exotic lost world.

On September 1, 1921, Dawn filed a Bill of Complaint in Los Angeles District Court, declaring he alone owned the rights to what he called "cinematographic picture composition." Ferdinand Earle, the suit claimed, was unlawfully applying Dawn's techniques to his *Rubaiyat*. Named in the suit were Earle, the "Rubaiyat

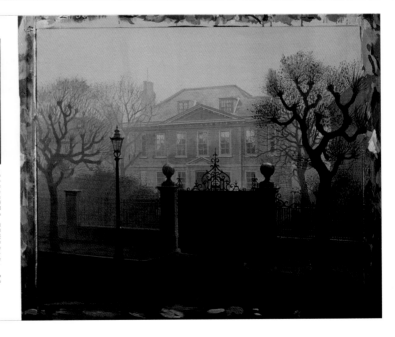

Above: In the course of their adventures, the heroes of Bedknobs and Broomsticks (1971) travel to London on a "magical bed" with a twist of its bedknob.

Opposite: This Alan Maley matte painting shows a mansion in the city, shrouded in typical London fog.

Special Events coverage of the Apollo moon flights. As a kid growing up in Billings, Montana, McQuarrie was thrilled to see barnstorming stunt pilots and faithfully followed the outer space adventures of Flash Gordon and Buck Rogers, never thinking that manned flight and the human imagination would lead to the moon, and that he would help chronicle it.

McQuarrie even mused that his Apollo space flights artwork, with classic cel animation of rocket ships and lunar modules matted into backgrounds of outer space or the lunar surface, probably prepared him for his *Star Wars* matte work. "One time I painted a 12-inch-wide image of Cape Canaveral from the air as you would see it from a rocket launching, and then photographed it onto 35 mm film on an animation stand. I saw it projected in a screening room and was amazed how realistic it looked. That was kind of my introduction to [the concept of] matte painting."

But McQuarrie hadn't seen an actual matte painting until *Star Wars* was in production and he went to Disney

Studio to meet Harrison Ellenshaw, who showed him samples of matte artwork. "One thing that struck me was they looked more painterly and rough than I thought would work," McQuarrie recalled. "Later, I appreciated the necessity for not bringing out every detail, because that gives it away as an illustration. In an illustration each leaf of a tree might be rendered, but oddly enough, your eye and the camera don't see things that way. In reality, when you squint at it, a matte painting blurs things together."

Harrison himself had almost passed on *Star Wars*. "I came very close to not working on *Star Wars*, because I hadn't been in England when they shot the [background] plates," he revealed. "One of the precepts he'd learned at Disney Studio was to take charge of plate shoots to ensure the camera was locked down and that there'd be 'no jiggling plates.'" Harrison's mentor was not his father, but the artist who succeeded his father as head of the department, Alan Maley.

The Disney Studio matte department that Harrison Ellenshaw came to in 1970, after a three-year hitch in the

CUBA: DIARIO VISUAL ▶

[STUDIO] Teikna Design Inc.
[ART DIRECTOR/DESIGNER] Claudia Neri
[PHOTOGRAPHER] Evan Dion
[CLIENT] Evan Dion Photography Inc.
[PAPER] Mead Signature
[COLORS] 4, process plus varnish
[SIZE] 5½" × 8" (14 × 20cm)
[TYPE] Bell Gothic, Trade Gothic, Helvetica 35, Vag Rounded, Trixie
[SPECIAL COST-CUTTING TECHNIQUES] We partnered with the printer (CJ Graphics, Toronto), the film house (Graphic Specialties, Toronto) and the paper company (Mead, Unisource) to coproduce the piece," says art director Claudia Neri. "The client received a discount, and all the suppliers involved were able to showcase the piece in their portfolio."

"The book is based on photographer Evan Dion's images of Cuba," says art director Claudia Neri. "Upon seeing the film, I was struck by how the photos all seemed to show gesture, human and otherwise. So that element became the main inspiration or, rather, provided a unifying principle."

The challenge is to create something that is relevant. We are all so inundated with "noise," useless piles of marketing crap, that keeps accumulating on our desks that it's hard to get the right kind of attention.

CLAUDIA NERI

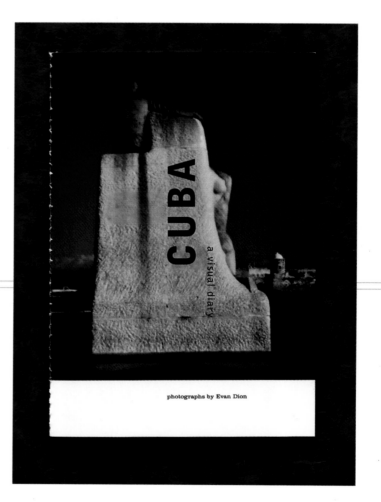

CUBA
a visual diary

photographs by Evan Dion

ANIMUS MAGAZINE ◄

[STUDIO] Close Design
[ART DIRECTOR] Lucianne Close
[SENIOR DESIGNER] Julia Barassi
[EDITORS] María Facio, Mercedez Reincke
[ILLUSTRATORS] Hugo Horita, Alfredo Sábat
[PHOTOGRAPHER] Lucila Blumencweig
[CLIENT] Publirevistas, La Nación, Buenos Aires, Argentina.
[CLIENT'S PRODUCT/SERVICE] Publishing house
[PAPER] Matte
[COLORS] 4 and a special color, coating or die cut on cover; offset printing
[SIZE] 9" × 11" (23 × 28.5cm)
[PRINT RUN] 10,000 per issue
[TYPE] Melior roman (text); Futura (titles)
[SPECIAL PRODUCTION TECHNIQUES] Localized UV bright coating over matte coating on the cover.
[INSPIRATION/CONCEPT] "The integration between pictures and text produced a challenge in trying to maintain a clean and readable design," say the designers.

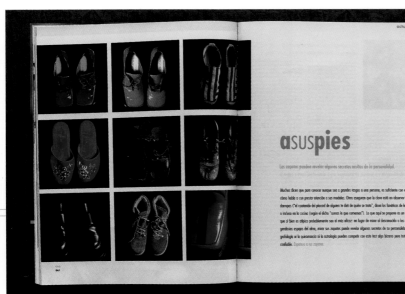

I AM ALMOST ALWAYS HUNGRY ◄

[STUDIO] Cahan & Associates
[ART DIRECTOR] Bill Cahan
[DESIGNER] Bob Dinetz
[ILLUSTRATOR] Carol Fabricatore
[PHOTOGRAPHERS] Tony Stromberg, William Mercer McLeod, Robert Schlatter, William Howard, Bob Dinetz
[CLIENT] Princeton Architectural Press
[PAPER] Potlatch McCoy
[SIZE] 8½" × 11" (22 × 28cm)
[PRINT RUN] 8,500
[TYPE] Avenir

"When we first set out to create this book we had no idea how difficult the task would be," say the designers. "In fact, it was the toughest job we've ever done. It's one thing to produce work for a client but something else entirely when you have to act as both client and designer. Looking back on it now, it's clear why the experience proved so daunting. We greatly underestimated the scope of a project that, in essence, required us to define ourselves as a firm. The process evolved from being a job to being an education, as the experience of examining and refining our current working methods helped us discover where we want to go in the future."

DESERT PLACES ▶

[STUDIO] The Viking Penguin Design Group
[ART DIRECTOR] Paul Buckley
[DESIGNER] Martin Ogolter
[PHOTOGRAPHY] Courtesy of Robyn Davidson
[CLIENT] Viking
[TYPE] Decoder, Leviathan
[COLORS] 4, process
[PRINT RUN] 10,000

The book is a memoir that describes the experiences of a white Australian woman traveling alone in India. Martin Ogolter's intention was "to mimic a travel diary or scrapbook bought in India—the sort of common, everyday journal made cheaply using low-tech, old-fashioned production." The title type was created using Decoder with a contemporary experimental font to suggest Sanskrit.

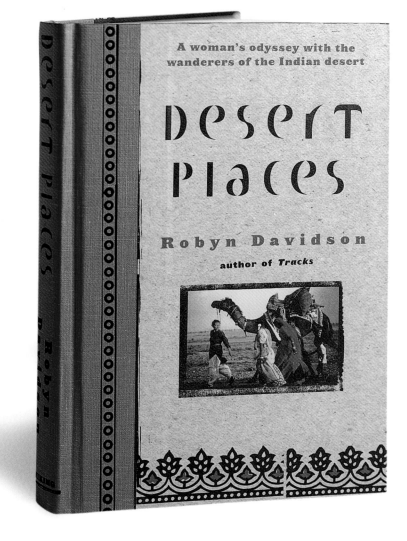

THE POCKET MUSE ▼

[STUDIO] F&W Publications
[ART DIRECTOR/DESIGNER] Lisa Buchanan
[PAGE MAKEUP] Matthew DeRhodes
[CLIENT] Writer's Digest Books, an imprint of F&W Publications
[CLIENT'S PRODUCT/SERVICE] Book and magazine publisher

[COLORS] 4, process (cover); 2, match (interior)
[SIZE] 5" × 7" (13 × 18cm)
[SPECIAL TYPE TECHNIQUES] Type on vertical axis, Type on objects, type in motion
[SPECIAL PRODUCTION TECHNIQUE] Faux leather spine and glossy varnish over the image and label

"The goal for this book was to create a fun, visually appealing package to target writers," designer Lisa Buchanan says. "I decided that shape and texture were extremely important, so we used a faux leather spine on the book, as well as matte and glossy spot varnishes. The use of black-and-white photography and the fun type treatments contribute to the variety of visuals within the book and help keep the audience's attention. No two pages are alike."

FLAIR MAGAZINE ▼

[STUDIO] Platinum Design, Inc.
[ART DIRECTORS] Vickie Peslak, Victoria Stamm, Kelly Hogg, Mike Joyce
[DESIGNERS] Kelly Hogg, Mike Joyce, Arya Vilay
[PHOTOGRAPHER] Fabrice Trombert
[CLIENT] Hearst Custom Publishing
[CLIENT'S PRODUCT/SERVICE] Fashion and lifestyle magazine for women
[COLORS] 4, process
[SIZE] 8½" × 10½" (20 × 27cm)
[PRINT RUN] 2 million
[TYPE] Franklin Gothic, Foundry

"The goal was to relate to young, hip female readers nationally," art director Vickie Peslak explains. *"With the type, we wanted to remain classic but have a little edge."*

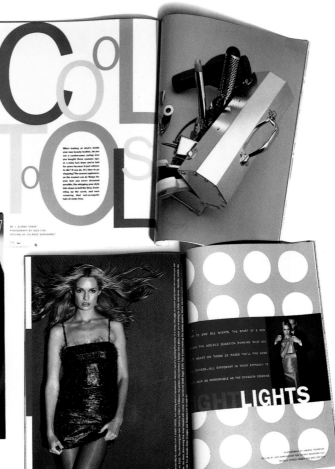

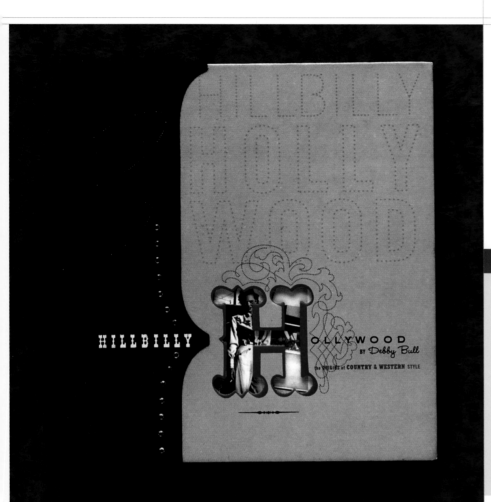

HILLBILLY HOLLYWOOD ◄

[STUDIO] Werner Design Werks, Inc.
[ART DIRECTOR] Sharon Werner
[DESIGNERS] Sharon Werner, Sarah Nelson
[PHOTOGRAPHERS] Kyle Ericksen and various
[CLIENT] Debby Bull (author) and Elizabeth Sullivan (editor)/Rizzoli Publishing
[CLIENT'S PRODUCT/SERVICE] Books
[COLORS] 4, process
[SIZE] 10½" × 11¼" (27 × 29cm)
[COST PER UNIT] $39.95 retail
[SPECIAL PRODUCTION TECHNIQUE] Rhinestones on cover
[SPECIAL COST-CUTTING TECHNIQUE] By using colored text just for proper names and page numbers, only the black plates would need to change for foreign-language editions of the book.

"Like the fancy cowboys whose stories it tells, this book is over the top with glitz and sparkle," say the designers. *"The country stars in Hollywood in the thirties and forties, along with their tailors, set the standard for country and western fashion today. The book is an oral history collection from the hillbillies themselves, not just straight narrative. We designed it so it doesn't need to be read from front to back—the reader can jump in at any point and read what Buck Owens had to say on the subject of sound quality ('the amps weren't loud so our clothes had to be') or what Roy Rogers said about costumes and playing large venues ('I got them to put more and more rhinestones on the clothes. I'd light up the whole arena')."*

Elicit an emotion with each turn of the page— excitement or surprise or even boredom. Read the content and use it to create the concept and design. Develop a grid and then ignore it, break it and hide it.

SARAH NELSON

ANATOMY OF PEACE ▶

[STUDIO] Group Baronet
[ART DIRECTOR] Willie Baronet
[DESIGNER] Meta Newhouse
[ILLUSTRATOR] Ettiene Delessert
[CLIENT] Dallas Symphony
[COLORS] 4, process

[SIZE] 5" × 7" (13 × 18cm) (folded)
[PRINT RUN] 2,000
[INSPIRATION/CONCEPT] "The dove carrying an olive branch reflects nations that were at war in World War II," art director Willie Baronet says.

88

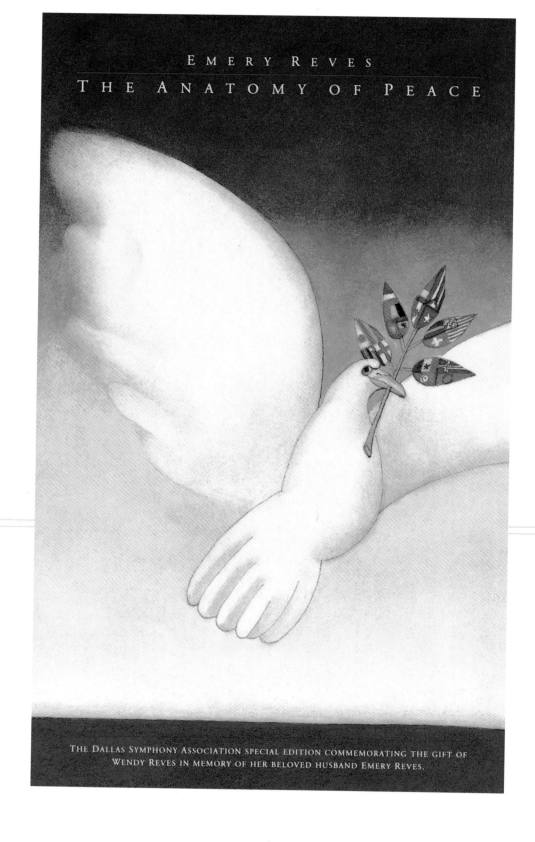

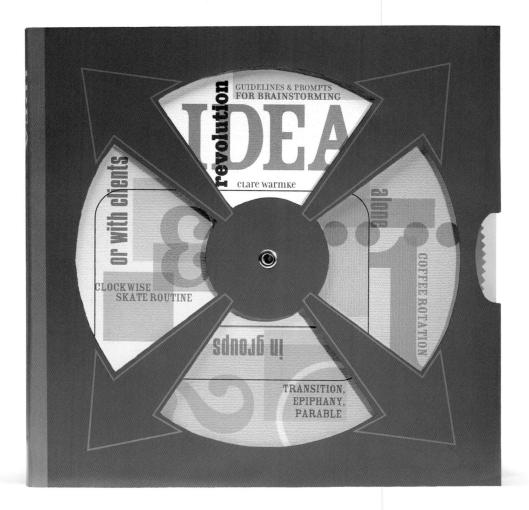

On the cover:

revolution

GUIDELINES & PROMPTS FOR BRAINSTORMING

IDEA

clare warmke

or with clients

CLOCKWISE SKATE ROUTINE

in groups

alone

COFFEE ROTATION

TRANSITION, EPIPHANY, PARABLE

IDEA REVOLUTION ▲

[STUDIO] F&W Publications
[ART DIRECTOR/DESIGNER] Lisa Buchanan
[CLIENT] HOW Design Books, an imprint of F&W Publications
[CLIENT'S PRODUCT/SERVICE] Book and magazine publisher
[COLORS] 4, process
[SIZE] 8" × 8" (20 × 20cm)
[SPECIAL PRODUCTION TECHNIQUES] Die cut and spinning wheel on cover

"The concept for the design of this cover was derived directly from its content," says designer Lisa Buchanan. "The book contains 120 activities, anecdotes and tips from graphic designers expressing how they overcome common creative obstacles and find pathways to new ideas. In order to express that concept, a revolving circle became the focal point of the book's design. With the spinning wheel, the cover was constantly changing its appearance. The active and changing nature of the design reflects the way the author suggests living a creative professional life."

I.D. MAGAZINE ▼ ▶

[STUDIO] F&W Publications/*I.D. Magazine*
[ART DIRECTOR/DESIGNERS] Kelly N. Kofron
[ILLUSTRATOR] Kelly N. Kofron
[PHOTOGRAPHER] James Chiang
[SIZE] 9" × 10⁷/₈" (23 × 27cm)
[PRINT RUN] 38,839 circulation
[COST PER UNIT] $6.95 retail
[TYPE] Meta, Scala
[SPECIAL TYPE TECHNIQUES] Type outlines in Adobe Illustrator were used to get the zigzag sewing effect that connects the headline to the line art of the figures.
[SPECIAL COST-CUTTING TECHNIQUES] In-house illustration

"The written article featured Nice Collective, the creators of a popular clothing line called 'Sound,' which was inspired by a mix of techno and rave culture. While sound cannot be seen, it can be represented as a series of lines that make patterns. To translate the idea of sound to fabric, the fashion designers cut patterns into the shapes of sound waves," says art director Kelly Kofron. "This communication is incorporated into the layout, which combines type treatment, line illustration and photography for the fashion spreads themed after 'sound.' The zigzag line is meant to represent both sewing and sound and is used to add illustrative value to the title of the piece. It was important to carry the concept through all four pages, so the line work grew to physically connect the title to the figures of the models. The line art also adds to the feel of the urban style and modern creative energies of the clothing but does not overpower the work exhibited. The continuous thread ends in a knot that is a modified version of the I.D. Magazine end stop—a character that signals the end of all of our feature articles. It's a subtle nod to the overall concept and wraps up the visual cues and writing into its finished state."

Moving from raves to rayon, Nice Collective mixes techno with textiles for its latest urban collection, "Sound."

by Sue Campbell

SINCE ITS 1994 BIRTH IN SAN FRANCISCO, Nice Collective has been breaking the rules in urban wear with casual, experimental clothing that's original and adaptable. Designs from the firm's past collections, exploring cerebral themes ranging from time and body mechanics to flight and data retrieval, have been worn by models and celebrities on a number magazine covers, including *TV Guide* and *Newsweek*. And the group's connection to pop-music stars hasn't hurt the clothing's rising popularity. Techno king Moby helped launch the most recent line, wearing Nice T-shirts for publicity shoots. Macy Gray wore the women's Tab Top in a music video. Aerosmith's recent "post-apocalyptic" video for "Flyaway" showcases clothing from the Nice guys. And Gavin Rossdale, singer for the alternative band Bush, sported a Nice jacket at this year's Grammys.

But Joe Haller, 31, and Ian Hannula, 29, insist that their clothes aren't just for celebrities. "It's a lifestyle brand," Haller says. "We do some pieces that are more extreme or out there and lots for everyday, like t-shirts and shorts."

Nice Collective's latest collection, "Sound," is not only worn by rock stars, but also peripherally inspired by the beats they create. Techno-house enthusiasts turned fashion entrepreneurs, Haller and Hannula tapped into the science of sound while researching their latest spring fashion collection. The theme might seem strange—after all, sound can't be seen—but sound can be represented as a series of lines that make patterns. The Sound line sells in top shops, including Fred Segal/Ron Herman in Los Angeles, the first to discover Nice; Rolo in San Francisco; PF in downtown Portland, Ore.; and Barneys New York.

"We don't reference the past," Haller says. "Enough other designers do that. We try not to put too much nostalgia into our clothes. We want to represent our age, our time period, with clothes that are current and modern."

Nice Collective's own past is a colorful one. Haller, previously a radiology technologist, and Hannula, a former Marine Corps combat photographer, were sharing a flat in San Francisco's Richmond district with a group of friends—deejays, record-label owners, club promoters, designers, artists and photographers—who dubbed themselves Nice Collective. Although other members of the group eventually drifted away, Haller and Hannula—both influenced

Manifestations of Nice Collective's sound inspirations range from material and seams to simple graphics, such as the Soundwave Skirt (right) and the Sound Tee (bottom left).

by the emergence of techno-music and the rave explosion of the early '90s—continued to collaborate on various promotional endeavors. When they realized that their camouflage promotional T-shirts were hot items with local club-goers, the pair focused their creative energies on fashion.

Inspired by their techno-pop roots and an interactive installation that launched a previous line, Haller and Hannula started to ponder the idea of sound as a fashion concept. They asked explorative questions: What does sound evoke in people? What are the physics of sound? How do we capture the excitement we ourselves feel when we hear music and translate it into clothes? They researched waveforms, echoes, volume, pitch and vibrating particles, but avoided making their collection overly scientific; Nice's clothes have always been of and for pop culture.

To translate the idea of sound to fabric, they cut materials on a bias, mimicking the movement of sound waves. They experimented with unusual, sound-related materials for inspiration, such as subwoofer speaker foam. Sound graphics were screened, tone-on-tone, onto T-shirts, and decibel levels were fodder for others.

The line also includes some of the subtleties for which Nice is widely known. The two-layered Soundwave Skirt, made of rayon-linen and cotton and enhanced by invisible side-slit zippers, features two curved seams on the outside that represent pulsing sound waves. The Harness Windbreaker has tiny zippers that open under the arms, so a parachute-like harness can be pulled out and across the back. The Pressure Jacket has a back collar that opens and lifts away. The Bent Button Up jacket has multi-option closures that allow wearers to button askew if they choose. And many of the clothes feature whimsical internal patches; you might not find them until you put the item in the wash. (An earlier collection, for example, featured hidden bar codes in various places on and inside the clothes; wearers could have them scanned to find out that they were for everything from Campbell's soup to aspirin to a CD.)

"It's exciting to cut patterns into the shapes of sound waves," Haller says. "But the clothes still have to be flattering and wearable. The concept has to look good." Sales figures for the Sound collection aren't in yet, but it's already the duo's most successful line. ✺

Sue Campbell is features editor at the St. Paul Pioneer Press in Minnesota.

EINSTEIN IN LOVE ▶

[STUDIO] Base Art Co.
[ART DIRECTOR] Roseanne Serra/Penguin Putnam
[DESIGNER] Terry Rohrbach
[PHOTOGRAPHY] Wedding portrait of Einstein to first wife, Mileva Maric, 1903 (detail). Reproduced with permission from Evelyn Einstein.
[CLIENT] Penguin Putnam
[CLIENT'S PRODUCT/SERVICE] Trade paperback publisher
[COLORS] 4, process plus one spot metal
[SIZE] 5½" × 8½" (14 × 22cm)
[TYPE] Helvetica Condensed

"Obviously, the title is a great starting point from which to draw inspiration for a book cover," says designer Terry Rohrbach. "Einstein in Love. Hmmm, OK...got it! The molecular attraction of love, the bond between us."

A NEW YORK TIMES NOTABLE BOOK

EINSTEIN IN LOVE

A Scientific Romance

DENNIS OVERBYE

author of *Lonely Hearts of the Cosmos*

"This is the best account of Einstein the human being ever written. . . . A great accomplishment in narrative and the history of science."–Richard Preston, author of *The Hot Zone* and *The Cobra Event*

UP IN SMOKE ▶

[STUDIO] Golf Magazine Properties/Time4 Media
[ART DIRECTOR] Allison V. Foltz
[DESIGNER] Golf Magazine Properties/Time4 Media
[PHOTOGRAPHER] Keiichi Sato
[CLIENT] *Senior Golfer Magazine*
[COLORS] 4, process
[SIZE] 8" × 10¾" (20 × 27cm)
[PRINT RUN] 480,000
[TYPE] Bembo

"This is the opening spread for an article about Larry Laoretti, a golfer on the Senior PGA Tour and one-time winner of the Senior U.S. Open. He's never without a cigar, so we knew we'd have him puffing away at his signature Te-Amo," says art director Allison V. Foltz. "I chose the profile view of the subject because he looks pensive and forward thinking, mirroring the story's theme. The original was a full-color photo but I thought a sepia duotone would help the smoke stand out from the background as well as contrast nicely with the blue display type. Laoretti's a playful guy, and I could picture him blowing smoke rings—so altering the O in the headline seemed like a natural alteration."

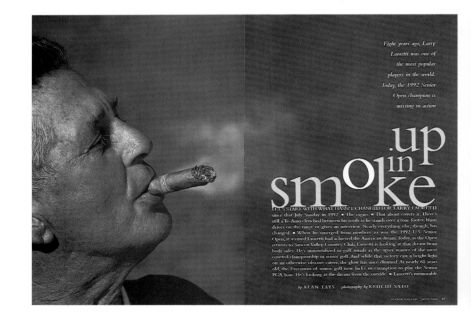

Eight years ago, Larry Laoretti was one of the most popular players in the world. Today, the 1992 Senior Open champion is missing in action

up in smoke

LET'S START WITH WHAT HASN'T CHANGED FOR LARRY LAORETTI since that July Sunday in 1992. ■ The cigar. ■ That about covers it. There's still a Te-Amo clenched between his teeth as he stands over a four-footer, blasts drives on the range or gives an interview. Nearly everything else, though, has changed. ■ When he emerged from nowhere to win the 1992 U.S. Senior Open, it seemed Laoretti had achieved the American dream. Today, as the Open returns to Saucon Valley Country Club, Laoretti is looking at the dream from both sides. He's immortalized in golf annals as the upset winner of the most coveted championship in senior golf. And while that victory cast a bright light on an otherwise obscure career, the glow has since dimmed. At nearly 61 years old, the Everyman of senior golf now lacks an exemption to play the Senior PGA Tour. He's looking at the dream from the outside. ■ Laoretti's memorable

by ALAN TAYS photography by KEIICHI SATO

SENIOR GOLFER JULY 2000 45

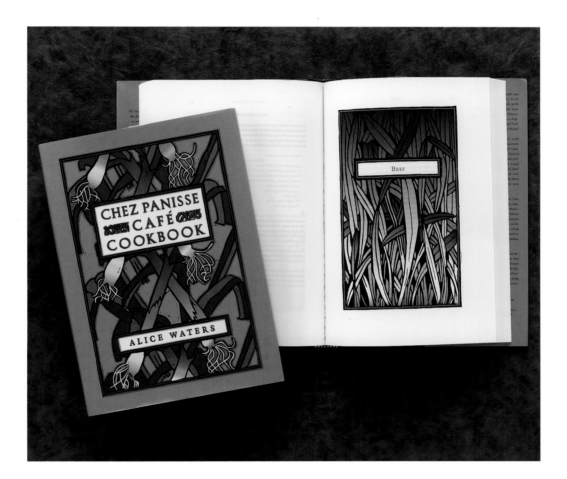

CHEZ PANISSE CAFÉ
COOKBOOK ▲

[STUDIO] Saint Hieronymus Press
[ART DIRECTOR/DESIGNER] David Lance Goines
[ILLUSTRATORS] David Lance Goines, Lynn M. Gregory
[TYPESETTING] Wilsted and Taylor, Oakland, California
[CLIENT] Chez Panisse Cafe & Restaurant/Harper Collins
 (publisher)
[PAPER] Finch Vanilla
[COLORS] 4, process
[SIZE] 7" × 10" (18 × 25cm), 267 pages
[PRINT RUN] Approximately 130,000

[TYPE] Bembo
[SPECIAL TYPE TECHNIQUES] Keep every recipe on a single or double page spread so the cook would not find it necessary to turn the page while preparing it; make sure there is adequate room in the bottom and outer margins for the cook's thumb without obscuring the type; make sure nothing falls into the gutter; type large enough to be read at arm's length
[SPECIAL PRODUCTION TECHNIQUES] Illustrations initially were linocuts, which were then scanned and colored in Photoshop. Page layouts were finished first, then the illustrations were added to fit as appropriate.

Art director David Lance Goines says that he strove "to render images of food that were appetizing and colorful and to create a useful, attractive cookbook."

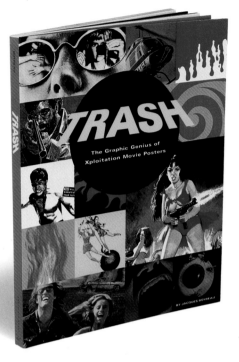

TRASH: THE GRAPHIC GENIUS OF XPLOITATION MOVIE POSTERS ▲ ►

[STUDIO] Chronicle Books
[ART DIRECTOR/DESIGNER] Sara Schneider
[CLIENT] Chronicle Books
[CLIENT'S PRODUCT/SERVICE] Book publisher
[PAPER] 157 gsm Japanese matte art
[COLORS] 4, process
[SIZE] 9" × 12" (23 × 30cm)
[PRINT RUN] 7,500
[TYPE] Univers (various weights)
[SPECIAL TYPE TECHNIQUE] The manipulated type on the
 cover was pulled and stretched to mimic a style found on
 many of the featured movie posters. The book's title
 appears to soar toward the reader.

*"This book proudly assembles 150 masterpieces of twist-
ed brilliance: low-brow graphic art from the sickest,
sleaziest, sexiest and weirdest films from the 1950s
through the 1980s," says art director Sara Schneider.
"The cover and chapter openers capitalize on the
fantastically cliché expressions, moments and details
that graphically represent the trash-film genre. The
bold layout pulls the collection of posters together
in a comprehensible way, alongside color palettes as
obnoxious and as loud as the posters themselves."*

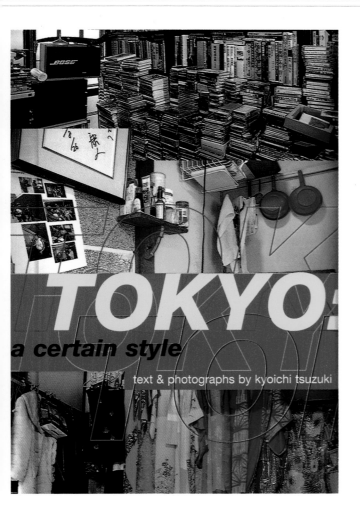

Design also means *organize*. The most important thing in designing anything is to come up with a really good grid, some system to hang everything on. A system that not only accommodates various types and amounts of information but also the inevitable changes to the information you already had laid out. Grids can be fun to set up, but they require a lot of thought. I usually push around some of the elements first to establish the scale of the different pieces, then come up with a unit that supports that scale as well as that of the page. Then I go back and push things around some more on that structure.

SHAWN HAZEN

TOKYO: A CERTAIN STYLE ◄

[STUDIO] Chronicle Books
[ART DIRECTOR/DESIGNER] Shawn Hazen
[PHOTOGRAPHER] Kyoichi Tsuzuki
[CLIENT] Chronicle Books
[CLIENT'S PRODUCT/SERVICE] Book publisher
[PAPER] 80 gsm matte art
[COLORS] 4, process
[SIZE] 4⅛" × 5¹³/₁₆" (10 × 15cm))
[PRINT RUN] 15,000
[TYPE] Helvetica Neue, Helvetica Condensed
[SPECIAL FOLDS/FEATURES] The book is small and full, like the apartments it illustrates.

"Most of the photos are of jam-packed, eccentric little apartments in Tokyo," says designer Shawn Hazen. "For the cover, I wanted the colors and the layout to evoke the same wild feeling. This piece is an American reprint. I actually only designed the cover, half-title page, title page, copyright page, table of contents, introduction and conclusion. I 'inherited' the rest of the layout from the Japanese edition."

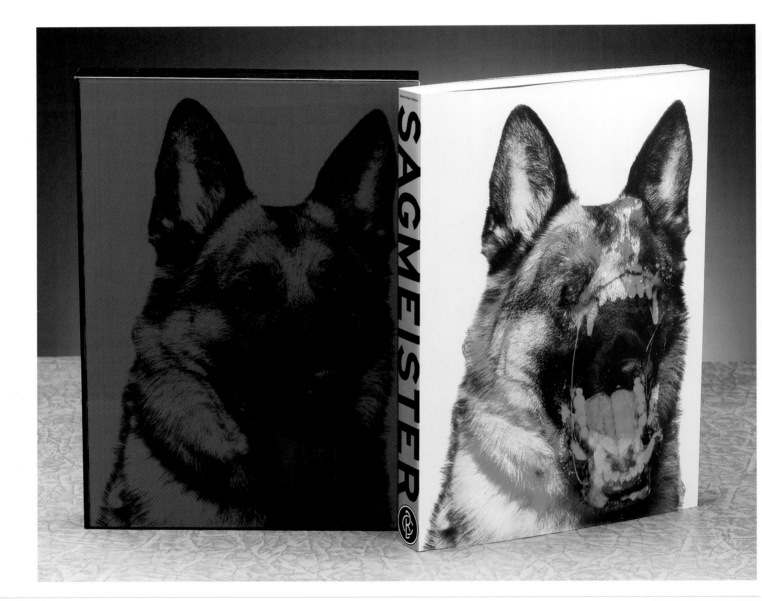

SAGMEISTER: MADE
YOU LOOK ▲ ▶

[STUDIO] Sagmeister Inc.
[ART DIRECTOR] Stefan Sagmeister
[DESIGNER] Hjalti Karlsson
[PHOTOGRAPHER] Kevin Knight (cover)
[CLIENT] Booth-Clibborn Editions
[PAPER] Matte coated
[COLORS] 4, process
[SIZE] 6¾" × 9½" (17 × 24cm); 294 pages
[PRINT RUN] 12,000

[COST PER UNIT] $44 retail
[TYPE] Hand type, Franklin Gothic, Spartan
[SPECIAL TYPE TECHNIQUES] "A lot of hand
 type was used to distinguish the text from my
 diaries from the much better-written text by
 Peter Hall," says Stefan Sagmeister.
[SPECIAL PRODUCTION TECHNIQUES] Pub-
 lished as a paperback in a red transparent
 slip case. Removing the book from the slip
 case causes the mood of the dog to worsen
 considerably

*"The book contains practically all the work we ever
 designed," says art director Stefan Sagmeister,
"including the bad stuff. The concept came directly
 out of our work: You can play with it."*

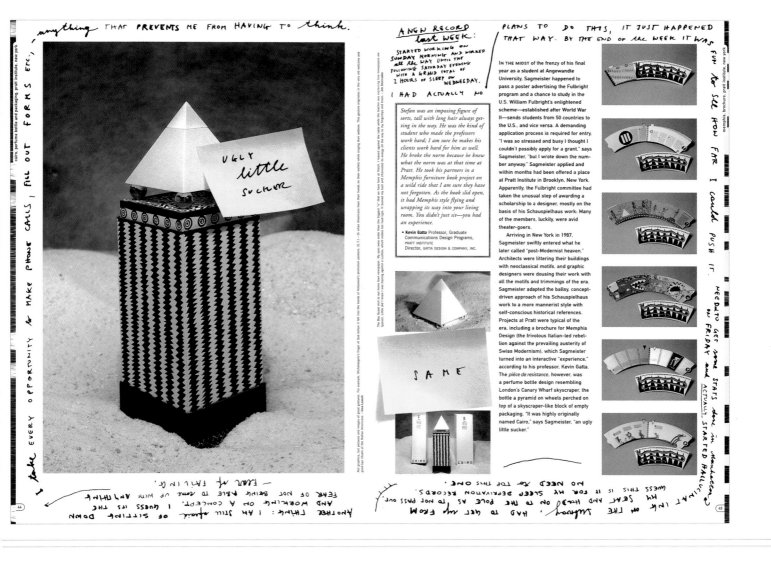

I take EVERY OPPORTUNITY to MAKE PHONE CALLS, FILL OUT FORMS ETC.,

cairo, perfume bottle and packaging, pratt institute, new york
memphis, brochure, pratt institute, new york

UGLY little sucker

SAME

A NEW RECORD last WEEK: STARTED WORKING ON SUNDAY MORNING AND WORKED all the WAY UNTIL THE FOLLOWING SATURDAY EVENING WITH A GRAND TOTAL OF 2 HOURS OF SLEEP ON WEDNESDAY.

I HAD ACTUALLY NO

PLANS TO DO THIS, IT JUST HAPPENED THAT WAY. BY THE END OF the WEEK IT WAS

FUN to SEE HOW FAR I could PUSH IT. NEEDED TO GET some STARS done in manhattan, on FRIDAY and ACTUALLY STARTED HALLUCINATING on the subway, HAD to GET my FROM

Stefan was an imposing figure of sorts, tall with long hair always getting in the way. He was the kind of student who made the professors work hard; I am sure he makes his clients work hard for him as well. He broke the norm because he knew what the norm was at that time at Pratt. He took his partners in a Memphis furniture book project on a wild ride that I am sure they have not forgotten. As the book slid open, it had Memphis style flying and wrapping its way into your living room. You didn't just sit—you had an experience.

• **Kevin Gatta** Professor, Graduate Communications Design Programs, PRATT INSTITUTE Director, GATTA DESIGN & COMPANY, INC.

IN THE MIDST of the frenzy of his final year as a student at Angewandte University, Sagmeister happened to pass a poster advertising the Fulbright program and a chance to study in the U.S. William Fulbright's enlightened scheme—established after World War II—sends students from 50 countries to the U.S., and vice versa. A demanding application process is required for entry. "I was so stressed and busy I thought I couldn't possibly apply for a grant," says Sagmeister, "but I wrote down the number anyway." Sagmeister applied and within months had been offered a place at Pratt Institute in Brooklyn, New York. Apparently, the Fulbright committee had taken the unusual step of awarding a scholarship to a designer, mostly on the basis of his Schauspielhaus work: Many of the members, luckily, were avid theater-goers.

Arriving in New York in 1987, Sagmeister swiftly entered what he later called "post-Modernist heaven." Architects were littering their buildings with neoclassical motifs, and graphic designers were dousing their work with all the motifs and trimmings of the era. Sagmeister adapted the ballsy, concept-driven approach of his Schauspielhaus work to a more mannerist style with self-conscious historical references. Projects at Pratt were typical of the era, including a brochure for Memphis Design (the frivolous Italian-led rebellion against the prevailing austerity of Swiss Modernism), which Sagmeister turned into an interactive "experience," according to his professor, Kevin Gatta. The pièce de resistance, however, was a perfume bottle design resembling London's Canary Wharf skyscraper, the bottle a pyramid on wheels perched on top of a skyscraper-like block of empty packaging. "It was highly originally named Cairo," says Sagmeister, "an ugly little sucker."

ANOTHER THING: I AM STILL afraid of SITTING DOWN AND WORKING ON A CONCEPT. I GUESS ITS THE FEAR OF NOT BEING ABLE TO some UP WITH ANYTHING - FEAR of FAILING.

AM SEAT AND HEAD ON to THE POLE AS to NOT PASS OUT. GUESS THIS IS IT FOR MY SLEEP DEPRIVATION RECORDS, NO NEED to TOP THIS ONE.

NEW YORK MAGAZINE PROMOTIONS ▼

[STUDIO] Platinum Design, Inc.
[ART DIRECTORS] Mike Joyce, Kelly Hogg
[DESIGNERS] Mike Joyce, Kelly Hogg, Arya Vilay
[CLIENT] *New York Magazine*
[PAPER] Vellum, corkboard and transparency
[COLORS] 4, process
[PRINT RUN] 6,500

"Our goal was to create promotional pieces that reflect the subject matter of New York Magazine's *special issues, in an attempt to entice advertisers who receive tons of these types of mailers," says Platinum Design's Vickie Peslak.*

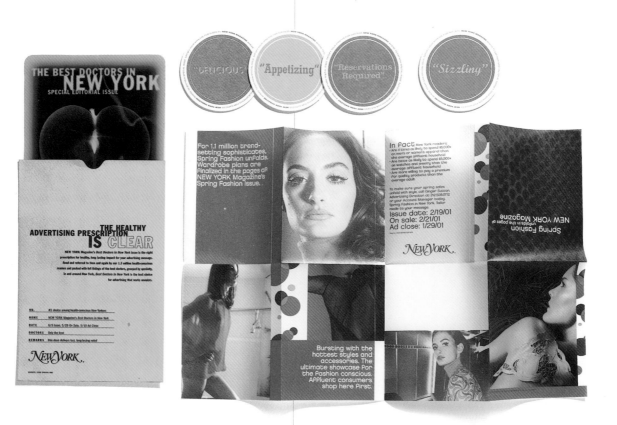

Hothouses for Healing

As cutting-edge medical sleuthing redefines disease, a cutthroat battle wages among upstart genome scientists, health institutes, and pharmaceutical companies to patent new drugs, with billions of dollars at stake.

Jean Claude Zenkhusen made a career out of stalking a killer. He had spent seven years studying it: in virtually every day, looking for clues to some fatal weakness he could exploit. Finally, he followed the trail of evidence to a soldier he could enlist in his cause – a warrior named ST7.

Zenkhusen targeted a well-known foe in the world of medical sleuthing: cancer-causing tumors. His drawn-out quest to find this cancer-fighting gene is a common tale. Hundreds of research scientists in laboratories throughout the country tell a similar story. But last year, their slow-motion work suddenly hit the fast-track with sequencing of the majority of the human genome – the human body's operating manual. By taking the profile of a tumor-suppressing gene and using a computer database to look for others just like it, Zenkhusen found another cancer fighter – B47 – in just six months. It's as if, he says, researchers could suddenly turn on the lights after spending years fumbling through a huge pile of balls in a dark room, trying to find one of a particular color. "We still have the balls," he says, "but it is much easier to look through them."

Zenkhusen's work at the National Institutes of Health in Bethesda, Maryland, represents cutting-edge medical sleuthing, the origination point of the drugs of the future. Genome research companies scattered from Maryland to Silicon Valley are all using the

By John Carroll
Illustrations by Brian Cronin

HOTHOUSES FOR HEALING ◄

[STUDIO] American Airlines Publishing
[ART DIRECTOR/DESIGNER] J.R. Arebalo, Jr.
[ILLUSTRATOR] Brian Cronin
[CLIENT] Southwest Airlines
[CLIENT'S PRODUCT/SERVICE] National airline
[PAPER] 44 lb. Mission
[COLORS] 4, process
[SIZE] 8" × 10⅞" (20 × 28cm) (single page), 16" × 10⅞" (41 × 28cm) (spread)
[PRINT RUN] 355,000
[TYPE] Interstate (headline, deck and initial cap); Eidetic Serif (body copy)

Art director J.R. Arebalo, Jr., says he strove to show the more human side of the patent drug research race. "I wanted to get away from the cold, sterile scientific aspect," says Arebalo, "to show that behind all the money and all the latest-and-greatest science, in the end it effects the life of one human being at a time. Brian's natural and organic illustration clarifies the point perfectly."

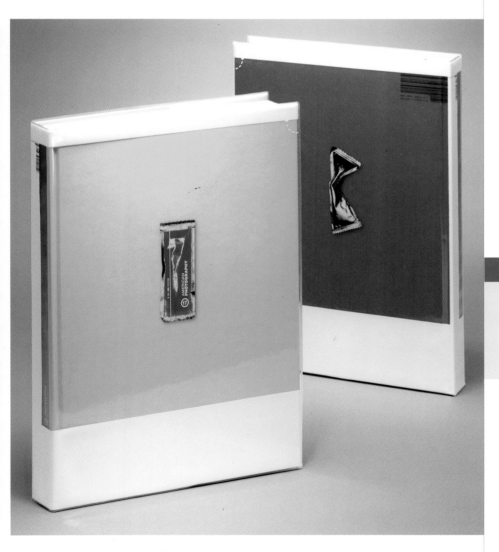

AMERICAN PHOTOGRAPHY 17 ◄

[STUDIO] 344 Design, LLC
[ART DIRECTOR/DESIGNER] Stefan G. Bucher
[PHOTOGRAPHER] Craig Cutler (covers)
[CLIENT] Mark Heflin/Amilus Inc.
[CLIENT'S PRODUCT/SERVICE] Publisher of *American Photography* and *American Illustration* annuals
[PAPER] Biberest, 135 gsm, demi-matte
[COLORS] 4, process plus one match and spot varnish
[SIZE] 9½" × 12½" (24 × 32cm)
[PRINT RUN] 3,000
[COST PER UNIT] $60 retail
[TYPE] Helvetica
[SPECIAL PRODUCTION TECHNIQUES] Book title, barcode and white bars are silk-screened onto a custom clear vinyl slip cover, thus "cropping" the full-bleed cover image underneath.

"We set out to create a gallery with a spine, a space that showcases 400 brilliant images in an elegant, modern way," says art director Stefan Bucher. "Yet it is also a complete book that, by means of pacing and suggested narrative, becomes an object journey in its own right."

INSIDE HAVANA ▼

[STUDIO] Chronicle Books
[ART DIRECTOR/DESIGNER] Vivien Sung
[PHOTOGRAPHER] Andrew Moore
[CLIENT] Chronicle Books
[CLIENT'S PRODUCT/SERVICE] Book publisher
[PAPER] Japanese matte art
[COLORS] 4, process

[SIZE] 9" × 11½" (23 × 29cm)
[PRINT RUN] 7,500
[TYPE] Knockout (Hoefler), Mrs Eaves (Emigre), Clifford (Fontshop)
[SPECIAL PRODUCTION TECHNIQUES] Black cloth case with blind deboss and white foil; endpaper PMS 448 gray

"This book showcases Andrew Moore's photographs in Cuba, which are shot meticulously using a large-format camera. They capture and portray the nuances of the city's inner life, showing intimate details from the past and present," says art director Vivien Sung. "My inspiration for the design and typography was to capture the subtlety of character and flavor encapsulated in the frozen moments of the photographs. The type treatment is as studied as the photographs and the peeling walls in the photographs themselves."

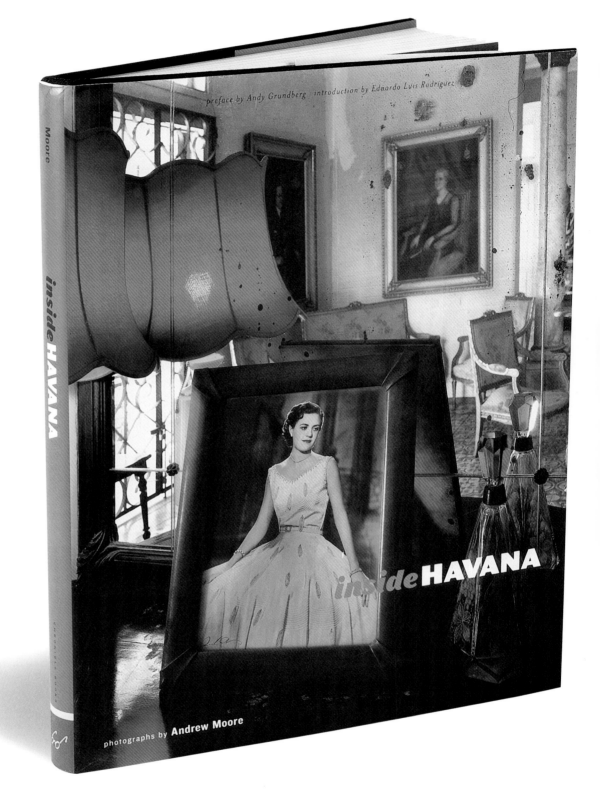

PRAGMATISM

[STUDIO] Vintage Books
[ART DIRECTOR/DESIGNER] John Gall
[PHOTOGRAPHER] Katherine McGlynn
[CLIENT] Vintage Books/Random House
[TYPE] Trade Gothic Condensed, Centaur
[COLORS] 4, process
[PRINT RUN] 15,000

"Occasionally I like to design covers (concept permitting) where the components of a book can function as the cover itself," says art director John Gall. "In this case, the book is a collection of writing about pragmatism—an interesting topic but potentially boring subject matter for a book cover." Gall adds, "My concept was to somehow depict a way of thinking that cuts through the malarkey and gets to the point in a visually intriguing way."

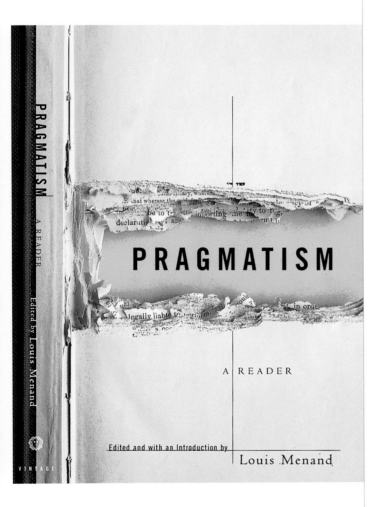

33 MOMENTS OF HAPPINESS ▶

[STUDIO] Alfred A. Knopf, Inc.
[ART DIRECTOR] Carol Devine Carson
[DESIGNER] Archie Ferguson
[PHOTOGRAPHER] Lev Poliakov
[ILLUSTRATOR] Archie Ferguson
[CLIENT] Alfred A. Knopf, Inc./Random House
[CLIENT'S PRODUCT/SERVICE] Book publisher
[TYPE] Bodoni Old Face Medium Italic, Bell Gothic Bold,
 Corvinus, Skyline
[COLORS] 2-color flat halftone plus matte silver foil stamp-
 ing, printed on an uncoated, superwhite stock
[PRINT RUN] 2,000

The inspiration for this book cover was "progressively
strange stories about life in post-perestroika St. Peters-
burg—go figure," says designer Archie Ferguson. "This is
the first photograph I showed to the editor, who had me
spend the next six months looking for something better.
Two prints of the photograph had been smuggled out
of Russia by Lev Poliakov years earlier, before the iron
curtain was parted. 'They' kept his negatives."

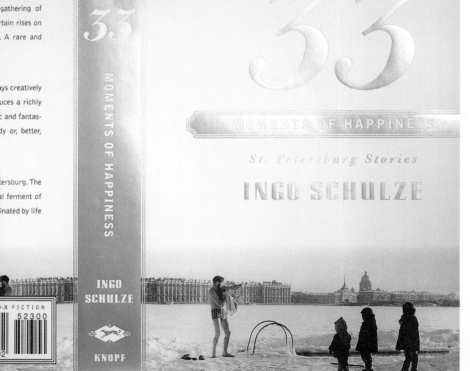

Praise for *33 Moments of Happiness*

"A tour de force of short-story writing, a remarkable gathering of
'sketches' of modern-day St. Petersburg ... When the curtain rises on
each brief piece, the reader is instantly transported ... A rare and
memorable work."
—*Publishers Weekly*

"These stories are simply masterpieces ... Ingo Schulze plays creatively
and deftly with that exotic place called Russia and produces a richly
varied series of shrewdly constructed prose pieces—satiric and fantas-
tic tales, some verging on the surreal, others on tragedy or, better,
tragicomedy ... Told with great ease and humor."
—*Frankfurter Allegemeine Zeitung*

"During 1993, Ingo Schulze lived as a journalist in St. Petersburg. The
special air he breathed must have been rich with the local ferment of
fantasy, for he has turned the whole mix into literature fascinated by life
in all its mad manifestations."
—*Süddeutsche Zeitung*

PRINTED IN U.S.A. © 1998 ALFRED A. KNOPF, INC.

ISBN 0-375-40029-X FICTION
52300
9 780375 400292

33
MOMENTS OF HAPPINESS
INGO
SCHULZE
KNOPF

33
MOMENTS OF HAPPINESS
St. Petersburg Stories
INGO SCHULZE

[STUDIO] Pylon
[ART DIRECTORS] Kevin Hoch, Scott Christie
[DESIGNER] Kevin Hoch
[CLIENT] Random House Canada
[CLIENT'S PRODUCT/SERVICE] Book cover design
[COLORS] 3, match
[SIZE] 4½" × 7¾" (11 × 20cm)
[TYPE] Bembo
[SPECIAL PRODUCTION TECHNIQUE] The whole concept of the translucent cover depended on the layering of words.

"The book was the author's outward reflections on a life so far, while the dust cover featured the 'Inside' of the book using the author's own prose," explains designer Kevin Hoch. "Also, being a memoir of an author, using words seemed appropriate."

The goal of any good book cover is to decipher the author's written work, to portray their heart and soul meaningfully while engaging the audience with a concept that will make them want to pick up the book. It's challenging to find this "soul." Especially when designing a cover with little or no direction from the author. We depend a lot on the publishers and the brief they supply.

KEVIN HOCH

REAL STYLE MAGAZINE ▼

[STUDIO] Platinum Design, Inc.
[ART DIRECTOR] Vickie Peslak
[DESIGNER] Victoria Stamm
[PHOTOGRAPHER] Shannon Greer (cover), David Bartolomi (spread)
[CLIENT] Lynne Berentson
[CLIENT'S PRODUCT/SERVICE] Magazine consultant
[COLORS] 4, process
[SIZE] 9" × 10½" (23 × 27cm)
[PRINT RUN] 3,500

"The concept was classic and modern, so we mixed beautiful classic and modern fonts to project the identity of this magazine for women," says art director Vickie Peslak.

I LOVE YOU LIKE A PIG LOVES CORN! ◄

[STUDIO] Peterson & Company
[ART DIRECTOR/DESIGNER] Scott Ray
[ILLUSTRATOR] Anthony Russo
[PHOTOGRAPHER] Neal Farris
[CLIENT] Dallas Society of Visual Communications (*Rough Magazine*)
[CLIENT'S PRODUCT/SERVICE] Graphic Communications Club
[PAPER] Scheufelen, Xantur, 100 lb. text
[COLORS] 4, process
[SIZE] 7½" × 11" (19 × 28cm)
[PRINT RUN] 2,500
[TYPE] Hand-rendered type by Scott Ray
[SPECIAL COST-CUTTING TECHNIQUE] The size and length of the publication was designed to fit on a single press sheet and it required only four colors.

"The design club has an annual crawfish boil," says designer Scott Ray. "I grew up in New Orleans, so the headline and the style was a natural direction for me."

GOOD FANTASY & BAD FANTASY ◄

[STUDIO] Cognition Design
[DESIGNER] Dwayne Cogdill
[ILLUSTRATOR] Tim Jessel
[CLIENT] Christian Research Institute/Christian Research Journal
[PAPER] Newport Matte, 60# text
[COLOR] 4, process
[SIZE] 8½" × 10⅞" (22 × 28cm)
[PRINT RUN] 40,000
[TYPE] La Figura (background script), Linotext (headlines), Caslon (body)

"The popularity of the Harry Potter books has spawned a great interest in fantasy literature among children. Many parents are asking questions about the appropriateness of fantasy with its witches, goblins and graphic depictions of evil," says designer Dwayne Cogdill. "Everything about the layout and design of this article was meant to help parents experience fantasy literature. The art, type and layout all look like an old fairy tale book."

SAFFRON SHORES: JEWISH COOKING OF THE SOUTHERN MEDITERRANEAN ▶

[STUDIO] Chronicle Books
[ART DIRECTOR/DESIGNER] Sara Schneider
[PHOTOGRAPHER] Leigh Beisch
[CLIENT] Chronicle Books
[CLIENT'S PRODUCT/SERVICE] Book publisher
[PAPER] 157 gsm Japanese matte art
[COLORS] 4, process
[SIZE] 8½" × 9¼" (22 × 23cm)
[PRINT RUN] 20,000
[TYPE] Trade Gothic, Garamond 3

"This book's geographical origins, beautiful North African art and ethnic food background provided a fantastic source of inspiration," art director Sara Schneider says. *"The book's warm color palette and ornate patterns are directly linked to the book's content. Paint washes were scanned in and colorized for the chapter openers. Hand-drawn patterns reminiscent of those found in North African art were overlapped to create pages of rich color and depth."*

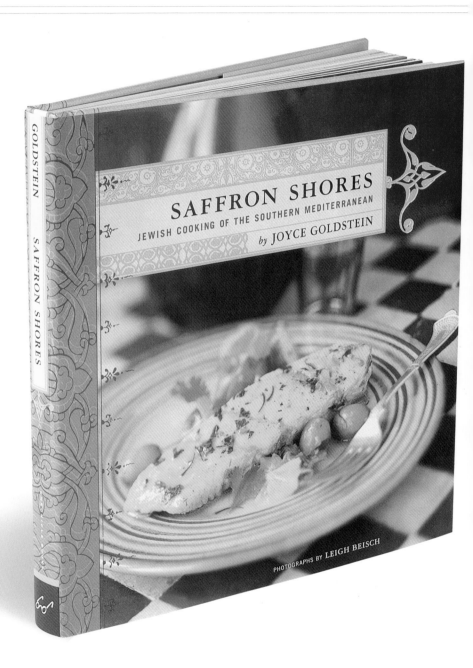

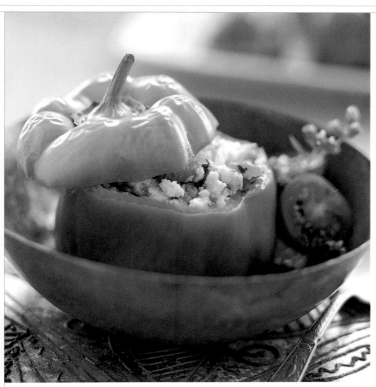

POIVRONS *de la* VEUVE
THE WIDOW'S PEPPERS

A signature dish of the Sephardic Jews, stuffed vegetables are usually filled with meat, meat and rice, or just a savory rice mixture, but this recipe uses a bread filling. Daisy Taieb, in *Les fêtes juives à Tunis*, and Andrée Zana-Murat, in *La cuisine juive tunisienne*, both recall this recipe, named for a legendary widow who was too poor to use meat but made a great dish with frugal ingredients.

Serves 8

8 GREEN BELL PEPPERS
4 CLOVES GARLIC
2 CUPS FRESH BREAD CRUMBS, SOAKED IN WATER AND
 SQUEEZED DRY
3 TABLESPOONS CHOPPED FRESH FLAT-LEAF PARSLEY
¼ CUP CHOPPED FRESH CORIANDER (CILANTRO)
1 TEASPOON GROUND CARAWAY
1 TEASPOON GROUND CORIANDER
1 TOMATO, PEELED, SEEDED, AND CHOPPED
2 HARD-COOKED EGGS, DICED
2 EGGS, LIGHTLY BEATEN
SALT AND FRESHLY GROUND PEPPER TO TASTE

Preheat the oven to 350 degrees F. Carefully cut across the top of each pepper and reserve the cap, or "little hat." Scoop out the seeds with a sharp knife. Boil the shells for 5 minutes in lightly salted water. Drain well. In a bowl, combine all the rest of the ingredients to make a filling.

Stuff the filling into the peppers. Place the peppers in a baking pan and add 1 inch of water. Cover the pan and bake until peppers are tender, 25 to 30 minutes.

: : : : : :

MUJADDARA
RICE AND LENTIL PILAF

The lentils for this pilaf must be perfectly cooked: not too soft and not too crunchy. Green or black lentils are best, as they will hold their shape. Brown and red lentils soften quickly and are often too tricky to control. Red onions seem to caramelize more easily, but you can also use yellow or white ones. Most versions of this recipe stir in the onions; I like to stir in half and leave half on top.

Serves 6

1 CUP GREEN OR BLACK LENTILS
5 TABLESPOONS OLIVE OIL
3 LARGE RED ONIONS, SLICED
SALT AND FRESHLY GROUND BLACK PEPPER TO TASTE
¼ TEASPOON GROUND CINNAMON
1 CUP BASMATI RICE
2 TABLESPOONS CHOPPED FRESH FLAT-LEAF PARSLEY
 (OPTIONAL)

Rinse and pick over the lentils. In a medium saucepan, combine the lentils and salted water to cover. Bring to a boil, reduce heat to a simmer, cover, and cook until tender but firm, 25 to 30 minutes, but keep watching! You don't want to overcook these.

In a large sauté pan or skillet, heat the oil and sauté the onions, stirring often, until deep golden brown, about 20 minutes. Stir in the salt, pepper, and cinnamon. Drain on paper towels.

Cook the rice until al dente, about 20 minutes. Add to the lentils and toss to combine. Stir in half the onions. Taste and adjust the seasoning. Top with the remaining onions. Serve warm or at room temperature, garnished with parsley, if using.

POIVRONS *de la* VEUVE ✳ **THE WIDOW'S PEPPERS**

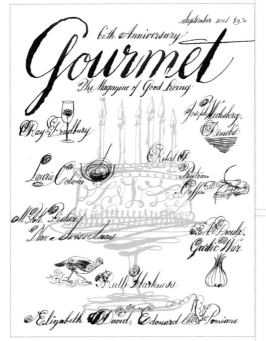

60TH ANNIVERSARY: GOURMET ◄

[STUDIO] Molloy & Son Box Company/Elvis Swift Library
[ART DIRECTOR] Diana LaGuardia, Art Director/*Gourmet Magazine*
[DESIGNER] Flavia Schepmans, Associate Art Director/*Gourmet Magazine*
[ILLUSTRATOR] Elvis Swift
[CLIENT] *Gourmet Magazine*
[PAPER] white bond paper (original work); 60 pound cover glossy (final printed cover)
[COLORS] 2 (dark blue and two hues of magenta)

"We researched decades of old Gourmet magazines in preparation for this special 60th anniversary issue," says associate art director Flavia Schepmans. *"One of the objectives was to reflect the rich history of great writing that we discovered. Writers' names displayed prominently accomplished this tribute. Even long after photography became the norm for modern magazines, Gourmet remained committed to the use of illustration. The style of Elvis' line work evokes this tradition, and the use of illustration in the first place was a quick signal to the readers that this was something special, as indeed it was."*

PAD: THE GUIDE TO ULTRA LIVING ►

[STUDIO] Chronicle Books
[ART DIRECTOR/DESIGNER] Shawn Hazen
[ILLUSTRATOR] Susan Tudor
[PHOTOGRAPHER] Jack Gould
[CLIENT] Chronicle Books
[CLIENT'S PRODUCT/SERVICE] Book publisher
[PAPER] 157 gsm Japanese matte art
[COLORS] 2 foil stamps (cover); 2 over 1 (end pages), 4-color process (interior)
[SIZE] 8½" × 9" (22 × 23cm)
[PRINT RUN] 20,000
[TYPE] New Century Schoolbook, ITC Franklin Gothic, Corpus Gothic, Trade Gothic and Trade Gothic Extended
[SPECIAL PRODUCTION TECHNIQUES] Iridescent foil, die cuts, 4-color endpapers, leatherette paper, black foil stamp for text

"The book is full of kitschy do-it-yourself ideas. The funky nature of the projects and homes featured inspired the big patterns on the chapter openers and the vivid color palette. The type is 'old school' but restrained due to the incredible amount of information," explains designer Shawn Hazen.

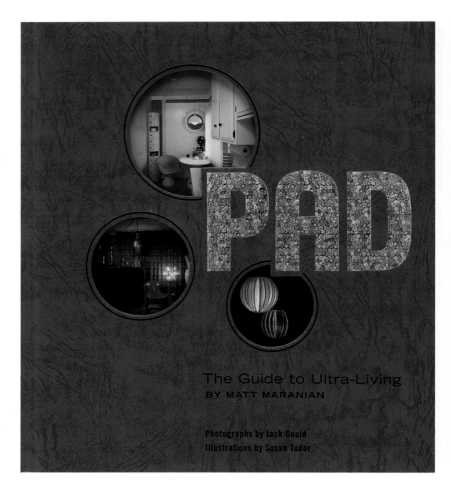

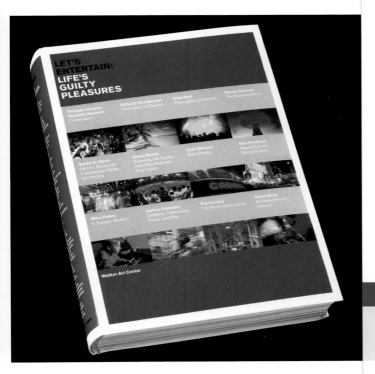

LET'S ENTERTAIN:
LIFE'S GUILTY PLEASURES ◄ ▼

[STUDIO] Walker Art Center
[DESIGN DIRECTOR] Andrew Blauvelt
[DESIGNER] Santiago Piedrafita
[PUBLICATIONS MANAGER] Michelle Piranio
[EDITOR] Karen Jacobson
[PAPER] 170 gsm BVS matte (interior), 150 gsm uncoated white (endpapers), 135 gsm BVS matte (cover)
[COLORS] 4 (inside), 1 (endpapers), 5 (cover)
[PRINTING] Sheet-fed offset lithography with gloss varnish, Smythe sewn, flexible hard-back binding
[SIZE] 6⅝" × 9²⁄₅" (17 × 24cm)
[PRINT RUN] 7,500
[TYPE] Akzidenz Grotesk
[SPECIAL TYPE TECHNIQUE] We wanted a simple uniform typographic palette. The only black type is on the cover.
[SPECIAL PRODUCTION TECHNIQUES] The cover binding is created from flexible boards, allowing for rigidity and flexibility. The cover features a series of scratch-offs, like a lottery card. This was previously untested on a book cover.

Design director Andrew Blauvelt says the goal was to "create an art exhibition catalogue that didn't look or function like one."

March 27, 1999—Bellagio Casino and Art Gallery, Las Vegas.
Olukemi Ilesanmi and Philippe Vergne continue their conversation. As we meet them, they are sitting on a bench in front of the casino, watching the "dancing waters" with 125 other visitors.

Olukemi Ilesanmi: So is Bellagio everything you expected and more?
Philippe Vergne: Yes. I have no idea where I am. It is my first time in Vegas, and I feel that I am not equipped for it. It is very shiny. Up to now my only Vegas experiences were through fiction, movies: *Leaving Las Vegas* by Mike Figgis in 1995 and *Fear and Loathing in Las Vegas* by Terry Gilliam in 1998. How is your suite? Mine is okay. I watched Jerry Springer.
OI: Pretty nice; I have a great view of the strip.
PV: What I really love is the big billboard that reads, "Now Appearing: Henri Matisse, Vincent van Gogh, Pablo Picasso." I think it's a brilliant publicity campaign.
OI: "Have Lunch with the Masters" is another good tag line. Do you think cultural institutions like museums can learn from Bellagio?
PV: Oh, yes. I think we learn something from the fact that Bellagio exists and appears to be succeeding thus far. I kind of like the idea that you can gamble in the proximity of masterpieces of twentieth-century art, but I don't know how to judge that...or even if I want to judge that. I don't know if I should be alarmed about this initiative or not.
OI: When we last talked, we were getting into some of the stickier issues. Tell me, were there any artists who were a little hesitant to be included in a show called *Let's Entertain*?
PV: Yes, some of the artists questioned the project. At least one, Gabriel Orozco, questioned it strongly, which I think was very healthy. When I talked to him early in the planning stages, he was hesitant to be included in an exhibition with such a title and questioned the overall topic of the exhibition. We had an exchange of letters, and I explained to him that the title of the show is a comment on packaging and marketing that is suggestive of a provocation or a joke. After all, one can joke only about serious things. Obviously the exhibition is not an uncritical celebration of the entertainment industry, but a way to question it and to learn about it. I wanted very much to include his work in the show because he has done several pieces that alter the idea of games and, more than that, the idea of rules. In particular, I am thinking about *Horses Running Endlessly* (pp. 44–45), a work that challenges the notion of an "end goal" as well as the idea of a definitive "winner," thereby challenging fundamentals in our culture. *Horses Running Endlessly* is a chessboard that has only horses—no queens, kings, or bishops—so you can only move sideways. Thus, the game becomes a circular loop, and traditional chess strategy is useless.
OI: I recently read an article by Salman Rushdie in which he wrote about his obsessional love of soccer and how this love of the game dovetails with so many other issues about identity and place." One of the most interesting things to me about Orozco's pieces and Maurizio Cattelan's *Stadio* (p. 32), an elongated foosball table, revolves around games as a site of identity construction, as a moment of inclusion in or exclusion from a cultural

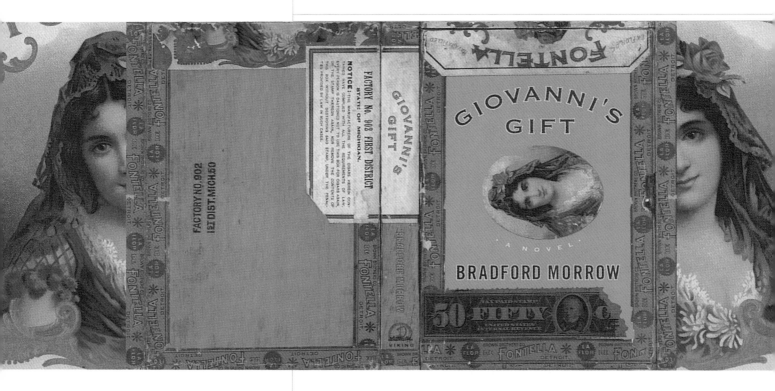

GIOVANNI'S GIFT ▶

[STUDIO] Penguin USA
[ART DIRECTOR/DESIGNER] Paul Buckley
[CLIENT] Penguin USA
[CLIENT'S PRODUCT/SERVICE] Publishing house
[TYPE] Copperplate, Trade Gothic
[COLORS] 4, process plus two match
[PRINT RUN] 30,000
[SPECIAL PRODUCTION TECHNIQUE] Multiple scans
 create the illusion of a box; extensive color correction
 ensured a suitably weathered look.

*"A cigar box is a key element in this mystery," says
designer Paul Buckley. "It holds many of the clues to the
questions that are raised in this story. The reader opens
the book the same way the main character opens the
box—both for the story contained within."*

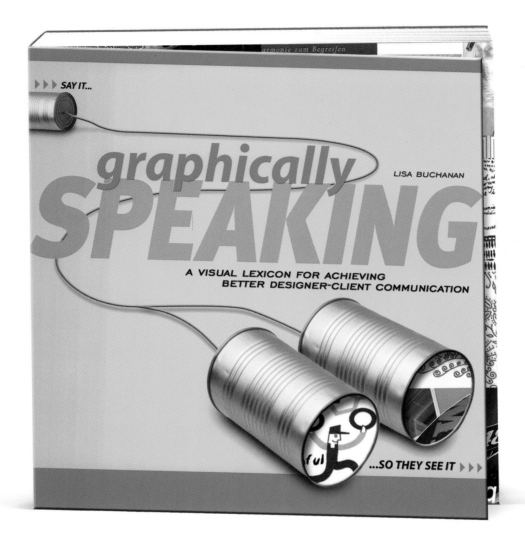

GRAPHICALLY SPEAKING ▲

[STUDIO] F&W Publications
[ART DIRECTOR/DESIGNER] Lisa Buchanan
[PHOTOGRAPHER] Tim Grondin
[CLIENT] HOW Design Books, an imprint of F&W Publications
[CLIENT'S PRODUCT/SERVICE] Book and magazine publisher
[COLORS] 4, process
[SIZE] 8" × 8" (20 × 20cm)
[SPECIAL PRODUCTION TECHNIQUES] Die cut and spot varnish on a matte cover

"This book is about designer/client communication problems that arise when the client, a typically nonvisual person, works with a designer, an obviously visual person. The book aims to facilitate a type of communication that will enable the designer or client to 'say it so they see it.' The different styles of design are classified and defined both visually and literally within the pages of the book, taking the often misunderstood verbal design brief into something both parties can tangibly understand," designer Lisa Buchanan explains. "My concept for the cover started with the idea of bad communication, shown by the proverbial two cans attached with string. To communicate that the book helps readers transform unclear verbal dialogue into clear visual communication, I added another can to the string, signifying the use of your eyes as well as your ears. The die cut through the cans on the cover reveals another hidden layer: When the cover is flipped open, the endpaper visually defines each style featured in the book."

Find your own design identity.
GWENAEL NICOLAS

CURIOSITY MAGAZINE ▲

[STUDIO] Curiosity Inc.
[ART DIRECTOR/DESIGNER] Gwenael Nicolas
[CLIENT] Self
[PAPER] Zanders Dull Special
[COLORS] 4, offset
[PRINT RUN] 500
[TYPE] Akzidenz Grotesk

"The process of unfolding makes people curious and is fun," states designer Gwenael Nicolas.

BOYHOOD ◄

[STUDIO] The Viking Penguin Design Group
[DESIGNER] Paul Buckley
[DESIGNER] Martin Ogolter
[PHOTOGRAPHER] Barbara Morgan
[CLIENT] Viking
[TYPE] Mrs Eaves, Tema Contante
[COLORS] 4, flat
[PRINT RUN] 10,000

In the first part of Boyhood, the memoirs of J.M. Coetzee, the book describes in simple and powerful prose the hardships of a young boy torn by love, by fear and by art. "The Barbara Morgan photograph, in its simplicity, seemed to best evoke the notion of looking back at the tortures and pains of childhood," says designer Martin Ogolter. "Stuck like a thorn in the back of the head is the typography."

BOWLED OVER ► ▼

[STUDIO] Chronicle Books
[ART DIRECTOR/DESIGNER] Benjamin Shaykin
[CLIENT] Chronicle Books
[CLIENT'S PRODUCT/SERVICE] Book publisher
[PAPER] 128 gsm Japanese gloss (cover); 157 gsm Japanese
matte art (interior pages)
[COLORS] 4, match and process
[SIZE] 7" × 7" (18 × 18cm)
[PRINT RUN] 15,000
[TYPE] Futura, Brody, Century Expanded, FF Zapata
[SPECIAL TYPE TECHNIQUE] Manual and mechanical
manipulation of type on the cover and chapter openers
to match the look and feel of the cheap printing of old
matchbook covers and other memorabilia featured
throughout the book
[SPECIAL PRODUCTION TECHNIQUE] Hardcover, paper
over board (no jacket); cover printed in 4-color match
process using three PMS colors (the red is a double hit).

*"I wanted to avoid the visual clichés found in most
retro bowling books and products,"* says art director
Benjamin Shaykin. *"For a book on the history of bowl-
ing, it seemed most appropriate to base my design on
the paraphernalia that surrounds the game. The cover,
for example, is derived from an old matchbook cover
from Guttormsen's Lanes of Kenosha, Wisconsin."*

THE ETIQUETTE OF BOWLING

In the 1950s, repositioning bowling as a recreational activity appropriate for the entire family required not only a fundamental rethinking of the game's infrastructure—its location, setting, and facilities—but a retooling of human behavior. If the game were to attract respectable, clean-living folk, proprietors realized, moving it from shabby, marginal locales into sparkling, hygienic facilities would only be part of the solution. Solving the rest of the problem would require transposing the manners of the drawing room into what had largely been a rough-and-tumble bastion of manly camaraderie. To this end, bowling associations from the local to the national levels began to append guides to bowling etiquette to their rulebooks, and bowling alley operators posted lists of behavioral do's and don'ts where their patrons would be sure to see them. *Politeness* and *timeliness* were the operative words. Team bowlers were encouraged to arrive at the lanes punctually. If anything should detain them or prevent them from coming, they were to communicate with their team captain so that a substitute could be arranged. As in driving, so in bowling, players observed certain fundamental "rules of the bowl." For example, when two bowlers on adjoining lanes are rolling first balls, or each one is bowling at a spare, the bowler on the right has the "honor" to proceed.

Team spirit is always advocated to prevent ruffled feathers and foul tempers. "Just as in football or baseball, a good sport congratulates his opponent on his strikes and good conversions," advises *The Etiquette of Bowling.* "It is highly improper to 'needle' an opponent or an opposing team with taunts or comments on misses or splits." Every bowling etiquette expert warned that exhibitions of temper or complaints about alley conditions or "luck" were in terribly bad taste.

Bowlers also should never offer "free advice" to other bowlers unless explicitly asked to do so. One of the top bowling teams in the country enforced a strict rule that warned team members against making any suggestions to each other without the express permission of the team captain, which, incidentally, was given only in the most extreme cases. "The reason for this rule, which should be observed by all team bowlers, is that the bowler who is bowling badly becomes more confused than ever when criticism or suggestion for correction is offered. The best advice, if advice must be given, is 'Take your time,' which really is more of a psychological correction, good no matter what he is doing wrong."

Don't needle an opponent while he's making his shot.

Give priority to the man on your right.

Don't use someone else's ball without permission.

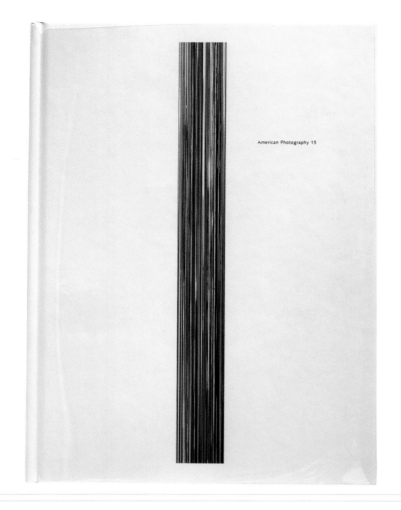

AMERICAN PHOTOGRAPHY 15 ◄ ▼

[STUDIO] Sagmeister Inc.
[ART DIRECTOR] Stefan Sagmeister
[DESIGNER] Hjalti Karlsson
[PHOTOGRAPHERS] Various
[CLIENT] Amilus Inc.
[PAPER] Matte coated
[COLORS] 4, process
[SIZE] 20" × 15½" (51 × 39cm), 334 pages
[PRINT RUN] 5,000
[COST PER UNIT] $45 retail
[TYPE] News Gothic
[SPECIAL PRODUCTION TECHNIQUES] By slicing an image into 420 parts and printing it as a bleeding frame on all pages, this *American Photography* features a panoramic photograph of a quintessential American landscape around the spine and edges of the book.

Art director Stefan Sagmeister says the concept was to make a photo book with no photo on the cover. "We could not decide on a single image and ended up showing them all," he says. "The striped, almost abstract pattern on the cover features tightly compressed versions of every photograph in the book."

Make it as easy as possible for the art director or person viewing your portfolio! We are bombarded with so many resumes on a monthly basis that it takes a portfolio that stands out but is also easy to view to get our attention. Portfolios I'll look at first include ones that are on CD or a Web site. Another tip: Show diversity in your work. For instance, some illustrators have several styles they work in. One of those styles might land you the job.

SUSAN M. KNIGHT

QUICK FIX ▶ ▼

[STUDIO] McMurry Publishing, Inc.
[ART DIRECTOR] Susan M. Knight
[ILLUSTRATORS] Stacy Innerst
[CLIENT] *Vim & Vigor Magazine* (a syndicated publication of McMurry Publishing, Inc.)
[PAPER] 45# Bowater Gloss
[COLORS] 4, process
[SIZE] 8³/₈" × 10¹/₂" (21 × 27cm)
[PRINT RUN] 903,000
[TYPE] The Sans, Kepler
[SPECIAL TYPE TECHNIQUES] *Vim & Vigor's* style is monochromatic with simplified type faces. The typography in this instance was meant to support the illustration.

"The article is about different fad diets such as 'the grapefruit diet,' 'Beverly Hills diet' and 'cabbage soup diet,'" explains art director Susan M. Knight. *"Since the 1930s, people have been trying crazy diets to lose weight quickly. I tried to think of icons who would represent each era of fad diet mentioned, and Marilyn Monroe and Madonna seemed like powerful pop culture icons. I just pictured incorporating their image in combination with the fad diets. I gave the illustrator, Stacy Innerst, my idea and he executed the rest!"*

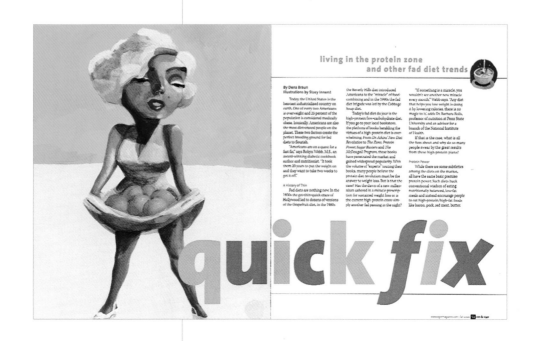

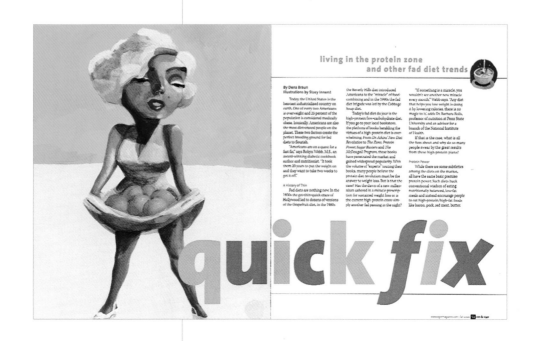

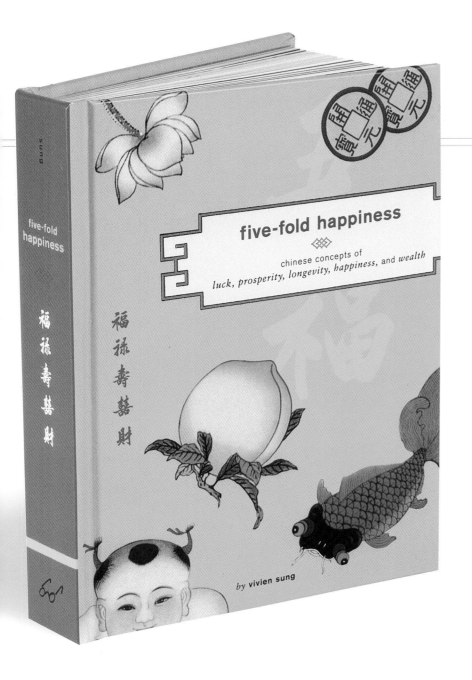

FIVE-FOLD HAPPINESS ◄

[STUDIO] Chronicle Books
[ART DIRECTOR/DESIGNER] Vivien Sung
[PHOTOGRAPHER] Richard Weinstein (color), Vivien Sung (black-and-white)
[ILLUSTRATOR] Youshan Tang (Chinese calligraphy)
[CLIENT] Chronicle Books
[CLIENT'S PRODUCT/SERVICE] Book publisher
[PAPER] Japanese matte art
[COLORS] 5 plus spot matte varnish; 4-color process plus PMS 85 red
[SIZE] 5⅛" × 6¹¹⁄₁₆" (13 × 17cm)
[PRINT RUN] 7,500
[TYPE] Berthold Akzidenz Grotesk, Sabon (English fonts); Ming, Hei (Chinese fonts)

"The content of the book is steeped in tradition but is part of everyday modern life, too, so I wanted to present it in a manner that references tradition while speaking primarily to the contemporary world," says art director Vivien Sung. "The book consists of a rich play between many components—Chinese calligraphy, English text and Chinese text. Each element is integral to the others. My aim was to create an exciting balance, rhythm and flow of elements from one page to the next while keeping the spreads playful and accessible— much like a room that has good feng shui."

DANGEROUS PILGRIMAGES ▼

[STUDIO] The Viking Penguin Design Group
[ART DIRECTOR] Paul Buckley
[DESIGNER] Gail Belenson
[ILLUSTRATOR] Shasti O'Leary

[CLIENT] Viking
[TYPE] Trade Gothic, Bauer Bodoni
[COLORS] 4, process
[PRINT RUN] 6,000

*"This was an attempt to make a potentially dry subject—transcontinental literary comparisons—look intriguing,"
says art director Paul Buckley. "The perfect old, red book was found in a used bookstore, photographed and
superimposed with the type treatment." Gail Belenson created the map texture, which the illustrator turned into a
box and incorporated into the final collage in Adobe Photoshop.*

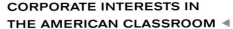

CORPORATE INTERESTS IN THE AMERICAN CLASSROOM ◄

[STUDIO] Plazm Media
[ART DIRECTOR] Joshua Berger
[DESIGNER] Pamela Racs, Johnson & Wolverton
[ILLUSTRATOR] Pamela Racs, Johnson & Wolverton
[CLIENT] Plazm Media
[CLIENT'S PRODUCT/SERVICE] Magazine, digital type
 foundry, design group
[TYPE] Clarendon, News Gothic, Times
[COLORS] Two, black and match
[PRINT RUN] 8,000
[SPECIAL PRODUCTION TECHNIQUES] Hand-drawn type,
 Photoshop collage

"The inspiration for the piece was the parallel between the environmental needs of a plant to ensure healthy growth and those of a child—equating a plant's need for light with a child's need for knowledge," says designer Pamela Racs. "The depicted problem divides photosynthesis by corporate propaganda, causing the viewer to question what corporate involvement in the classroom means for a child's growth and development."

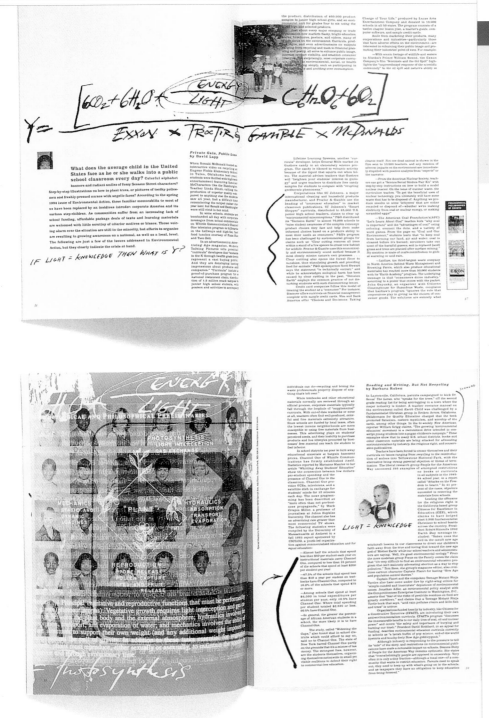

TRANS-FORM (THE MAGAZINE), TRANS-IT (THE ATTACHED CD-ROM) ▶ ▼

[STUDIO NAME] FL@33
[ART DIRECTORS/DESIGNERS/ILLUSTRATORS/PHOTO-
 GRAPHERS] Agathe Jacquillat, Tomi Vollauschek
[CLIENT] self
[PAPER] JMC Challanger Offset, 190 gsm, uncoated
[COLORS] 4, process
[SIZE] 500 × 320 mm, portrait
[PRINT RUN] 1,000 (limited edition)
[COST PER UNIT] £ 19.95, 30 Eur, $ 33 (first issue)
[TYPE] Courier New
[SPECIAL FEATURE] attached CD-Rom

"The exploration of the magic of urban sculptures—in this case tower cranes—combining a magazine, a CD-Rom and a web site," explain the designers.

STEEL WHEELS ▶

[STUDIO] Graphic Havoc
[CLIENT] FotoKings

"Steel Wheels Magazine *is a pictorial and literary journal that covers graffiti on trains around the globe,*" say the designers at Graphic Havoc. "Steel Wheels will cover *train graffiti from its humble beginnings on the Philadelphia and New York transit authorities to the explosion of aerosol graffiti on the North American freight system, as well as train scenes in Europe and Australia.*"

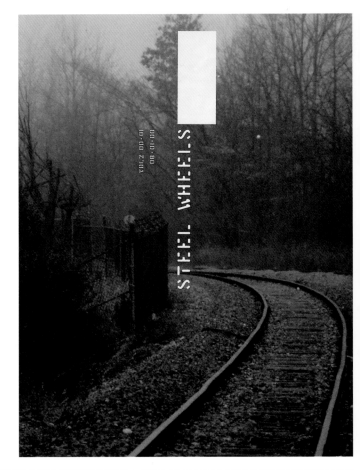

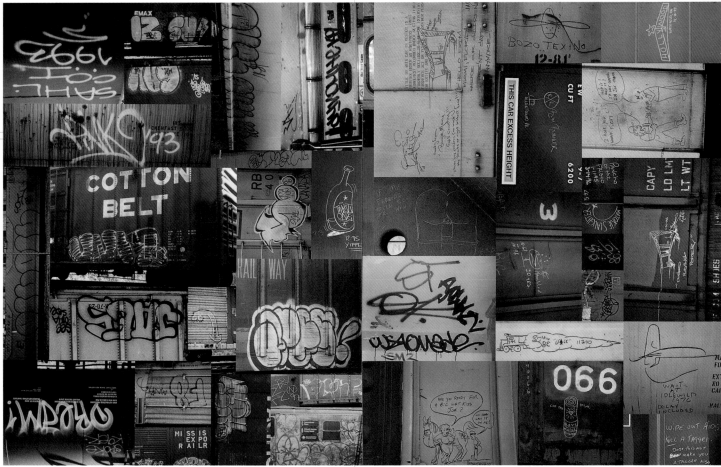

CHRYSLER CUSTOM PUBLICATION: "A GIFT FOR ME" ▼

[STUDIO] Platinum Design Inc.
[ART DIRECTOR/DESIGNER] Mike Joyce
[CLIENT] Hearst Custom Publishing/Chrysler
[CLIENT'S PRODUCT/SERVICE] Magazine
[COLORS] 4, process
[SIZE] 8" × 10½" (20 × 27cm)
[PRINT RUN] 45 million
[TYPE] Helvetica, Mrs Eaves
[SPECIAL FOLDS/FEATURES] Double gatefold centerfold

"The goal of this project was to create a custom magazine of interest to successful women," says art director Mike Joyce.

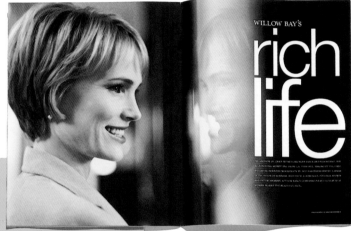

123

STORIES IN THE WORST WAY ▶

[STUDIO] Alfred A. Knopf, Inc.
[ART DIRECTOR] Carol Devine Carson
[DESIGNER] Archie Ferguson
[PHOTOGRAPHER] Nole Lopez
[CLIENT] Alfred A. Knopf, Inc./Random House
[TYPE] Trade Gothic, Trade Gothic Bold Condensed
[COLORS] 4, process, with spot varnish over sauce packets
[PRINT RUN] 2,000

"This idea came to me while having dinner with friends one evening," says designer Archie Ferguson. "I slipped the art into my pocket before making my way out. Hopefully, my host didn't notice."

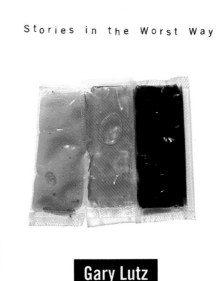

GOING ALL THE WAY ▶

[STUDIO] Farrar, Straus and Giroux
[ART DIRECTOR] Michael Ian Kaye
[DESIGNER] Rodrigo Corral
[PHOTOGRAPHER] Sylvia Plachy
[CLIENT] Hill and Wang
[TYPE] Mheadline Bold
[COLOR] 1, flat
[PRINT RUN] 5,000

"For a book that illustrates the urgency teenagers often experience when they first encounter sex, I tried to make the cover feel a little bit uncomfortable—a little risque," says art director Michael Ian Kaye. "I wanted people to have mixed feelings, just like the kids in the photo do."

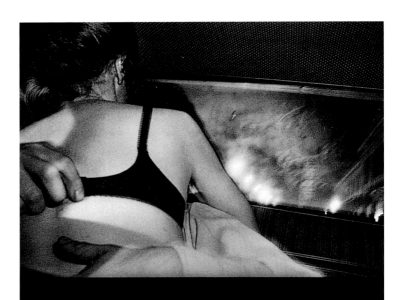

BOMB MAGAZINE ▼

[STUDIO] Platinum Design Inc.
[ART DIRECTORS] Mike Joyce, Kelly Hogg, Kathleen Phelps
[DESIGNERS] Mike Joyce, Kelly Hogg
[CLIENT] *Bomb Magazine*
[CLIENT'S PRODUCT/SERVICE] Quarterly magazine covering literary and art-related topics
[COLORS] 4, process (cover); 2, match (interior)
[SIZE] 9" × 10^{15}/$_{16}$" (23 × 28cm)
[TYPE] Bell Gothic, Scala, Clarendon

"The inspiration for this project was art, literature and film—the subject matter of the magazine," says art director Mike Joyce.

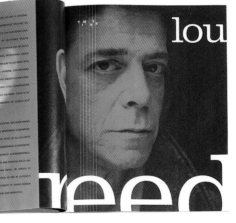

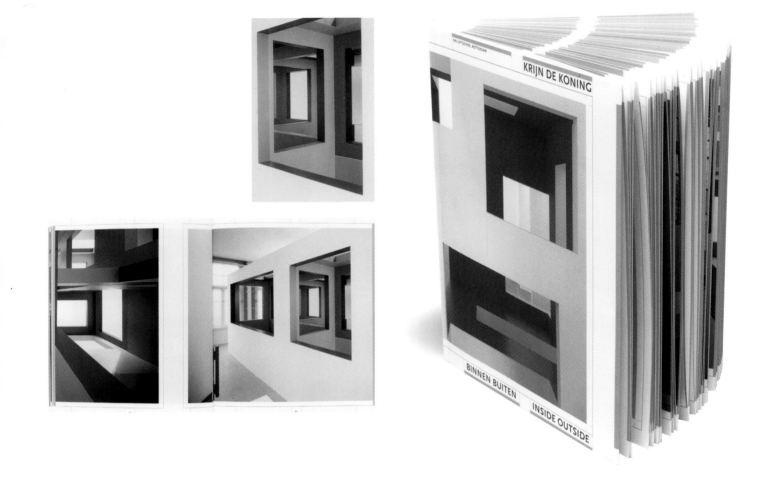

KRIJN DE KONING: INSIDE OUTSIDE ▲

[STUDIO] COMA Amsterdam/New York
[ART DIRECTORS/DESIGNERS] Cornelia Blatter, Marcel Hermans
[CLIENT] NAi Publisher, Rotterdam, The Netherlands
[CLIENT'S PRODUCT/SERVICE] Publisher of books on Architecture and Fine Arts
[PAPER] Libra mat, Bührmann Ubens, The Netherlands
[COLORS] 5/5 process
[SIZE] 8¼" × 6⅝" (21 × 17cm)
[TYPE] Scala Sans
[SPECIAL COST-CUTTING TECHNIQUE] Economical size of book, maximum use of paper on press

"Since the early nineties, Krijn de Koning has been creating site specific sculptures, many of which are temporary," explain art directors Cornelia Blatter and Marcel Hermans. "De Koning constructs his work from floor, walls and corridors, sometimes vividly colored, sometimes in an immaculate white. His work raises questions about how architecture conditions and limits us; the perception of beauty remains important. Experiencing his work means to walk from room to room, looking from window to window, space to space, experiencing the inside/outside. Our challenge was to create a site specific design to Krijn de Koning's work. The resulting design is based on the experience of inside/outside, by using the inside/outside and horizontal/vertical grid of the book—the idea of a book inside a book. The horizontal and vertical grid are overlapping layers that shift over each other. For the outside book, the blue bars indicate the horizontal and vertical grid. For the inside book, the vertical grid is used for all background information including drawings, models, artist interview and traveling pictures. The horizontal structure is used as the big window, showing all installations and main reading texts. Marked as a page with crop marks, the frame shifts throughout the book slowly to the right, looped like a video."

[STUDIO] Chronicle Books
[ART DIRECTOR/DESIGNER] Benjamin Shaykin
[ILLUSTRATOR] CSA Archive
[CLIENT] Chronicle Books
[CLIENT'S PRODUCT/SERVICE] Book publisher
[PAPER] 80 lb. Mohawk Tomahawk Text (cover)
[COLORS] 4, process
[SIZE] 5½" × 8" (14 × 20cm)
[PRINT RUN] 12,500
[TYPE] Knockout, FF Zapata, Viceroy, Woodtype Ornaments
[SPECIAL TYPE TECHNIQUE] Manual and mechanical
 manipulation of type on the cover and spine to match the
 irregularities and warmth of wood type
[SPECIAL PRODUCTION TECHNIQUE] The jacket was print-
 ed on an uncoated, very toothy paper stock to replicate
 the feel (quite literally) of an old poster.

*"For this novel about a young female country/western
singer, I took my inspiration from the posters of Hatch
Show Print, as well as the classic country album covers
of the 1950s," explains art director Benjamin Shaykin.*

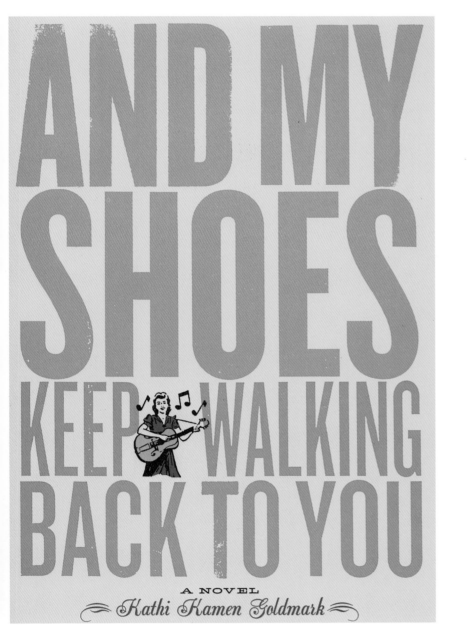

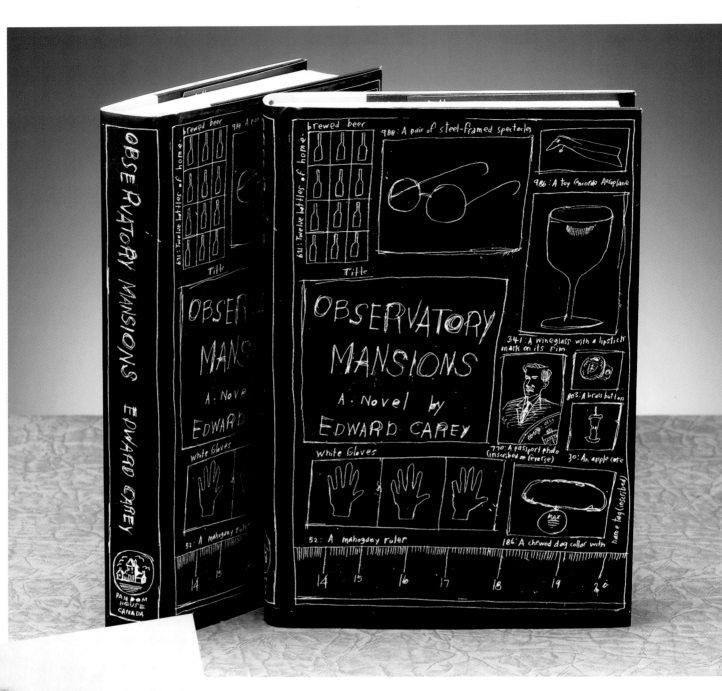

The most challenging part of book cover design for me is getting the publisher and their marketing team to buy into the idea. Many great book cover ideas have been put aside and replaced with more typical approaches.

SCOTT CHRISTIE

OBSERVATORY MANSIONS ▲

[STUDIO] Pylon
[ART DIRECTOR] Scott Christie
[DESIGNERS] Scott Christie, Gary Clement
[ILLUSTRATOR] Gary Clement
[CLIENT] Random House Canada
[CLIENT'S PRODUCT/SERVICE] Book covers
[COLORS] 1
[SPECIAL TYPE TECHNIQUE] Hand lettering

"The inspiration was to do a better job than the previous designers. The concept was to capture the dark mood of the book," says art director Scott Christie.

DEAN & DELUCA FOOD AND WINE COOKBOOK ▼

[STUDIO] Chronicle Books
[ART DIRECTOR] Sara Schneider
[DESIGNER] Vanessa Dina/Flux
[PHOTOGRAPHER] Steven Rothfeld
[CLIENT] Chronicle Books
[CLIENT'S PRODUCT/SERVICE] Book publisher

[PAPER] 157 gsm Japanese matte art
[COLORS] 4, process
[SIZE] 8¹/₄" × 9" (21 × 23cm)
[PRINT RUN] 20,000
[TYPE] Bell Gothic, Trade Gothic, Copperplate
[SPECIAL PRODUCTION TECHNIQUE] Metallic inks

"Our goal was to reflect the look, feel and style of California wine country and the Dean & Deluca Market-place," says designer Vanessa Dina.

A PASSION FOR CACTUS ▼

[STUDIO] Platinum Design, Inc.
[ART DIRECTORS] Vickie Peslak, Kathleen Phelps
[DESIGNER] Kathleen Phelps
[CLIENT] Welcome Publishing
[CLIENT'S PRODUCT/SERVICE] Book packaging
[COLORS] 4, process
[SIZE] 6" × 5¾" (15 × 14.5cm)
[TYPE] Blackoak, Helvetica Bold
[SPECIAL PRODUCTION TECHNIQUE] Liquid lamination on jacket covers

"This piece is full of whimsy and humor, and we did a lot of mixing of fonts to show that," explains art director Vickie Peslak. *"We also used little dash lines that direct the reader's eyes from place to place."*

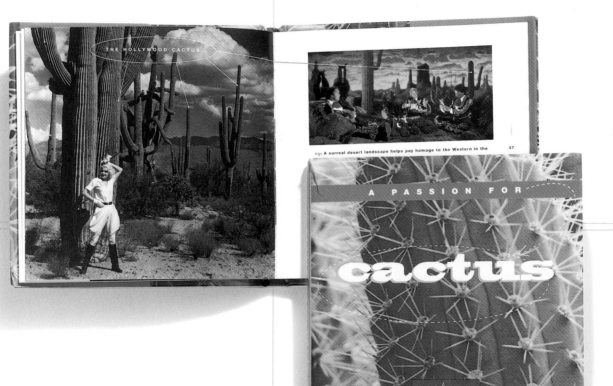

UHO, GRLO, NOZ ◄

[STUDIO] Mirko Ilic Corp.
[DESIGNERS] Melina Mikulic/Studio Grafickihideja
[ILLUSTRATOR] Mirko Ilic
[CLIENT] AZ Best
[CLIENT'S PRODUCT/SERVICE] Publisher
[COLORS] 5, match
[SIZE] 9" × 6½" (23 × 17cm)

"This illustration was part of a 3-D show I did in Croatia called 'Sex and Lies,'" explains illustrator Mirko Ilic. "The designer liked the image and thought it was a perfect fit for this novel about a Croatian woman's life."

ROLLING STONE: THE DECADES OF ROCK & ROLL ▼

[STUDIO] Chronicle Books
[ART DIRECTOR/DESIGNER] Azi Rad
[PHOTOGRAPHER] Michael Ochs Archives
[PAPER] 140 gsm wood-free sheet
[COLORS] 2 (interior), 4 (jacket), 1 (color case); process
[SIZE] 8½" × 11¾" (22 × 30cm)
[PRINT RUN] 20,000

[TYPE] Giza, Belizio, Tasse, Acropolis, Knockout, Centaur, Woodtype Ornaments
[SPECIAL PRODUCTION TECHNIQUE] "The printer whipped up a super black ink that allowed us to maintain saturation and richness despite printing on a woodfree sheet," art director/designer Azi Rad says.

"The intention was to create a timeless design that at once feels historic and contemporary, one that integrates well with the character of each of the five decades presented in the book," art director Azi Rad explains. "I wanted it to feel recognizably Rolling Stone and yet offer something new."

dick clark

By HENRY SCHIPPER

There's something ambiguous and slightly out of focus about Dick Clark. As host of *American Bandstand*, he brought rock & roll—*the* cultural controversy of the Fifties—into America's living rooms, which was no small accomplishment, considering the hysterical opposition the new music provoked. Clark succeeded, however, largely by doing everything he could to take the controversy out of rock & roll.

The boyish, edgeless and well-groomed Clark was reassuring to adults. Though one could sense he genuinely liked the music, it was hard to tell how deep the feeling ran. An easygoing pitchman, he brought the same sunny attitude to Little Richard and Chuck Berry that he did to Clearasil and Beech-Nut gum.

The man whose tombstone will probably read AMERICA'S OLDEST TEENAGER never really was a teen—at least not in the rock & roll sense of the word. Clark became host of *American Bandstand* in 1956 at the age of twenty-six, and he was in many ways older than his years. A product of the Eisenhower era, he was driven, ambitious and savvy enough to turn a Philadelphia dance show into a national obsession.

In Clark's hands, *American Bandstand* was a phenomenal success. Five days a week in the late afternoon, the show held teenage America in its thrall, launching careers, breaking hits, sparking dance fads and drawing the highest ratings of any daytime program in the land. *American Bandstand* featured two live performances a day—more than ten thousand overall—including national debuts by Chuck Berry, James Brown, Johnny Cash, Sam Cooke, Fats Domino, Buddy Holly, Jerry Lee Lewis and many others who couldn't get a booking on the antirock TV variety shows of the day.

Clark's own success paralleled the show's. By the time he was thirty, he was a millionaire, not from his *Bandstand* salary but from spinoff investments. His light and smiling persona aside, Clark was a hungry entrepreneur, working every angle to build a small empire of music concerns, including record labels, music publishers and pressing plants.

In 1960, Clark's publishing interests drew the attention of congressional payola investigators, who accused him of trading *Bandstand* airtime for copyrights to songs. Clark denied the charge, though he did hold the copyrights to more than 150 tunes, some of which were assigned to him gratis and were played on the show.

Clark's grilling on Capitol Hill was the crisis and crucible of his life. The man who groomed himself so carefully, whose career depended on a clean, trustworthy image, was having his clock cleaned on the front pages of America's newspapers. Ultimately, the pols couldn't nail him on anything, and Clark, one of the era's great survivors, walked away with his reputation and his image more or less intact. His empire, however, fell apart. ABC ordered him to choose between *American Bandstand* and his other holdings, and Clark decided to stay with the show. He then set about building a less vulnerable portfolio.

He has since branched out to become one of the busiest producers in the world, handling everything from TV specials (*Bloopers, Live Aid, American Music Awards*), feature films and game shows to beauty pageants (*The Most Beautiful Girl in the World*), sitcoms and an

‹ **dick clark** questions **don** and **phil everly** [ca. 1957]
MICHAEL OCHS ARCHIVES/VENICE, CA

the eighties

By ANTHONY DeCURTIS

Who could have foreseen the brutal superficiality and greed of the Gimme Decade? In November 1980, Ronald Reagan was elected to his first term as president of the United States. A little more than a month later, on December 8, John Lennon was shot to death outside his apartment building in New York City. Each of those two events had its own all too real causes and consequences, but each has also come to bear the weight of symbol: Each is a lens through which the mood and the manners of the Eighties, the cultural climate of the decade that followed, may be read.

Some say the Sixties died at Altamont; others say the Sixties died at Kent State. In any case, whatever vestige of Sixties-style visionary thinking and progressive politics managed to survive the Seventies—when, after all, the Watergate revelations and Nixon's resignation at least partly vindicated Sixties radicalism and inspired a brief resurgence of idealism among the young—who can deny that the election of Ronald Reagan proved to be the fatal blow to the Sixties dream? Even the liberal values of the Great Society, which were little more than an extension of the civilizing efforts of FDR's New Deal, were anathema to Reagan—let alone the wild utopian urges that were meant to transport us to the Gates of Eden, the road of counterculture excess that would lead us to the Palace of Wisdom.

The generous collective impulses of the Sixties may ultimately have yielded to the Me Decade hedonism of the Seventies, but who knew that the next stop would be the pinched privatism, the smug selfishness, the glib pragmatism, the grim status consciousness, the greed masking as taste, the brutal superficiality of the Eighties? Who knew that the hungover sybarites of the Me Decade would transform, as if in the course of a nationwide Night of the Living Dead, into the desperately sober workaholics of the Gimme Decade?

Could there possibly have been a place for the likes of John Lennon in such a world? The point is not that Lennon was a saint, too good to live among the gleefully solvent sinners of the Eighties. It's just that he was too ungovernable, too unlikely to play by the rules, too interested in the margins to succumb to the savage mainstreaming of those ten years. The willful experimentalism, loopy romanticism and smiling politics that Lennon represented—this was a man, you will recall, who believed that bed-ins and planting acorns could bring about world peace—are not virtues that would have carried much weight in an era during which greed was the ultimate good. The characteristics that define the personality of Lennon's assassin, Mark David Chapman—an obsession with Lennon's media image to the point of obliterating the reality of Lennon the person, a worship of Lennon's power and celebrity so intense that it shaded into violence and hatred, a need to destroy the ideal he could not himself attain—are far more central to an understanding of the decade.

◄ EBET ROBERTS

Playola
in-store rock/pop sampler
UNIVERSAL
UNIVERSAL MUSIC &
VIDEO DISTRIBUTION
VOLUME I

13 WAYS TO BLEED ON STAGE
COLD
PARENTAL
ADVISORY
EXPLICIT CONTENT

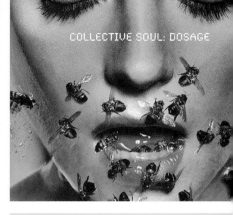

COLLECTIVE SOUL: DOSAGE

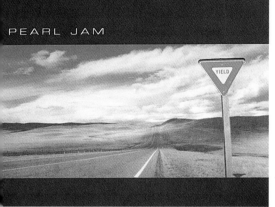

PEARL JAM
YIELD

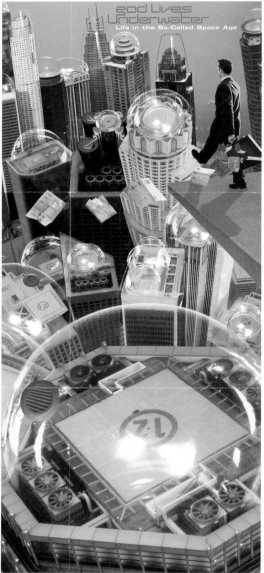

god Lives
Underwater
Life in the So-Called Space Age
12

STING
BRAND NEW DAY

THE REMIXES

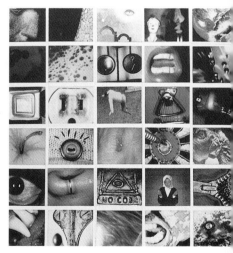

NO CODE

musicfor anopenstudio

love,
whitney

HANDPICKED → volume 2 MTV 2

VITALOGY

CD & MUSIC GRAPHICS

Musicians and designers often share the dance floor when it comes to creating groundbreaking CD packaging. Progressive bands encourage progressive designs—as long as they can keep their record labels happy—which is why some of the most ingenious designs first surface in the music industry.

Beyond the velvet ropes of this section, see a smattering of the latest designs to arrive on the music scene. It's the place to be for design rock stars.

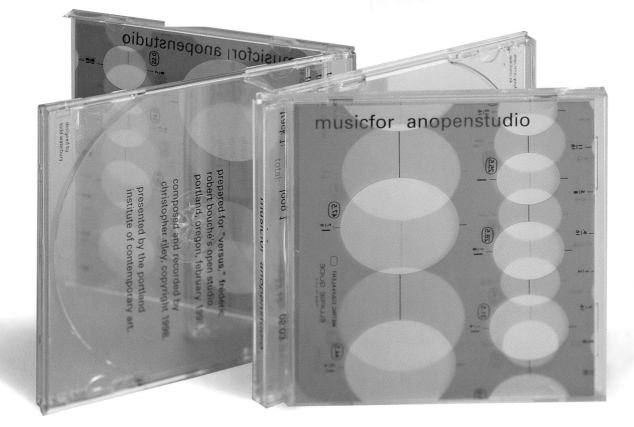

MUSIC FOR AN OPEN STUDIO ▲

[STUDIO] studioriley
[ART DIRECTOR/DESIGNER] Todd Waterbury
[CLIENT] Christopher Riley
[CLIENT'S PRODUCT/SERVICE] Composer
[TYPE] Univers

"The music on the CD explores the relationship between personal and universal space, the connections between the two," explains Christopher Riley. "It was designed for a sound and visual installation and premiered as an open studio piece. The sound of the universe is represented by a frequency and the sound of humanity is represented by the sounds of static. The typeface choice reflected the theme and the geometry of the concept responded to the layers of sound that linked the human and the universal. The design became a reflection on the sound installation rather than a representation of it. As such, it became part of the work—not simply its packaging."

SALT TANK "SCIENCE AND NATURE ST7" CD ◄

[STUDIO] Prototype 21
[ART DIRECTOR/DESIGNER] Paul Nicholson
[CLIENT] Internal Records
[TYPE] Eurostile, Salt Tank (designed by Prototype 21)
[COLORS] 4, process

"The sleeve and album title are the continuation of a theme initiated by the Salt Tank logo," says designer Paul Nicholson. "The logo was designed in 1992 and is based on the Golden Section and ammonite fossils, hence the reference to 'Science and Nature.' The sleeve itself features a complex visual representation of time—that of the tracks and the history of the band's existence. As with all sleeves I design, continuity of layout—from the front to the back through to the inner sleeves and labels—is of paramount importance."

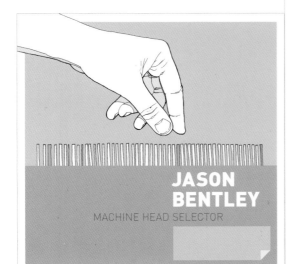

JASON BENTLEY-MACHINE HEAD SELECTOR ◄

[STUDIO] 344 Design, LLC
[ART DIRECTOR/DESIGNER] Stefan G. Bucher
[ILLUSTRATOR] Stefan G. Bucher
[CLIENT] Machine Head
[CLIENT'S PRODUCT/SERVICE] Music production house
[PAPER] Discmakers Standard
[COLORS] 4, process
[SIZE] 5" × 5" (13 × 13cm)
[PRINT RUN] 500
[TYPE] DIN

"Jason Bentley is one of L.A.'s most widely recognized and influential DJs through his NPR show Metropolis and his DJ residence at bossa:nova. This CD of his mixes is the calling card for his music supervision day job," says designer Stefan Bucher.

ROSE TATTOO ▶

[STUDIO] LiquidNoise
[ART DIRECTOR/DESIGNER] Stacie Hampton
[PHOTOGRAPHERS] Honey Cohn-Parker, Nicholas Prior,
 Stacie Hampton
[ILLUSTRATOR] Stacie Hampton
[CLIENT] Epiphany Records
[CLIENT'S PRODUCT/SERVICE] Record label for independ-
 ent music
[COLORS] 4, process
[SIZE] 5½" × 4⅞" (14 × 12cm)
[PRINT RUN] 5,000
[TYPE] Manson, Arial, Blackoak, Bustle

*"The title of the CD, 'Tattoo,' inspired much of the imagery
and the use of texture and layers," explains art director
Stacie Hampton. "'Tattoo' also inspired the use of vari-
ous fonts for song titles. I wanted it to have the feel of a
wall in a tattoo shop."*

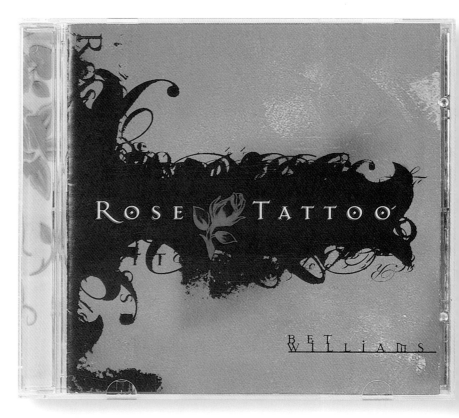

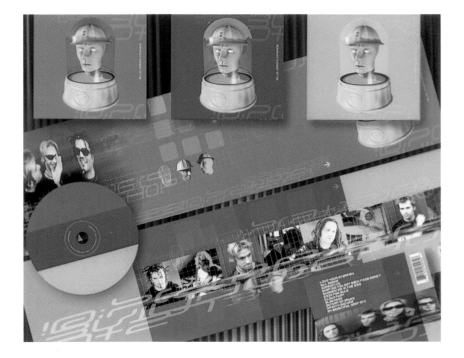

COLLECTIVE SOUL, DOSAGE ◄

[STUDIO] Atlantic Records
[ART DIRECTOR/DESIGNER] Benjamin Niles
[PHOTOGRAPHER] Yves Bottalico
[CLIENT] Atlantic Records
[COLORS] 4, process
[PRINT RUN] 750,000
[TYPE] Synchro

"We shot three concepts for Dosage *and the 'bee cover' was chosen," says designer Benjamin Niles. "Yes, they're real, but they're dead. The cover was created by compiling five shots, moving the bees each time. Diane Murkovich, the model, was terrific even though she had been covered in honey for most of the day. Actually, everyone was terrific, a blast to work with."*

I MOTHER EARTH ◄

[STUDIO] Amoeba Corp.
[ART DIRECTOR] Michael Kelar
[DESIGNERS] Jason Darbyson, Michael Kelar
[ILLUSTRATORS] Steve McArdle
[PHOTOGRAPHERS] Margaret Malendruccolo, Mark Bartkiw
[CLIENT] Universal Music
[CLIENT'S PRODUCT/SERVICE] record company
[COLORS] 5 (4, process plus 1 special silver 877 PMS)
[SIZE] 5½" × 5" (14 × 13cm)
[PRINT RUN] 100, 000
[TYPE] Eurostile (body); I Mother Earth (word mark and headers) created by Michael Kelar and Jason Darbyson
[SPECIAL PRODUCTION TECHNIQUES] Metallic ink as fifth color; three different color covers created based on title of album
[SPECIAL FOLDS/FEATURES] Four panel fold-out booklet with a 12-page saddle stitch book inside; all pages short folded and set up so the viewer reads info from back to front

The crew at Amoeba Corp. point to the colonization of Mars and a new society of robot workers as inspiration. The three colors represent the colors of the flag.

PEARL JAM, VITALOGY ▼

[STUDIO] Ames
[ART DIRECTORS] Joel Zimmerman, Eddie Vedder
[DESIGNER] Barry Ament
[ILLUSTRATORS] Barry Ament, Eddie Vedder
[PHOTOGRAPHERS] Jeff Ament, Lance Mercer

[CLIENT] Epic/Sony Music, Pearl Jam
[TYPE] Hand rendered; typewritten
[COLORS] 4, process
[PRINT RUN] 5,351,127

"We basically gutted a medical book from the nineteenth century," say the designers. "After two long days and nights, it was out the door. It's pretty scrappy and rough around the corners, which I think works. We also made the CD format vertical to compliment the book feel. Great idea but not very functional in your CD rack."

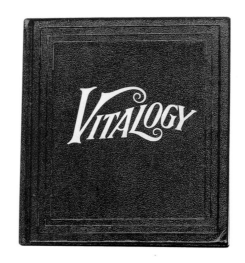

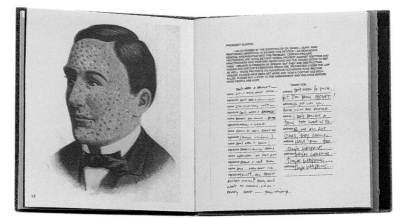

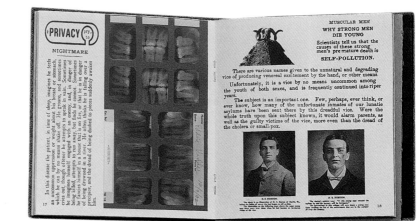

RISKY MUSIC KIT ▼

[STUDIO] Sprecher Design House
[ART DIRECTORS] Jeannie Sprecher, Matt Ward
[DESIGNER] Matt Ward
[CLIENT] Scott Benson, Risky Music
[CLIENT'S PRODUCT/SERVICE] Risky Music is a Boston-based, independent record label. Risky's business model is to focus on a small number of bands and to provide long-term artist development.
[PAPER] 16 pt. Carolina C2S
[COLORS] Black, metallic green, metallic silver, overall aqueous coating, spot gloss and dull UV coating
[SIZE] 8½" × 9¼" (22 × 23cm)
[PRINT RUN] 2,500
[COST PER UNIT] Approximately $6
[TYPE] Dr. NÓ, BankGothic, Moonbase Alpha
[SPECIAL PRODUCTION TECHNIQUE] Register emboss, die cut

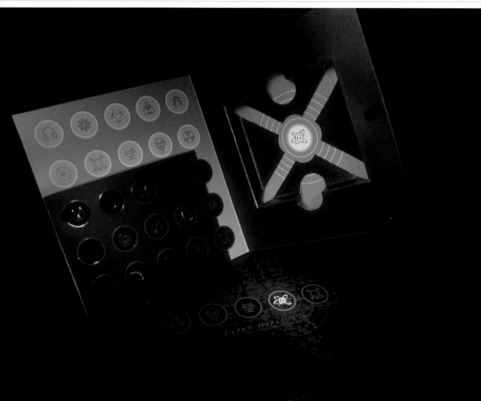

"This almost never happens," says art director Jeannie Sprecher, "but the client was the inspiration for this piece. He said, 'Have complete creative freedom, and—hey—here's a real budget. Do what you do best! Our goal was to develop a piece that would help showcase Risky's music by creating a package that would stand out in the sea of thousands of competitors. We wanted the package to say: 'Listen to our music.' It worked."

The most challenging part of designing anything is not the designing at all. It's integrating the often oil and water qualities of the two players that are involved in every piece: client and designer. It's convincing clients to accept the unexpected creative solution and designers that clients actually have good ideas, too (really). Most days I feel like we're sticking two opposing political figures in a sandbox and telling them to build an incredible sand castle together (and play nice). Much sand hurling commences until each side is convinced the other brings a valid, and necessary, perspective to the problem. Facing the challenge comes from embracing our goals in commercial design: A) we want the client to be wildly successful, and B) it sure wouldn't be a bad thing to win a design award—in that order.

JEANNIE SPRECHER

141

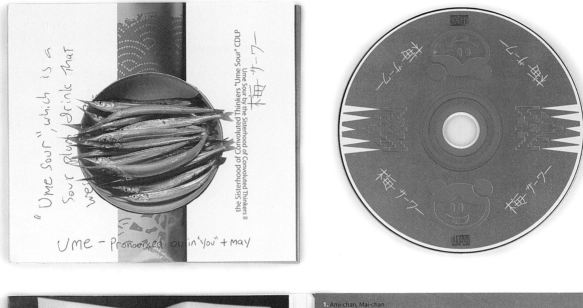

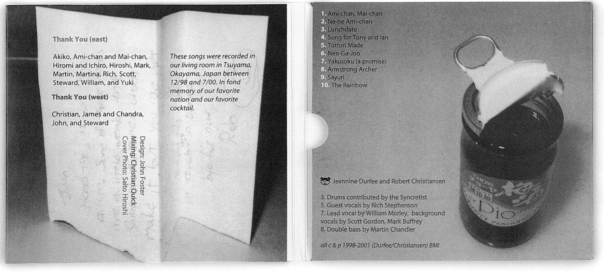

Thank You (east)

Akiko, Ami-chan and Mai-chan, Hiromi and Ichiro, Hiroshi, Mark, Martin, Martina, Rich, Scott, Steward, William, and Yuki

Thank You (west)

Christian, James and Chandra, John, and Steward

These songs were recorded in our living room in Tsuyama, Okayama, Japan between 12/98 and 7/00. In fond memory of our favorite nation and our favorite cocktail.

Design: John Foster
Mixing: Christian Quick
Cover Photo: Saito Hiroshi

1. Ami-chan, Mai-chan
2. Ne-ne Ami-chan
3. Lunchdate
4. Song for Tony and Ian
5. Tottori Made
6. Nen-Ga-Joo
7. Yakusoku (a promise)
8. Armstrong Archer
9. Sayuri
10. The Rainbow

Jeannine Durfee and Robert Christiansen

3. Drums contributed by the Syncretist
5. Guest vocals by Rich Stephenson
7. Lead vocal by William Morley, background vocals by Scott Gordon, Mark Buffrey
8. Double bass by Martin Chandler

all c & p 1998-2001 (Durfee/Christiansen) BMI

SISTERHOOD OF CONVOLUTED THINKERS "UME SOUR" CD ▲

[STUDIO] Fuszion Collaborative
[ART DIRECTOR/DESIGNER] John Foster
[PHOTOGRAPHERS] Saito Hiroshi, John Foster
[CLIENT] Darla Records
[CLIENT'S PRODUCT/SERVICE] Record Label
[COLORS] 4, process
[SIZE] 5" × 5½" (13 × 14cm)
[TYPE] Hand-scrawled English and Japanese
[SPECIAL TYPE TECHNIQUE] Handwritten pieces from notes exchanged during the design process were incorporated along with drawn Japanese characters

"For this CD, which was recorded in Japan and includes some Japanese lyrics, The Sisterhood of Convoluted Thinkers wanted packaging that reflected the up close view of Japan and its people and the journey that brought them there," explains art director John Foster. "The husband-and-wife duo had collected lots of mementos of their travels in Japan, so when it came time to design the CD, a lot of reference material was available. Sprinkled throughout the design are images from their travels and handwritten notes from their correspondence, including a helpful explanation as to how to properly pronounce the album's title. The group and record company were very surprised and pleased with the results and felt that they could now share a few years of their lives with thousands of others with just a tiny package and a quick listen."

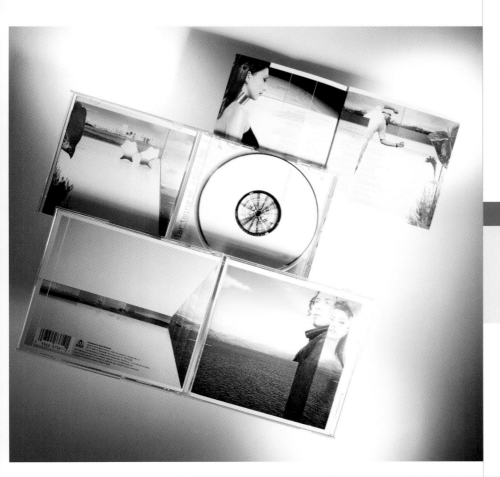

SOLAR TWINS ◄ ▼

[STUDIO] 344 Design, LLC
[ART DIRECTOR/DESIGNER] Stefan G. Bucher
[PHOTOGRAPHERS] Geoff Moore, Ann Short, StGB, Cal-
 Tech/NASA/JPL
[CLIENT] Maverick Recording Co.
[PAPER] Warner Standard
[COLORS] 4, process
[SIZE] 5½" × 5" (13 × 14cm), 19" × 4¾" (48 × 12cm)
 (booklet)
[PRINT RUN] 20,000
[COST PER UNIT] $17.99 retail
[TYPE] Helvetica

"For the debut album of British electronica duo Solar Twins, we set out to design a package that merges the lavish style of an old Pink Floyd sleeve with the modern vibe of British fashion magazines on a Kubrickian space station," says art director Stefan Bucher.

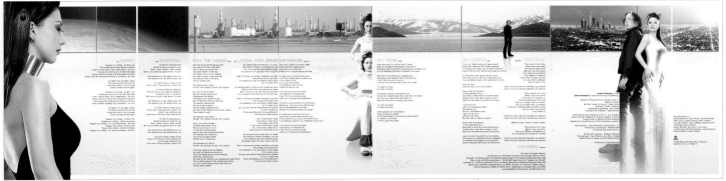

3 DAY BIG & TALL CD ▶

[STUDIO] Duncan|Channon

[ART DIRECTOR] Jacquie Van Keuren

[PHOTOGRAPHER] Will Yarbrough

[CLIENT] 3 Day Big & Tall/Gumjoy Records

[PAPER] Fraser Pegasus Midnight Black Text, Mohawk
SuperFine Ultrawhite Cover

[COLORS] 4-color over 1-color PMS 877 silver (cover), 1-color
PMS 877 silver (interior)

[SIZE] 5" × 5½" (13 × 14cm)

[PRINT RUN] 1,000

[COST PER UNIT] $4.75

[TYPE] Base Monospace (body), OCR (headers)

[SPECIAL FOLDS/FEATURES] Rounded corners and three
circles die-cut out of cover

[SPECIAL COST-CUTTING TECHNIQUES] "I sourced every-
thing myself," says art director Jacquie Van Keuren. "The
cover and inside pages were printed by different printers,
then I sent them to the die-cutter directly. The CDs were
mastered and printed by a CD manufacturer, the metal
cases were purchased and silk-screened through yet
another vendor."

[INSPIRATION/CONCEPT] "Mainly the album title, along
with the music and personality of the band," says art
director Jacquie Van Keuren.

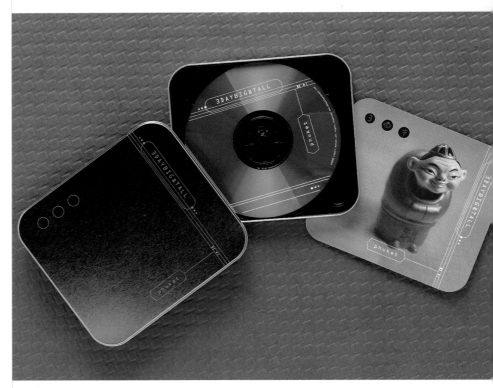

JOHNNY CASH, LOVE GOD MURDER ▶

[STUDIO] Skouras Design

[ART DIRECTORS] Howard Fritzson/Sony Music, Angela
Skouras/Skouras Design

[DESIGNERS] Angela Skouras, Michael Curry

[PHOTOGRAPHERS] Don Hunstein (all front covers and
inside photo on "Murder"); Leigh Weiner (inside photo
on "God"); Jim Marshall (inside photo on "Love")

[CLIENT] Sony Music

[COLORS] 4-color process for the digipaks, 4 flat colors for
the box, 2 flat colors for the CD labels

[TYPE] Cheltenham (box cover), Smokler Bold (box spine,
back and on the individual covers and backs); Univers
(body)

[SPECIAL TYPE TECHNIQUE] Distressed type used on the
digipak covers

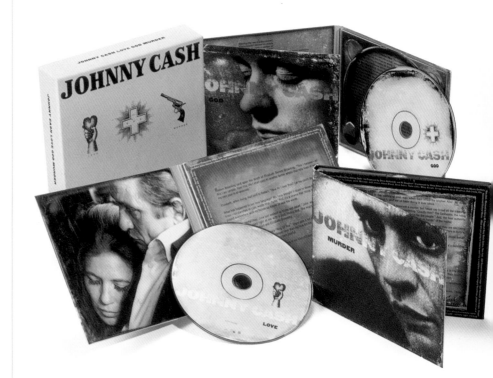

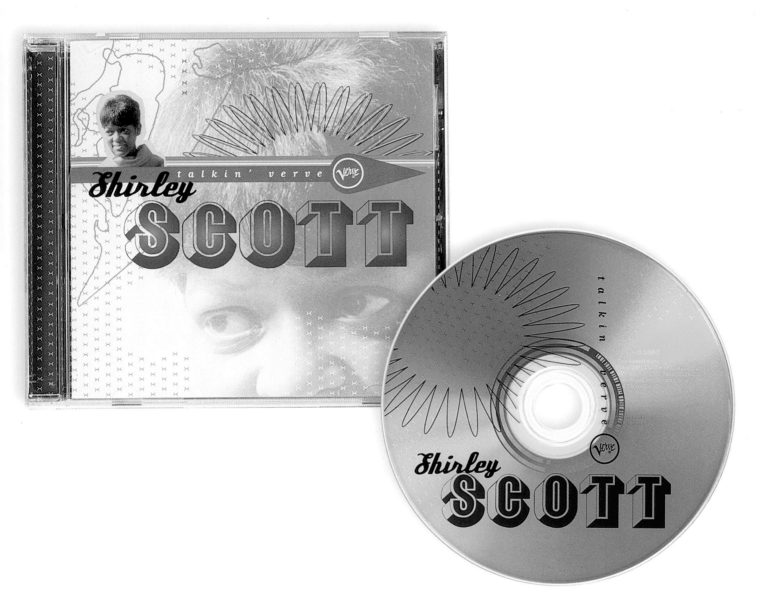

SHIRLEY SCOTT,
TALKIN' VERVE ▲

[STUDIO] Edward ODowd Graphic Design
[ART DIRECTOR] Hollis King/The Verve Music Group
[DESIGNER] Edward ODowd
[PHOTOGRAPHER] Chuck Stewart
[CLIENT] The Verve Music Group
[COLORS] 5 (4, process plus PMS 8043)
[SPECIAL TYPE TECHNIQUES] Creating objects from type in
 Illustrator in order to introduce gradations

"The first thing that struck me when I listened to Shirley Scott's music was how bold and colorful it was," says designer Edward ODowd. "Because her keyboard playing was so lively and fluid, I wanted to convey that in the look of the packaging. When I was given a choice of Chuck Stewart's photographs, I was drawn to a particular shot of Scott looking off to the side, as if lost in her own world. Cropping in tight on her face and printing it using a luscious metallic pink halftone was my way of magnifying visually that feeling of contentedness one gets when lost in music. As for the rest of the packaging, color was most definitely a major factor. I kept closing my eyes while listening to the music and just let the color combinations come to me."

"PEEL SLOWLY AND SEE" BOX SET BOOKLET AND CD COVERS ▶

[STUDIO] Smay Vision, Inc.
[ART DIRECTORS/DESIGNERS] Phil Yarnell, Stan Stanski;
 Spencer Drate, Jütka Salavetz, Sylvia Reed (for box set
 booklet)
[PHOTOGRAPHERS] Various
[TYPE] Rotis Semi-Serif (body)
[COLORS] 4, process
[PRINT RUN] 50,000

*"When we started this project, we were basically present-
ed with a huge pile of incredibly cool stuff from Velvet
Underground guitarist Sterling Morrison's personal
archive," explain designers Phil Yarnall and Stan Stan-
ski. The "stuff" included posters for the band's concerts.
They also had original master tape boxes covered in the
band's handwriting, rubber stamps, recording notes,
and so on. Using these bits of the band's history, they
created a booklet and CD covers that maintains "the
rawness of the set."*

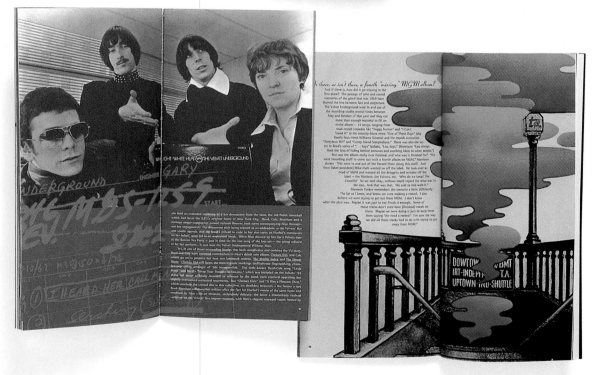

1967 / 1968
DISC THREE

1. THERE IS NO REASON demo (2.12)
(Lou Reed / John Cale)

2. SHELTERED LIFE demo (2.52)
(Lou Reed)

3. IT'S ALL RIGHT
(THE WAY THAT YOU LIVE) demo (2.46)
(Lou Reed / John Cale)

4. I'M NOT TOO SORRY
(NOW THAT YOU'RE GONE) demo (2.17)
(Lou Reed / John Cale)

5. HERE SHE COMES NOW demo (2.46)
(Lou Reed / John Cale / Sterling Morrison)

6. GUESS I'M FALLING IN LOVE live (4.10)
(Lou Reed / John Cale /
Sterling Morrison / Maureen Tucker)

7. BOOKER T. live (6.30)
(Lou Reed / John Cale /
Sterling Morrison / Maureen Tucker)

8. WHITE LIGHT/WHITE HEAT (2.45)
(Lou Reed)

9. THE GIFT (8.17)
(Lou Reed / John Cale /
Sterling Morrison / Maureen Tucker)

10. LADY GODIVA'S OPERATION (4.54)
(Lou Reed)

11. HERE SHE COMES NOW (2.02)
(Lou Reed / John Cale / Sterling Morrison)

12. I HEARD HER CALL MY NAME (4.39)
(Lou Reed)

13. SISTER RAY (17.27)
(Lou Reed / John Cale /
Sterling Morrison / Maureen Tucker)

14. STEPHANIE SAYS (2.48)
(Lou Reed)

15. TEMPTATION INSIDE YOUR HEART (2.30)
(Lou Reed)

16. HEY MR. RAIN (VERSION ONE) (4.40)
(Lou Reed / John Cale /
Sterling Morrison / Maureen Tucker)

BLUE SERIES ▼

[STUDIO] Dahlia Digital Inc.
[ART DIRECTOR/DESIGNER] Cynthia Fetty
[PHOTOGRAPHER] Cynthia Fetty
[CLIENT] Thirsty Ear Recordings
[CLIENT'S PRODUCT/SERVICE] Record Label
[PAPER] Sappi, semigloss
[COLORS] 4/1, process
[SIZE] 9½" × 4½" (24 × 11cm)
[TYPE] Meta

I think it is just as important to know production as it is to make pretty graphics. The fact is, if you can't get your pretty graphics to print right, you've wasted a lot of time and money.

CYNTHIA FETTY

"The Blue Series started as this experimental project with avant garde jazz musician Matthew Shipp. He and I came up with the original idea in the sense that he gave me a bunch of materials and color swatches and it was my job to interpret them into something for the series," says art director Cynthia Fetty.
"The idea was that somehow the visuals would match and/or interpret the music and also work as a series."

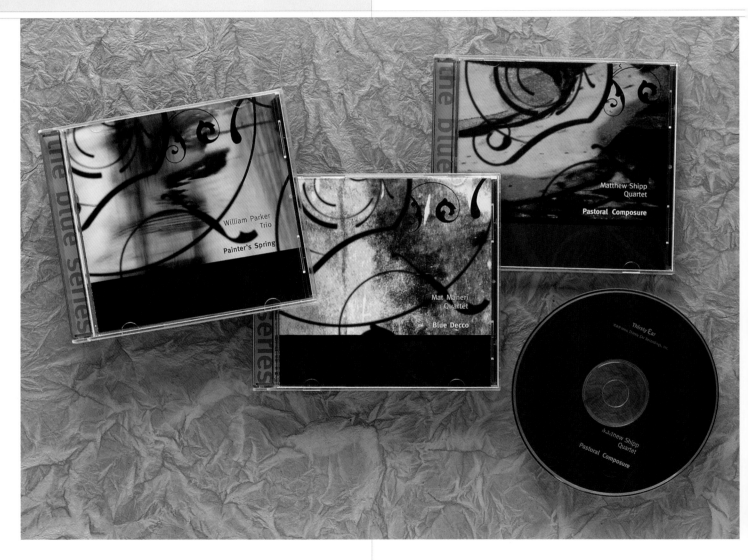

GOD LIVES UNDERWATER: LIFE IN THE SO-CALLED SPACE AGE ▼

[STUDIO] Sunja Park Design
[ART DIRECTOR/DESIGNER] Sunja Park
[PHOTOGRAPHER] John Eder
[CLIENT] 1500 Records

[TYPE] Euphoria, Gill Sans
[COLORS] 4, process
[PRINT RUN] 50,000

"The package needed to reflect the dense, surreal, urban environment that spawned the band (a Los Angeles-based DJ duo) and their music," says art director Sunja Park. "John Eder had just gotten back from Bangkok with photos of crazy buildings. We got him in a helicopter weaving through downtown Los Angeles skyscrapers for the rest."

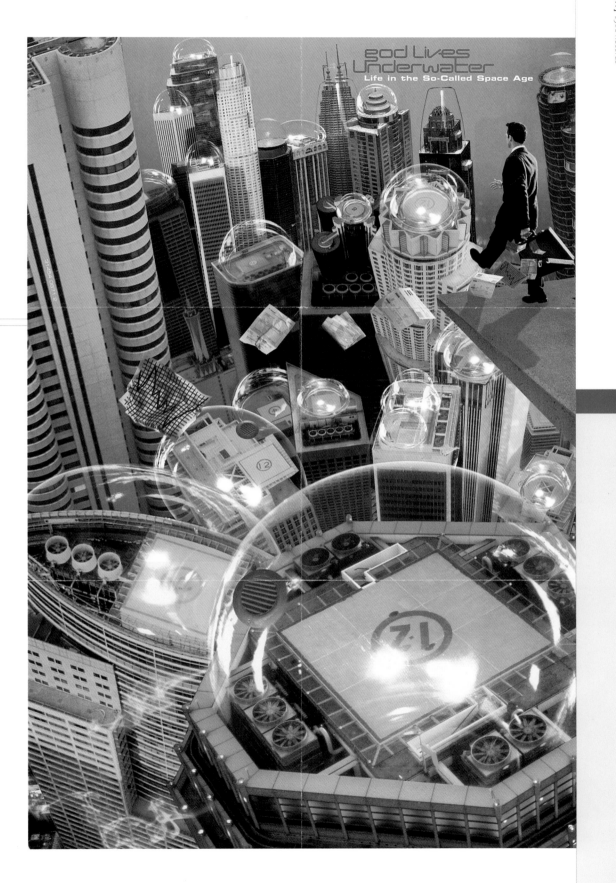

149

PEARL JAM, YIELD ▼

[STUDIO] Ames Design
[ART DIRECTORS/DESIGNERS] Barry Ament, Coby Schultz, George Estrada
[PHOTOGRAPHERS] Jeff Ament, Jerry Gay, Greg Montijo
[CLIENT] Epic/Sony Music, Pearl Jam
[TYPE] Eurostile
[COLORS] 4, process, matte varnish, high-gloss varnish
[PRINT RUN] 1,809,098
[SPECIAL PRODUCTION TECHNIQUE] Die cut
[INSPIRATION/CONCEPT] "We kept it super simple on the design and tried to drive the great photography," say the designers.

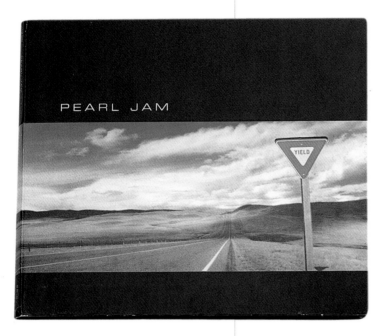

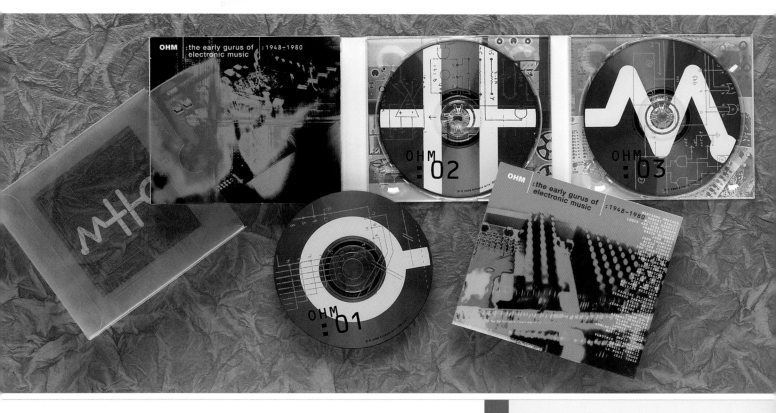

OHM: THE EARLY GURUS OF ELECTRONIC MUSIC ▲

[STUDIO] Stoltze Design
[ART DIRECTOR] Clifford Stoltze
[DESIGNERS] Clifford Stoltze, Tammy Dotson
[PHOTOGRAPHERS] Various
[PRINTER] Triplex, NYC
[CLIENT] Ellipsis Arts
[CLIENT'S PRODUCT/SERVICE] Music publishing
[COLORS] 4, process for the booklet and silkscreen for the slipcase
[SIZE] 5" × 5½" (13 × 14cm)
[TYPE] Helvetica, Trade Gothic Condensed
[SPECIAL PRODUCTION TECHNIQUES] Three CD Digi-pak, transparent plastic slipcase

"OHM features music from 1980, when academic electronic music began to branch into the ground soil of pop and dance music. The design reflects the retro-futuristic quality of this music as well as the contrast between the high and the low technology used to create the music. The custom OHM logo-type, choice of typefaces, photographs and line details all reference the early electronic machines while maintaining a contemporary quality in their various combinations. Ellipsis Arts provided the raw inspiration both in the form of music and documentation," says designer Clifford Stoltze.

BUDDY GRECO "TALKIN' VERVE" ▶

[STUDIO] Edward ODowd Graphic Design
[ART DIRECTOR] Hollis King/The Verve Music Group
[DESIGNER] Edward ODowd
[PHOTOGRAPHY] Courtesy of the Wayne Knight Collection
[CLIENT] The Verve Music Group
[COLORS] 4, process
[SPECIAL TYPE TECHNIQUES] Creating objects from type in Illustrator in order to merge first and last names, creating a logotype

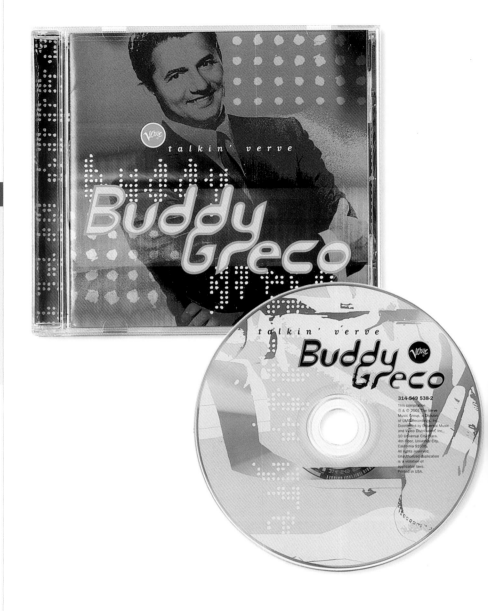

"One of the major challenges about designing packaging for reissues is that the record company is selling something that was already once on the market. The packaging needs to stay true to the artist but somehow grab the attention of younger music buyers. According to the liner notes on the back of the package, Buddy Greco virtually invented acid jazz. By going for a hip, futuristic look, I feel I was able to very successfully produce an energetic yet appropriate design that young music buyers could relate to," says designer Edward ODowd.

PLAYOLA IN-STORE CD SAMPLER ▶

[STUDIO] Top Design Studio
[ART DIRECTOR/DESIGNER] Peleg Top
[CLIENT] Universal Music and Video Distribution

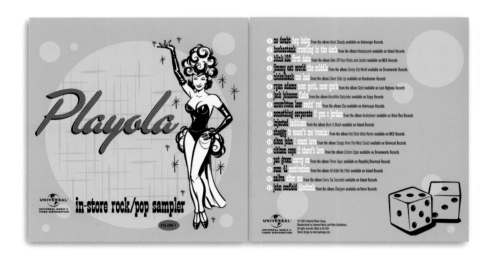

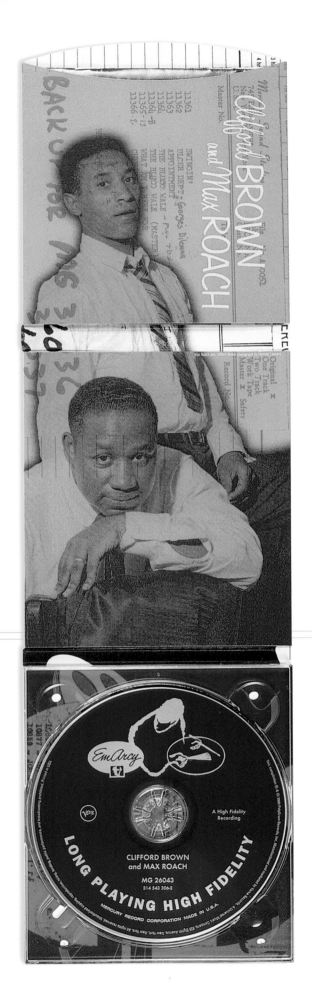

CLIFFORD BROWN AND
MAX ROACH ◄

[STUDIO] Edward ODowd Graphic Design
[ART DIRECTOR] Hollis King/The Verve Music Group
[DESIGNER] Edward ODowd
[CLIENT] The Verve Music Group
[COLORS] 4, process

EPIPHANY PROJECT ▶

[STUDIO] LiquidNoise
[ART DIRECTOR/DESIGNER] Stacie Hampton
[PHOTOGRAPHERS] Stacie Hampton, Nina Schultz,
 Robert Hakalski
[ILLUSTRATOR] Stacie Hampton
[CLIENT] Epiphany Records

[CLIENT'S PRODUCT/SERVICE] Independent
 record label
[PAPER] Neenah
[COLORS] 4, process
[SIZE] 5 1/2" × 4 7/8" (14 × 12cm)
[PRINT RUN] 5,000
[TYPE] Phalanx, Cezanne, Courier

[SPECIAL PRODUCTION TECHNIQUE] An uncoat-
 ed, textured stock was used to enhance the pho-
 tographic texture of the design.
[INSPIRATION/CONCEPT] "We were inspired by
 the artists and their music," art director Stacie
 Hampton says.

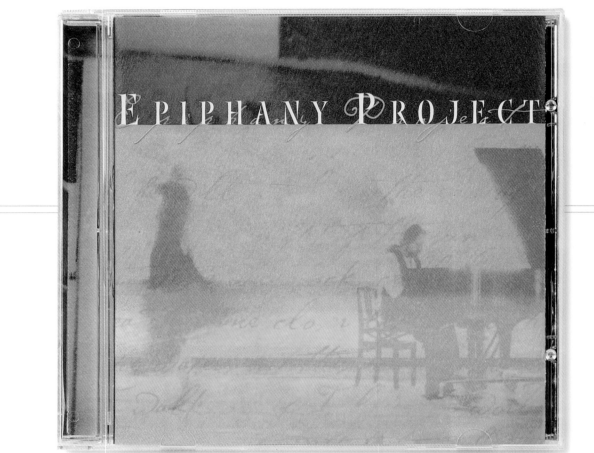

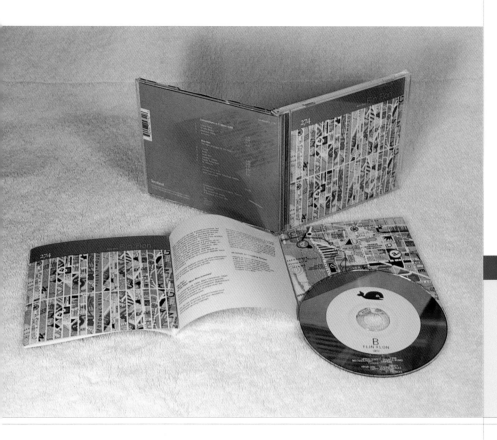

FLIN FLON 'BOO-BOO' ◄

[STUDIO] Timonium
[ART DIRECTOR/DESIGNER] Mark Robinson
[ILLUSTRATOR] Mark Robinson
[PHOTOGRAPHER] Pat Graham
[CLIENT] *Teenbeat*
[CLIENT'S PRODUCT/SERVICE] Audio compact disc and vinyl LP jacket
[PAPER] 80 lb. white
[COLORS] 5, process plus 1 metallic PMS 8003
[SIZE] 5" × 5½" (13 × 14cm) (CD), 12½" × 12½" (32 × 32cm) (LP).
[PRINT RUN] 5,000
[COST PER UNIT] $1.70 (CD), $2.65 (vinyl LP)
[TYPE] Helvetica Neue, Minion, Rotis SemiSans
[SPECIAL FOLDS/FEATURES] Four folds to create a ten-page folder

"The general layout spoofs England's Factory Records' modern classical music approach of the early 1990s," says designer Mark Robinson. *"While those CDs featured a grayscale image of the artist, we decided to brighten it up a bit with map images of the band's hometown. The map is based on the Washington, DC, street grid, but all the street and building names are fictional, specific to the band's lyrics and in-jokes."*

GOLDEN SLUMBERS CD PACKAGE ◄

[STUDIO] Top Design Studio
[ART DIRECTOR] Peleg Top
[DESIGNERS] Peleg Top, Rebekah Beaton
[CLIENT] Rendezvous Entertainment and Warner Bros. Records

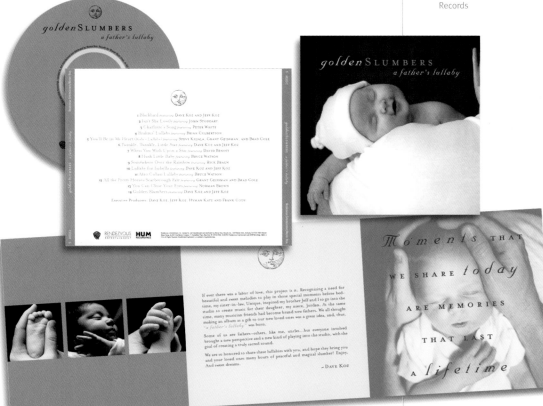

STEVIE RAY VAUGHAN AND DOUBLE TROUBLE ▶

[STUDIO] Skouras Design
[ART DIRECTOR] Josh Cheuse/Epic Records
[DESIGNER] Angela Skouras
[PHOTOGRAPHERS] Various
[CLIENT] Sony Music
[CLIENT'S PRODUCT/SERVICE] CDs, DVDs
[COLORS] 4, process (box and booklet), 2, match
 (CDs and DVD)
[TYPE] Egiziano Classic Black (spine and all distressed
 quotes throughout book); Cheltenham (various cuts
 used on back of box, on contents page, track listings,
 liner notes, credits and catalog pages)

"We were heavily inspired by Stevie Ray Vaughan's guitar playing and singing long before we received this project," says designer Michael Curry. *"His playing reminds me of Hendrix and I believe he was one of the greatest blues musicians. We scanned in several old paper samples, manipulated a lot of the type and used old photos to play off of the natural grittiness of his style. We were also lucky to work with a photo shoot taken by James R. Minchin III and art directed by Josh Cheuse."*

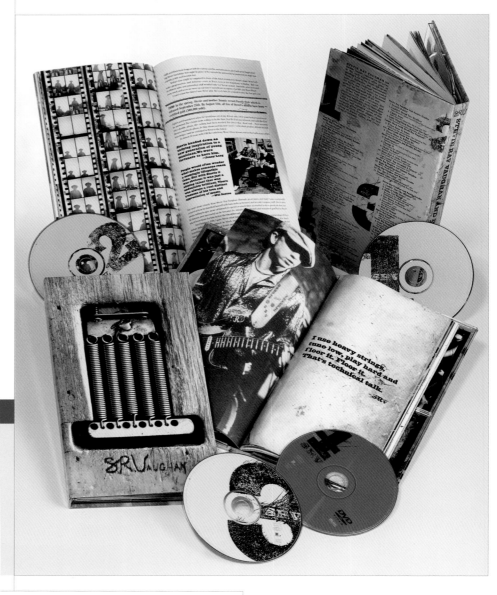

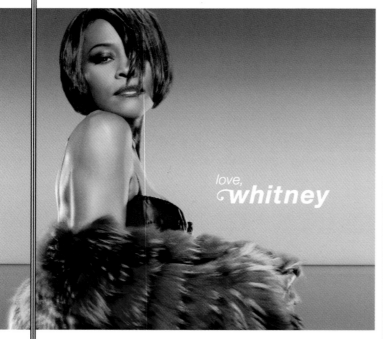

LOVE, WHITNEY ◀

[STUDIO] 344 Design, LLC
[CREATIVE DIRECTOR] Joe Mama-Nitzberg
[ART DIRECTOR/DESIGNER] Stefan G. Bucher
[PHOTOGRAPHER] Warwick Saint
[CLIENT] Arista Records
[PAPER] Arista Standard
[COLORS] 4, process
[SIZE] 5½" × 5" (13 × 14cm)
[COST PER UNIT] $18.99 retail
[TYPE] Helvetica with custom swirl

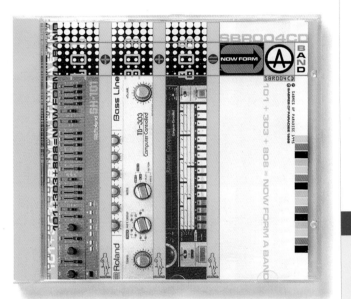

101+103+808 NOW FORM A BAND ◄

[STUDIO] Prototype 21
[ART DIRECTOR/DESIGNER] Paul Nicholson
[CLIENT] Sabres of Paradise
[CLIENT'S SERVICE/PRODUCT] Record label
[TYPE] OCRA, Microgramma
[COLORS] 4, match

Art director Paul Nicholson describes this CD as "an amalgam of trashy elements from four decades: Warhol of the sixties, Punk of the seventies, cheap Japanese keyboards of the eighties (Roland 101, 303 and 808—basic instruments of techno-music) and nineties computer graphics. The resulting effect is chaotic and abrasive."

MUSLIMGAUZE, HUSSEIN MAHMOOD JEEB TEHAR GASS ◄

[STUDIO] Plazm Media
[ART DIRECTORS] Joshua Berger, Niko Courtelis, Pete McCracken, Riq Mosqueda
[DESIGNER] Riq Mosqueda
[PHOTOGRAPHER] Shirin Neshat
[CLIENT] Soleilmoon Recordings
[TYPE] Interface
[COLORS] 4, process
[PRINT RUN] 2,500

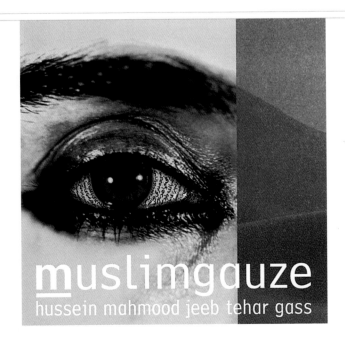

HATE BOMBS, HUNT YOU DOWN ▶

[STUDIO] Backbone Design
[ART DIRECTORS] Steve Carsella, Chris Jones, Scott Sugiuchi
[DESIGNER] Scott Sugiuchi
[PHOTOGRAPHER] Bob Deck
[CLIENT] Dionysus Records
[TYPE] hand-rendered, distressed Garamond
[COLORS] 4, process
[PRINT RUN] 5,000

"The band wanted to capture the vintage feel of Capitol Records releases, circa 1950,"
say the art directors. "This was achieved by re-creating pin-up art (à la Gil Elvgren) and
relying on exotic-inspired hand lettering, instead of computer-set faces."

STING-BRAND NEW DAY: THE REMIXES ▼

[STUDIO] 344 Design, LLC
[CREATIVE DIRECTOR] Joe Mama-Nitzberg
[ART DIRECTOR/DESIGNER] Stefan G. Bucher
[CLIENT] A&M Records
[PAPER] A&M Standard
[COLORS] 2, process
[SIZE] 5½" × 5" (13 × 14cm), 27¼" × 4¾" (71 × 12cm) (booklet)
[COST PER UNIT] $18.99
[TYPE] Helvetica

"Instead of going for the standard star treatment, a glamorous shot of Sting, we con-
vinced his management to let us use a very bold, minimalist typographic approach to
make to this remix compilation stand out in stores," says art director Stefan Bucher.

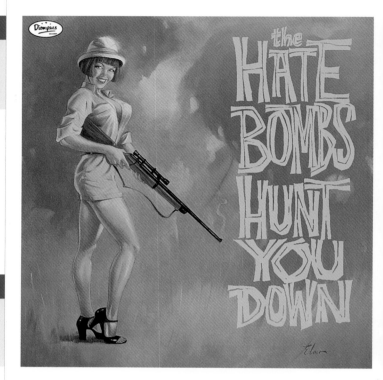

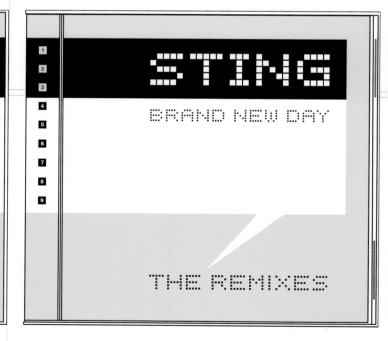

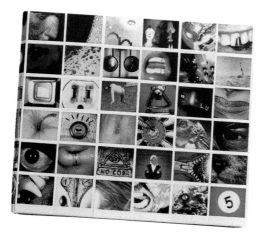

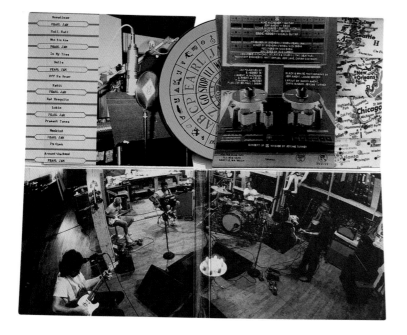

PEARL JAM, NO CODE ◄

[STUDIO] Ames Design
[ART DIRECTOR] Jerome Turner
[DESIGNERS] Barry Ament, Chris McGann, Jerome Turner
[PHOTOGRAPHERS] Jeff Ament, Lance Mercer (black and white); Eddie Vedder, Jeff Ament, M. McCready, Barry Ament, A. Fields, Chris McGann, Lance Mercer, P. Bubak (Polaroids)
[CLIENT] Epic/Sony Music, Pearl Jam
[TYPE] Children's home printing kit
[COLORS] 4, process and matte varnish
[PRINT RUN] 2,205,906

"This was all laid out on the floor of our shop. Over several weeks, photos were added and through process of elimination, here's what you got," art director Jerome Turner explains. *"A bonus for the kids—there's a secret symbol in the photos (stand back and squint). Each CD came with a set of nine cards out of a possible thirty-six (we were going for the trading card theory). We used high-gloss and matte varnishes on the cards to give them a Polaroid feel. We also use three forensics cameras (Polaroids) and cases of film. My personal fave of all the Pearl Jam CDs, mostly because of the insane amount of work and effort."*

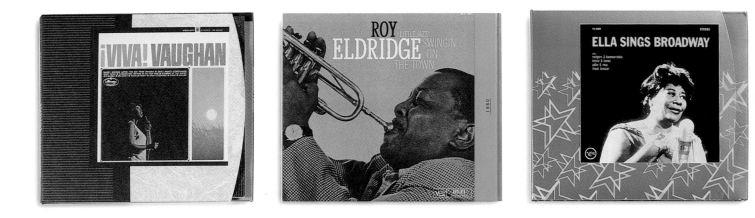

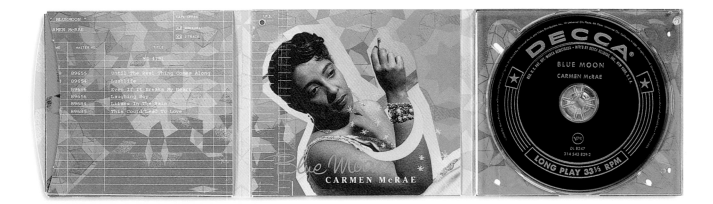

**SARAH VAUGHAN,
ROY ELDRIDGE,
ELLA FITZGERALD,
CARMEN MCRAE** ▲

[STUDIO] Edward ODowd Graphic Design
[ART DIRECTOR] Hollis King/The Verve Music Group
[DESIGNER] Edward ODowd
[CLIENT] The Verve Music Group
[COLORS] 4, process

"These packages are part of two different reissue series from The Verve Music Group. VME (Verve Master Edition) and VEE (Verve Elite Edition) were created in order to reissue previously released material as limited collector's editions. The packaging was specially created to look like nothing else on the market by using original die cuts on the Digipaks. The parameters for the projects are fairly simple: you are supplied with an original cover design (which is always featured on the front of the packaging) and some black-and-white photography. I've designed many pieces in these series and the challenge has always been how to top the last one!" says designer Edward ODowd. "Finding new ways to create art for these series has been fairly endless and a great source of fun. Another challenge has been trying to stay diverse. Many designers have worked on these series and it has been essential to visit the archive department at The Verve Music Group to make sure we don't repeat what others have done. Found art, photography, painting, basically anything goes!"

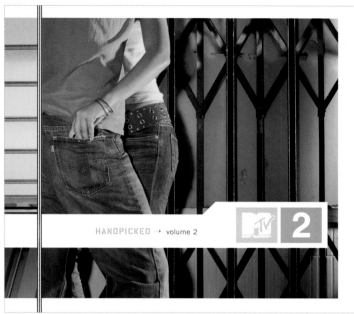

MTV2 HANDPICKED VOL.2 ▲

[STUDIO] 344 Design, LLC
[ART DIRECTORS] Mary Fagot, Eric Roinestad, Stefan G. Bucher
[PACKAGE ART DIRECTION AND DESIGN] Stefan G. Bucher
[PHOTOGRAPHER] Joe Toreno
[CLIENT] Capitol Records, Inc.
[PAPER] Capitol Standard
[COLORS] 4, process
[SIZE] 5½" × 5" (14 × 13cm), 19" × 4¾" (48 × 12cm)(booklet)
[COST PER UNIT] $17.99 retail
[TYPE] Franklin Gothic

JUST PASSIN' THRU ▶

[STUDIO] C.I.A, Creative Intelligence Agency
[ART DIRECTOR/DESIGNER] Kurt Thesing
[CLIENT] Starbucks Coffee Corporation and WHFS
[CLIENT'S PRODUCT/SERVICE] Coffee chain
[PAPER] Mohawk superfine
[COLORS] 4, process plus dull varnish (CD case), 4/2
plus varnish (booklet), 1, process (CD)
[PRINT RUN] 20,000
[COST PER UNIT] $3
[TYPE] Garamond, Helvetica, Franklin Gothic
[SPECIAL PRODUCTION TECHNIQUES] Custom die-cut
CD case

*The inspiration was "music and coffee passing through
your body and affecting your senses," explains art direc-
tor Kurt Thesing.*

COLD–13 WAYS TO BLEED
ON STAGE ▲

[STUDIO] 344 Design, LLC
[ART DIRECTOR/DESIGNERS] Stefan G. Bucher, Cold
[PHOTOGRAPHERS] Myriam Santos Kayda, Jason
Timms
[CLIENT] Flip/Geffen Records
[PAPER] Geffen Standard
[COLORS] 4, process
[SIZE] 5½" × 5" (14 × 13cm)
[COST PER UNIT] $12.99 retail
[TYPE] Helvetica, Courier, custom

*"The CD booklet shows the scrapbook of a per-
son obsessed with the band Cold," says
designer Stefan Bucher.*

162

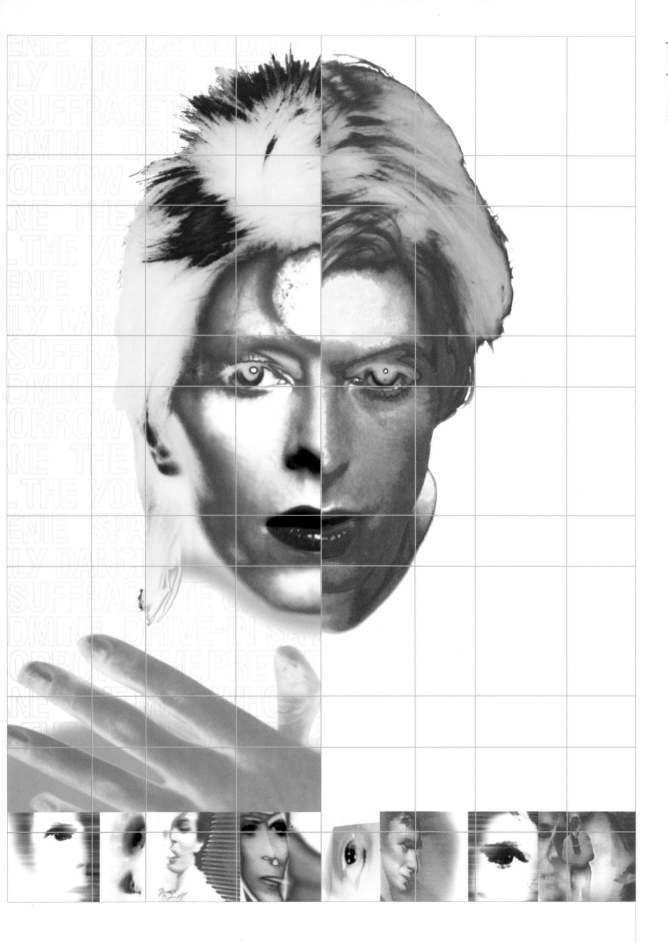

DAVID BOWIE "BEST OF" PACKAGING ▼

[STUDIO] Stylorouge
[DESIGNERS] Julian Quayle, Sheridan Wall
[ART DIRECTORS] Julian Quayle, Sheridan Wall
[PHOTOGRAPHERS] Mick Rock, Steve Schapiro
[CLIENT] EMI Records

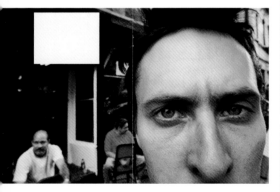

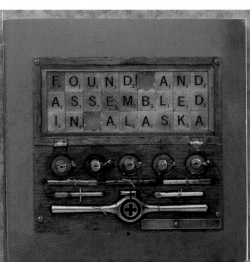

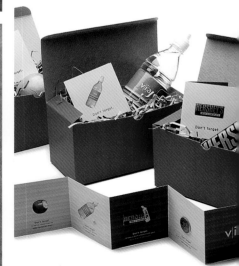

BROCHURES

A brochure is the first thing a consumer new to a product or company asks for—"Do you have any literature on that refrigerator/health care plan/art museum?" Brochures are a portable synopsis of all a company or organization has to offer. On as little as one folded page, a brochure reveals what a consumer might want to know about a business's services, personnel, credibility and personality. They are also opportunities for promotion and creative expression, since no particular format or design style defines "brochure." In this section, you'll see everything that fits into the brochure category—including a few invitations and promotional calendars. Using these many designs as inspiration, you're sure to wow your client's clients the next time they ask for additional information on the season's newest chrome double-door, ice-making refrigerating unit.

PATHÉ ▶

[STUDIO] Landor Associates
[CREATIVE DIRECTORS] Margaret Youngblood, Aaron Levin
[SENIOR DESIGN DIRECTOR] Eric Scott
[DESIGNERS] Douglas Sellers, Kirsten Tarnowski, Michele Berry, David Rockwell, Carlyn Ross, Remy Amisse, Patrick de Moratti
[PHOTOGRAPHERS] Michael Friel, Catherine Gailloud
[CLIENT] Pathé
[CLIENT'S PRODUCT/SERVICE] Entertainment, film, television
[COLORS] 4, process plus 2 match
[PRINT RUN] 100
[TYPE] Hand drawn typeface by Kirsten Tarnowski, Eric Scott; Trade Gothic Condensed

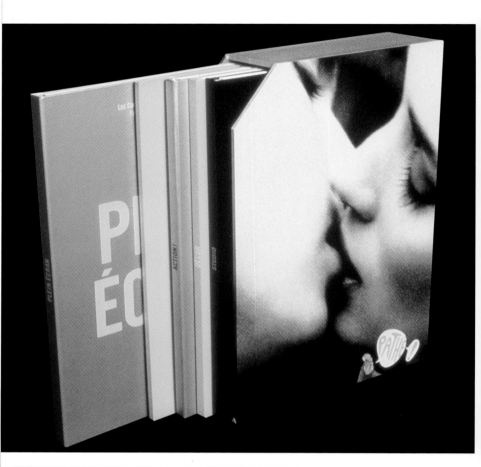

"Founded in 1896 by Charles and Emile Pathé, this French company boasts an enviable heritage in the entertainment business, from the manufacturing of cameras, phonographs and film to the production and distribution of movies and the management of movie theatres. The success of this broad-based activity was due in large part to the unquestionable vision, passion and commercial acumen so characteristic of Charles Pathé. Charles's genius and pioneering style have crowned him with such renown that his name remains synonymous with French cinema and the history of France itself," explain the designers at Landor Associates. "Post-Charles, during the thirties, forties and fifties, several generations of management steered the company through long and difficult times. Despite further efforts, Pathé continued to face an uncertain future up until the late eighties when Jérome Seydoux emerged Pathé from its holding company, Chargeurs, buying Pathé outright and turning it into a public company. And with this, the desire to restore this renown name into a great brand re-emerged."

[STUDIO] Paper Plane Studio
[ART DIRECTOR/DESIGNER] Jennifer Olsen
[PHOTOGRAPHY] Stock (Corbis, Stone, Photonica)
[CLIENT] Sapient
[CLIENT'S PRODUCT/SERVICE] Technology consulting services
[PAPER] Mohawk Superfine Smooth
[COLORS] 6 (4 process, plus 2 blacks), matte varnish

[SIZE] 5⅜" × 6⅞" (14 × 18cm)
[PRINT RUN] 5,000
[COST PER UNIT] $8
[TYPE] Sapient Sans (based on FF DIN)
[SPECIAL PRODUCTION TECHNIQUES] French-folded interior pages, red satin ribbon, handbound velvet cover with foil stamp title

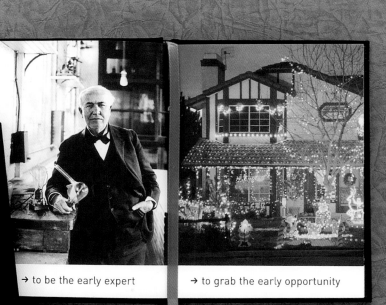

YOU ARE

HERE →

→ to be the early expert

→ to grab the early opportunity

"Our client wanted a piece to give to all employees to inspire and motivate, and to communicate the new company vision," says designer Jennifer Olsen. "We thought the idea of a keepsake book would be a nice way to reinforce their mission and to give each employee a piece they could refer to in their everyday business. The small book was the first piece of a campaign that included a poster series, a video and vision deliverables. The book introduces the company vision in a very simple and evocative manner. We used images of identifiable icons to relate to the text. The back of the book includes captions that talk about the relevance of each image."

Most challenging is for the piece to have an evocative and engaging concept or story. Too many designs are void of any concept and are just vehicles for bland technical prose. In this day of technology, a print piece must demonstrate more than it used to. It has to be worth the paper it is printed on, and therefore must contain conceptual stories and messaging that engage the reader. I've found as a designer I get into the role of a copywriter more and more, as my job is to tell stories visually.
JENNIFER OLSEN

167

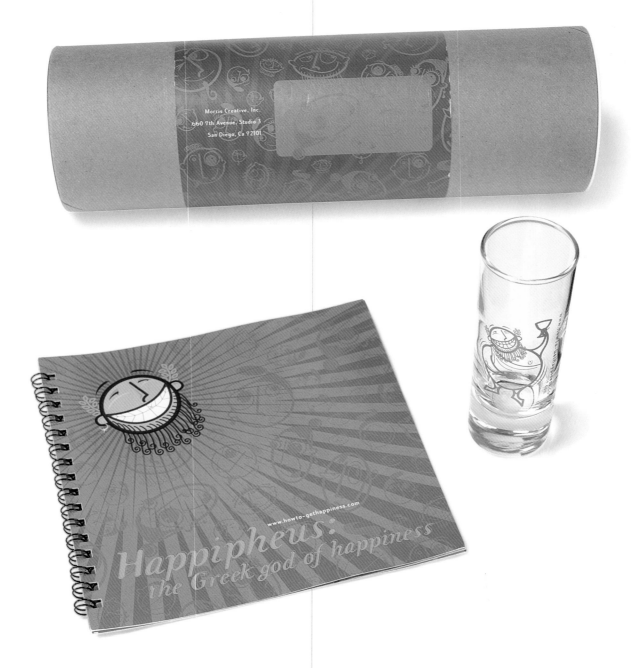

HOW TO GET HAPPINESS ▲

[STUDIO] Morris Creative
[ART DIRECTOR/DESIGNER] Steven Morris
[ILLUSTRATOR] Steven Morris
[PAPER] Potlatch McCoy
[COLORS] 4, process
[PRINT RUN] 2,000
[TYPE] Teme Cantate

"The inspiration for this project was obvious—getting happy," explains art director Steve Morris. *"The character Happipheus was created because there is no god of happiness. So we created one with a history and a legacy. We want to spread happiness."*

168

EMERGENCY HANDBOOK ◀

[STUDIO] J. Walter Thompson Singapore (Advertising)
[ART DIRECTOR/DESIGNER] Benson Toh
[COPYWRITER] Yuen Chee Wai
[CREATIVE DIRECTOR] Norman Tan
[ILLUSTRATOR] Walter Teo
[CLIENT] Singapore Civil Defense Force
[CLIENT'S PRODUCT/SERVICE] Public education
[PAPER] Japanese Artcard
[COLORS] 4, process
[SIZE] 8" × 8" (20 × 20cm)
[PRINT RUN] 1.8 million copies
[COST PER UNIT] $.70
[TYPE] Hanzel, New Baskerville
[SPECIAL PRODUCTION TECHNIQUES] Die-cut mold
 created for the tabs used in the book

*"The handbook is meant to educate Singapore citizens in
the proper reactionary procedures in the event of an
emergency," explains art director Benson Toh. "Hence, it
calls for ease of use and understanding. More impor-
tant, it must be handy and ideal for quick references."*

LEE HISTORY BOOK ◀

[STUDIO] Willoughby Design Group
[ART DIRECTOR] Deb Tagtalianidis
[DESIGN] Nicole Satterwhite
[PHOTOGRAPHER] Eli Reichman
[CLIENT] Lee Jeans
[CLIENT'S PRODUCT/SERVICE] Jeans apparel company
[PAPER] Finch Opaque
[COLORS] 4, process plus 2 match
[SIZE] 8¼" × 9½" (21 × 24cm)
[PRINT RUN] 10,000
[TYPE] Garamond 3, Meta
[SPECIAL PRODUCTION TECHNIQUES] Printing on a
 cream-colored, uncoated stock to produce an older, vin-
 tage look
[SPECIAL FOLDS/FEATURES] Thread-stitched binding
 reflective of jeans stitching
[SPECIAL COST-CUTTING TECHNIQUES] The thread-
 stitched books went to a specific audience and the rest
 of the books were saddle stitched.

*"Our inspiration came from a basement filled with 100
years of Lee archives and a Lee historian who had been
with the company for 30 years," explains the Willoughby
Design Group team.*

[STUDIO] Pacifico Integrated Marketing
Communications
[CREATIVE DIRECTOR] Boyd Tveit
[ART DIRECTOR] Phillip Mowery
[ILLUSTRATOR] Boyd Tveit
[CLIENT] The Tech Museum of Innovation

[CLIENT'S PRODUCT/SERVICE]
Entertainment/education
[TYPE] Garamond, Quartet, Cezanne
[SPECIAL TYPE TECHNIQUE] Scanned and manipu-
lated text over images

"We were inspired, without a doubt, by Ernest Shackleton's tale of survival," says art director Phillip Mowery. "This piece echoes a style of expedition and the drama of surviving a shipping and navigational disaster in the early 1900s."

170

Good design doesn't come in a flash of inspiration. You have to spend a substantial amount of time to realize a good and unique design idea. You also have to have lots of ideas. There are always many "right" answers. But you can't stop with your first idea. What's the second one? What other great ideas are just below the surface? What wonderful thing will occur to me if I spend an extra 15 minutes working on this and thinking about it? When you have five or ten options, you can feel confident that the solution you finally decide to go with is the best one.

STEPHAN FÄRBER

FINANCIAL BROCHURE ▲

[STUDIO] Carlson Marketing Group
[ART DIRECTOR] Stephan Färber
[CLIENT] a financial institution
[PAPER] 50 lb. Wyndstone Facade Cream (cover); 80 lb. Text Duotone Butcher Offwhite and 100 lb. Cover Strathmore Beau Brilliant Palm Beach (interior)
[COLORS] 4, process plus 3 match
[SIZE] 9½" × 13" (24 × 33cm) closed
[PRINT RUN] 850
[TYPE] Lombar
[SPECIAL PRODUCTION TECHNIQUES] A dark leather material was used for the spine, the Japanese binding, and the custom-designed closing mechanism.

"In designing the layout of this piece, I made it a priority to introduce the four main travel destinations and the cruise ship—both were key elements in this very upscale recognition/incentive program," says designer Stephan Färber. "The page layout was designed to provide a quick visual impression of just how extensive this trip was going to be. This was accomplished by giving each travel destination page a different shape. The pages were also staggered to lead the reader through the piece, ultimately to the back, where pockets contain important forms for program participants."

ACCLAIM TECHNOLOGY
LEAD GENERATION ▶

[STUDIO] Fine Design Group, Inc.
[ART DIRECTOR] Kenn Fine
[DESIGNERS] Megan Stohr, John Taylor
[PHOTOGRAPHER] Richard Seagraves
[CLIENT] Acclaim Technologies, Inc.
[CLIENT'S PRODUCT/SERVICE] Computer Network and
 Hardware VAR
[PAPER] Westvaco Kraftpak 30 pt., Mohawk Navajo Brilliant
 White #65 Cover
[COLORS] 4-color process plus 2 TOYO (#0121 and #1015)
 plus O/A aqueous; process color with florescent inks
 added to yellow and magenta
[PRINT RUN] 1,500 pieces
[COST PER UNIT] $7.28
[TYPE] Officina Sans Family
[SPECIAL PRODUCTION TECHNIQUES] Blind embossed
 cover, Wire-O binding

*Art director Kenn Fine describes this piece as "dramatic
simplification of message with strong visuals intended to
pierce skeptic armor. It was a follow-up to a similarly
packaged tube of toys that arrived without any reference
to whom it's from. The next day this book arrived turning
each of the toys in the previous day's delivery into a
metaphor for a promise of service."*

LITHOGRAFIX
SAN DIEGO BOOK ▶

[STUDIO] Louey/Rubino Design Group Inc.
[ART DIRECTOR] Robert Louey
[DESIGNERS] Robert Louey, Gerry Bustamante, Mires
 Design, Visual Asylum, Mentus Inc.
[ILLUSTRATOR] Gerry Bustamante
[PHOTOGRAPHERS] Various
[CLIENT] Lithografix
[CLIENT'S PRODUCT/SERVICE] Printing
[PAPER] 100# Text and Cover McCoy Matte
[COLORS] 8/8 (4-color process, 3 match colors, matte var-
 nish)
[SIZE] 7½" × 9½" (19 × 24cm)
[PRINT RUN] 5,000
[TYPE] Clarendon book, Trade Gothic Light Condensed
[SPECIAL TYPE TECHNIQUES] Hand-lettered text
[SPECIAL PRODUCTION TECHNIQUES] Debossed type
 throughout, special match Dayglo Inks
[SPECIAL FOLDS OR FEATURES] Gatefold front and back
 cover
[INSPIRATION/CONCEPT] San Diego

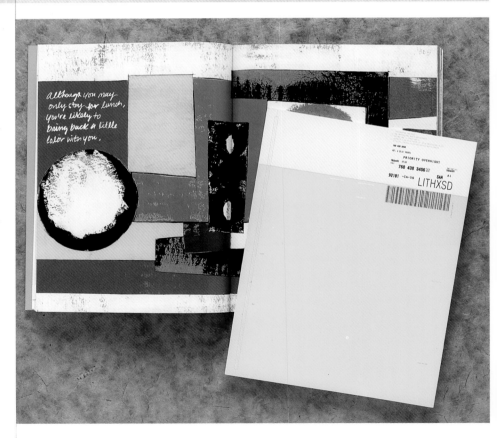

[STUDIO] Platinum Design, Inc.
[ART DIRECTOR] Vickie Peslak
[DESIGNER] Kelly Hogg
[CLIENT] Rubenstein Associates
[CLIENT'S PRODUCT/SERVICE] Public relations
[PAPER] Lustro satin finish
[COLORS] 3, match
[SIZE] 5" × 7" (13 × 18cm)

[PRINT RUN] 5,000
[TYPE] Clarendon, Akzidenz Grotesk
[SPECIAL TYPE TECHNIQUE] The initials *RU* show
through die-cut holes through every layer, and as you
flip through the pages, there are oversize numbers for
impact.
[SPECIAL FOLDS/FEATURES] Saddle-stitch binding

"Our inspiration for this idea was to play off of Rubenstein, the company name," says art director Vickie
Peslak. "Invitations like this need to be very 'in your face,' and although it's good if it reinforces the com-
pany image, more importantly it must make you feel like it's a party you can't miss."

ANTIWALL ▼ ►

[STUDIO] Mirko Ilic Corp.
[CREATIVE DIRECTORS] Nada Rajicic, Stanislav Sharpe
[ART DIRECTOR] Mirko Ilic
[DESIGNERS] Mirko Ilic, Ringo Takahashi
[ILLUSTRATOR] Slavimir Stojanovic
[CLIENT] Publikum
[CLIENT'S PRODUCT/SERVICE] Printer
[COLORS] 6, process and spot silkscreen
[PRINT RUN] 2,001 (because it was printed in 2001)
[COST PER UNIT] Donated
[TYPE] Cifrillica, Englic (both designed by Mirko Ilic)
[SPECIAL TYPE TECHNIQUE] "Everything—every letter of every little word—is handwritten (traced from original typeface output)," art director Mirko Ilic says.
[SPECIAL PRODUCTION TECHNIQUES] Specially mixed inks (to imitate graphite); glow-in-the-dark ink
[SPECIAL FEATURES] Hand-assembled, custom-made box

"This is about breaking cultural barriers through art," art director Mirko Ilic explains. "Given that this project was realized in Serbia, a country that has gone through several wars in just the last decade, along with political crises causing economic catastrophe, this project is in itself more than ordinary art publishing project. It is a means of communication among artists and a variety of people, as this calendar is donated to various cultural institutions, artists, art organizations and media in Serbia and in limited numbers worldwide."

фотографија за групу Дикипинана, аутор Ме Соmpany / Map photo заует by Me Company, 1997, је финансиран / courtesy Oskar Thorvaldsen and Me Company

Бјörk

"Рођена сам с потребом да певам. И више од тога - била сам једно од оне деце из познатог клишеа: могла сам да певам пре него што сам научила да говорим".

"I was born with the need to sing. Even worse; I was one of those kids from that famous cliché: I could sing before I could talk."

Специфичним гласом и иновативним идејама у музици бјörk је покупила глобалну пажњу. Познатa као чудо од детета, свој први албум - колекцију исландских песама - снимила је са 11 година. Током осамдесетих провела је неколико година у популарном бенду **The Sugarcubes**, да би затим започела своју каријеру. Рођена 1965. на Исланду, бјörk је мешавица стилова прошла кроз панк, поп/рок, џез. Снимила је 14 албума међу којима и *Debut* 1993, *Post* 1995, и *Homogenic* 1997. Иако себе сматра "најгором глумицом на свету", прихватила је главну улогу у филмову Larsа Von Trierа *Dancer in the Dark*, који је 2000. награђен Златном палмом на Канском филмском фестивалу.

Њен успех у музици народрачен је визуелном креативношћу Me Company, који за бјörk обликује футуристичке слике омота за CD-ове и остале везујуће производе. Специјализована за стварање и развој идентитета, лондонска фирма Me Company је тим од шест људи који уједињују исте страсти: модернизам, технологија, уметност и мода.

Слика у којој је сједињена визуелна имагинација бјörk и Me Company указују тако изузетан дизајн настао из заједништва музике и дизаја деведесетих година.

Björk's vocals and shrieks and innovative musical ideas have attracted global attention. She released her first album, a collection of Icelandic songs, at the age of 11. In eighties she spent several years with the internationally popular band *The Sugarcubes*, then launched a solo career. Born in Iceland in 1965, Björk has involved her vary rapidly through punk and jazz, pop/rock, and jazz styles. Among her 14 albums are *Debut* (1993), *Post* (1995), and *Homogenic* (1997). Although she considers herself "the worst actress in the world," she played the leading role in Lars von Trier's movie *Dancer in the Dark*, which received a Palme d'Or award at the 2000 Cannes Film Festival.

Björk's success as a singer has been enhanced by the visual creativity of the London-based Me Company, designers of the futuristic graphics for her CD and record covers and related materials. Specialists in identity development, the firm is composed of six members who share a passion for modernism, technology, art, and fashion.

The graphics, which combine the artistry of both singer and design firm, are highly evocative of design in the 1990s.

REICH PAPER
TRANSLUCENTS
SWATCHBOOK ▶

[STUDIO] Drew Souza Studio
[ART DIRECTOR/DESIGNER] Drew Souza
[PHOTOGRAPHER] Roger Hirsch
[CLIENT] Reich Paper
[CLIENT'S PRODUCT/SERVICE] Translucent Paper
[PAPER] Reich Paper Chartham Translucents, various
[COLORS] 4-color process, 1 match, 1 foil stamp
[SIZE] 6" × 9" (15 × 23cm)
[TYPE] Engraver's Gothic (Cover Title), Helvetica family
[SPECIAL PRODUCTION TECHNIQUE] Foil-stamping
[SPECIAL FOLDS/FEATURES] Standard 2 pt. scoring

"The concept for the swatchbook was to celebrate the material itself," says designer Drew Souza. "The Chartham material is very dynamic in that it allows a multitude of effects to be achieved in many applications. The translucency is inherently appealing and intriguing. The goal was to show how versatile and appealing the material is using common print and binding techniques."

Variety in a portfolio is important, but a thread of clarity should span the entire body of work, regardless of the demands and identity of the projects. Simplicity and rational page architecture are key. Maintain the integrity of the design by keeping it pure across different styles.
DREW SOUZA

176

wouldn't it be refreshing...

Piper Rudnick

Piper Rudnick LLP and related entities including an Illinois General Partnership

PIPER RUDNICK ◄ ▼

[STUDIO] Greenfield Belser
[ART DIRECTOR] Burkey Belser
[DESIGNER] Jonathan Burns
[PRODUCTION ARTIST] Chris Atkin
[PAPER] 83 Parilux Gloss Cover, 115# Parilux Gloss Text
[COLORS] 4, process plus spot varnish and dull varnish
[SIZE] 8½" × 11" (22 × 28cm)
[PRINT RUN] 20,000
[TYPE] Legault, Barver Bodoni, Helvetica Black, Futura Caps, Bogeda Serif, Machine, Geo Slab 703, Cent 725 Condensed

The concept is built around the text, *"Wouldn't it be refreshing..."*

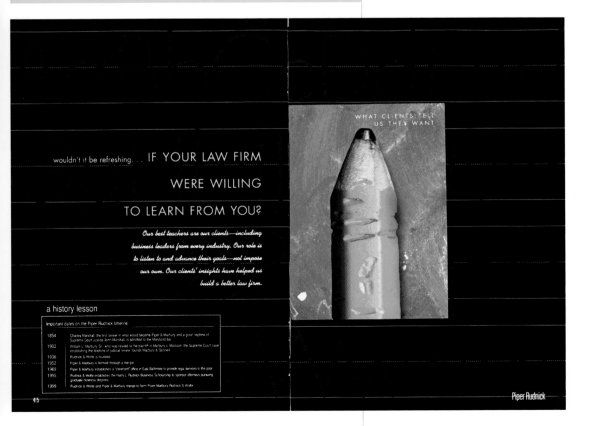

To make the print look as good as possible within the client's budget, you must communicate your objective and concerns to the printer. Bring samples of what you are looking for before you assign the print, then press check at important points in the production of the work—proofing, printing, cutting and binding if necessary.

TODD BAER

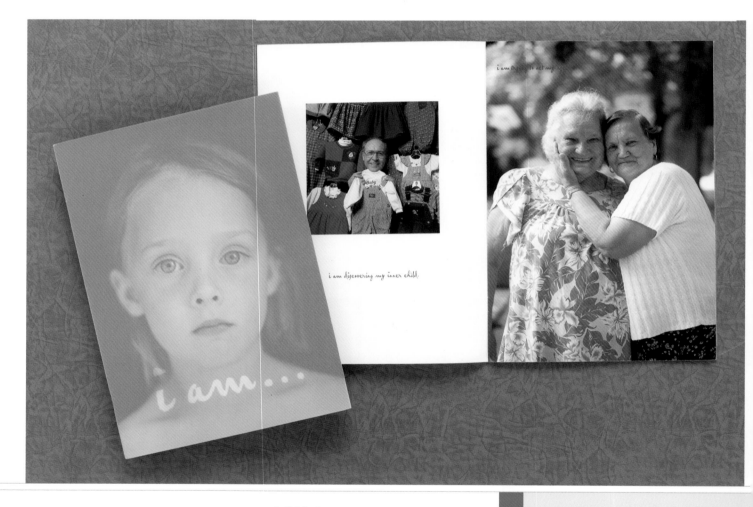

I AM ▲

[STUDIO] Baer Design Group
[ART DIRECTOR] Melanie Dickerson
[PHOTOGRAPHER] Roark Johnson
[CLIENT] Roark Johnson Photography
[CLIENT'S PRODUCT/SERVICE] Photography
[PAPER] Gil Clear (cover); McCoy Satin (inside)
[COLORS] 6, match and process
[SIZE] 9" × 11½" (23 × 29cm)
[PRINT RUN] 10,000
[COST PER UNIT] $7.50
[TYPE] Picasso (throughout and cover), Universe (for remaining credits and contact information)
[SPECIAL FOLDS/FEATURES] Translucent cover wrapped around regular stock cover

Roark's photos are casual portraits, taken in people's own environment. "These people always seem to be saying something to the audience, so we just helped them out with quotes that they might say," explains principal Todd Baer.

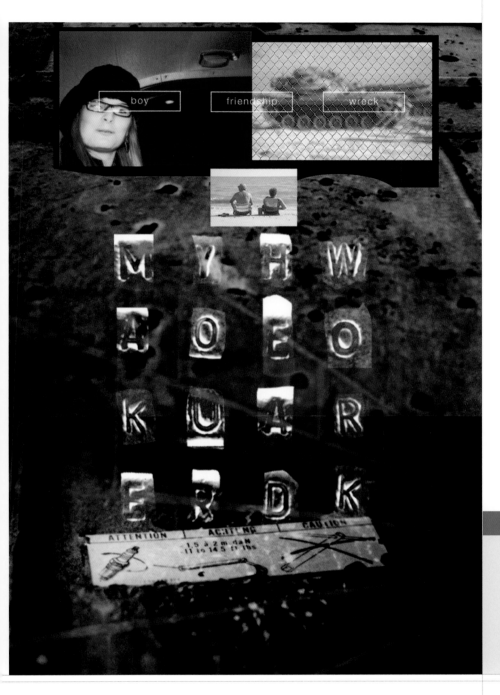

PROPOSAL FOR EUROPEAN LAUNCH OF PHOTOLIBRARY ◄

[STUDIO] Stylorouge
[DESIGNER] Sheridan Wall
[CLIENT] European Photolibrary

"We wanted a concept that highlighted visual interpretation of words, creating a strong argument for using images," says Stylorouge's Rob O'Connor. *"The word string of* boy, friendship *and* wreck *makes a word game of sorts:* boy, boyfriend, friendship, ship, shipwreck, wreck. *'Make your head work' was a proposed copy line, that invited art directors to think laterally about their choice of imagery."*

Build trust with your client. This ulti-
mately will allow you to produce the
most successful work.

DAVID SCHIMMEL

DELTA ASSET MANAGEMENT CONNECTIONS
BROCHURE ▶

[STUDIO] And Partners
[CREATIVE DIRECTOR] David Schimmel
[DESIGNERS] David Schimmel, Aimee Sealfon
[PHOTOGRAPHY] Photonica (stock), Vincent Ricardel (portraits)
[CLIENT] Delta Asset Management
[CLIENT'S PRODUCT/SERVICE] Financial services
[PAPER] Mohawk Superfine, Canson Satin
[PRINTER] Dickson's, Atlanta
[COLORS] 2, match
[SIZE] 7" × 7" (18 × 18cm)
[PRINT RUN] 5,000
[TYPE] Akzidenz Grotesk
[SPECIAL PRODUCTION TECHNIQUES] Translucent overlays that build the logo as one pro-
gresses through the book

*"Our approach to the design of the Delta Connections brochure immediately sets
the firm apart from other more traditional, stodgy or old-fashioned financial serv-
ice companies," explains art director David Schimmel. "The theme of the
brochure stems directly from the firm's corporate identity and appropriated visual
metaphors, ultimately conveying the firm's unique approach to investing."*

FAST COMPANY CALENDAR ◄

[STUDIO] Visual Dialogue
[ART DIRECTOR] Fritz Klaetke
[DESIGNERS] Fritz Klaetke, Ian Varrassi
[ILLUSTRATORS] Various
[PHOTOGRAPHERS] Various
[CLIENT] Fast Company
[CLIENT'S PRODUCT/SERVICE] Business magazine
[COLORS] 5, 4-color process plus silver
[SIZE] 6¾" × 9¼" (17 × 23cm)
[COST PER UNIT] $16.95 retail
[TYPE] Knockout
[SPECIAL PRODUCTION TECHNIQUES] Embossed cover
[SPECIAL FOLDS/FEATURES] The silver wrap, which contains all the necessary marketing info for retail sales (barcodes, subscription numbers, web sites, logos, and so on), can be removed after purchase, leaving only the plain embossed orange cover.

"In addition to designing this appointment book, we were responsible for everything that went into it," says designer Fritz Klaetke. "For each week of the year, we selected quotes and artwork which we thought were interesting or thought provoking. If the user was intrigued as well, a URL for the archived story enabled him or her to read the whole story on the Fast Company web site."

STRATHMORE GRAPHICS GALLERY 2000 ◄

[STUDIO] CO:LAB
[ART DIRECTOR] Williams and House
[PROJECT MANAGER] Williams and House
[DESIGNER] CO:LAB
[ILLUSTRATOR] Leigh Wells
[CLIENT] Strathmore Paper
[CLIENT'S PRODUCT/SERVICE] Paper manufacturer
[PAPER] Strathmore, various grades
[COLORS] 4, process plus 2 match touch plates
[TYPE] Sabon (headlines and text), Gill Sans (subheads)
[SPECIAL PRODUCTION TECHNIQUES] Printing manipulated hand lettering on a very chunky rubber band, fluorescents and other extra colors

"I put a spin on the notion of 'fin du siecle,' which translated means the 'end of the century' or loosely the end of a cycle. By reconstituting the new millennium language and calling it 'le Commencement du siecle,' or 'the beginning of the century,' we implied that the next 1,000 years will be born from the spark of creativity ignited against the Mobius strip of possibility," says Richard Hollant of CO:LAB.

EXPONENTIAL
POSSIBILITIES

SUPER EIGHT ANNOUNCEMENT BROCHURE ▲

[STUDIO] Belyea
[ART DIRECTOR] Patricia Belyea
[DESIGNER] Ron Lars Hansen
[PHOTOGRAPHER] Dan Taylor/Studio 360
[CLIENT] ColorGraphics
[CLIENT'S PRODUCT/SERVICE] Premium printing

[SIZE] 8" × 8" (20 × 20cm)
[TYPE] Futura
[SPECIAL TYPE TECHNIQUE] "In this booklet, many details revolve around the number 8," explains art director Patricia Belyea. "The main graphic on the cover is a close crop of the numeral 8 printed with a gloss varnish. Inside, some type is oversize and printed in colors that have minimal contrast with the background, huge symbols reverse out of photos and other type is printed in almost illegible 'mouse type' to create interest and contrast."

"The goal of this brochure was to quickly let the reader know that ColorGraphics now has the only eight-color process in the state of Washington," art director Patricia Belyea explains. "In developing the concept, we decided that the brochure would be 8 inches square, with an eight-page cover and eight pages of text. The tone of the piece is upbeat and fast. Although the brochure promotes a new eight-color press, it was printed with 12 ink colors because ColorGraphics is passionate about creating uncompromised print communication."

PAINTING AT THE EDGE OF
THE WORLD ◄

[STUDIO] Walker Art Center
[DESIGN DIRECTOR] Andrew Blauvelt
[GRAPHIC DESIGNER] Santiago Piedrafita
[PUBLICATIONS MANAGER] Eugenia Bell
[EDITOR] Michelle Piranio
[PAPER] 135 gsm BVS matte and 100 gsm BVS matte (body),
 300 gsm BVS matte (cover)
[COLORS] Sheetfed offset lithographic press
[SIZE] 6¼" × 9" (16 × 23cm), 352 pages
[PRINT RUN] 4,500
[COST PER UNIT] $29.95
[TYPE] Monotype Grotesque
[SPECIAL FOLDS/FEATURES] This is in fact two books
 bound as one: a collection of essays that explore the
 contemporary status of painting and a collection of
 artists's works specific to the exhibition, *Painting at
 the Edge of the World*. The essays are bound as French-
 folded sheets that literalize the exhibition's title, allowing
 images to wrap to the edge of the page. The second sec-
 tion contains a series of gatefold pages for each of the
 30 artists included in the exhibition. Both devices allow
 for more dramatic presentation of the art.

*"We wanted to emphasize the object qualities of the
paintings, rather than present them more typically as
flattened graphic images,"* explain the designers.

VIZ & LIZ, A HOLIDAY ADVENTURE ▼

[STUDIO] Visual Asylum
[ART DIRECTORS] Maelin Levine, Amy Jo Levine
[DESIGNERS] Charles Glaubitz, Joel Sotelo, Paul Drohan
[ILLUSTRATOR] Charles Glaubitz
[COPYWRITER] Troy Viss
[CLIENT] Self
[PAPER] French Butcher Paper
[COLORS] 4, process (cover), black (interior)
[SIZE] 11" × 8½" (28 × 21cm), 40 pages
[PRINT RUN] 200
[TYPE] Futura
[SPECIAL PRODUCTION TECHNIQUES] The total holiday package included the coloring
 book, crayons with VA wrappers and a miniature train, all packaged in a cloth bag screen
 printed with the studio's logo and sealed with a huge red tag.
[SPECIAL COST-CUTTING TECHNIQUES] The contents of the coloring book were printed in
 black on newsprint. The book cover and crayon box were printed together on the same
 press sheet, the crayon labels were laser printed and applied by hand.

"Childhood memories of the holiday season were our inspiration," says art director
MaeLin Levine. *"We created fictitious characters who land on Earth at Visual Asy-*
lum and want to learn about the spirit of the holiday season. The characters visit
each team member's memory for an individual interpretation of the season."

184

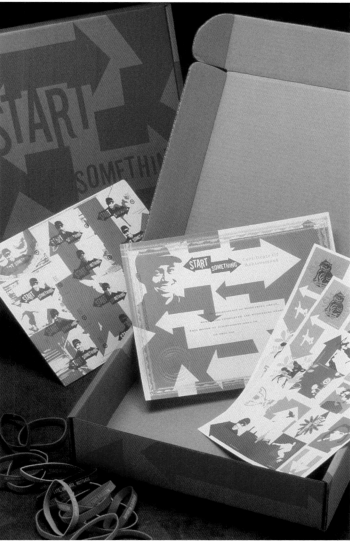

START SOMETHING ▲

[STUDIO] Wink
[ART DIRECTORS] Scott Thares, Richard Boynton,
 Karen Lokensgard
[DESIGNER] Scott Thares
[ILLUSTRATOR] Scott Thares
[CLIENT] Target
[CLIENT'S PRODUCT/SERVICE] Retail
[TYPE] Sterofidelic, Clarendon, Trade Gothic, Helvetica,
 Engravers Gothic

"Start Something is a mentoring program that helps kids 8 to 17 figure out what they might want to do in life," says designer Scott Thares. "The program needed to appeal to a wide age spectrum of kids as well as act as an informational piece for teachers and group leaders. The goal was to make the graphics and visuals fun and hip. The use of arrows reinforced the 'Starting Something' concept, and high-contrast images provided the right blend of youthful appeal."

DOUG SCALETTA PROMO ▶

[STUDIO] Fry Hammond Barr
[CREATIVE DIRECTOR] Tim Fisher
[DESIGNER] Sean Brunson
[PHOTOGRAPHER] Doug Scaletta
[CLIENT] Doug Scaletta Photography
[PAPER] French Muscletone
[COLORS] 4, process
[SIZE] 5" × 7" (13 × 18cm)
[TYPE] Trade Gothic
[SPECIAL PRODUCTION TECHNIQUE] A sticker with the client's number was placed on each card.
[SPECIAL FEATURES] The cards are wrapped with vellum and placed in a custom-made cardboard box sealed with a large mailing label.

"For this project, we wanted to create a special, hand-built, personalized gift for each recipient," says designer Sean Brunson.

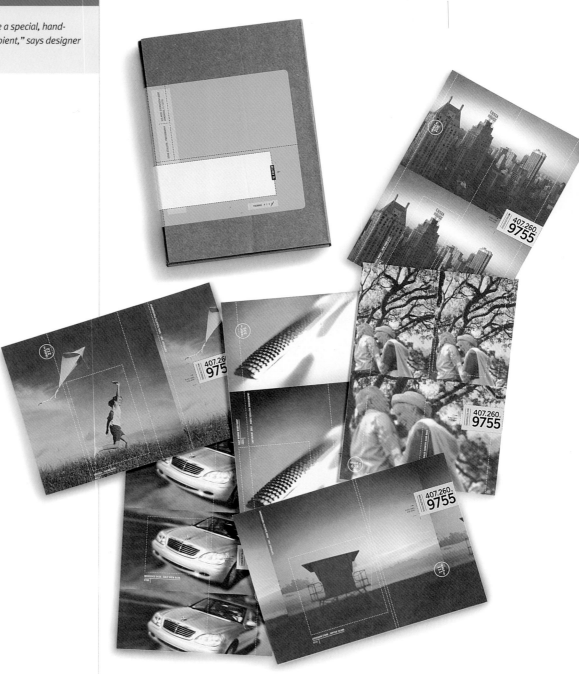

DOWNTOWN LIVE ◄

[STUDIO] Iconologic
[ART DIRECTOR/DESIGNER] Mike Weikert
[ILLUSTRATORS] Elise Woodward, Rebecca D'Attilio
[CLIENT] Central Atlanta Progress
[CLIENT'S PRODUCT/SERVICE] Urban revitalization
[PAPER] Georgia Pacific
[COLORS] 4, process
[SIZE] 24" × 36" (61 × 91cm) open, 9" × 12" (23 × 31cm) closed
[PRINT RUN] Approximately 2,000
[TYPE] Berthold Akzidenz Grotesk
[SPECIAL FOLDS/FEATURES] Folds to brochure and poster size

Mike Weikert, art director, says the inspiration was taken from grassroots posters that promote events, parties and record releases often seen on vacant storefronts and along stretches of urban brick walls and alleys. "The concept was to use the aesthetic to communicate that downtown Atlanta is an exciting place with a lot going on," he says. "The safety of the downtown area was communicated through the depiction of ambassador volunteers who roam the streets of downtown Atlanta promoting safety, helping people with directions, and so on. The ambassadors are very recognizable in their distinctive uniforms and hats."

There's a kind of inward momentum building in Downtown ⇨

Take the time to get to know your client and their specific communicative needs for any given project. Then take the time to think of a solution that speaks in the client's voice and in your voice as well. The result: ideas the client never would have expected that also express your thought process and personality as a visual communicator.

MIKE WEIKERT

TABULA RASA: APPLETON COATED UTOPIA PROMOTION ▶

[STUDIO] EAI

[CREATIVE DIRECTOR] Matt Rollins

[DESIGNERS] Matt Rollins, Todd Simmons, Lea Nichols

[PHOTOGRAPHER] Ken Schles

[CLIENT] Appleton Coated

[PAPER] Appleton Utopia Premium Blue White Dull (cover and text)

[COLORS] 4, process plus match silver metallic and varnish

[SIZE] 11 3/8" × 8 1/2" (29 × 21cm)

[TYPE] Helvetica Neue

According to creative director Matt Rollins, two things inspired him: "Driving past a blank billboard on I-85 in Atlanta and nodding in and out of a Philosophy 101 class on John Locke back in college. In 1690, Locke penned a lengthy treatise entitled 'An Essay Concerning Human Understanding,' in which he established the idea of tabula rasa, or 'blank slate.' Locke claimed (controversially) that ideas are not innate, that we begin with a blank slate and construct ideas by interpreting our surrounding world. We depicted the creative process as it often unfolds: unpredictably. The story of searching for ideas is told in stages, beginning at square one and ending in Utopia. In each photo, a blank rectangle represents the elusive idea (and reminds the reader of paper). The resulting piece, targeted at designers, positions Appleton Coated Utopia as the only constant in the organic process of finding a great idea: a tabula rasa that dares one to begin. The main character is a painter from Brooklyn. We painted his studio wall light blue for the cover photo. He left it that way. The 'Osmosis' shot was taken at the New York Metropolitan Museum of Art; it took a long time to find an empty room. The transvestites in 'Reevaluation' are Cyndi Lauper's backup singers."

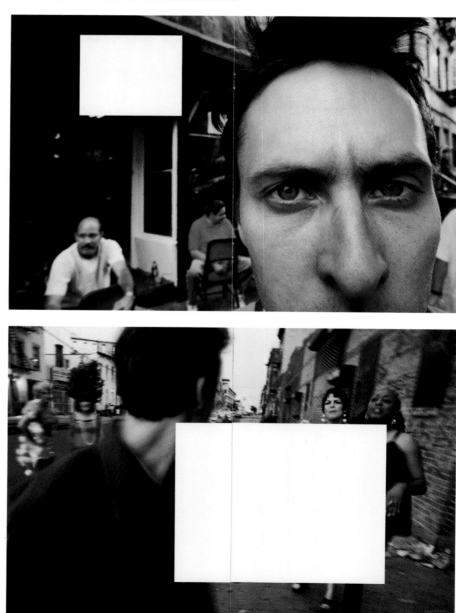

188

[STUDIO] Group Baronet
[ART DIRECTOR] Meta Newhouse
[DESIGNER] Bronson Ma
[ILLUSTRATOR] Jon Flaming
[CLIENT] eMake
[CLIENT'S PRODUCT/SERVICE] Software management for the manufacturing industry
[SIZE] 8½" × 11" (22 × 28cm)
[PRINT RUN] 5,000
[TYPE] Dax Condensed
[SPECIAL PRODUCTION TECHNIQUES] Metallic duotones, dry trap varnish

"We wanted to give a clear sense of what eMake can do for customers by keeping the project simple but following the look and feel of the rest of the pieces in the campaign," says designer Bronson Ma.

THINK OF US AS A BOTTLENECK OPENER.

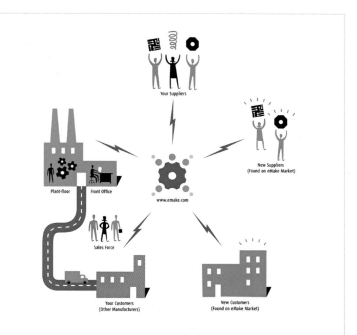

Monthly subscription
eMake is designed as a monthly subscription fee, featuring a predicable, controllable and scalable cost structure. We know you need choices, so we offer several hardware and software options, empowering you to decide which is best for your company.

Unlimited training
All of our eMake solutions include free and unlimited Fast Start and Step Up workshops at eMake Solution Centers across the globe.

Plant-floor visibility
eMake features a complete accounting to shop-floor business solution, designed for phased and fast implementation. Our application integrates production, scheduling and tracking, inventory control, resource capacity and job costing. Plant visibility has never been easier.

24/7 tech support
And after you've adjusted to your new software, troubleshooting is available through

intuitive documentation, online help and 24/7 technical support by telephone or Internet.

Internet connectivity
eMake includes myemake.com – a tightly integrated and secure environment for publishing critical shop-floor data to the Internet when your customers or suppliers need it. eMake Market – found on myemake.com – features online bidding, buying and selling for make-to-order manufacturers just like you. You choose open or closed auctions for security, privacy and opportunity.

JEWISH COMMUNITY FOUNDATION ANNUAL REPORT ▼

[STUDIO] Morris Creative
[ART DIRECTOR] Steven Morris
[DESIGNER] Tracy Meiners
[CLIENT] Jewish Community Foundation
[CLIENT'S PRODUCT/SERVICE] Community and endowment/trust services
[PAPER] Waussau
[COLORS] 4, process
[PRINT RUN] 5,000
[TYPE] Rotis family
[SPECIAL FEATURES] Wire-O binding and die cuts reveal words and letters

"The concept behind this project is that through Jewish value teachings, the mission statement of the Jewish Community Foundation is revealed," explains art director Steven Morris. "We used inventive and illustrative typography to convey emotion."

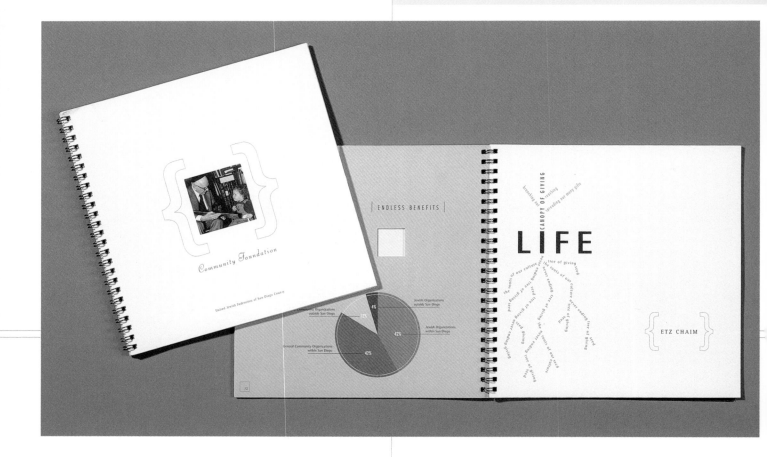

TEXTILE FIBRES: CHARACTERISTICS, CARE AND APPLICATIONS ◄

[STUDIO] Setezeroum Design
[ART DIRECTOR/DESIGNER] José Manuel Da Silva
[CLIENT] Portuguese Knitwear Association (APIM)
[PAPER] Munkken Lynx
[COLORS] 4, offset
[PRINT RUN] 1,000
[COST PER UNIT] 10 euros
[TYPE] Swiss 721, Swiss 721 Light (body); Swiss 721 Thin (titles); Trebuchet MS (numbers)
[SPECIAL PRODUCTION TECHNIQUES] Cover is in Frosted PVC 500 micron, printed in one color with an epoxy sticker glued in the middle

"The idea was to present a different kind of technical manual for the textile engineers, not conservative and austere as it used to be," says designer José Manuel Da Silva. *"It was hard to influence the technical team responsible for the textile research to use colorful pages instead of the regular one color. The second issue was the size and the spiral finishing, but the major issue was the page design. Once we explained how we intended to set up text, images, icons and tech tables using practical examples, they gave us freedom to express ourselves."*

THE PLAYWRIGHTS CENTER BROCHURE ◄

[STUDIO] Initio
[DESIGNER] Sean Lien
[PHOTOGRAPHER] Charissa Uemura
[CLIENT] The Playwrights Center
[CLIENT'S PRODUCT/SERVICE] Theater
[COLORS] 4, process
[SIZE] 11" × 8½" landscape
[TYPE] Clarendon, Filosophia (quotes)
[SPECIAL FOLDS/FEATURES] Membership form on back page is perforated and can be folded and mailed.

"Different colored lines flow from page to page representing the connection of all the theater members, while bright colors represent their positive and enthusiastic attitude," says designer Sean Lien.

ACD, LIVING SURFACES CONFERENCE 2000 ▲

[STUDIO] MetaDesign
[ART DIRECTORS] Rick Lowe, Neil Sadler
[DESIGNERS] Neil Sadler
[PHOTOGRAPHERS] Neil Sadler, Melissa Guzman
[CLIENT] ACD (American Center for Design)
[CLIENT'S PRODUCT/SERVICE] Nonprofit design resource
[COLORS] 4/1 (postcard), 4/1 (poster), 5/5 (conference schedule)
[SIZE] 8½" × 5½" (22 × 14cm) (postcard), 33" × 25½" (84 × 65cm) (poster), 11" × 8½" (28 × 22cm) (conference schedule)
[TYPE] FF DIN

"Through a fresh interpretation of the ACD conference theme, everyday 'living surfaces' were shown in micro detail," explain the designers at MetaDesign. "Applied to a wide variety of materials (reminder cards, poster and signage) the strong images contrasted with a clean typographic grid on the back. This became tactile at the conference with the use of thermographic ink that changed value through touch or temperature."

192

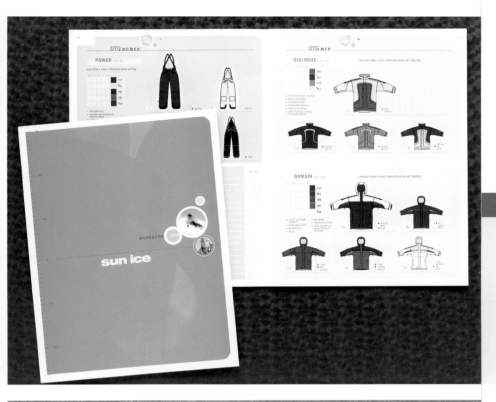

SUN ICE WORKBOOK 2001 ◄

[STUDIO] Tétro Design
[ART DIRECTOR] Paul Tétrault
[DESIGNERS] Andrea Tétrault, Paul Tétrault
[PHOTOGRAPHERS] Various
[CLIENT] Gemini Fashions of Canada
[CLIENT'S PRODUCT/SERVICE] Ski and snowboard apparel
[PAPER] Domtar Weeds, Milkweed Writing 24 lb.
[COLORS] 4, process
[SIZE] 8½" × 11" (22 × 28cm), 24 pages
[PRINT RUN] 1,200
[TYPE] Trade Gothic, Bell Gothic, Platelet
[SPECIAL PRODUCTION TECHNIQUES] Hemp-based paper

"Sun Ice was re-emerging in the fickle world of ski and snowboard apparel," explain the designers. *"Our approach was to present the brand without the usual noise and flash that generally floods this market. To clearly present a magnitude of information, we opted for a minimalist design. We drew our inspiration from old lab books filled with muted colors, diagrams and charts. Once the framework of the pages and information logic was working, we balanced the clinical appearance with small injections of contemporary typography and photography."*

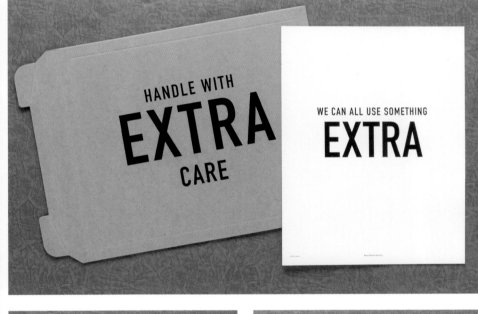

EXTRA ◄

[STUDIO] Axiom Creative Group
[ART DIRECTORS] Brian Fink, Brandon Scharr
[PHOTOGRAPHERS] David Neff Photography, Aaron Stevenson Photography, stock
[CLIENT] Transamerica
[CLIENT'S PRODUCT/SERVICE] Mutual fund
[PAPER] Mohawk Superfine 100 lb. Text
[COLORS] 4, process
[SIZE] 11" × 14" (28 × 36cm) (folded)
[PRINT RUN] 10,000
[TYPE] FF DIN Engleschrift, DIN Mittleschrift
[SPECIAL PRODUCTION TECHNIQUES] Silk screened Calumet envelopes for shipping
[SPECIAL FOLDS/FEATURES] Mini page folded within larger piece

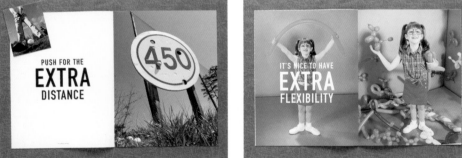

"The focus was on making sure the brokers who received this piece would remember it when a representative called later to make the sale," say designers Brian Fink and Brandon Scharr. *"What we decided was to play off the name 'Extra,' centering everything around the name. Extra large size, extra large envelopes, and so on. We then carried that idea through to the imagery and copy, all to make sure it stood out from all the other mutual fund direct mail that the target audience normally receives."*

ANNI KUAN DIRECT MAIL ▶

[STUDIO] Sagmeister Inc.
[ART DIRECTOR] Stefan Sagmeister
[DESIGNER] Hjalti Karlsson
[ILLUSTRATOR] Martin Woodtli
[PHOTOGRAPHER] Tom Schierlitz
[CLIENT] Anni Kuan
[PAPER] Newsprint
[COLORS] 1
[SIZE] 20" × 15½" (51 × 40cm)
[PRINT RUN] 1,000
[TYPE] Hand type, Franklin Gothic
[SPECIAL TYPE TECHNIQUE] Built some type to form part
 of the image
[SPECIAL PRODUCTION TECHNIQUE] Included a wire
 hanger

"We really only had the budget to print a postcard," says
art director Stefan Sagmeister. *"But a friendly designer
told us about a really cheap newspaper printer who
could do the entire run for under five hundred dollars.
We then bought wire hangers (at two cents a piece) and
corrugated boards (twelve cents each). We bought a
shrink-wrap machine ($500) and the client hired a stu-
dent to put it all together."*

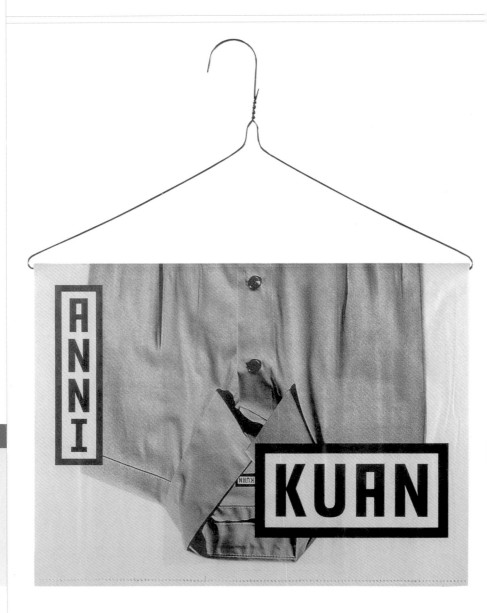

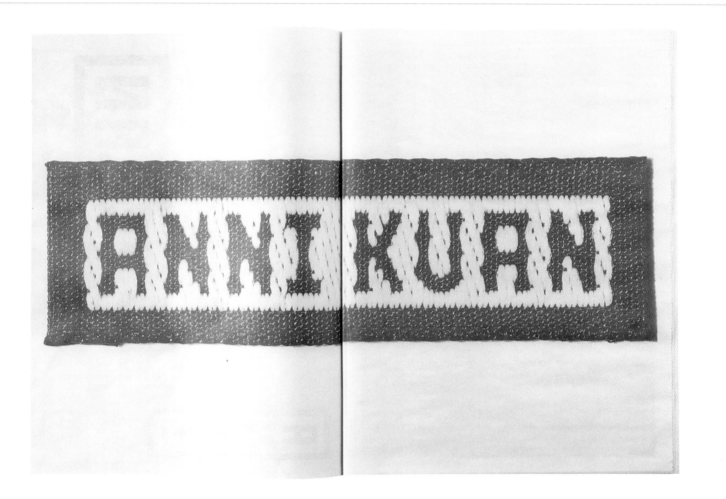

HEALTH CONNECTIONS BROCHURE ▼

[STUDIO] Group 55 Marketing
[ART DIRECTOR/DESIGNER] Shane Morris
[CLIENT] Health Connections Inc.
[CLIENT'S PRODUCT/SERVICE] Health insurance
processing services
[PAPER] Porcelain Gloss cover 80 lb.
[COLORS] 4, process

[SIZE] 8½" × 11" (22 × 28cm)
[PRINT RUN] 2,500
[COST PER UNIT] $1.41
[TYPE] Myriad, hand-lettered logo
[SPECIAL PRODUCTION TECHNIQUES] Metallic ink
with high-gloss laminate, foil emboss logo

"We wanted to bring the client into the twenty-first century with a new logo and look that communicated the highly digital and extensively networked nature of the client's services," explains Group 55 Marketing's Catherine Lapico. "Layered artwork reminiscent of web site designs place the client squarely in the Information Age. The folder's metallic ink with foil emboss adds a rich, tactile element to the digital-looking art of the brochure."

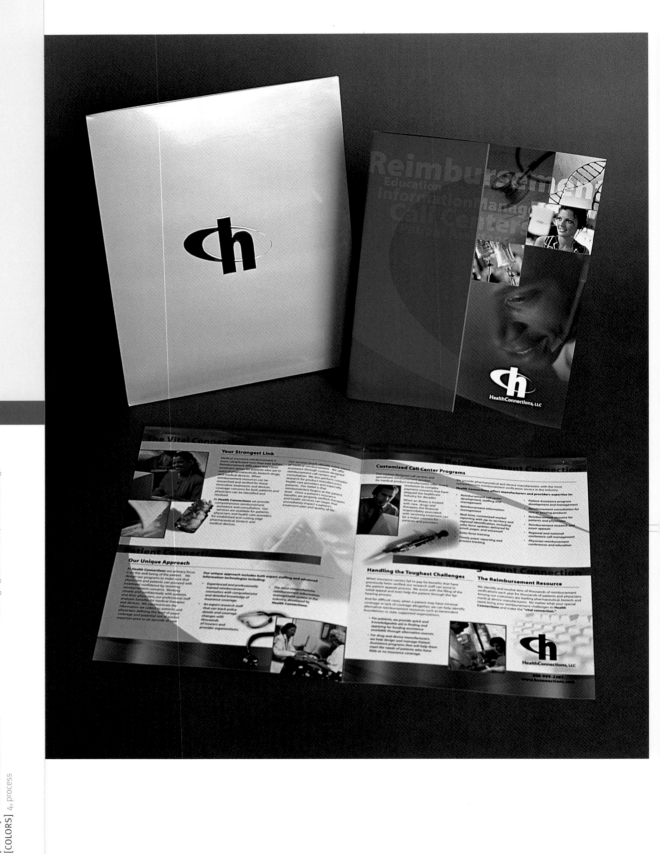

VASSAR COLLEGE
RECRUITMENT PACKAGE ◄

[STUDIO] Nesnadny + Schwartz
[ART DIRECTORS] Joyce Nesnadny, Mark Schwartz
[DESIGNERS] Joyce Nesnadny, Michelle Moehler, Stacie Ross, Cindy Lowrey
[PHOTOGRAPHERS] Russel Monk, Will Faller
[CLIENT] Vassar College
[CLIENT'S PRODUCT/SERVICE] Education
[PAPER] Sappi, Lustro Gloss, 100#T and 100#C; Sappi, Lustro Dull, 100#T; French, construction, Cement Green, 70#T
[COLORS] 4, process plus 2 match and gloss spot varnish
[PRINT RUN] Approximately 50,000
[TYPE] Bembo, Disturbance, Trade Gothic
[SPECIAL FOLDS/FEATURES] Gatefolds divide each major section of the book

"The inspiration is being at Vassar College, the place, the people," says creative director Joyce Nesnadny. "When it comes time to take the next important step in their education, high school students (targeted candidates) are inundated with direct mail from universities. This first recruiting effort needs to pique the interest of the prospective student while communicating to the parent who is helping make the decision. Any materials that are sent as a follow-up must have a continuity of style that brands Vassar and makes it instantly identifiable. The ongoing challenge with various new commissions is to try to stay fresh while applying the same visual vocabulary."

The challenge is to stay true to the original design while allowing for in-process discovery. So much can get lost between the conceptual stage and the final printed pieces. To make sure the project needs are being met without sacrificing the integrity of design, we work closely with the client at the front end of the project (research, inventory, interviews, gathering) to establish a program. If we are clear about our goals from the outset it is much more likely that we will design something that holds together.

JOYCE NESNADNY

197

A JOURNEY OF TIMELESS MATCHBOXES ▶

[STUDIO] LeBoYe
[ART DIRECTOR] Ignatius Hermawan Tanzil
[DESIGNERS] Ignatius Hermawan Tanzil, Cecil Mariani,
 Albert H. Tejakusukmana
[ILLUSTRATOR] Cecil Mariani
[PAPER] Cougar, Weyerhaeuser, HVS, Indah kiat, handmade
 tissue paper (for wrapping the book)
[COLORS] 4/4 process for book; black silkscreen for sticker
 of wrapping paper; pearl foil
[SIZE] 6" × 8" (15 × 20 cm)
[PRINT RUN] 2000
[COST PER UNIT] $6.00
[TYPE] Fastrac Fashion, Aquiline extra bold, Caslon openface
[SPECIAL FOLDS/FEATURES] Tri-fold panel inside

"Graphic design is not known to most of Indonesia," says
art director Ignatius Hermawan Tanzil. *"A lot of big com-*
panies still go to advertising agencies to design annual
reports, company profiles, and even corporate identi-
ties. As a design company we would like to educate peo-
ple that graphic design is a part of life. It is a work of art.
It is the art of communication. Old matchbox labels were
the inspiration for this project. A lot of them are more
than 100 years old; they're not just works of art, but also
tell so much about our history."

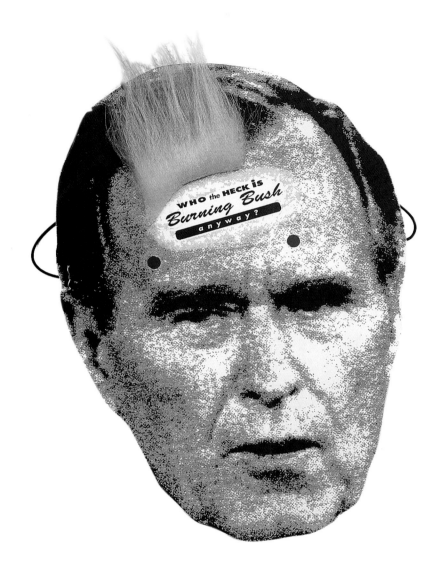

BURNING BUSH STUDIO
"GEORGE BUSH" MAILER ▲

[STUDIO] Burning Bush Studio
[ART DIRECTOR] Frank Zepponi
[DESIGNERS] Frank Zepponi, Mike Styskal
[ILLUSTRATOR] Frank Zepponi
[TYPE] Futura, Brush Script, Meta, Fette Fractur,
 Franklin Gothic
[PRINT RUN] 75

This piece was created to establish relevant meaning and name familiarity for Burning Bush Studio.

WINDTALKERS PREMIERE MATERIALS ▶ ▼

[STUDIO] Fuszion Collaborative
[ART DIRECTOR/DESIGNER] John Foster
[CLIENT] MGM movie studio
[PAPER] Sundance Felt, Clearfold, Kaos
[COLORS] 4/4 process (invitations and tickets); 1 match (envelopes and invitation cover)
[TYPE] Trajan, Officina Sans, handwritten type
[SPECIAL TYPE TECHNIQUES] Handwritten type overlaps with traditional typefaces, burn techniques used on some type
[SPECIAL PRODUCTION TECHNIQUE] Burn techniques used on various photos to help translate a unique and roughened feel
[SPECIAL FEATURES] Clearfold cover and reverse barrel fold create the opening spread and the business card lay-in for the breakfast invitation
[SPECIAL COST-CUTTING TECHNIQUES] Print runs were ganged to save costs; paper company buy-in for promotional purposes also helped with costs.

"For this MGM movie promotion, we needed to relate to the studio's marketing materials but more important, we needed to make the world-premiere pieces really special," art director John Foster says. *"We drew inspiration from code books the code talkers used to transcribe messages and from the written translations of English to Navajo, which were often colorful. We also wanted to make the custom ticket package and wrap double as a keepsake for attendees, so we used a system that featured the photos of the starring actors to help ticket holders determine which section they were seated in and to provide an attractive remembrance of the event."*

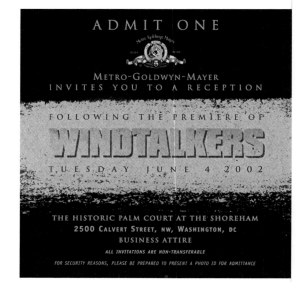

Don't follow standards. Follow function, but not standards, when it comes to size, format, and so on. Push your clients out of the safety zone and they're more likely to stand out. Few projects will be completely open—you will have restrictions, but constantly push boundaries as far as you can. Don't offer up safe solutions, at least not in the first round. Clients will often pick the safest route if it's offered, and you'll end up disappointed in the direction they choose.

JACQUIE VAN KEUREN

OTIS AND CLAUDE SALES KIT ▼

[STUDIO] Duncan|Channon
[ART DIRECTOR] Jacquie Van Keuren
[CLIENT] Otis and Claude
[CLIENT'S PRODUCT/SERVICE] Designer/manufacturer of high-end dog toys
[PAPER] French Frostone, Polar White
[COLORS] 4 process plus black
[SIZE] 9" × 9" (23 × 23 cm)
[PRINT RUN] 100 full kits
[COST PER UNIT] $5.00
[TYPE] Interstate family
[SPECIAL PRODUCTION TECHNIQUES] Metal stamp and die cut
[SPECIAL COST-CUTTING TECHNIQUES] "The low quantity enabled me to do all the hand work myself," says Jacquie Van Keuren. "Also, we manufactured extra metal tags to be used for additional pieces within her marketing system (PR folders and so on), so that cost could be spread out and the higher quantity of tags yielded a better unit cost. I think we did 500 metal tags. I also used an existing die for the shape of the tags. Luckily they had exactly what I was looking for. The only die we had to create was for stamping the logo.
[INSPIRATION/CONCEPT] The product itself was the inspiration for Van Keuren. "The design of the toys, and just dogs."

VISUAL ASYLUM TOP TEN THINGS TO DO IN SAN DIEGO ▶

[STUDIO] Visual Asylum
[ART DIRECTORS] Maelin Levine, Amy Jo Levine
[DESIGNER] Charles Glaubitz
[ILLUSTRATOR] Charles Glaubitz
[CLIENT] American Institute of Graphic Arts, San Diego (AIGA)
[COLORS] 4, process
[SIZE] 3" × 3" (8 × 8 cm) folded; 6" × 6" (15 × 15 cm) unfolded
[PRINT RUN] 500
[TYPE] Futura

Art director Maelin Levine says the inspiration for this piece was a childhood fortune-telling puzzle. "This piece was created specifically for HOW Conference attendees," she says. "The top ten design firms in San Diego each made a piece recommending their top ten must-see San Diego highlights. The idea was to create something fun and interactive," she says.

ANDY POST FLASHLIGHT PROMOTION ◄ ▼

[STUDIO] GibbsBaronet
[ART DIRECTORS] Steve Gibbs, Willie Baronet
[DESIGNER] Meta Newhouse
[PHOTOGRAPHER] Andy Post
[CLIENT] Andy Post, photographer
[PAPER] Fox River Confetti, French Construction, French Dur-o-Tone, Potlatch Quintessence
[COLORS] 4, process plus varnish (a second run was produced in black only)
[SIZE] 7¾" × 5" (20 cm × 13 cm), 40 pages
[PRINT RUN] 3,000
[TYPE] Gill Sans, Garamond
[SPECIAL PRODUCTION TECHNIQUES] The 4-color pages were printed using dryography, a
300-line waterless printing process. Leaf rubbings and rubberbanding were done by hand.

*Designer Meta Newhouse says the inspiration is the story told on the pages, of a father
and son going camping and discussing whether the father's heart would break if the son
died. "It was so heartwarming and true that it was important for the design not to get in
the way of the storytelling," she says.*

AS WE DROVE BACK
TO CAMP, BEN AND I
HAD THE FOLLOWING
CONVERSATION:

Boy, I sure love my
new flashlight.

You know
how much?

No. How much?

I love it so much,
I'm going to take it up
to heaven when I go.

Well, they say you can't take it with you, but I'm not sure they were
talking about flashlights.

Tell you what – I'll
go up first, then
you can come up
after me.

Well...it could happen that way. Sure.

You would have to
come up, because
you would have a
broken heart.

Yes. **Yes, I would.**

DE YOUNG "WE LISTENED" DIRECT MAIL ▼

"This direct-mail brochure was designed in response to public comment on the proposed plans for the new de Young Museum in San Francisco's Golden Gate Park," art director Bill Cahan explains. "The idea 'We've Listened' acknowledges that the architects, contractors and curators have implemented the public's ideas and that the new museum will be a place for everyone."

[STUDIO] Cahan & Associates
[ART DIRECTOR] Bill Cahan
[DESIGNER] Michael Braley
[PHOTOGRAPHER] Jock McDonald
[ILLUSTRATORS] Nanette Biers, Walter Hood

[CLIENT] Fine Arts Museums
[PAPER] Weyerhauser opaque vellum
[SIZE] 10" × 18" (25 × 46 cm)
[PRINT RUN] 60,000
[TYPE] Sabon

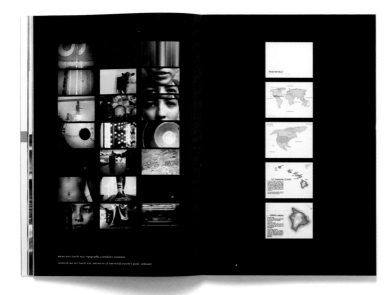

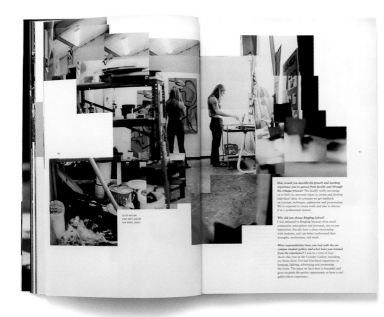

2000–2002 RINGLING
SCHOOL CATALOG ▲ ◄

[STUDIO] Ringling School Design Center at the Ringling
School of Art & Design
[ART DIRECTOR] Jennifer Mumford
[DESIGNERS] Brian Mah, Katherine Micky (students)
[PHOTOGRAPHER] Frank Atura
[CLIENT] Jim Dean, Dean of Admissions
[PAPER] 80# Dull Porcelain Text (front); 70# Quantum
Opaque White text (back)
[COLORS] 4, process with overall dull varnish
[SIZE] 7½" × 11¼" (19 × 29 cm) (folded)
[PRINT RUN] 40,000
[COST PER UNIT] $5.21
[TYPE] Sabon
[SPECIAL PRODUCTION TECHNIQUES] Cross processing
and collage; matte laminate on the cover and slipcase

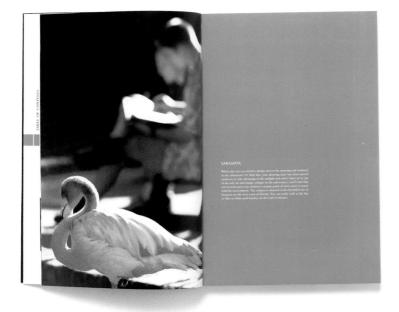

"The saturated palette and balmy weather of southwest
Florida's gulf coast inspired the tone, while the tight-
knit, supportive communities of Ringling and Sarasota
inspired the voice," says art director Jennifer Mumford.
"The concept behind the visual structure is drawn from
process, that is, as it relates to artistic growth, and more
specifically, as the integral constituent of all majors at
Ringling. To visualize this idea, we directed alternate-
angle photography to connote different points of view
and multifaceted experiences. The repetitive use of a
heavy black grid implies 'storyboard' as a narrative
device to engage the prospective student into glimpses
of what may be."

TSUNAMI MARKETING
BROCHURE ▶

[STUDIO] Wink
[ART DIRECTORS] Scott Thares, Richard Boynton, Anthony Arnold
[DESIGNER] Scott Thares
[PHOTOGRAPHER] Gelston Dwight
[CLIENT] Tsunami Marketing
[TYPE] Trade Gothic, Helvetica, Courier, hand lettering
[SPECIAL PRODUCTION TECHNIQUES] Die cuts, odd-sized paper, spinal binding

"The goal of this piece was to create a marketing brochure that showcases the philosophy of Tsunami Marketing as it relates to sports-driven clients," says art director Scott Thares.

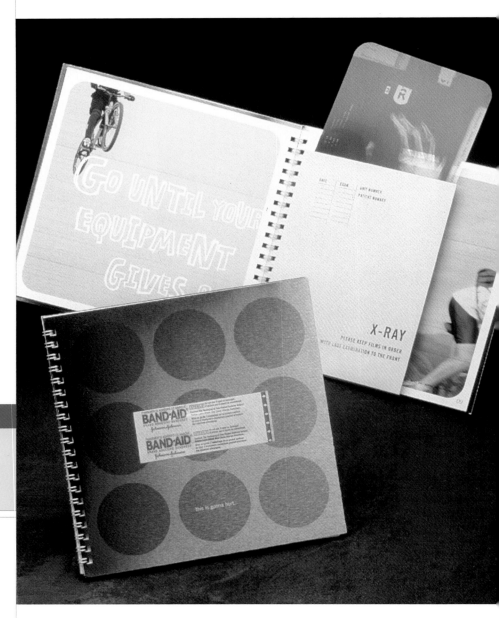

KEY² DECISIONWARE ROLLOUT BROCHURE ▼

[STUDIO] Belyea
[ART DIRECTOR] Patricia Belyea
[DESIGNER] Ron Lars Hansen
[ILLUSTRATOR] Ron Lars Hansen
[CLIENT] Keystroke Technology Solutions
[CLIENT PRODUCT/SERVICE] Mortgage software developer
[TYPE] Bell Gothic, Delta Jaeger
[SPECIAL TYPE TECHNIQUE] The main headline of the brochure, "Turbo-charged intelligent
 decisioning," is rendered on the inside spread with a motion blur.

*"Key² DecisionWare is a new software product that was introduced at an international
trade show," says art director Patricia Belyea. "This brochure was the first printed piece
that described the product's features and benefits. The theme of the brochure is speed.
Whichever financial institution can approve and close a mortgage fastest is the winner
in the lending game. This software super-accelerates the loan-origination process while
allowing more control for mortgage product managers. The brochure is linear with
arrows and lines traveling across the graphic panels in a blur to tell this story."*

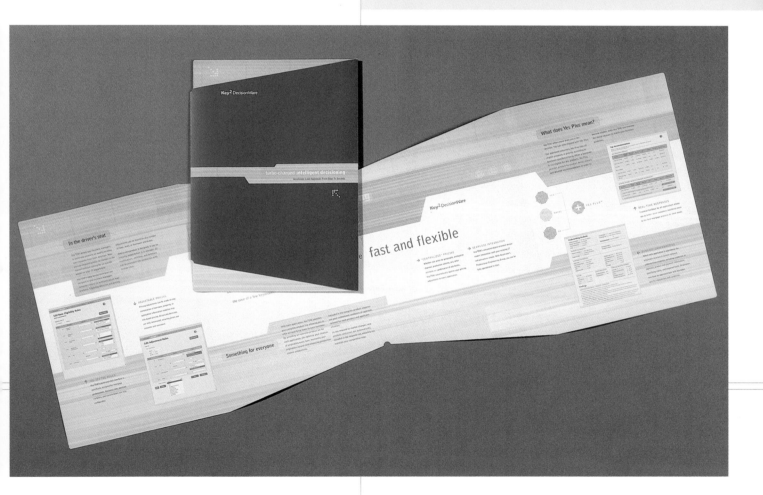

207

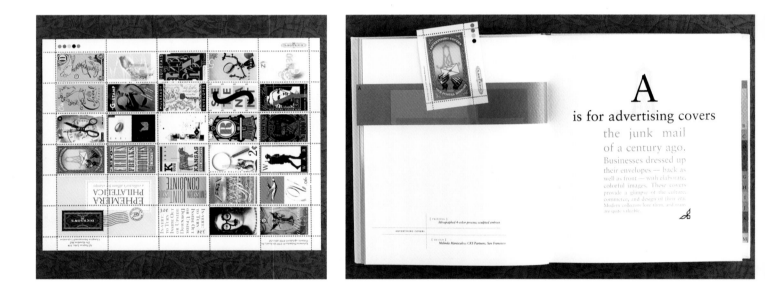

EPHEMERA PHILATELICA ▲

[STUDIO] MOD/Michael Osborne Design
[ART DIRECTOR] Michael Osborne
[DESIGNERS] Michael Osborne, Paul Kagiwada
[CLIENT] Dickson's
[CLIENT'S PRODUCT/SERVICE] Speciality printing
[PAPER] Gmund
[SIZE] 10" × 15" (25 × 38 cm)
[PRINT RUN] 3,500
[TYPE] Mrs Eaves
[SPECIAL PRODUCTION TECHNIQUES] Letterpress, foil stamping, engraving, embossing, thermography, 4-color process, spot match color, die-cuts, perforation.

[SPECIAL FOLDS/FEATURES] Box that holds a tabbed, hardbound book, which in turn contains individual, speciality-printed stamps for every letter of the alphabet; the box includes an assortment of smaller boxes that contain stamp collecting items, such as stamp hinges, glassine envelopes and a magnifying glass
[SPECIAL COST-CUTTING TECHNIQUES] Dickson's spared no expense!

Art director Michael Osborne says his inspirations were simply postage stamps and speciality printing techniques.

Do what YOU like!
Don't compromise!
CLAUDIA CHRISTEN

SMART DESIGN BROCHURE ◄

[STUDIO] Smart Design LLC
[ART DIRECTOR] Rie Norregaard
[DESIGNER] Smart Design LLC
[PHOTOGRAPHERS] David Ortega, Claudia Christen, Nao Tamura, Michel Gastl, Jim Cooper, Peter Jennings
[COLORS] 4, process
[SIZE] 9" × 12" (23 × 30 cm)
[PRINT RUN] 7000
[COST PER UNIT] $1
[TYPE] Univers, Smart Futura
[SPECIAL COST-CUTTING TECHNIQUE] "Our decision to use the noncoated stock was based on a design decision and a style we wanted to create, but one benefit was an overall reduction in paper cost versus more traditional papers used for brochures," says designer Claudia Christen.

"People inspire our process, and designing for people inspired our visual brand identity and brochure," explains Christen. "So that's why our focus is on people, and not on things. We wanted our brochure to reflect our focus on designing for the way people live and work. Everyday people appear in just about every page of our brochure, letting us put our designs into context, rather than just emphasizing the designs themselves."

CUE KIDS CATALOG ▶ ▼

[STUDIO] Khana Shiro
[ART DIRECTOR/DESIGNER] Sophia Hirokawa
[CLIENT] I'VORY
[CLIENT'S PRODUCT/SERVICE] Fashion clothing design
[COLORS] 4, process
[SPECIAL COST-CUTTING TECHNIQUE] Used printer's in-
house coated paper stock to save on paper cost

*"Cue Kids is a children's clothing line carried at Blooming-
dale's and other high-end department stores,"* art direc-
tor Sophia Hirokawa explains. *"The clothing is fun,
active and vibrant, perfect for girls ages six to twelve.
The catalog captures this feeling with a clean and
dynamic layout using colors that play off the color of
the clothing. The catalog also serves as a company
press kit that targets fashion editors and buyers. The
company has generated five additional collections since
its first catalog last year, with national sales reaching an
all-time high."*

cue Kids

sunkissed

Flounce Lace Neck Tank Top STYLE KGZK16. Flare Patchwork Pant with Heart Pocket STYLE KLBNJ09 / oppo-
site page: Off-the-Shoulder Flutter Sleeve Gauze Top STYLE KGZK17. Flare Patch Work Pant STYLE KLBNJ05

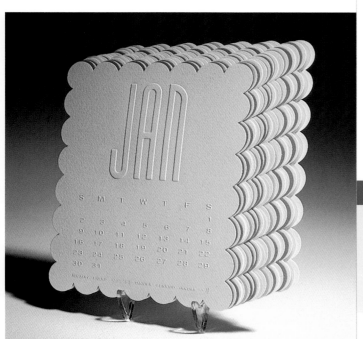

"DOES ANYBODY REALLY KNOW WHAT TIME IT IS?" AERIAL 2000 CALENDAR ◄

[STUDIO] StudioMoon (formerly Aerial)
[ART DIRECTOR/DESIGNER] Tracy Moon
[PAPER] Somerset Natural White 100% Cotton Rag
[SIZE] 4¾" × 5½" (12 × 14 cm)
[PRINT RUN] 1,000 collated calendars
[COST PER UNIT] About $4.00
[TYPE] Trade Gothic
[SPECIAL PRODUCTION TECHNIQUES] Offset lithography using matte white ink on colored vellum for flyleaf; blind embossed using brass dies.
[SPECIAL FOLDS/FEATURES] scalloped die cut

"I wanted to design a piece that flaunted form over function," shares designer Tracy Moon. "I decided that a virtually unreadable calendar would be appropriate. Since we rely on calendars to be accurate, essential guides, the best ones are simple, clear and easy to read. Our 2000 calendar is not. I also liked the notion of visually portraying the fact that we don't really know what time or day it is, we just agree on a convention to avoid chaos."

THERE'S NO PLACE LIKE HOME ▼

[STUDIO] Spur
[ART DIRECTOR/DESIGNER] David Plunkert
[ILLUSTRATOR] Philippe Lardy
[PHOTOGRAPHER] Chris Hartlove
[CLIENT] AIDS Interfaith Residential Services (AIRS)
[CLIENT'S PRODUCT/SERVICE] Housing services for individuals with HIV/AIDS
[PAPER] Mohawk Superfine
[COLORS] 4, process (cover); 2, match (interior)
[SIZE] 9" × 6" (23 × 15 cm)
[PRINT RUN] 5,000
[TYPE] Handwriter
[SPECIAL PRODUCTION TECHNIQUES] Interior illustrations were supplied as separate black-and-white pieces and converted to two colors using channels in Adobe Photoshop
[SPECIAL COST-CUTTING TECHNIQUES] "I begged everyone involved to work as cheaply as possible because the budget is small and the client is worthy," says David Plunkert.

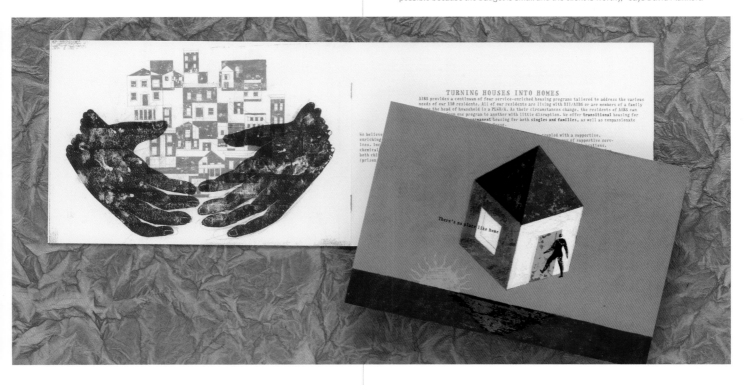

"GROUNDED FOR LIFE" LAUNCH KIT ▼

[STUDIO] Fox Broadcasting Company Creative Services
[CREATIVE DIRECTOR] Barbara Hamagami
[PROJECT MANAGER] Karen Nefsky
[DESIGNER] Sherry Lambie
[ILLUSTRATORS] Sherry Lambie, Eunwook Chung
[COLORS] 4, process
[PRINT RUN] 750
[COST PER UNIT] $50.00
[TYPE] Comics Cartoon, Cochin, Univers (body copy and some headings)

"It's a twist on the game 'Life,' where, in the traditional way, first you got married, then you had kids," say the designers at Fox Broadcasting Company Creative Services. "The concept of this show was a couple right out of high school raising kids. So, in our version, first you get pregnant, then you get married. And instead of buying a house and saving for your kids' college education, you live paycheck to paycheck, bail your brother out of jail and buy mundane appliances."

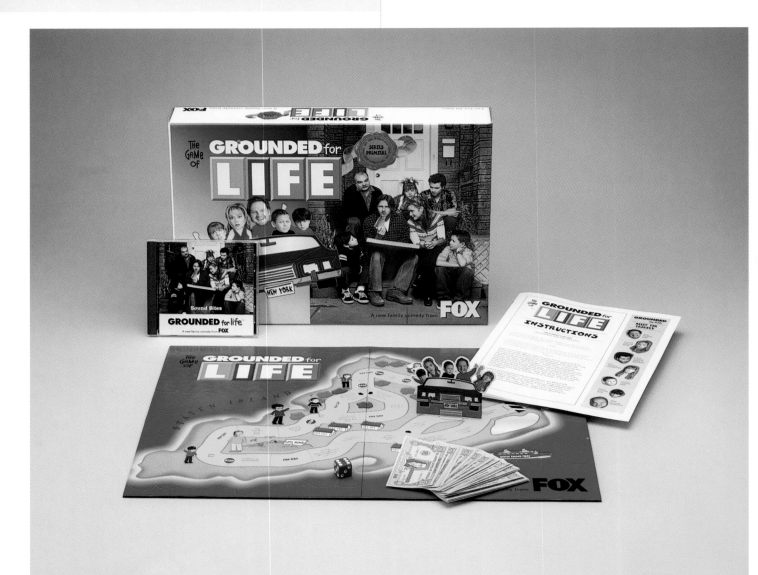

[STUDIO] Wasco
[ART DIRECTOR] Steffanie Lorig/Art With Heart
[DESIGNER] Chip Wass
[ILLUSTRATOR] Chip Wass
[CLIENT] Art With Heart/AIGA Seattle
[CLIENT PRODUCT/SERVICE] Youth charity that creates
activity books for chronically and terminally ill children

[COLORS] 4, process
[SIZE] 12½" × 10½" (32 × 27 cm)
[PRINT RUN] 10,000
[TYPE] Hand-drawn type
[SPECIAL FEATURES] Cover folds over and binds at open
end; a board was inserted at the back cover to add
strength and make activity book lap friendly
[PAPER] CIS Carolina

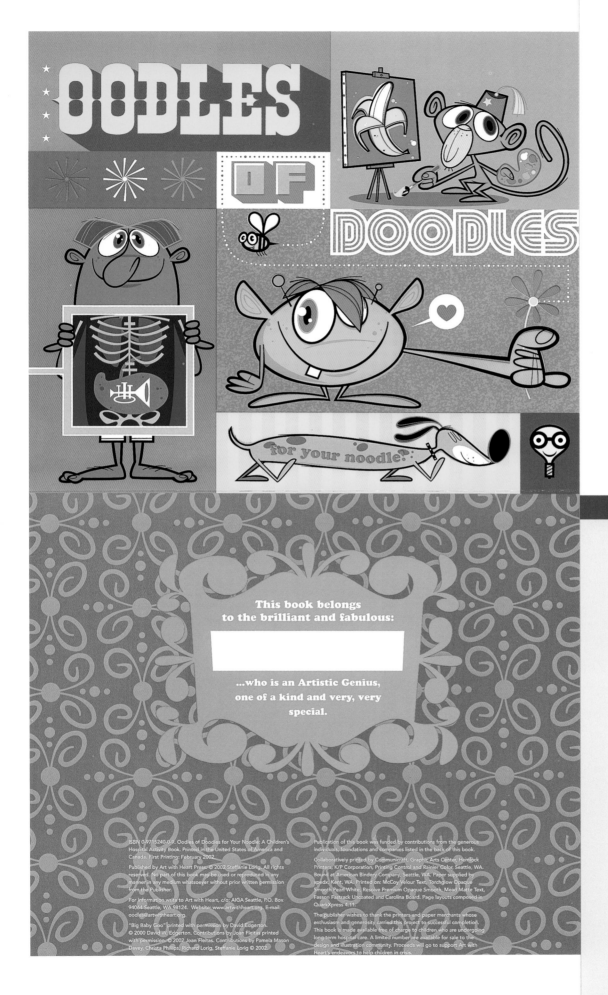

"Since the purpose of this piece was to entertain kids in the hospital, I thought the tone of it should be irreverent but still sweet," designer Chip Wass says. "I tried to suggest stories and worlds that the characters in my drawings might inhabit without being too literal so the kids might complete the story on their own. Beyond that, I'm fond of a souped-up 1975 sugar-coated cereal box/Saturday morning television aesthetic: old time meets innocence meets disco-era anything-goes pleasure."

GOOD STUFF ▶

[STUDIO] Herman Miller Marketing Communications
[ART DIRECTOR] Steve Frykholm
[DESIGNER] Brian Edlefson
[COPYWRITERS] Clark Malcolm, Dick Holm
[PRODUCTION MANAGER] Marlene Capotosto
[PHOTOGRAPHERS] Jim Warych, Bill Hebert
[CLIENT] Herman Miller Inc
[CLIENT'S PRODUCT/SERVICE] Furniture for office, health-
 care, and residential environments
[PAPER] Domtar Plainfield Opaque 40lb text, 65lb cover
[COLORS] 4, process
[SIZE] 6" × 6" (15 × 15 cm)
[PRINT RUN] 40,000
[COST PER UNIT] $3.30
[TYPE] Meta + Family
[SPECIAL FOLDS/FEATURES] Japanese folded text pages

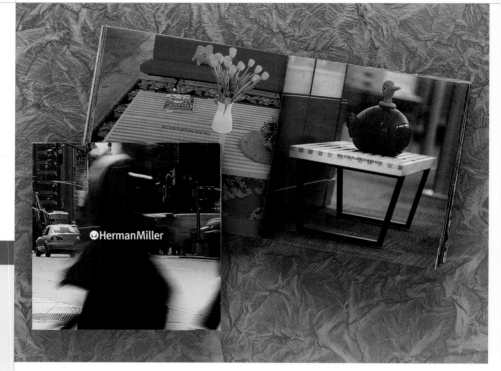

"We wanted to present a comprehensive look at the entire Herman Miller furniture offering," explains designer Brian Edlefson. *"This piece was intended to be displayed and distributed at trade shows so it was important that it be cost efficient and convenient to grab and carry around at an all-day event. We also wanted to contrast the clean, sophisticated showroom experience by showing the products in a very honest way. We achieved this by photographing all of the products in real-life environments that we found throughout the company, with real Herman Miller employees, complete with stacks of paper and family photos."*

The biggest challenge is to create work with character. We try to approach the subject with honesty. It may sound trite, but that immediately forces the product or message to be clearly communicated. I think honesty is also what scares so many companies (and designers) because when honesty is present there are no extraneous elements or trendy jargon to hide the flaws.

BRIAN EDLEFSON

[STUDIO] Design: MW
[ART DIRECTOR] Allison Williams
[DESIGNERS] Allison Williams, Yael Eisele
[PHOTOGRAPHER] Gentl + Hyers
[CLIENT] Takashimaya New York
[CLIENT'S PRODUCT/SERVICE] luxury retail store
[PAPER] Various "curious" paper stocks
[SIZE] 8" × 8" (20 × 20 cm)
[TYPE] Akzidenz Grotesk
[SPECIAL PRODUCTION TECHNIQUES] UVX printing
[SPECIAL FOLDS/FEATURES] Short sheets

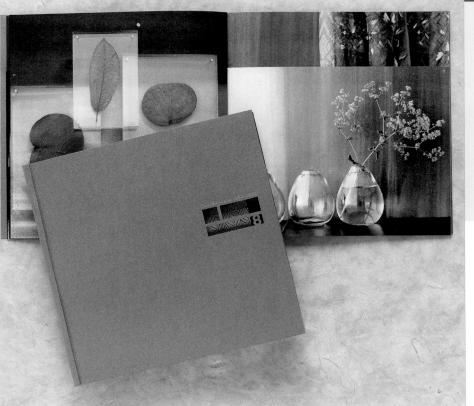

"Takashimaya is a unique shopping experience, and each year we endeavor to make the catalog an experience to savor," says art director Allison Williams. "Our aim for volume 9 was to continue a sense of discovery throughout; to create a journey, a discrete world. Various short sheets and die cuts create a cinematic continuum, a quiet accretion of insights. The resulting juxtapositions allow for new combinations of textures and products, embodying the retail experience of the store. The papers were chosen to reflect the myriad textures and neutral tonality for which Takashimaya's merchandise mix is known. The subtle shifts in sheen, sparkle, translucency, and iridescence also contribute to the fluidity of the brochure."

CALIFORNIA CENTER FOR THE ARTS, SEASON BROCHURE ▶ ▼

[STUDIO] Morris Creative
[ART DIRECTOR] Steven Morris
[DESIGNER] Tom Davie, Deanne Williamson
[CLIENT] California Center for the Arts

"We felt it was important to underscore the powerful experiential aspects of the Center's programs, performances and exhibitions," says art director Steven Morris. "At the same time we wanted the design to support the architectural elegance of the California Center for the Arts."

dimension

Remember Shakti

John McLaughlin, Guitar Zakir Hussain, Tabla
V. Selvaganesh, Ghatam U. Shriving, Mandolin

What happens when one of the most influential musicians of jazz meets one of the most innovative artists of Indian Music? Find out when Shakti's legendary musicians collaborate in a performance that combines beauty, intelligence and power. Originally formed in 1975, the quartet broke new musical ground with its fluid, organic sound that became the template for today's world music. The limited reunion tour of this powerhouse ensemble stars British jazz guitar icon John McLaughlin, founder of the Mahavishnu Orchestra in the 60's.

"Remember Shakti" was voted the Best Jazz Album of 1999 by George Varga of the *San Diego Union-Tribune*

Behind the Scenes:
The Artist, The History
Lecture with Wine and Cheese
6:30 - 7:30 pm
Member $9.60, Non-Member $12

Friday, November 17, 2000 8 pm Concert Hall $20-$50

Denyce Graves, Mezzo-Soprano

Denyce grew up singing gospel music and in this very special solo recital will perform her favorite arias and spirituals. Heralded as the singer destined to become the operatic superstar of the 21st Century, mezzo-soprano Denyce Graves has already made her mark as the most exciting vocal star of our time. Her signature portrayals in the title roles of *Carmen* and *Samson et Dalia* reveal rich, expressive vocalism, elegant stage presence and thrilling theatrical abilities. Since making her debut as Carmen in the Metropolitan Opera's 1995-96 season, she has performed at some of the world's greatest opera houses – often sharing the stage with Placido Domingo.

Friday, December 1, 2000 8 pm Concert Hall $20-$50

Deck the Halls: A Holiday Celebration

In conjunction with the Palomar College Performing Arts Department

The Center celebrates the warmth and joy of the holiday season in this community concert featuring outstanding musicians from the Palomar College Performing Arts Department. From the sweet, clear voices of the Palomar Youth Chorale to the ringing power of the Palomar Symphony Orchestra, you will delight in the many musical moods of the holiday season. This concert also features the Palomar Brass Ensemble, the Civic Youth Symphony Orchestra, a special guest and the ever-popular SING ALONG.

Saturday, December 2, 2000 8 pm Concert Hall $10-$15

"Annie" The Musical

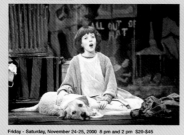

What better way to celebrate the holidays and family than with a Broadway show! It's time to let the kids stay up past their bedtimes. "Annie," the musical about the ageless, Depression-born, red haired orphan comes to The Center in a production praised for its singing, acting and sets. It's a classic theatrical experience with such hits as "Tomorrow" and "It's a Hard Knock Life" that will enthrall and enchant audience members of all ages. The Center's holiday gift to you and yours.

42 Friday - Saturday, November 24-25, 2000 8 pm and 2 pm $20-$45

43

216

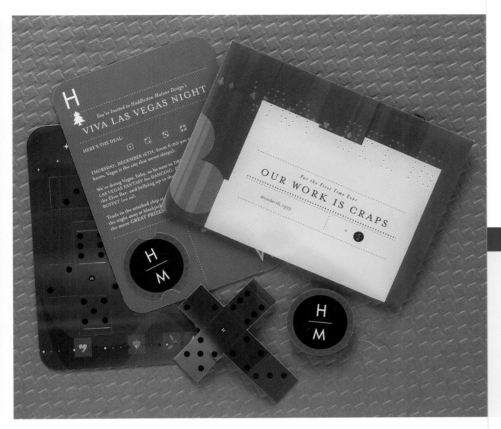

VEGAS PARTY INVITATION ◄

[STUDIO] Huddleston Malone Sligting
[ART DIRECTORS] Barry Huddleston, Dave Malone
[DESIGNERS] Celeste Rockwood-Jones
[PAPER] Topkote Dull Cover, GilClear Medium Text
[COLORS] 4, process
[SIZE] 4⅜" × 6⅜" (11 × 16cm)
[PRINT RUN] 300
[TYPE] Futura, Mrs Eaves
[SPECIAL PRODUCTION TECHNIQUES] perforations and
 die cuts.
[SPECIAL FOLDS/FEATURES] The translucent envelope
 offers a glimpse of its unique content.

"The theme of the party had already been established—
Las Vegas—so the trick was to come up with a concept
that would attract party goers," says art director Barry
Huddleston. "The idea was to give them build-your-own
dice and a couple of paper chips that could be
redeemed at the party for real chips. The real chips could
be used to play a variety of casino-style games and any
winnings could then be used to bid on door prizes. As
for the headline on the envelope, perhaps this piece
wasn't 'the craps' after all."

CASIE AND HUNTER GET MARRIED: A WEDDING INVITATION ◄

[STUDIO] HLWdesign
[ART DIRECTOR/DESIGNER] Hunter Lewis Wimmer
[PHOTOGRAPHERS] Hunter Lewis Wimmer, Brad Rhodes
[CLIENT] Casie Permenter (bride)
[PAPER] Weyerhauser Cougar Opaque 100#C
[COLORS] 4/1, process
[PRINT RUN] 1000
[COST PER UNIT] $.80
[TYPE] Trade Gothic Bold2, Trade Gothic Bold Light
[SPECIAL FOLDS/FEATURES] Accordion fold

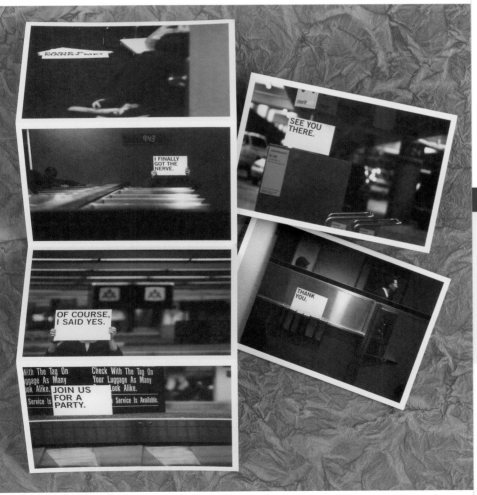

"I proposed at San Francisco International Airport when
picking Casie up from a trip," says art director Hunter
Lewis Wimmer. "I was standing at the back of the termi-
nal holding a sign—limousine driver style. I had booked
a flight to Las Vegas the next morning—good thing
she said yes. We sent the invitations for our reception
within a month of the ceremony. In many cases, the
invitation was the first news many of our friends and
relatives received."

LEVY CREATIVE MANAGEMENT
MOVING CARD ▼

[STUDIO] Mirko Ilic Inc.
[ART DIRECTOR] Mirko Ilic
[DESIGNERS] Mirko Ilic, Heath Hinegardner
[CLIENT] Levy Creative Management
[CLIENT'S PRODUCT/SERVICE] Artist representative
[COLORS] 5, spot
[SIZE] approximately 6" × 8" (15 × 20 cm)
[TYPE] Interstate (Tobias Frere-Jones)
[SPECIAL PRODUCTION TECHNIQUE] Die cuts
[SPECIAL COST-CUTTING TECHNIQUE] By flooding the entire surface and using over-printing, many distinct pieces were created for the cost of one.

"I wanted to create a bright, colorful piece that moves," art director Mirko Ilic says. *"The leftover Ls became fluorescent business cards in the shape of the L logo."*

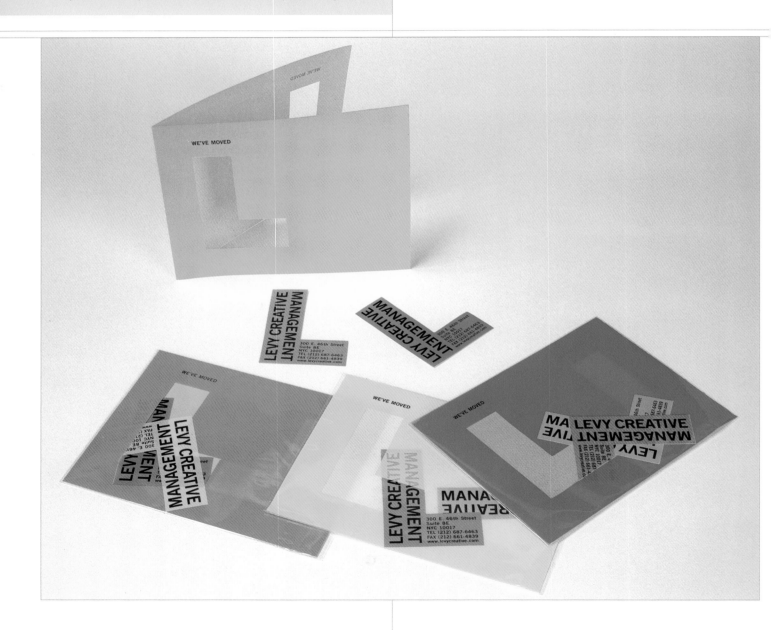

MONROVIA INFORMATION CENTER PRESS BOX ◄

[STUDIO] Erbe Design
[ART DIRECTOR] Maureen Erbe
[DESIGNERS] Maureen Erbe, Efi Latief, Rita Sowins
[ILLUSTRATOR] Anne Smith
[CLIENT] Monrovia
[CLIENT'S PRODUCT/SERVICE] Plant grower
[PAPER] 70 lb. Speckletone Madero Beach (box, brochures), Glassine (envelope), 100# Elite Gloss Book (insert)
[SIZE] 10⅜" × 12¾" (26 × 32cm)
[PRINT RUN] 2,500
[COST PER UNIT] $14.50
[TYPE] Hand-lettering by Anne Smith, Garamond, Mrs Eaves, Gill Sans
[SPECIAL PRODUCTION TECHNIQUES] "To achieve embossing on the box and to attain the specific color and texture we wanted, we had to print a solid color on and off-white stock," says art director Maureen Erbe. "The paper was printed lithograpically, embossed and wrapped/laminated to our custom-engineered box. A rubberband printed with the project name secures the press kit and serves as the headline for the box."

"The assignment was to do a press kit to send out to Garden Writers to promote a free in-store information center available in retail garden centers across the United States and Canada," says art director Maureen Erbe. "The Monrovia Information Center is of a series of free educational brochures with gardening tips. The idea was to come up with a piece that would house the brochures in a manner that would catch the Garden Writers' attention and make them excited enough to want to learn more about the program. The box was designed to be a keepsake—something the Garden Writers would hang on to and be reminded of Monrovia and the program again and again."

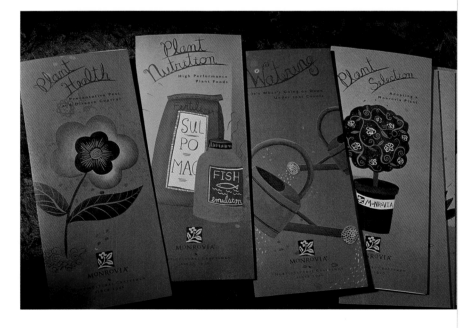

THIS IS NOT A TEST ▲

[STUDIO] Kinetik Communication Graphics, Inc.
[ART DIRECTORS] Samuel Shelton, Jeffrey Fabian
[DESIGNER] Mimi Masse
[CLIENT'S PRODUCT/SERVICE] Watson Wyatt Worldwide (consulting)
[PAPER] Champion Celebration, Circa Select
[COLORS] 1, match (cover); 2, match (interior)
[SIZE] 11" × 8½ " (28 cm × 22 cm), 12 pages plus cover
[PRINT RUN] 325
[TYPE] New Baskerville

[SPECIAL PRODUCTION TECHNIQUES] "A die-cut circle on the cover reveals the clock image on page one," says Sam Shelton. "Binding is done with rivets, through which a custom-imprinted pencil is attached with a rubber band. A die-cut slit on the inside back cover holds the return envelope."

[SPECIAL FOLDS] The back cover folds back on itself to allow for a die-cut slit, which holds a return envelope. The back cover also wraps around the front to create a double-thick spine, through which the rivets are attached.

The inspiration for this project was standardized tests. The concept, says art director Sam Shelton, was "to create a unique and memorable presentation for a utilitarian product (a survey) by disguising it as something it's not."

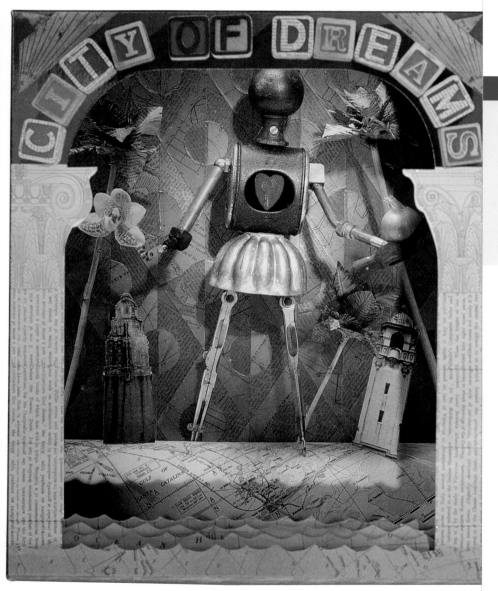

ORCHIDS AND ONIONS: "CITY OF DREAMS" ▼

[STUDIO] Visual Asylum
[ART DIRECTORS] MaeLin Levine, Amy Jo Levine
[DESIGNER] Nicole Schlueter
[ILLUSTRATOR] Dan Renner
[PHOTOGRAPHER] Jim Coit
[COPYWRITER] Jennifer Mallory
[CLIENT] American Institute of Architects
[PAPER] Carolina
[COLORS] 6, process plus UV coating
[SIZE] 7¾" × 6½" (20 cm × 17 cm)
[PRINT RUN] 4,200
[TYPE] Futura
[SPECIAL PRODUCTION TECHNIQUES] The piece was printed, scored, glued and laminated, then mailed flat. The invitation "pops" into a shadow box.

Inspired by the human scale of the built environment, the principal idea behind this invitation for an annual gathering of architects was a third dimension. "To create the sense of the built environment, we wanted the invitation brochure to take on a 3-D form," says art director MaeLin Levine. "The San Diego environment is built from elements found in the area: water, existing architecture, art, culture and, most important, the human element. The viewer receives the piece flattened and is invited to pop it into the shadow box form."

PILLSBURY WINTHROP FIRM BROCHURE ▶

[STUDIO] Greenfield/Belser
[ART DIRECTOR] Burkey Belser
[DESIGNER] Charlyne Fabi
[CLIENT] Pillsbury Winthrop
[CLIENT'S PRODUCT/SERVICE] Law firm
[PAPER] 100 lb. Signature Gloss Cover, 60 lb. Signature Gloss Cover
[COLORS] 4, match and process, plus 2 match and flood gloss aqueous
[SIZE] 8½" × 11" (22 × 28 cm)
[PRINT RUN] 15,000
[TYPE] MetaPlus Bold, MetaPlus Medium, MetaPlus Normal

"The design engages the reader in the new business universe, the marriage of business and technology," art director Burkey Belser says. "Fragmented shapes and repeated lines and arrows provide a skewed perspective—a world in which an ordinary experience like a cup of coffee can take on new meaning. The design communicates that a new day has come and invites the reader to partake in it."

>>>>>>> The new business universe

PILLSBURY WINTHROP LLP

After any revolution comes a moment when the future is yours to command.

In the revolution of business and technology, that moment is now. Innovation and zeal tempered by experience and strategy promise lasting achievements, vibrant companies and a global fusion of ideas and capital. The new business universe is a universe of opportunity. Welcome to the brave new day.

>>>>>>>> Wake up and smell the future

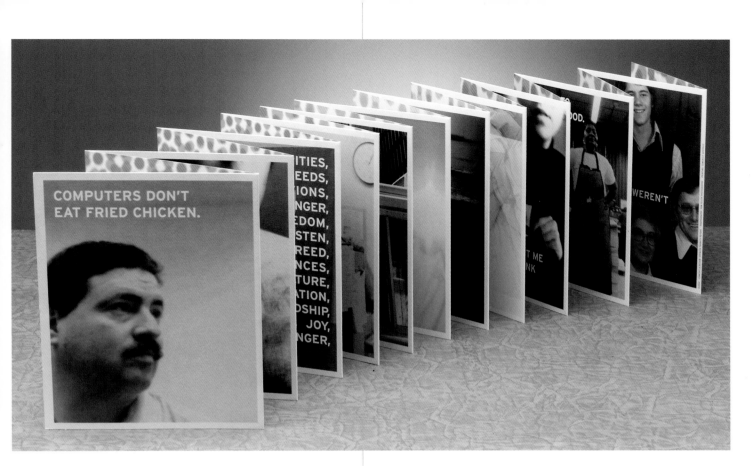

BRANDS LIVE HERE ▲

[STUDIO] Spencer Francey Peters
[ART DIRECTOR/DESIGNER] Barry Quinn
[PHOTOGRAPHER] Tom Feiler
[PAPER] Curious papers, POP SET
[COLORS] 4/1, process and 1 match
[SIZE] 5" × 6" (folded) , 9' × 6" opened
[PRINT RUN] 2,000
[TYPE] Interstate
[SPECIAL PRODUCTION TECHNIQUES] Stochastic printing on a strange pearl sheet
[SPECIAL FOLDS/FEATURES] It folds out to 9 feet long

*"I was really tired of all the hype that surrounded branding," says designer Barry Quinn.
"People kept trying to make what we do more complicated, when what we do is simplify.
We thought we would cut to the chase and tell it like it is."*

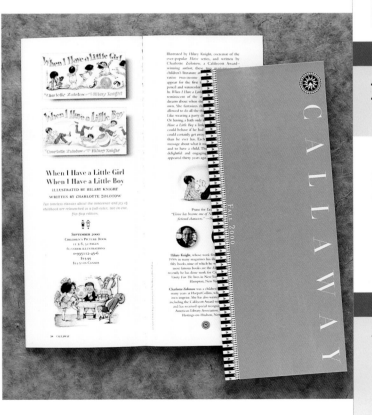

CALLAWAY 2000 CATALOG ◄

[STUDIO/DESIGNER] Motoko Hada
[ART DIRECTOR] Nicholas Callaway/Callaway Editions Inc.
[EDITOR] Christopher Steighner
[CLIENT] Callaway Editions Inc.
[CLIENT'S PRODUCT/SERVICE] Publishing
[COLORS] 2 match (cover) 4, process plus one match (interior)
[SIZE] 4.5" × 11.5" (11 × 29 cm)
[TYPE] Didot, Garamond, Deepdene, Bembo and Matrix, Mrs Eaves, Centaur, GriffithGothic,
Trajan, Felix, Futura, ETen, Mantinia, Ironwood, AdLib, DIN

*"We wanted it to be simple and distinctive," says designer Motoko Hada. "We made the
exterior look like a gift box or invitation card since it's very first catalog from the publish-
er. We made the interior very straightforward. The information is simple and clear, and
the slim elegant shape is a bonus since it's sales material."*

VISUALIZING THE BLUES INVITATION ▶

[STUDIO] Archer/Malmo
[ART DIRECTOR/DESIGNER] Gary Golightly
[PHOTOGRAPHER] Paul Buchanan
[CLIENT] The Dixon Gallery and Gardens
[CLIENT'S PRODUCT/SERVICE] Art museum
[PAPER] Acetate
[COLORS] 4, process
[PRINT RUN] 5,000
[TYPE] American Typewriter, Franklin Gothic Condensed
[SPECIAL COST-CUTTING TECHNIQUES] Digital printing on acetate

"The piece was an invitation to attend a special grand opening reception and view-
ing of 'Visualizing The Blues,' a photography exhibit featuring southern photogra-
phers and southern themes," explains designer Gary Golightly. "The Dixon
Gallery and Gardens had never mounted a photography exhibit, so to instantly
deliver the message that this was something unique for the Dixon, we made the
invitation resemble a negative of one of the more striking photographs in the
exhibit. The event particulars were designed to look like archive information on a
perforated catalog tag placed on top of the photo."

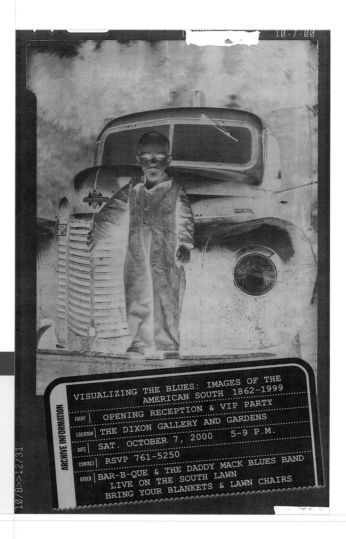

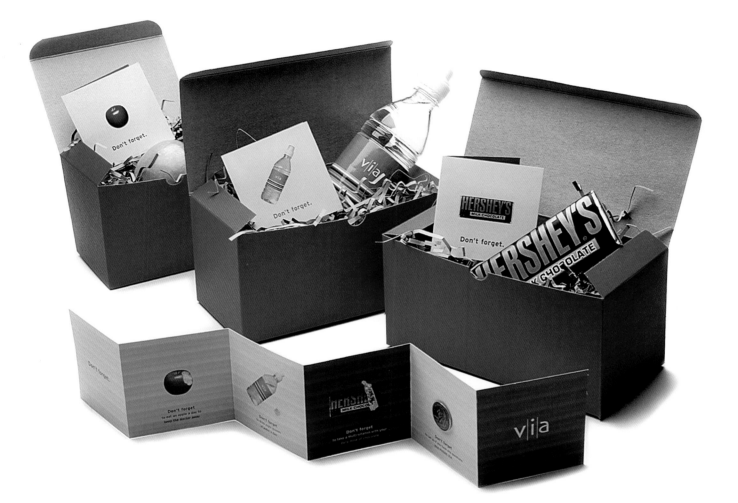

DON'T FORGET ▲

[STUDIO] Williams and House
[ART DIRECTOR] Pam Williams
[DESIGNER] Fred Schaub, Fred Schaub Design,
 Oxford, CT
[CLIENT] Via Papers
[CLIENT'S PRODUCT/SERVICE] Paper company

"Via Papers was moving its customer service operation. All of the phone numbers were changing. They couldn't afford to miss one telephone call for an order," explain the designers. "Before the client 'flipped the switch,' we sent a series of mailings to the customer service reps at paper merchants (distributors) nationwide to remind them that the phone numbers would change and when. They received a total of three hand-assembled dimensional mailings, followed by a small printed piece. It worked! The program was so successful, it has become a model 'best practice' for International Paper."

AFTA "ARTWORKS" CONVENTION SERIES ▶

[STUDIO] Fuszion Collaborative
[ART DIRECTOR] John Foster
[DESIGNER] Christian Baldo
[CLIENT] Americans for the Arts
[CLIENT'S PRODUCT/SERVICE] Nonprofit organization dedicated to advancing the arts
[PAPER] Strobe, Matrix
[COLORS] 4/4, process
[TYPE] Gill Sans, Garage Gothic, Antique Condensed, Birch, Blackoak
[SPECIAL TYPE TECHNIQUE] The copy was roughened and pulled in a number of ways before reconstruction into poster formats.
[SPECIAL PRODUCTION TECHNIQUES] Custom dyes for the folder pockets; die cuts of record holes for forty-fives and guitars adorn some covers; shorter bind-in registration form

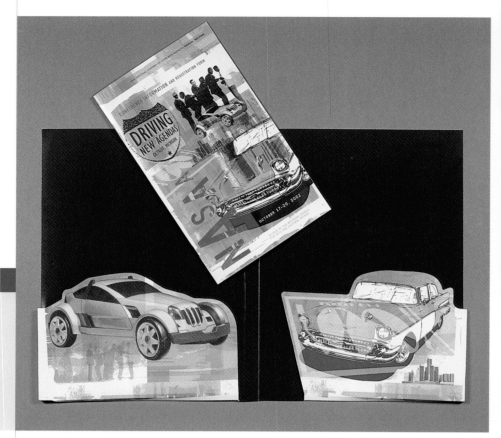

"Generating excitement for a convention in a small city not on the coasts can be very challenging," art director John Foster explains. "Nashville has a lot of charm, but there's just no getting around its title, Music City USA. So we couldn't help but go for it. The world-famous work of Hatch Show Print seemed to encapsulate the merging of art and music in Nashville and served as the jumping-off point for our mock posters."

HILLBILLY HOEDOWN HANKY ▶

[STUDIO] Chris Rooney Studio
[ART DIRECTOR/DESIGNER] Chris Rooney
[ILLUSTRATOR] Chris Rooney
[CLIENT] Young & Rubicam
[CLIENT'S PRODUCT/SERVICE] Advertising agency
[COLORS] 1 match, white silkscreening on a red bandanna
[SIZE] 21" × 21" (53 × 53 cm)
[PRINT RUN] 200
[COST PER UNIT] About $3.00
[TYPE] Karton, Garage Gothic, Frankie, Akzidenz Grotesk
[SPECIAL FOLDS/FEATURES] The Hillbilly Hoedown Hanky could act as a kerchief to protect from the sun, a bib when participating in the pie eatin' contest, a net for the egg toss, or when wet, a great towel snapper to whip unsuspecting co-workers on the behind.

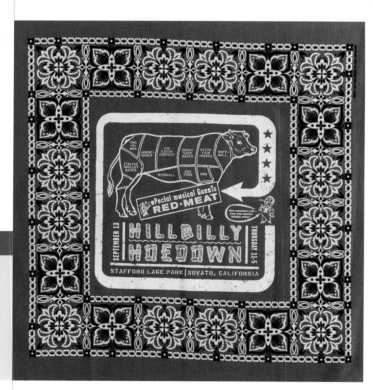

"The theme of the company picnic was Hillbilly Hoedown so it seemed only appropriate that the design be influenced by vintage country and western posters," remarks designer Chris Rooney. "Since it was an invitation for an outdoor event on a hot late summer day in the country, a bandanna seemed like the perfect way to accessorize and promote the festivities."

NEBRASKA WESLEYAN PRESENTS ▼

[STUDIO] Archrival
[ART DIRECTORS/DESIGNERS] Clint! Runge, Randall Myers
[CLIENT] Nebraska Wesleyan University, Theatre Department
[CLIENT'S PRODUCT/SERVICE] Theatre shows for the public
[COLORS] 3, match
[SIZE] 5" × 5" (13 × 13 cm)
[PRINT RUN] 1000
[SPECIAL TYPE TECHNIQUES] "We kept each page of type white in nature but complex with the number of types. We found that the eclectic mix of type nicely mirrored the individuals learning how to work together on a stage," says Clint! Runge.

"We found that most theater brochures tend to miss the point of a university theater as a place for young, vibrant and experimental actors and actresses. We wanted to conceptually present the information of the upcoming season's shows just as the student actors do on stage," says designer Clint! Runge.

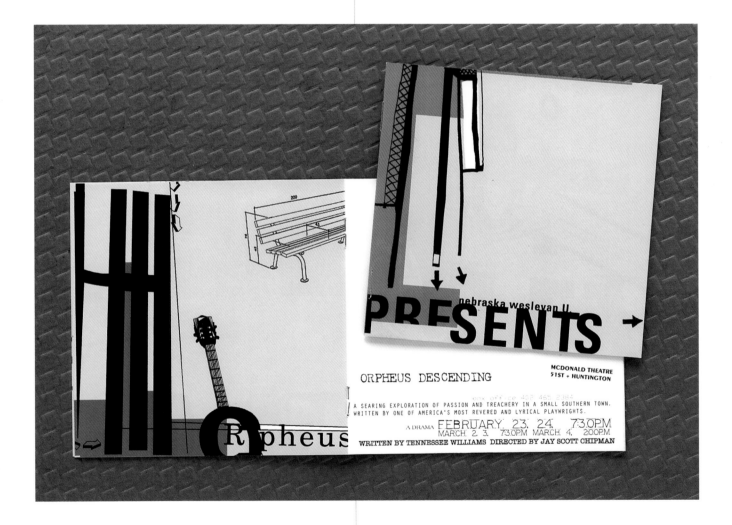

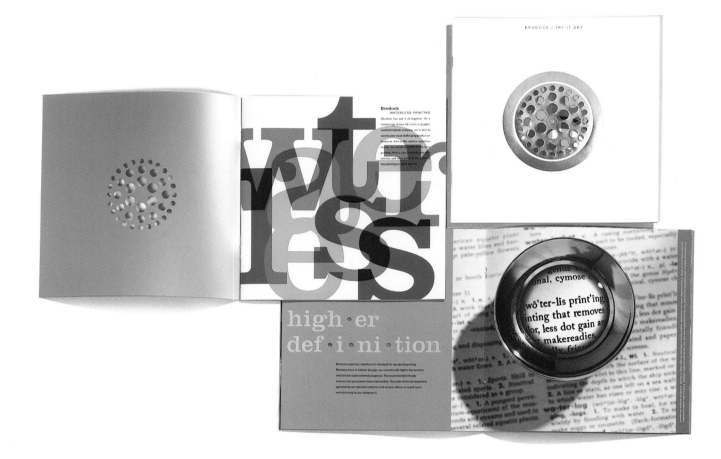

BRODOCK PRESS
BROCHURE ▲

[STUDIO] Platinum Design Inc.
[ART DIRECTORS/DESIGNERS] Mike Joyce, Kelly Hogg
[PHOTOGRAPHER] Bart Gorin
[CLIENT] Brodock Press
[CLIENT'S PRODUCT/SERVICE] High-quality printing
[PAPER] 100 lb. Centura Dull cover, 100 lb. Centura
 Gloss text, 17 lb. UV UltraRadian White, 100 lb.
 Mohawk Superfine Ultra White Smooth text
[COLORS] 6, process; plus fluorescent and metallic
[SIZE] 9" × 9" (23 × 23 cm)
[TYPE] Akzidenz Grotesk
[SPECIAL TYPE TECHNIQUE] Overlapping letters and
 colors
[SPECIAL PRODUCTION TECHNIQUE] Overprinting
 type; die cuts
[SPECIAL FEATURES] Vellum overlays, hand-applied
 stickers

"The goal was to create something visually stimulating and unique while maintaining readability and delivering the message," designer Mike Joyce says.

228

WEDDING ANNOUNCEMENT ▼

[STUDIO] William Pflipsen
[ART DIRECTOR] William Pflipsen
[DESIGNERS] William Pflipsen, Julie Manthe
[PAPER] Wausau Royal Fiber
[COLORS] 4-color process (letterpress) plus black (container)
[SIZE] 4" × 2⅝" (10 × 7cm) (cards)
[PRINT RUN] 200
[COST PER UNIT] $3.00
[TYPE] Trade Gothic
[SPECIAL PRODUCTION TECHNIQUES] Letterpress on plastic
[SPECIAL FEATURE] "It's inflatable!" says designer William Pflipsen.

"We wanted to do a non-traditional invitation," says Pflipsen, "Something that would grab your attention."

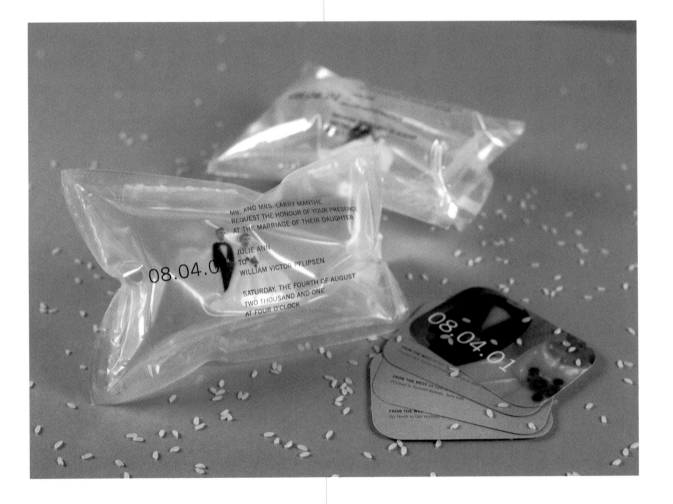

CE SOFTWARE "POODLE" CAMPAIGN ▶

[STUDIO] Planet Design Company
[ART DIRECTOR] Kevin Wade
[DESIGNER] Martha Graettinger
[CLIENT'S PRODUCT/SERVICE] CE Software/e-mail
 software
[PAPER] Fox River Confetti
[COLORS] 4, match
[SIZE] 8" × 5" (20 cm × 13 cm)
[SPECIAL FEATURES] The graphic design features a dot-
 screen image of a rubber poodle which was included in
 the promo as a tongue-in-cheek incentive.

*"Through clever copywriting and the use of bold type and
color,"* says designer Martha Graettinger, *"we attempted
to grab the attention of resellers of e-mail software and
set them up for a special sales promotion."*

QuickMail/CE Software, Inc., P.O. Box 65580, 1801 Industrial Circle, West Des Moines, IA 50265

Attention valued creative person: Your rubber poodle has arrived.

CONTENTS: ONE RUBBER POODLE. SOME SETTLING MAY OCCUR DURING SHIPPING.

NEWSPAPER CONFERENCE INVITATION ▼

[STUDIO] Wink
[ART DIRECTORS] Scott Thares, Richard Boynton
[DESIGNER] Scott Thares
[CLIENT] Target
[CLIENT'S PRODUCT/SERVICE] Retail
[TYPE] Helvetica, Clarendon, Trade Gothi
[SPECIAL PRODUCTION TECHNIQUE] Die cut

"This invitation to a newspaper conference is an effort to increase attendance of an annual Target-sponsored event," art director Scott Thares says.

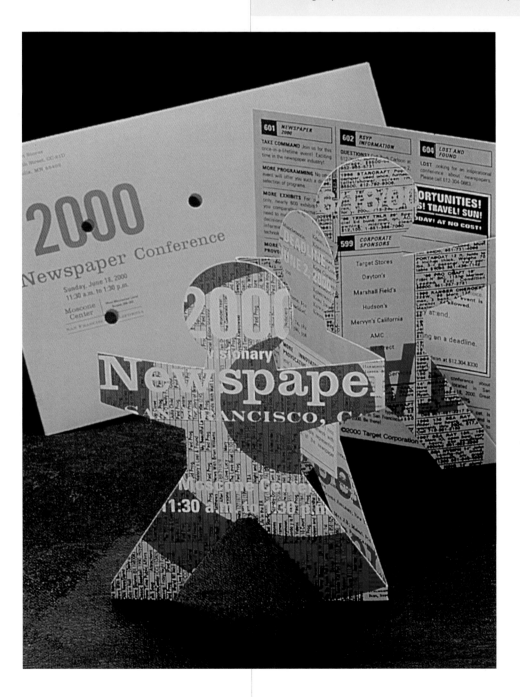

TITAS BROCHURE ▶ ▼

[STUDIO] Group Baronet
[ART DIRECTOR] Meta Newhouse
[DESIGNER] Bronson Ma
[CLIENT] Titas
[CLIENT'S PRODUCT/SERVICE] Performing arts
[PAPER] 80 lb. text
[COLORS] 3, match
[SIZE] 7" × 12" (18 × 30 cm)
[PRINT RUN] 10,000
[TYPE] Trade Gothic, New Baskerville
[SPECIAL PRODUCTION TECHNIQUE] Use of three spot colors and overall dull varnish to protect the piece
[SPECIAL FOLDS/FEATURES] Pages on the right-hand side unfold to reveal more info and a schedule.
[SPECIAL COST-CUTTING TECHNIQUES] Black-and-white photography instead of color; usage of three spot colors

"Using type and having it interact with photography, the piece expresses the energy and excitement of the performances Titas is bringing to the audience," says designer Bronson Ma.

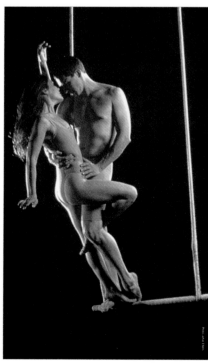

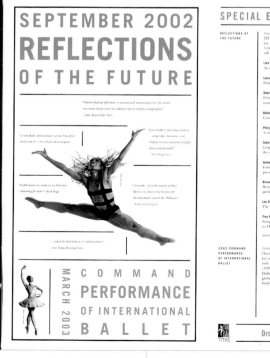

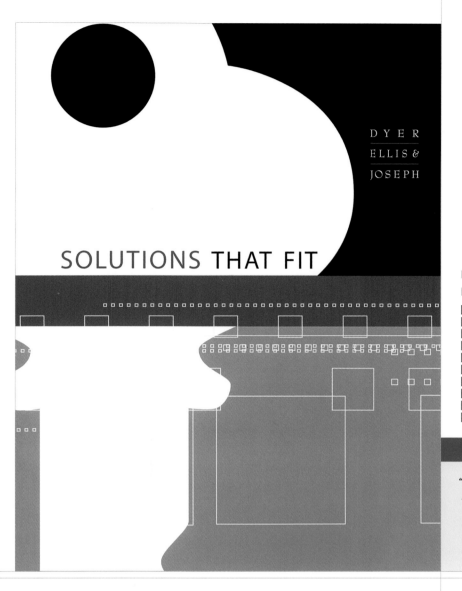

SOLUTIONS THAT FIT

DYER
ELLIS &
JOSEPH

DYER ELLIS & JOSEPH
BUSINESS BROCHURE ◀ ▼

[STUDIO] Greenfield/Belser
[ART DIRECTOR] Burkey Belser
[DESIGNER] Tom Cameron
[CLIENT] Dyer Ellis & Joseph
[CLIENT'S PRODUCT/SERVICE] Law firm
[PAPER] 100 lb. McCoy Silk cover
[COLORS] 7, match and process
[SIZE] 8½" × 11" (22 × 28 cm)
[PRINT RUN] 5,000
[TYPE] CB Helvetica Condensed, Bernhard Modern

*"The 'eye of the storm' spread conveys how Dyer Ellis &
Joseph protects clients who are in deep trouble," art
director Burkey Belser says. "At first glance, the spread
appears flat, but one soon sees the complexity of the
multilayered illustration, an apt metaphor for the experi-
ence and nuanced perspective of these attorneys."*

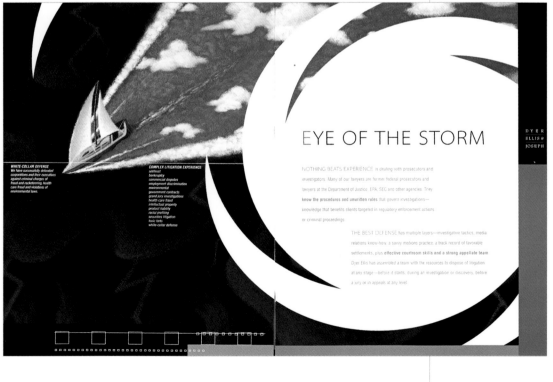

EYE OF THE STORM

DYER
ELLIS &
JOSEPH

WHITE-COLLAR DEFENSE
We have successfully defended
corporations and their executives
against criminal charges of
fraud and racketeering, health
care fraud and violations of
environmental laws.

COMPLEX LITIGATION EXPERIENCE
antitrust
bankruptcy
commercial disputes
employment discrimination
environmental
government contracts
grand jury investigations
health care fraud
intellectual property
product liability
racial profiling
securities litigation
toxic torts
white-collar defense

NOTHING BEATS EXPERIENCE in dealing with prosecutors and
investigators. Many of our lawyers are former federal prosecutors and
lawyers at the Department of Justice, EPA, SEC and other agencies. They
know the procedures and unwritten rules that govern investigations—
knowledge that benefits clients targeted in regulatory-enforcement actions
or criminal proceedings.

THE BEST DEFENSE has multiple layers—investigative tactics, media
relations know-how, a savvy motions practice, a track record of favorable
settlements, plus **effective courtroom skills and a strong appellate team**.
Dyer Ellis has assembled a team with the resources to dispose of litigation
at any stage—before it starts, during an investigation or discovery, before
a jury or in appeals at any level.

NATURAL HISTORIES ▶ ▼

[STUDIO] Pentagram Design
[ART DIRECTOR] DJ Stout
[DESIGNERS] DJ Stout, Julie Savasky
[PHOTOGRAPHER] Keith Carter
[CLIENT] The Museum of Southeast Texas, Beaumont Texas
[CLIENT'S PRODUCT/SERVICE] Photography Exhibition
[PAPER] Scheufelen Job Paralux
[COLORS] 2
[SPECIAL FOLDS/FEATURES] "Because the photographer's
 pictures are always shot in a square format and usually
 include a rough photo border, we made the shape of the
 opened exhibit catalog a square," says art director DJ
 Stout. "When it folds up, however, it is the long vertical
 shape of half of a square. This made for interesting full-
 bleed spreads with the photo borders cropped off and
 for long vertical-shaped pages with one or two square
 images on them."
[SPECIAL COST-CUTTING TECHNIQUES] 2-color printing

*According to art director DJ Stout, the piece was
influenced by the typography used for plate titles in old
illustrated scientific journals. "The shape and format was
influenced by the fact that I had designed seven books for
this photographer and all of them ended up being square
books," he says. "For this catalog I wanted to do some-
thing different with his square format photographs."*

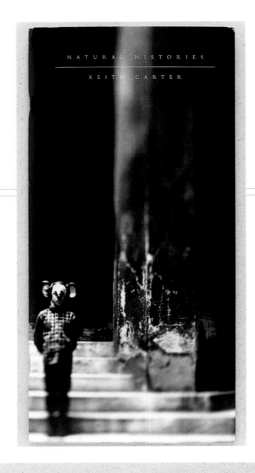

The biggest challenge
always is convincing the
client to think differently. You
try to convince them to see
your way by working harder
than they do.
DJ STOUT

234

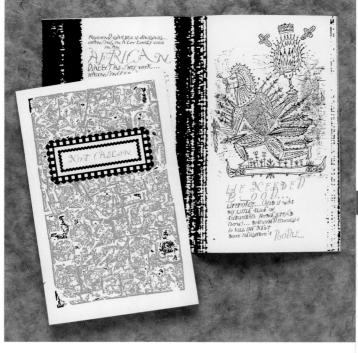

NOT CASLON: A FONT SPECIMEN BOOKLET ◄

[STUDIO] Mark Andresen Illustration
[ART DIRECTOR/DESIGNER] Mark Andresen
[ILLUSTRATOR] Mark Andresen
[CLIENT] Emigre
[CLIENT'S PRODUCT/SERVICE] Type Foundry
[PAPER] Reincarnation Matte (100% recycled/50% post-consumer waste; processed, chlorine free)
[COLORS] 2, match
[SIZE] 5¼" × 8¼" (13 × 21 cm)
[PRINT RUN] 52,000
[COST PER UNIT] $.12 (printing only)
[TYPE] Not Caslon (designed by Mark Andresen)

"Rudy VanderLans at Emigre asked me to produce a type specimen booklet of our font Not Caslon," says designer Mark Andresen. "He was starting a series of type specimen booklets that illuminate the creativity involved in making Emigre fonts. He said 'Do something New Orleans-y,' so I did. The concept is a short ghost story about a real incident."

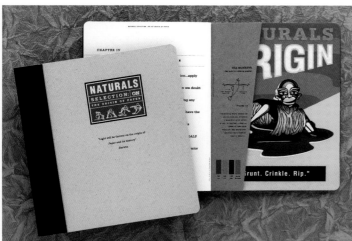

DOMTAR NATURALS PROMOTIONAL PIECE ◄

[STUDIO] Bradbury Branding & Design Inc.
[ART DIRECTOR/DESIGNER] Catharine Bradbury
[ILLUSTRATOR] Dean Bartsch
[PHOTOGRAPHER] Paul Austring/Mad Cow Studio Inc.
[CLIENT] Domtar Communication Papers
[PAPER] Domtar Naturals
[COLORS] 6, match
[SIZE] 8½" × 9" (22 × 23 cm)
[PRINT RUN] 3,000 French, 15,000 English
[TYPE] Egyptienne, Clarendon, Helvetica Condensed
[SPECIAL PRODUCTION TECHNIQUES] Side-stitched wrap cover, rounded corner die cut

"The inspiration was Charles Darwin's theory of natural selection," say the designers at Bradbury Branding & Design Inc. "We thought it would be fun to invite people to 'select' the Domtar Naturals line above other papers. It was designed as a scientific textbook that traces the evolution of the superior Naturals line. The text was adapted directly from Darwin's work, On the Origin of Species.*"*

IMAGE BANK CAPABILITIES BROCHURE ▶

[STUDIO] Sibley Peteet Design
[ART DIRECTOR/DESIGNER] David Beck
[ILLUSTRATORS] Various
[PHOTOGRAPHERS] Various
[COPYWRITER] Margie Bowles
[CLIENT'S PRODUCT/SERVICE] stock photography, illustration and film
[COLORS] 4, process plus 2 match
[SIZE] 12" × 8⅛" (31 × 21 cm), 24 pages
[PRINT RUN] 10,000 (first run)
[COST PER UNIT] $.85
[TYPE] Bodoni, Futura, Bernhard Modern
[SPECIAL PRODUCTION TECHNIQUES] Because The Image Bank is an international company, copies of the book needed to be printed in six languages. "We let this influence our layout by placing all of the copy on uncoated short sheets that would run through the book," art director/designer David Beck explains. "This way print production would be easier, because only that uncoated press form would have to be altered to accommodate the type changes. The majority of the book—with all the color images—would be universal to all versions. All this set up a nice contrast between the different paper stocks and different image styles."
[SPECIAL FOLDS/FEATURES] Various graphic die cuts, including a face in profile and a movie ticket, enhance the concept. The back cover folds in to reveal three perforated, full-color postcards.
[SPECIAL COST-CUTTING TECHNIQUES] "We were able to print in Hong Kong, where The Image Bank prints its big catalogs," says Beck, "so it cost about one-third of what it would have cost here."

"The Image Bank wanted to do a piece that shows innovative use of their stock photography and illustration— not a 'hard sell' piece," says art director David Beck. "Using some unexpected juxtapositions, we helped show some of the depth and breadth of their vast collection of images."

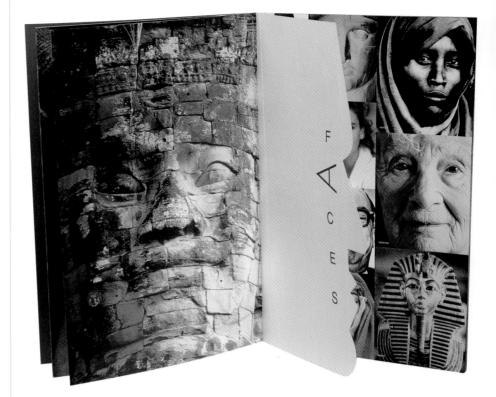

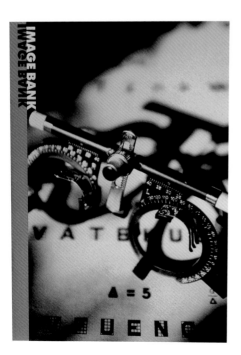

FOUNDATIONS PRESS SIX COLORS ◄

[STUDIO] Louey/Rubino Design Group Inc.
[ART DIRECTOR] Robert Louey
[DESIGNERS] Robert Louey, Alex Chao
[ILLUSTRATOR] Alex Chao
[PHOTOGRAPHERS] Various
[CLIENT] Foundation Press
[CLIENT'S PRODUCT/SERVICE] Lithography
[PAPER] Onion Skin over Industrial Chipboard (cover), 100#
Mohawk Superfine (text)
[COLORS] 4-color process plus 2 match colors
[SIZE] 4" × 5½" (10 × 14 cm)
[PRINT RUN] 5,000
[TYPE] Janson, Trade Gothic
[SPECIAL TYPE TECHNIQUES] Case binding, special mix
colors
[SPECIAL FOLDS/FEATURES] The dust jacket, made of
onion skin, adds an enhanced sense of texture and
depth.
[SPECIAL COST-CUTTING TECHNIQUES] Keeping the book
a smaller size makes the book more intimate and allows
the production of a larger quantity using less paper.

Art director Robert Louey says the inspiration was "the cultural use of color."

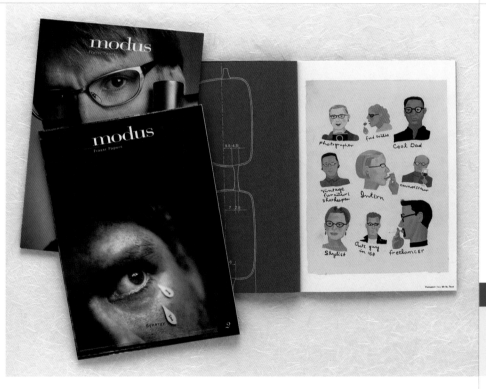

FRASER PAPERS SWATCHBOOKS ◄

[STUDIO] Douglas Joseph Partners
[DESIGNERS] Scott Lambert, Susan Foti, Mark Schwartz
[ILLUSTRATORS] Various (inside demo pages)
[PHOTOGRAPHERS] Neal Brown (covers), various
[CLIENT] Fraser Papers Inc.
[CLIENT'S PRODUCT/SERVICE] Paper manufacturer
[PAPER] Fraser Papers grades: Fraser Brights, Genesis, Glac-
ier 92 Opaque, Glacier 95 Opaque, Halopaque, Magna
Carta, Mosaic, Outback, Pegasus, Torchglow Opaque,
Synergy, Passport, Worx
[COLORS] 4-color process plus 2 match colors and spot dull
varnish
[SIZE] 6" × 9" (15 × 23 cm)
[PRINT RUN] 700,000 (for all books)
[TYPE] Bauer Bodoni, Univers 45, 55, 65, Zaph Dingbats
[SPECIAL PRODUCTION TECHNIQUES] Gatefolds (covers);
hand-bound, semiconcealed Wire-o; some engraving, foil
stamping and embossing

"The overriding concept was to create swatchbooks that were easy to use and presented the paper in a sophisti-cated manner," explains designer Doug Joseph.

"DOGGIE BAG" WEB SITE
ANNOUNCEMENT ▶

[STUDIO] Red Canoe
[ART DIRECTOR] Deb Koch
[DESIGNER] Caroline Kavanagh
[CLIENT] *The Bark* magazine
[CLIENT'S PRODUCT/SERVICE] Literary arts dog-lover
 magazine
[PAPER] Anti static bag, Epson ink-jet matte
[SIZE] 8" × 6" × 3" (20 × 15 × 8cm)(overall package)
[PRINT RUN] 150
[TYPE] Oakland Six (Zuzana Licko)
[SPECIAL PRODUCTION TECHNIQUES] "The labels were
 printed from an ink-jet printer and spray mounted to seal
 the antistatic bags," designer Caroline Kavanagh
 explains. "For the date-released field on the label, we
 used an old-fashioned ink pad and stamp with the actual
 launch date of the site. We hand punched 'breathable'
 holes. The boxes were wrapped with personalized
 addressing designed to properly fit the boxes."
[SPECIAL COST-CUTTING TECHNIQUE] Packaging for this
 project was done by hand and via in-house ink-jet print-
 ing by Red Canoe; toys were purchased directly from the
 manufacturer after the prototype design stage.

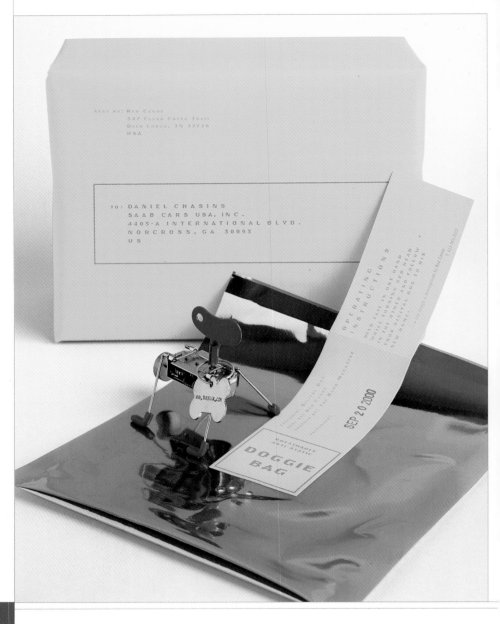

*"This promotion needed to announce the 'unleashing' of
The Bark's newly redesigned and developed web site,"
art director Deb Koch says. "We packaged the windup
doggies in labeled antistatic breathable doggie bags,
complete with air holes. The unwrapping process, a bit
mysterious, was part of the design concept—an experi-
ence. The pseudo-industrial label that closed the bag
used as few words as possible to replicate the feel of a
shipping label. The overall concept was to utilize this
surprisingly warm-fuzzy personality to bridge the gap
between the 'connected' World Wide Web with the real-
world connection of humans and dogs."*

238

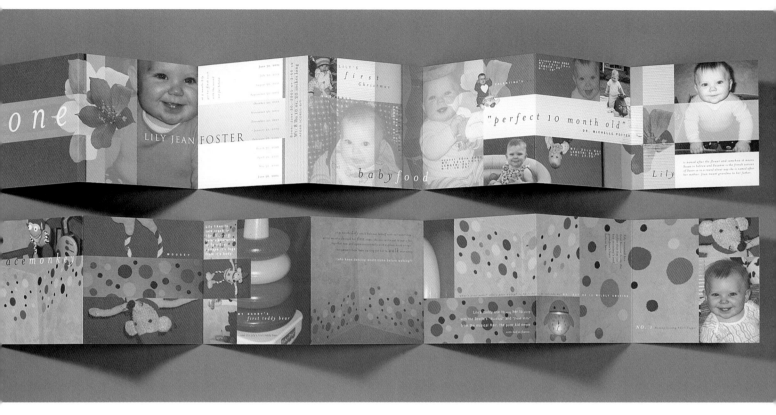

I'M ONE! ▲

[STUDIO/DESIGNER] John Foster
[PHOTOGRAPHERS] John and Suzanne Foster
[CLIENT] Lily Foster
[CLIENT'S PRODUCT/SERVICE] Most of her day is
 spent being ridiculously cute, but small percentage
 of gross output in deliverables known as "dirty dia-
 pers."
[PAPER] Coronado
[COLORS] 4/4, process
[SIZE] 5" × 5" (13 × 13 cm), 2 pages when unfolded
[PRINT RUN] 200
[COST PER UNIT] $.25 for envelopes plus postage
[TYPE] Trajan, Mrs Eaves, News Gothic
[SPECIAL FOLDS/FEATURES] Letterpress score for
 reverse accordion fold
[SPECIAL COST-CUTTING TECHNIQUES] "The piece
 was designed to fit on the press sheet with a job
 that I knew was reprinting with minor corrections
 and had previously had room on the sheet,"
 designer John Foster says.

*"I had been a bad, bad Dad and had neglected
to finish a baby announcement for my daugh-
ter despite the pleas and pressure from my
family and design peers to see what I would
come up with," says designer John Foster. "As
the first year flew by, I wanted to capture her
growth and personality and have a keepsake
for her to remember my undying devotion
to her through her teens when I will undoubt-
edly terrorize her prospective boyfriends. I also
had too many great photos to share with fami-
ly and friends now that I was sure that she
would be pretty like her mother and not afflict-
ed with the Billy Joel's daughter disease. The
front side shows her in various stages of
growth as she just gets bigger and bigger. The
back portion highlights her favorite toy, and
her nursery serves as constant inspiration, in
particular showcasing her painstakingly paint-
ed walls that took me several days to complete
as opposed to the hours I had estimated."*

HAIRFORCE - MOBILE HAIRDRESSERS ▶

[STUDIO] Nina Pavicsits
[DESIGNER] Nina Pavicsits
[PHOTOGRAPHER] Nina Pavicsits
[CLIENT] Hairforce - Mobile Hairdressers
[CLIENT'S PRODUCT/SERVICE] Mobile hairdressers
[SIZE] 16½" × 23½" (42 × 59 cm)"
[TYPE] Officina Sans, TrekkerTwo

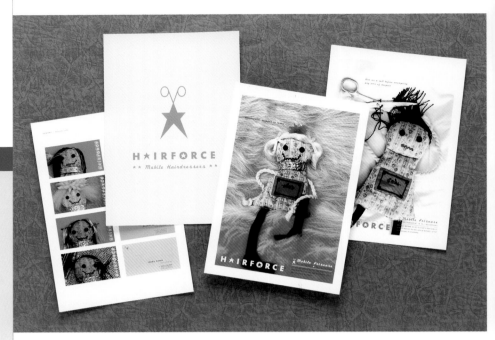

"Hairforce - Mobile Hairdressers is a comprehensive communication concept for mobile hairdressers which includes corporate identity, packaging, complementary postcards, T-shirts and poster campaign," says designer Nina Pavicsits. "It developed from a fictional thesis project into a soon-to-be realized campaign. Instead of showing happy people with beautiful hair, I chose to get people to identify themselves with the frustrated doll obviously having a bad hair day. The doll is nearly in despair about her hair until finally a mobile hairdresser shows up and eventually leaves behind a happy, thoroughly beautified creature. The aim of the campaign is to create sympathy in order to lose the fear of calling a hairdresser to your house."

STRATHMORE ONE-TO-ONE CASE STUDY: VOLVO ▶

[STUDIO NAME] Williams and House
[ART DIRECTOR] Pam Williams
[DESIGNER] Peter Good/Cummings & Good
[CLIENT] Strathmore Paper

The inspiration was "to create the first installment to a new series for Strathmore Papers to show successful one-to-one marketing campaigns," explain the designers. "Over time, the series is intended to inform designers of CRM marketing techniques, as well as keep the Strathmore brand top of mind."

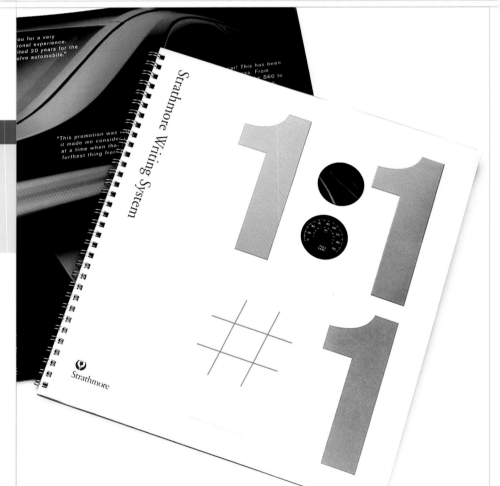

There are great designs all around you, not just those of the great designers and well-designed books or publications. Everything is designed by someone or nature. Think design all the time. Dream design when you go to sleep. And don't forget to read all the time—and not just design books.

TAY CHIN THIAM

CLAYTIVITY 2000 ▼

[STUDIO] Epigram
[ART DIRECTOR] Edmund Wee
[DESIGNER] Tay Chin Thiam
[PHOTOGRAPHERS] Lisa Anne Chong (artist portraits), William Oh (ceramic works)
[CLIENT] Studio 106
[CLIENT'S PRODUCT/SERVICE] Ceramic art works
[PAPER] 260 gsm MattArt Card (packaging), 360 gsm MattArt Card (cards)
[COLORS] 4, process plus 1 match
[SIZE] 4¾" × 6¼" (12 × 16cm)
[PRINT RUN] 1,000 sets
[COST PER UNIT] About $5.00
[TYPE] Univers (body text), OCRB (captions, running head, dimensions, page numbers, materials) Stencil Sans (main titles and main artist names)
[SPECIAL PRODUCTION TECHNIQUES] matte lamination
[SPECIAL FOLDS/FEATURES] rounded, die-cut corners

"We realized there was no need for a logical progression of the art pieces, which meant the catalog need not be in a book form," says designer Tay Chin Thiam. "This led us to think along the line of separate cards and freed us from doing it in the usual book size. A playing-cards concept helped cut costs because of its smaller size and the fact that we printed of the same pattern on one side.

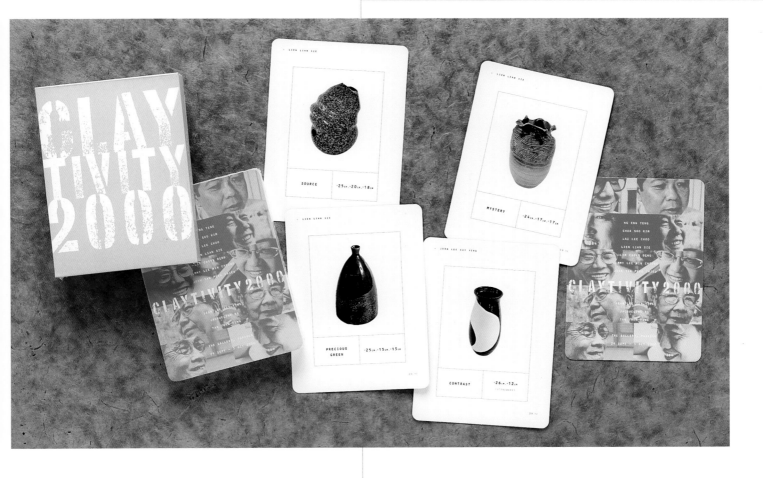

FOUND AND ASSEMBLED IN ALASKA ▶

[STUDIO] Decker Art Services
[ART DIRECTOR] Julie Decker
[DESIGNER] Julie Decker
[ILLUSTRATOR] Don Mohr
[PHOTOGRAPHERS] Chris Arend, Kevin Smith,
 James Barker

[CLIENT] Alaska State Museum
[COLORS] 4, process
[SIZE] 10" × 10" (25 × 25 cm)
[PRINT RUN] 1000
[COST PER UNIT] $50
[TYPE] Palatino (text); Charcoal (headings)

[SPECIAL COST-CUTTING TECHNIQUES] All design
work and typesetting was done in-house
[INSPIRATION/CONCEPT] "Art was made from
found objects, art catalogs, and art mono-
graphs," says designer Julie Decker.

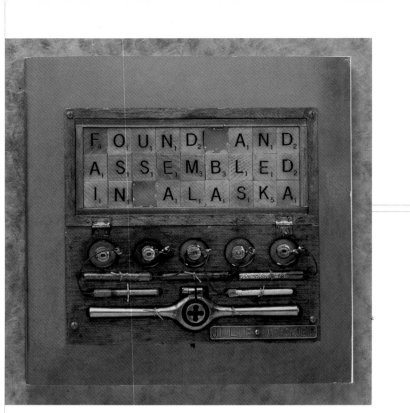

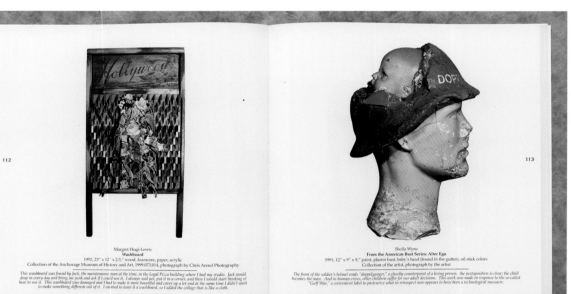

112

Margret Hugi-Lewis
Washboard
1992, 23" x 12" x 2.5," wood, foamcore, paper, acrylic
Collection of the Anchorage Museum of History and Art, 1999.073.014, photograph by Chris Arend Photography

*This washboard was found by Jack, the maintenance man at the time, in the Legal Pizza building where I had my studio. Jack would
drop in every day and bring me junk and ask if I could use it. I always said yes, put it in a corner, and then I would start thinking of
how to use it. This washboard was damaged and I had to make it more beautiful and cover up a lot and at the same time I didn't want
to make something different out of it. I wanted to leave it a washboard, so I added the collage that is like a cloth.*

113

Sheila Wyne
From the American Bust Series: Alter Ego
1991, 12" x 9" x 9," paint, plaster bust, baby's head (found in the gutter), oil stick colors
Collection of the artist, photograph by the artist

*The front of the soldier's helmet reads "doppelganger," a ghastly counterpoint of a living person, the juxtaposition is clear; the child
becomes the man. And in human crises, other children suffer for our adult decisions. This work was made in response to the so-called
"Gulf War," a convenient label to pasteurize what in retrospect now appears to have been a technological massacre.*

Don't always trust the computer screen. I
rely heavily on printed proofs to see if what
I think I'm communicating and presenting
on my screen is truly what I'm presenting in
the final product.

JULIE DECKER

242

11505TX71 ◀ ▼

[STUDIO] Pentagram Design, Austin
[ART DIRECTOR] Lowell Williams
[DESIGNERS] Julie Savasky, Wendy Carnegie
[ILLUSTRATORS] Julie Savasky, Wendy Carnegie
[PHOTOGRAPHER] Bill Kennedy
[CLIENT] CCNG Development
[CLIENT'S PRODUCT/SERVICE] Promotional piece for a
 new housing development
[PAPER] Coronado
[COLORS] 3, tri-tone photographs
[SIZE] 13" × 19" (33 × 48 cm)
[PRINT RUN] 10,000
[TYPE] Franklin Gothic
[SPECIAL PRODUCTION TECHNIQUES] Merging several
 different types of maps into one graphic
[SPECIAL COST-CUTTING TECHNIQUES] Additional photo
 pages were printed with the first run. As the develop-
 ment grew and changed, the maps would be updated
 and reprinted, but the photo pages would not have to be
 put back on press, just bound with the new maps.

*"The idea was to give the sales team a useful tool
that showed the phases of development, lots available
and projected scale of the residential development as
well as the town center and golf club," says designer
Julie Savasky.*

4TH ANNUAL WEBBY
AWARDS INVITATION ◀

[STUDIO] The Webby Awards
[ART DIRECTOR] Natalie Jeday
[CREATIVE DIRECTOR] Tiffany Shlain
[PHOTOGRAPHER] Jack Gescheidt
[CLIENT'S PRODUCT/SERVICE] Internet awards
[COLORS] 3
[SIZE] 4" × 4"
[PRINT RUN] 3,000
[COST PER UNIT] $5.00

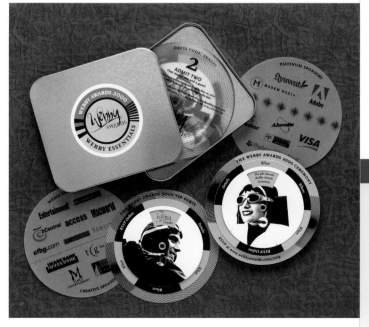

*"I had just quit smoking and my husband bought me an
aromatherapy wheel that suggested which scent to
smell to calm my nerves," says creative director Tiffany
Shlain. "It was great, and I loved the old-fashioned way
that wheels display different levels of information."*

it's been a **rough** year

may 2002

Founded in 1972, Frankfurt Balkind Partners is an integrated communications agency that provides brand strategy, identity, web development, advertising and marketing communications services to clients both small and large. With offices in New York and Los Angeles, Frankfurt Balkind's clients range from Global 2500 companies including Pitney Bowes, AOL Time Warner, Schering-Plough, and Bear Stearns to startup ventures like Tapestria, About.com, MarketAccess, and Volaris to nonprofit institutions including Fordham University, The Guggenheim Museum, The Getty Center and The Aspen Institute.

Aubrey Balkind, CEO

Starting his career as a CPA and a management consultant with Arthur Young & Co., Aubrey Balkind is the founder and strategist who shaped the unique inter-disciplinary makeup of Frankfurt Balkind. Today, he is recognized as a visionary in the world of communication and business. He is a frequent speaker at conferences across the U.S. and abroad, and is often cited in the press on issues relating to the use of communications to increase demand and grow businesses. A native of South Africa, Balkind received his MBA from Columbia University and was recently honored with Ernst & Young's "Entrepreneur of the Year" Award.

Kent Hunter, Executive Creative Director

Kent Hunter's mission at Frankfurt Balkind is to bring the strategic to life through design. His award-winning work ranges from traditional print design to new and emerging technologies. A native Texan, Hunter moved to New York from Nashville 15 years ago and has served on the board of the New York chapter of the AIGA. He frequently judges shows, lectures and is known to collect these pieces of cardboard that come in Chinese takeout.

BY PAUL JEROE

ROUGH ▲

[STUDIO] Group Baronet
[ART DIRECTORS] Meta Newhouse, Willie Baronet
[DESIGNERS] Bronson Ma, Brad Galles, Paul Booth, Mike Thompson
[PHOTOGRAPHERS] Andy Bennet, Paul Booth, Tom Hussey, Tadd Myers
[ILLUSTRATORS] George Toomer, Brad Galles, Bronson Ma, Meta Newhouse, Mark Priddy, Mike Thompson
[CLIENT] Dallas Society of Visual Communicators
[PAPER] VIA Ultra Smooth Pure White 80 lb. cover
[COLORS] 8 plus overall stain varnish; match and process
[SIZE] 9½" × 7½" (24 × 19 cm)
[PRINT RUN] 2,500
[TYPE] Avenir, Trade Gothic LH, Ext
[SPECIAL PRODUCTION TECHNIQUE] Ultraviolet inks

"This is the last issue of Rough for the 2001–2002 season," says designer Bronson Ma. "The idea here was to reinforce how rough this past year has been by poking fun at it as well as seeing the positive side of it."

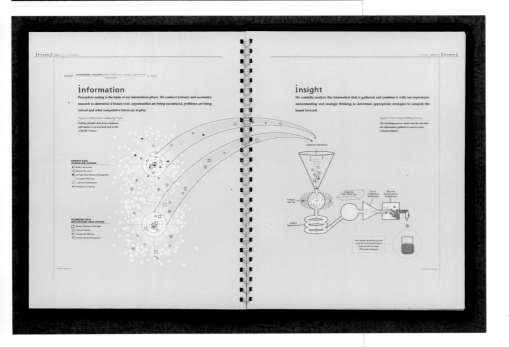

FORMULA PR CORPORATE PROMOTIONS BROCHURE ◄ ▼

[STUDIO] Tyler Blik Design
[ART DIRECTOR] Tyler Blik
[DESIGNER] Eric Vellozzi
[ILLUSTRATOR] Eric Vellozzi
[CLIENT] [formula] PR
[CLIENT'S PRODUCT/SERVICE] Public relations
[COLORS] 4 process plus 2 spot colors
[SIZE] 11½" × 15" (29 × 38 cm)
[PRINT RUN] 1,500
[COST PER UNIT] $8.00
[TYPE] Frutiger (body, headlines, subheads); Garamond (paragraph text)
[SPECIAL PRODUCTION TECHNIQUES] French folds; custom binding; metallic-like, plastic mailing envelope; custom stickers; embossing

"The new company name (:formula:) provided the design team with a rich metaphor of science and successful chemistry to promote this PR firm's brand message," says art director Tyler Blik. "The goal was to make the PR process more visual and more grounded in science, rather than the fuzzy, often dry marketing hype these firms typically present themselves with."

Come up with a concept that makes everything hang together. If you can't sell something as adding to the concept, don't do it. Know when to stop.
TYLER BLIK

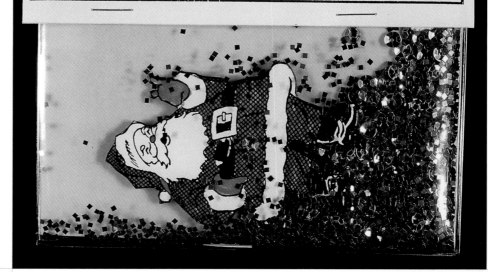

HAPPY FUCKIN' HOLIDAYS ▲

[DESIGNER] Michael Strassburger
[CLIENT] Warner Bros. Records
[INSPIRATION/CONCEPT] "This holiday greeting was a
 reaction to the endless politically correct, safe greeting
 cards," says designer Michael Strassburger.

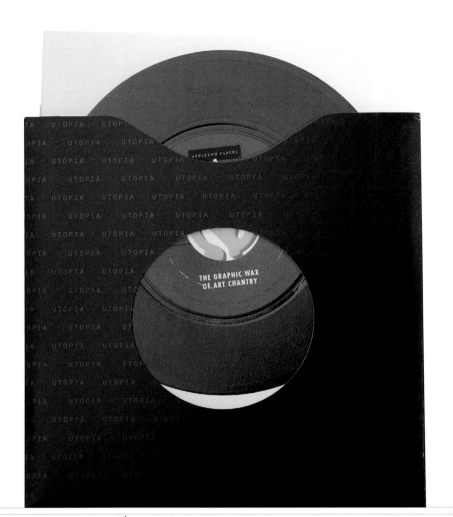

GRAPHIC WAX OF ART CHANTRY ◀

[STUDIO] Chantry/Sheehan
[ART DIRECTORS/DESIGNERS] Jamie Sheehan, Art Chantry
[PHOTOGRAPHER] Michels Studio
[CLIENT] Appleton Papers
[PAPER] Appleton Papers Utopia One dull cover and text gloss
[COLORS] 4, process plus 2 varnishes
[SIZE] 6¾" × 6¾" (17 × 17 cm)
[PRINT RUN] 15,000
[TYPE] Adobe Garamond (body), Copperplate 29 A-B (credits)
[SPECIAL PRODUCTION TECHNIQUES] "A very anal attention to detail," says designer Art Chantry. "Note the wear rings on the design, giving the piece a thrift store quality on purpose!"
[SPECIAL FEATURES] A die-cut hole reveals a plastic adapter printed on the first page. A "creative advisory" sticker on the black sleeve adds another note of humor.
[SPECIAL COST-CUTTING TECHNIQUE] Although the 'record' is embossed, the 'grooves' are replicated less expensively with varnish.

"Forty-five rpm records and sleeves were our inspiration," says designer Art Chantry. *"A promo tie-in to the AIGA CD-100 show, it showcases my cover art (mostly for forty-five rpm records) for bands (mostly punk)."*

BAND: JACK O' FIRE
TITLE: PUNKIN'
LABEL: ESTRUS RECORDS, 1994

Imagine blues/soul shoved through fifteen years of punk rock recorded with broken equipment on a dictaphone machine and then you might understand what these guys sound like. They collected Halloween and voodoo paraphernalia, so a diecut jack-o-lantern (a.k.a. Jack O' Fire) with glow-in-the-dark vinyl peeking through seemed a natural choice for the design.

Ibis Iguana

BEMBO'S ZOO ▶

[STUDIO] RVC Design
[ART DIRECTOR] Roberto de Vicq de Cumptich, RVC Design;
 Matteo Bologna, Mucca Design
[DESIGNERS] Roberto de Vicq de Cumptich,
 Matteo Bologna
[ILLUSTRATORS] Roberto de Vicq de Cumptich,
 Matteo Bologna
[CLIENT] Henry Holt
[CLIENT'S PRODUCT/SERVICE] Book publishing
[TYPE] Bembo
[SPECIAL PRODUCTION TECHNIQUES] The envelope was
 printed with UV inks on the inside with 4-color process
 first, 1 hit of opaque white and 2 hits of opaque silver.
[SPECIAL FOLDS/FEATURES] Envelope was die cut and
 scored; seams were taped and folded by hand.
[INSPIRATION/CONCEPT] Bembo's Zoo book

AUDREY INVITATION ▶

[STUDIO] Turner Duckworth
[ART DIRECTORS] David Turner, Bruce Duckworth
[DESIGNER] Lian Ng
[PHOTOGRAPHER] Lloyd Hryciw
[CLIENT] 3Com
[CLIENT'S PRODUCT/SERVICE] Technology products
[PAPER] .010 PVC (envelope) Invitation: Starwhite Vicksburg
 Cover, Tiara White, smooth
[COLORS] 6, process and match
[SIZE] $5\frac{3}{4}$" × $10\frac{1}{2}$" (15 × 27 cm) envelope, $5\frac{1}{2}$" × $10\frac{1}{4}$"
 (14 × 26 cm) invitation
[PRINT RUN] 18,750 (each)
[COST PER UNIT] $3.15 (envelope); $.55 (invitation)
[TYPE] Trade Gothic LH, Ext

"Audrey is an Internet appliance conceived as a solution
to the hectic schedules, clutter and chaos of everyday
family life," said account manager Elise Thompson. "The
challenge was to market sophisticated technology for
the home in a friendly, distinctive and unintimidating
way. We used the concept of a junk drawer and blender
to explain Audrey's functions."

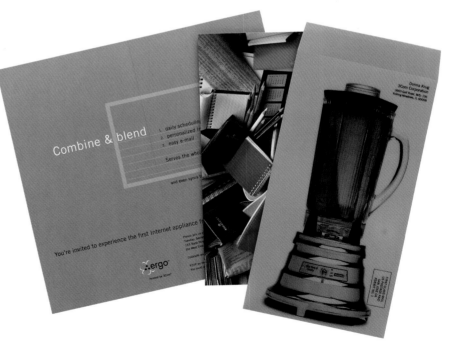

W.Y. CAMPBELL CORPORATE BROCHURE ▼

[STUDIO] Group 55 Marketing
[ART DIRECTOR/DESIGNER] Jeannette Gutierrez
[PHOTOGRAPHER] Richard Herneisen
[CLIENT] W.Y. Campbell Inc.
[CLIENT'S PRODUCT/SERVICE] Financial services
[PAPER] Strathmore Grandee, Sappi Lustro Dull
[COLORS] 2, match, plus emboss on cover
[SIZE] 8" × 11" (20 × 28 cm)
[PRINT RUN] 2,000
[COST PER UNIT] $10.75
[TYPE] Garamond, Gill Sans, hand lettering
[SPECIAL TYPE TECHNIQUE] Hand-lettered calligraphy for the client's logo, which was also
used as a screened element in the page design
[SPECIAL PRODUCTION TECHNIQUE] Calligraphy logo mark is blind embossed on the cover;
vellum flyleaf
[SPECIAL FOLDS/FEATURES] Pocket on back brochure cover holds companion color inserts

*"The concept was to convey a sense of stability essential to a financial services
provider through sober yet rich color and classic typography,"* Group 55 Marketing's
Catherine Lapico says. *"The piece has a very rich, spare-no-expense feel in spite of its
inexpensive two-color printing. The lavish use of burgundy makes the most of a two-
color print run."*

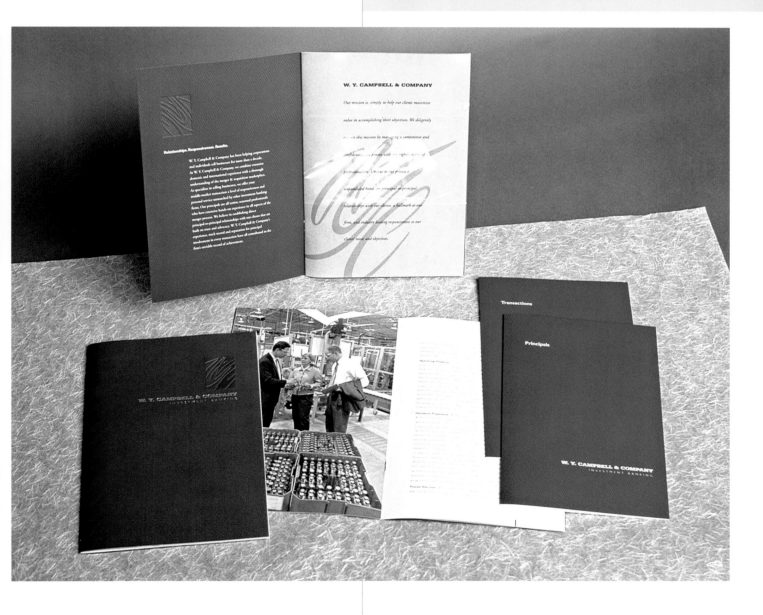

"THE FUTURE IS NOT WHAT IT USED TO BE" COASTERS ▼

[STUDIO] Signal
[ART DIRECTOR/DESIGNER] Britt Else
[ILLUSTRATOR] Britt Else
[CLIENT] Self
[PAPER] Crown Vantage Blotter Stock
[COLORS] 3, Match
[SIZE] 4" (10 cm)
[PRINT RUN] 1,000 of a six coaster set plus translucent vellum envelopes.
[COST PER UNIT] $2.00
[TYPE] Hand illustrated type for the Future logo, Rockwell Bold Italics (body copy), Franklin Gothic (Signal identity copy)
[SPECIAL TYPE TECHNIQUES] The future logo type was drawn with pen and ink (what a dinosaur!)
[SPECIAL PRODUCTION TECHNIQUES] Halftone illustrations, letterpress printing

The mail box, TV and Web flood our awareness with such a volume of stuff every day that only a unique and imaginative message will capture attention. "Blah blah blah" just won't cut it.
BRITT ELSE

"The overall concept came from the mid-century Popular Science pulps that assured us we'd be colonizing Mars by 1972, and the like. This unbridled technological enthusiasm produced a whole generation that expected to be flying around in their Fords by the year 2000. Domestic robots, laser pistols, lunar vacations—all naïve predictions based on the belief that technology would solve all our problems," says art director Britt Else.

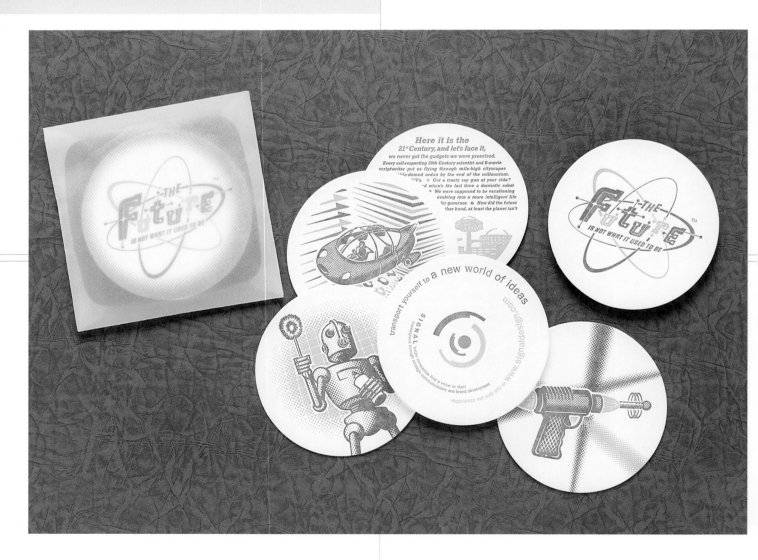

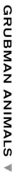

GRUBMAN ANIMALS ▼

[STUDIO] Liska + Associates, Inc.
[ART DIRECTOR] Steve Liska
[DESIGNER] Andrea Wener
[PHOTOGRAPHER] Steve Grubman
[CLIENT] Grubman Photography
[PAPER] Sappi, S.D. Warren Strobe Text
[COLORS] 4, process plus 2 match
[SIZE] 16" × 11" (41 × 28 cm)

[PRINT RUN] 6,000
[COST PER UNIT] $6.00
[TYPE] Futura
[SPECIAL FEATURES] High gloss paper and superb print-
ing bring out the unique details (fragile wings, supple
fur, gleaming scales) that are an important part of ani-
mal photography. Takeoffs of famous posters add a
humorous note.

*Design manager Kim Fry says the concept was "to gather Grubman's trademark animal photography into
a publication and demonstrate the breadth of the studio's work." A second objective was to show Grub-
man's expertise in digital manipulation and retouching.*

251

"NO SPIN" RECRUITING
BROCHURE ▶

[STUDIO] Greenfield/Belser
[ART DIRECTOR] Burkey Belser
[DESIGNER] Jill Sasser
[PHOTOGRAPHER] John Burwell, stock
[CLIENT] Orrick, Herrington & Sutcliffe
[CLIENT'S PRODUCT/SERVICE] Law firm
[PAPER] 80 lb. McCoy Gloss cover
[COLORS] 4, match and process; plus 1 PMS and spot gloss
 varnish
[SIZE] 6½" × 11" (16 × 28 cm)
[PRINT RUN] 6,000
[TYPE] MetaPlus Medium Condensed, MetaPlus Book Italic

"Aimed at law students, this brochure was part of the campaign that introduced Orrick's new visual identity," art director Burkey Belser says. " The inspiration is the O. The perfect circle drives the design and sells the name. In keeping with the title of the brochure, we kept the words to a bare minimum. The text consists entirely of quotes that back up the witty two-word headlines."

NO SPIN

O
ORRICK
GLOBAL LAWYERS

INTENSIVE TRAINING

"the ability to train associates on the essential
elements needed to be a good lawyer" *(vault.com)*

"a mix of on-the-job-training and in-depth formal
training" *(infirmation.com)*

JUICY WORK

"high-profile cases" and "cutting-edge finance deals"
(vault.com)

clients are "movers and shakers on both coasts"
(vault.com)

O
ORRICK

3

ELEMENTS RELAUNCH CAMPAIGN ▼

[STUDIO] Williams and House
[ART DIRECTOR] Pam Williams
[DESIGNERS] Lana Rigsby/Rigsby Design, John Johnson/John Johnson Art Direction
[CLIENT] Strathmore Paper

"Lana Rigsby was commissioned by Strathmore to help relaunch its award-winning Elements paper line. Our job was to prepare all of the launch support materials—all of the behind-the-scenes stuff to create excitement among the sales reps and the merchant community," explain the designers at Williams and House. "Sales reps received soup-to-nuts sales materials, including a lab coat and beakers to enable them to dramatize the creation of a new color of paper in sales meetings. T-shirts were designed to stack up pyramid style to create a functional display. They also received an informational binder with presentation tips, background information and scripts—all part of the work we did! The relaunch materials were developed, designed and produced in three weeks!"

AIGA VOICE BROCHURE ▼

[STUDIO] Cahan & Associates
[ART DIRECTORS] Bill Cahan, Michael Braley, Bob Dinetz, Kevin Roberson, Sharrie Brooks
[DESIGNERS] Michael Braley, Bob Dinetz, Kevin Roberson, Sharrie Brooks, Gary Williams
[PHOTOGRAPHERS] Bob Dinetz, Kevin Roberson, Sharrie Brooks
[ILLUSTRATORS] Gary Williams, Bob Dinetz
[CLIENT] American Institute for the Graphic Arts
[PAPER] Monadnock
[SIZE] 6¾" × 9" (17 × 22 cm)
[PRINT RUN] 4,500
[TYPE] Univers 55, Franklin Gothic

"What does it mean to use one's voice? Are designers using their own or merely embellishing their clients'?" art director Bill Cahan asks. " To us, voice is first and foremost an individual activity. It can be used to say many things, but it's essentially an expression in first person. While most graphic designers—ourselves included—have quieted their own voices in deference to their clients, there are still many examples of individuals making their ideas heard through design. These expressions range from the personal and cryptic to the social and zealous. Given the difficulties affecting people across the globe, we chose to focus on passionate pleas of a much smaller scale: from finding a home for a dog to rent control to homelessness. We found just a small sampling in our neighborhood. You'll undoubtedly find more by looking around your own city. Ironically, the most powerful work often comes not from marketing expertise or technical virtuosity but from desperation, passion and honesty. Our hope is that we all can take a cue from these voices and find our own."

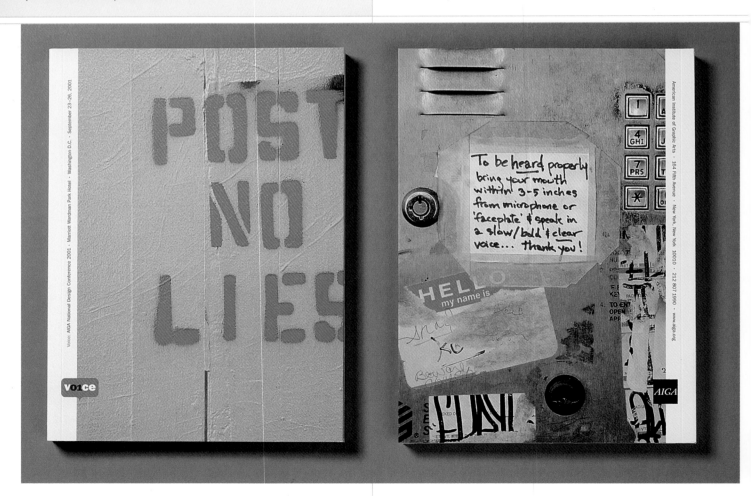

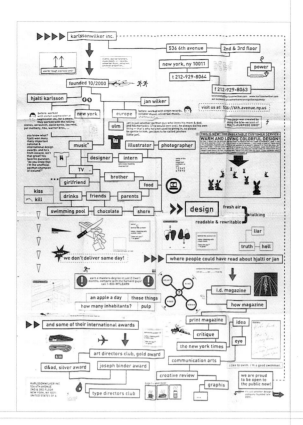

Do your thing. Have fun, believe in yourself and keep on rockin'. And most of all, be grateful that your parents paid for your education. Take them out for lunch and show them your page design projects. Parents like to be included.

JAN WILKER,
HJALTI KARLSSON

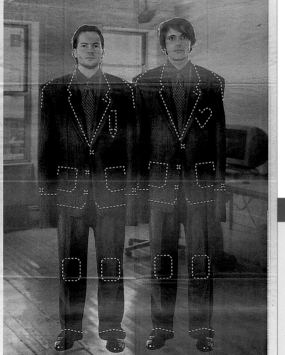

OPENING ANNOUNCEMENT ◄

[STUDIO] karlssonwilker inc.
[ART DIRECTORS/DESIGNERS] Jan Wilker, Hjalti Karlsson
[ILLUSTRATORS] Jan Wilker, Hjalti Karlsson
[PHOTOGRAPHERS] In-house and photo booth at Grand Central
[HAIR/MAKEUP] Verella.
[PAPER] Newsprint
[COLORS] 1
[SIZE] 23" × 32" (58 × 81 cm)
[PRINT RUN] 1,000
[COST PER UNIT] About $.70 (including envelope and postage)
[TYPE] FF DIN Bold, Albert-Jan Pool
[SPECIAL FOLDS/FEATURES] Super hand fold and high rising sheetfed

"We simply used some of the stuff that was on our minds at that time," says art director Jan Wilker. *"We just opened the studio, everything was so new (and still is). The clean black-and-white graphics just suited our self-written texts, stories and dialogues perfectly, and we definitely wanted to avoid a 'modern, young, always happy, stylish design studio' feeling, so there was no need to go crazy with the design. At least that's how we think about this project now, a year later."*

BOOK OF LIFE INVITATION ▲

[STUDIO] Morris Creative
[ART DIRECTOR] Steven Morris
[DESIGNER] Tracy Meiners
[CLIENT] Jewish Community Foundation
[COLORS] 4, process plus 1 match
[PRINT RUN] 3,000
[TYPE] hand-lettered typography mixed with Rotis family
[SPECIAL TYPE TECHNIQUE] Custom typography with
 blind embossing

"Our aim with this project was to convey a sense of sharing a legacy and/or endowment," says art director Steven Morris.

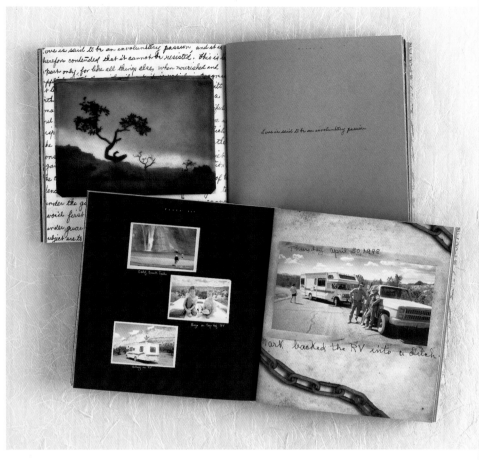

THE UTAH SCRAPBOOK ◄

[STUDIO] Ferguson & Katzman Photography
[ART DIRECTOR] Deanna Kuhlmann-Leavitt/Kuhlmann
Leavitt, Inc.
[DESIGNER] Michael Thede/Kuhlmann Leavitt, Inc.
[ILLUSTRATOR] Matthew Katzman
[PHOTOGRAPHER] Mark Katzman
[CLIENT] Ferguson & Katzman Photography
[COLORS] 5/5, 4-color process plus dull varnish
[SIZE] 7⅞" × 7¾" (20 × 20cm)
[PRINT RUN] 3,750
[COST PER UNIT] About $10.00
[TYPE] Copperplate 29bc; Adobe Garamond
[SPECIAL FOLDS/FEATURES] French folding,
side-stitched cover

"We wanted the piece to document the amazing journey taken by Mark and his family," says designer Michael Thede. *"A showcase for his beautiful imagery in the form of a scrapbook that is all about the work and Mark's memories of this special time with his family."*

/a. /a.

ᵒ¹/notice: For the past 15 years our firm has been called A K A G I R E M I N G T O N after its principals, Doug Akagi and Dorothy Remington. In that time we have evolved with our clients and the industry at large; now we find ourselves at the threshold of a new chapter. We are excited to announce our new name, our new location, and our new philosophy:

Alterpop

1001 mariposa street no. 304 san francisco california 94107

p. 415 558 1515 f. 415 558 8422 www.alterpop.com

AL´TĔR·POP: noun, adj.
Alterpop, by definition, has no definition. It cannot be predicted, but it can be thought of as what is yet to be. It does not rely on any established precepts of design, preferring to ask the question why — and then asks why of the answer. It is an evolving architecture for which the materials must be invented. Alterpop lurks in the shadows of chance, in the echoes of wit, in the rippled reflections of beauty. It is design in the future tense.

| Doug Akagi | Dorothy Remington | Kimberly Powell | Christopher Simmons | Jennifer Andreoni | Jasmin Dave | Ellen Malinowski |

ALTERPOP NAME CHANGE ANNOUNCEMENT ◄

[STUDIO] Alterpop
[ART DIRECTOR] Doug Akagi
[DESIGNER] Christopher Simmons
[PAPER] 130# Coronado Bright White Vellum
[COLORS] 2, process
[SIZE] 7⅞" × 5¼" (20 × 13 cm)
[PRINT RUN] 2,000
[COST PER UNIT] $0 (printer did it for free with the rest of
business system)
[TYPE] Futura, Mrs Eaves
[SPECIAL FEATURE] Letterpress printing

"The primary communication goal of this project was to announce our name and address change, introduce our new identity and position the identity via the vision statement/manifesto," says designer Christopher Simmons. *"Although it was designed as an oversize postcard, the preciousness of the deep-set letterpress printing and individual signatures lend it a more formal quality. The result is a piece that is both elegant and playful (and more likely to be read)."*

SALEM COLLEGE BROCHURE ▶

[STUDIO] Henderson Bromstead Art Co.
[ART DIRECTOR] Hayes Henderson
[DESIGNER] Christine Celtic
[PHOTOGRAPHER] Stock
[CLIENT] Salem College
[CLIENT'S PRODUCT/SERVICE] Education
[PAPER] Vintage Velvet
[COLORS] 2 (brochure); 4 (carrier), both match and process
[SIZE] 8" × 8" (20 × 20 cm)
[PRINT RUN] 6,000
[COST PER UNIT] $1.50
[TYPE] Handwritten
[SPECIAL PRODUCTION TECHNIQUES] Metallic duotones
[SPECIAL FOLDS/FEATURES] 4 fold carrier

"Our goal was to create a piece about the growth from childhood to womanhood through students' experiences while attending Salem College," says art director Hayes Henderson. "In the case of this brochure, creating an impactful piece on a limited budget proved to be a challenge. We kept the production of the brochure understated and put more towards the production of the carrier. A unique die cut and fold for the carrier—along with colors and markings like that of a quilt or wrapping paper—gave the package a gift-like feeling."

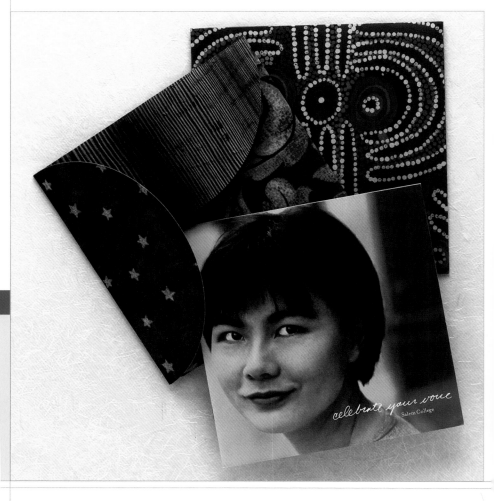

Sometimes a small budget is the best thing that can happen to a project.
HAYES HENDERSON

Just when you thought French stock options were limited, Mac Papers announces a ground breaking merger. Thanks to recent investment in Florida expansion, The following French papers are now readily available for next-day delivery in your area.

FRENCH PAPER STOCK ▲

[STUDIO] Fry Hammond Barr
[DESIGNER] Sean Brunson
[ILLUSTRATOR] French stock
[COPYWRITER] John Logan
[CLIENT] Mac Papers
[CLIENT PRODUCT/SERVICE] Paper company
[PAPER] French, various lines
[COLORS] 2, match
[SIZE] 8½" × 4¾" (22 × 12cm)
[TYPE] Clarendon, Trade Gothic
[SPECIAL PRODUCTION TECHNIQUE] All-black overprints eliminated the need to trap
[SPECIAL FOLDS/FEATURES] The cover is a full wraparound that tucks into a front flap; all interior pages are doublefolded.

"This piece was designed to make consumers aware of current French warehouse stock and played off a stock-market theme," says designer Sean Brunson.

MOSS EVENT GRAPHICS ▼

[STUDIO] Platinum Design, Inc.
[ART DIRECTORS] Vickie Peslak, Kelly Hogg
[DESIGNER] Kelly Hogg
[CLIENT] Event Associates
[CLIENT'S PRODUCT/SERVICE] Event Planners
[PAPER] 92 lb. KeayKolour Metallics, 120 lb. McCoy cover
[COLORS] 3, PMS
[SIZE] 5" × 7¼" (13 × 18 cm)
[PRINT RUN] 500
[TYPE] Akzidenz Grotesk Expanded Lite, Tarzana Narrow
[SPECIAL PRODUCTION TECHNIQUES] Die cut, emboss
[SPECIAL FOLDS/FEATURES] Round-edged invitation slides into silver slipcase; die-cut holes expose the party givers' names
[SPECIAL COST-CUTTING TECHNIQUE] No ink on silver slipcase; only three colors on invitation, gang printed with reply card in common colors

"Our inspiration for this project was a theme of 'modern meets pop art,'" art director Vickie Peslak says.

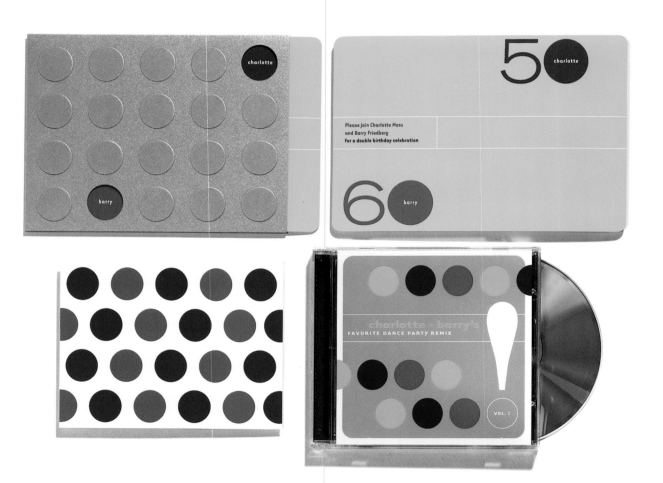

STORIES + PICTURES ◄

[STUDIO] Wood Design
[ART DIRECTORS/DESIGNERS] Tom Wood, Clint Bottoni
[PHOTOGRAPHER] Craig Cutler
[CLIENT] Craig Cutler/Hennegan Printing
[PAPER] Potlatch McCoy Matte
[COLORS] 4-color stochastic printing plus 4 match colors
 and varnish
[SIZE] 7⅝" × 9⅛" (19 × 23 cm), 96 pages
[PRINT RUN] 25,000
[TYPE] Trixie, Dead History, Bodoni, Univers, Copperplate
[SPECIAL PRODUCTION TECHNIQUES] Stochastic printing,
 fluorescent inks
[SPECIAL FOLDS/FEATURES] Slipcase, double gatefold

*The designers from Wood Design say the inspiration was
"collaboration, great photography, love of diners and
the people."*

LEATHERMAN TOOLS
CATALOG ◄

[STUDIO] Hornall Anderson Design Works, Inc.
[ART DIRECTORS] Lisa Cerveny, Jack Anderson
[DESIGNERS] Lisa Cerveny, Andrew Smith, Andrew Wick-
 lund, Don Stayner
[PHOTOGRAPHERS] Jeff Condit, Studio Three.
[CLIENT] Leatherman Tool Group, Inc.
[CLIENT'S PRODUCT/SERVICE] Tool manufacturer
[PAPER] Graphica Lineal 80# Cover (cover); McCoy 100#
 Matte Book (interior)
[COLORS] 4, process
[SIZE] 6" × 11" (15 × 28 cm)
[TYPE] Bell Gothic Family
[SPECIAL TYPE TECHNIQUES] 8 point type minimizes
 impact on product photography.
[SPECIAL FOLDS/FEATURES] Three wire loops add to the
 industrial appearance of the piece and allow it to be
 inserted into a three-ring binder.
[SPECIAL COST-CUTTING TECHNIQUES] "We used a
 digital camera to shoot the products in an intentionally
 larger-than-life, somewhat-out-of-focus, fun way," says
 art director Lisa Cerveny.

*The head of a pair of needle-nose pliers extends out from
the left edge of the cover, as if pointing to the company's
name. "We created layouts with a sense of energy and
exaggerated movement by positioning the catalog's
product photos at angles," says art director Lisa Cerveny.*

VIRGINIA HOLOCAUST MUSEUM FUND-RAISER

BROCHURE ▶

[STUDIO] Arnika
[ART DIRECTOR/DESIGNER] Michael Ashley
[ILLUSTRATOR] Michael Ashley
[CLIENT] Virginia Holocaust Museum
[PAPER] 60 lb. white card stock
[COLORS] 4, process

[SIZE] 6¾" × 10" (17 × 25cm)
[PRINT RUN] 500
[COST PER UNIT] All donated
[TYPE] Hand drawn
[SPECIAL COST-CUTTING TECHNIQUE] High-volume color copier reduced printing expenses

"The museum needed to raise money for new space in an already politically charged environment," explains art director Michael Ashley. "The message required broad appeal, something everyone could support. The client, one of the youngest Holocaust survivors and founder of the museum, led us to a message of tolerance. The design and concept were inspired by the journals that many Jews kept during Hitler's reign, as well as religious Hebrew text from local synagogues. We used cut out newspaper headlines of hate crimes from both Nazi Germany and modern-day America to show how some things really hadn't changed as much as we'd like to think. Many of the similarities between the old and new headlines were frightening."

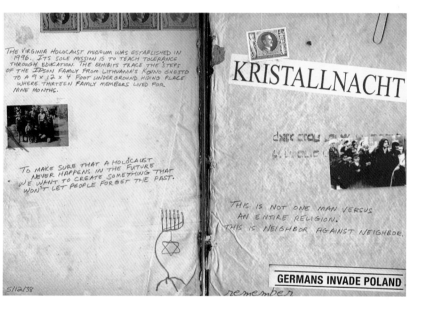

NORILSKIY NIKEL
CALENDAR ◄

[STUDIO] Direct Design Studio
[ART DIRECTORS] Peryshkov Dmitry, Feigin Leonid
[DESIGNER] Busygin Anton
[CLIENT] Norilsky Nikel Company
[CLIENT'S PRODUCT/SERVICE] Extraction and reduction of nonferrous metals
[PAPER] Classic Twid
[COLORS] 3, match
[SIZE] 60" × 40" (152 × 102 cm)
[PRINT RUN] 2,200
[COST PER UNIT] $20.00
[TYPE] Based on TimesPandre and Helios
[SPECIAL PRODUCTION TECHNIQUES] UF-varnish, three foil stamps, cutting, metallic insertion with logo
[SPECIAL FOLDS/FEATURES] tear-off leafs, fastened with nickel-plated bolts (handmade)

Art directors Peryshkov Dmitry and Feigin Leonid say they based the calendar's design on Mendeleev's Periodic Table of Elements.

To us, it seems that designers ought to create more sophisticated products. We like to create by hand, if the run is not too high, because it helps make things warm and friendly.

PERYSHKOV DMITRY,
FEIGIN LEONID

263

GREAT AMERICAN STATION FOUNDATION BROCHURE ▶

[STUDIO] Fuszion Collaborative
[ART DIRECTOR/DESIGNER] John Foster
[CLIENT] The Great American Station Foundation
[CLIENT'S PRODUCT/SERVICE] Restoration of existing or construction of new rail stations
[PAPER] Lustro
[COLORS] 4/4, process
[SIZE] 6" × 9" (15 × 23 cm)
[TYPE] Bookman, Bookman Old Style, Trade Gothic, Close Dotter
[SPECIAL PRODUCTION TECHNIQUE] Overprinting blacks
[SPECIAL FEATURES] Letterpress score

"The real challenge on a piece like this is the diverse quality and quantity you receive in terms of photo submissions," says art director John Foster. "Each individual station will have different resources to draw from, particularly those with historical photos that have undergone a restoration and those with construction still in the planning stages. Somehow we needed to make rail stations appear as a modern mode of transportation and make the overall idea of the rail station seem exciting and visionary. In order to accomplish this, we treated the various photos with different colors and layers of colors, tracks and open skies, and incorporated old airbrush patterns to add energy."

The Great American Station Foundation

The Great American Station Foundation was created in 1996 to revitalize communities through new construction or restoration of existing rail passenger stations, and the possible conversion of historic non-railroad structures to active station use. These railroad stations will improve rail access and intermodal connections as well as stimulate community development. As the organization has grown and evolved, it has set a goal to become the national intermediary organization not only for station revitalization, but also for community revitalization in areas surrounding intercity, commuter and urban rail stations.

In keeping with this redefined mission, the Great American Station Foundation is beginning a series of exciting new programs to ensure that station revitalization and station oriented development are an integral part of other initiatives including rural economic development, smart growth, urban infill, downtown revitalization, and improved quality of life. You can learn more about the Foundation and our work, including detailed explanations of recent success stories, at *www.stationfoundation.org* or *www.transittown.org*. Or call the Foundation at 1-505-426-8055.

Hank Dittmar, President and CEO
for the Board of the Great American Station Foundation

Funding Stations

The Station Foundation offers an annual grant program aimed at helping to jump-start community efforts to restore rail stations as active intermodal transportation facilities. General guidelines on the nature of the grant program, eligibility and funding levels are provided on the web site and a complete, downloadable application is available on the web at the end of January each year. Applications are due in April, with winners announced in June.

A major source of funding for many station projects is the Federal Enhancements Program, which is administered by state Departments of Transportation. Restoration of historic train stations is one of 12 categories of eligible projects; over 500 stations received almost $250 million through the various state programs during the 1990's. For more information go to: *www.enhancements.org.*

Reaping the Benefits

Recent examples of successful station projects can be seen in:

Maplewood, NJ – where the chamber of commerce has used the rail station to provide access to local businesses through a station concierge service, providing everything for the commuter from morning coffee to laundry service and event tickets. Local officials also partnered with the state transit agency to develop a viable jitney service to the station, eliminating the need for a 400-car garage that the community opposed.

Solana Beach, CA – where a station on a commuter rail line to San Diego built six years ago has become the catalyst for a flourishing specialty retail district for designers, architects, landscapers, antique dealers, artisans and retailers selling custom furniture, artwork and other things that are needed for all the new homes being constructed in booming San Diego County. This new center in turn has attracted sidewalk cafes and interesting stores, a ballet studio, yoga center, a farmer's market. There's even nightlife.

Memphis, TN – at Central Station, which shows how a public-private partnership can turn a dilapidated 100,000 sq. ft. building into a sought after address and a center for community events, while at the same time serve both local transit and intercity rail at little cost to the public.

Meridian, MS – which took a gamble on a dilapidated rail station complex, creating a new intermodal terminal and stimulating over $30 million in downtown residential, retail, cultural, and educational investments.

Transit Oriented Development (TOD)

The Foundation has taken on the challenge of bringing TOD to scale in the United States through a unique partnership involving groups from around the country. Our goal is to help the real estate, government and non-profit sectors meet the demand for walkable, transit oriented communities around rail stations and transit stops in a way that delivers on the equity and environmental promises of this kind of development. We see a need for an intermediary network to provide the financial, technical and institutional assistance needed to make these communities a reality. We've begun this effort through a learning exercise that involves literature reviews, practitioner interviews, site visits, regional conversations and the creation of a communications network to disseminate case studies, tools and best practices. We invite you to join in this worthy effort. Visit *www.transittown.org.*

KOMUNICIRAJ: 10TH ANNIVERSARY OF THE AGENCY ▼

[STUDIO] Kraft&Werk
[ART DIRECTOR] Damijan Vesligaj
[CLIENT] self
[COLORS] 3
[TYPE] Trade Gothic, Clarendon
[SPECIAL PRODUCTION TECHNIQUES] Offset printing, silkscreening
[SPECIAL FOLDS/FEATURES] "The invitation was cut so that by pulling a carrot out, a simple animation is performed in cut-out screen," says art director Damijan Vesligaj. "It's the story about the rabbit and its ability to communicate. If you pull out the carrot, the rabbit gets ears."
[SPECIAL COST-CUTTING TECHNIQUES] Using only three colors for printed pieces and two colors for CD box

"For the tenth anniversary of Kraft&Werk," says art director Damijan Vesligaj, "we wanted to emphasize the perception of agency as a solver of communication problems."

MASON BROCHURE ▶

[STUDIO] Spur
[ART DIRECTOR/DESIGNER] David Plunkert
[PHOTOGRAPHERS] Fredrik Brodén, Chris Ferebee, Jayne Hinds Biduat
[CLIENT] Mason Retail Group
[CLIENT'S PRODUCT/SERVICE] Real estate services for retail organizations
[PAPER] Gilbert Voice, LOE Dull
[COLORS] 6 (4 process, 2 match)
[SIZE] 6" × 10" (15 × 25 cm)
[PRINT RUN] Less than 1,000
[TYPE] Agency (heads, captions), Adobe Garamond (text)
[SPECIAL PRODUCTION TECHNIQUES] 2-color foil on cover
[SPECIAL FOLDS OR FEATURES] Rivet binding
[SPECIAL COST-CUTTING TECHNIQUES] 4-color section printed on 11" × 17" (28 × 43 cm) digital press using a single sheet. Existing client letterhead was used for end pages. Client binds brochures by hand on an as-needed basis.
[INSPIRATION/CONCEPT] The photography of Fredrik Brodén.

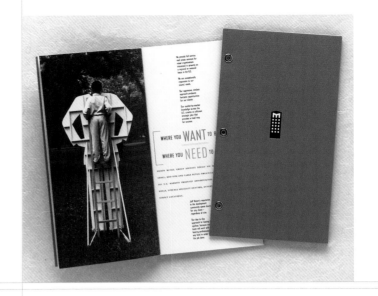

EVER PAPER SWATCHBOOK ▼

[STUDIO] Design: MW
[ART DIRECTOR] J. Phillips Williams, Allison Williams, Abby Clawson
[CLIENT] Buttenpapierfabrik Gmund
[PAPER] Ever
[SPECIAL PRODUCTION TECHNIQUES] Letterpress, embossing

"The project scope included 'design' of paper line (determining pallet and texture), naming and positioning," says art director Allison Williams. *"This line of paper from Gmund, a German paper mill started in the 1800s, was created to evoke a line of paper that was made many years ago and has remained unchanged but is still relevant today."*

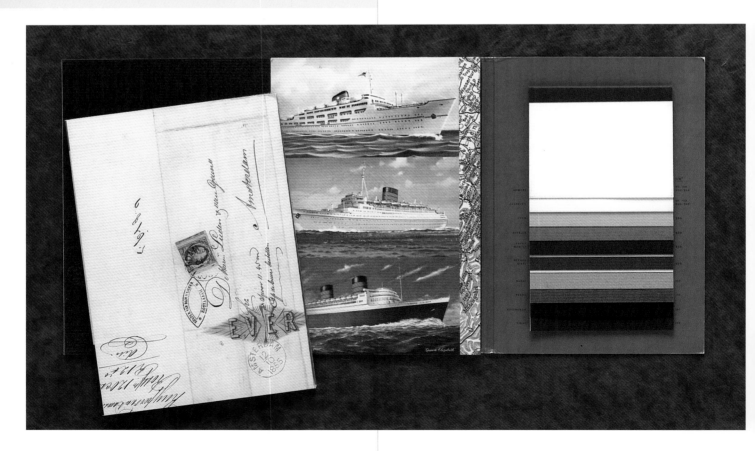

Every project is a unique and singular proposition. Never think in formulas. Every assignment is a clean sheet of paper. We are representing our clients and no two are the same.
STEVE SIKORA

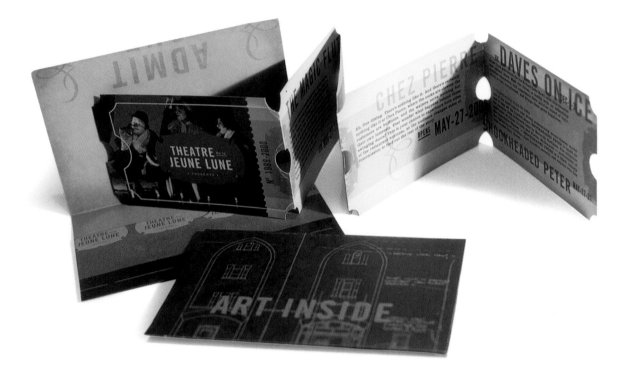

TJL DIRECT MAIL ▲

[STUDIO] Design Guys
[ART DIRECTOR] Steve Sikora
[DESIGNER] Dawn Selg
[PHOTOGRAPHER] Michal Daniel
[CLIENT] Theatre de la Jeune lune
[CLIENT'S PRODUCT/SERVICE] Theater productions
[PAPER] French Parchtone
[COLORS] 4, process
[SIZE] 4½" × 6¾" (11 × 17 cm)
[PRINT RUN] 3,000
[TYPE] Letter Gothic, Clarendon

[SPECIAL TYPE TECHNIQUES] Layering of graphic elements and information, repetition of a shield-shaped branding plaque both horizontally and vertically on the tickets and the envelope to unify the whole piece into a single concept (the envelope is not just the disposable outer shell).

[SPECIAL FOLDS/FEATURES] Takes the standard convention of the accordion-fold brochure one step further by die cutting it into a string of tickets.

[SPECIAL COST-CUTTING TECHNIQUES] Entire piece produced from the same stock, printed together and die cut from the same sheet

"We created a ticket folder and a string of tickets featuring each show for the upcoming season on its own ticket," says art director Steve Sikora. "Print registration of the layers is purposefully sliding out of register in order to pull the viewer from one show to the next. The combined shows make up the season."

SMITH FELLOWS BROCHURE ▶ ▼

[STUDIO] Fuszion Collaborative
[ART DIRECTOR/DESIGNER] John Foster
[CLIENT] David H. Smith Conservation Research Fellowship Program
[CLIENT'S PRODUCT/SERVICE] Endowment for research in science and conservation
[PAPER] Coronado
[COLORS] 4/4, process
[SIZE] 4" × 9" (10 × 23 cm)
[TYPE] Garamond, Officina Sans, handwritten type
[SPECIAL TYPE TECHNIQUE] Type is staggered and angled in various manners and includes a large amount of predominant handwritten type.
[SPECIAL FOLDS/FEATURES] Gatefold
[SPECIAL COST-CUTTING TECHNIQUE] A poster for the same organization was run on the press sheet.

"The Fellows are often out researching wildlife and agriculture in remote locations," says art director John Foster. *"We wanted to express the variety of scenery and objects of study in this piece as well as the day-to-day note taking and research compilation. This inspired the hand-scrawled type that eventually became the trademark for the organization."*

Program Description

The postdoctoral fellowship program enables selected scientists to improve and expand their research skills, to direct their research efforts toward urgent conservation issues, and to avail themselves of unique research opportunities by working closely with conservation practitioners. Each fellow is expected to design, initiate, and conduct an original research project developed in conjunction with an academic and a conservation mentor.

The program provides two years of support to each selected fellow. Applicants select the academic institution best suited for carrying out the proposed scientific research and a mentor at this institution who will encourage the fellow's continued growth as a conservation scientist. Applicants may also identify a Conservancy mentor in advance; alternatively, program staff will work with selected fellows to identify appropriate mentors. The program supports at least five new fellows each year.

Fellowship applications should propose research that will provide conceptual results or new technical conservation tools. Successful proposals will be consistent with the mission of The Nature Conservancy, and the proposed research should focus on the Conservancy's conservation sites or on questions germane to these sites. Overall, the Conservancy seeks both to generate new knowledge on the ecology of threatened ecosystems and to provide a solid scientific basis for designing strategies to ameliorate threats to these systems.

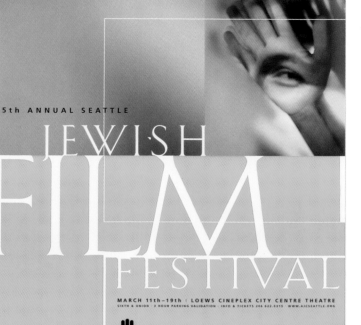

SEATTLE JEWISH FILM FESTIVAL ◄ ▼

[STUDIO] Piper Design Co.
[ART DIRECTORS/DESIGNERS] Brian Piper, Christina Stein
[PHOTOGRAPHER] Brian Piper
[CLIENT] American Jewish Committee's Seattle Jewish Film Festival
[COLORS] 4, process, 2 match colors
[TYPE] Schneidler Initials, Gill Sans
[SPECIAL COST-CUTTING TECHNIQUES] "For the Film Festival program, we only printed the cover as off-set, four color process, on a matte coated stock," says art director Brian Piper. "The interior pages were printed two-color (Pantone orange and black) on a cold-set web press. Furthermore, we printed all other campaign pieces in either two or one color only except for the poster where we begged and pleaded our printer to drop the price to record levels. And we shot the photography ourselves with a very affordable but not too cooperative 'shaky hand' model!"

"Since the campaign was for a not-for-profit Jewish Film Festival celebrating its fifth year, our inspiration was the Jewish Hamsa symbol of an eye in a hand with the fingers representing each year," say the designers. "This idea was the basis for both the logo and main image of the campaign," say the designers.

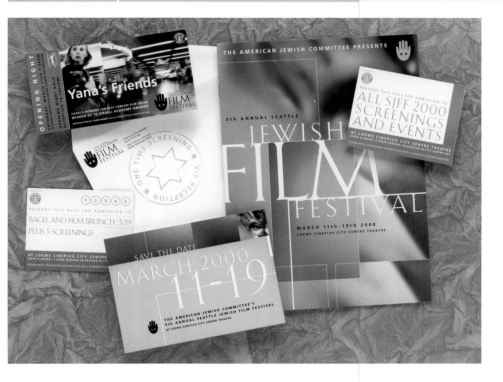

[STUDIO] Brainstorm, Inc.

[ART DIRECTORS/DESIGNERS] Chuck Johnson, Tom Kirsch,
Adam Hallmark, Ryan Martin

[ILLUSTRATORS] Chuck Johnson, Tom Kirsch, Adam Hall-
mark, Ryan Martin

[PHOTOGRAPHER] Doug Davis

[CLIENT] Self

[PAPER] French Dur-o-Tone Butcher, Potlatch McCoy Cover

[COLORS] 4, process plus satin varnish

[SIZE] 10" × 6½" (25 × 17 cm), 36 pages plus cover

[PRINT RUN] 500

[TYPE] Clarendon, AG Old Face, Tarzana, DIN Engschrift,
News Gothic

[SPECIAL PRODUCTION TECHNIQUES] Wire-O binding

[SPECIAL FEATURE] Screen-printed rubber cover

"To show off good design and concept," says designer
*Chuck Johnson. "Brainstorm's corporate tagline is 'We
Think. You'll See.' There are two sections. The 'We Think'
section is about corporate philosophy and the creative
process. The 'You'll See' section is the portfolio. The
Brainstorm graphic spiral is used throughout in different
treatments as subtle yet fun branding."*

The best clients hire designers to help them communicate, not decorate. We work hard to listen to our clients and just as hard to make sure clients know that we are listening so we get the best information. Our process is very collaborative, but our outside perspective is what adds value to our clients' messaging.
MICHAEL CONNORS

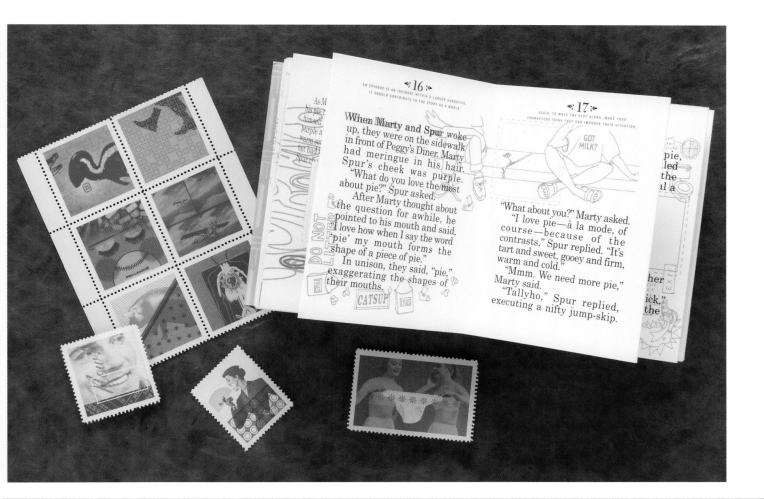

MOTIVE/WORDSLINGER NEW YEAR'S GIFT ▲

[STUDIO] Motive Design Research
[ART DIRECTORS] Michael Connors, Kari Strand
[DESIGNER] Heather Heflin
[ILLUSTRATORS] Heather Heflin, Michael Connors, Kari Strand, Karen Phipps
[COPYWRITER] Brittany Stromberg
[PAPER] 140 lb. Cover Muscletone Pure White (book); Tro-mark Gum English Finish (stamps)
[COLORS] 2/1 (book); 2/0 (stamps), match
[SIZE] 93" × 4½" (236 × 11 cm) book, 3½" × 4¼" stamps

[PRINT RUN] 500
[COST PER UNIT] $7.20
[TYPE] Century Schoolbook (main text); Franklin Gothic No. 2 (subtext); handwritten text by Heather Heflin (background)
[SPECIAL FOLDS/FEATURES] Printed on a single sheet of paper, trimmed to be four panels that were scored and glued to form one 93" (or 236cm) accordion folded panel. Panels fold around themselves to form what appears to be a bound book. The book is held shut by an elastic band attached through a hole in the back cover.

"The designer, Heather Heflin, and writer, Brittany Stromberg, decided to make this year's promo gift a children's book—combining what Brittany learned in a children's literature class and her passion for pie," says art director Michael Connors. "The story works on multiple levels with the background being instructions for how to write a children's book."

LUCKY STRIKE DESIGNER AWARD INVITATION ▶

[STUDIO] Williams and House
[ART DIRECTOR] Pam Williams
[DESIGNER] Fred Schaub/Fred Schaub Design
[CLIENT] Raymond Loewy Foundation

"The Lucky Strike Designer Award invitation was designed to be a highly unique piece that would immediately capture recipient's—primarily media and journalists—attention," say the designers at Williams and House. "The invitation was intended to communicate not only the type of event, but also to showcase its scope, quality and tone. It was intended to prompt the media from throughout the world to attend the event in Germany."

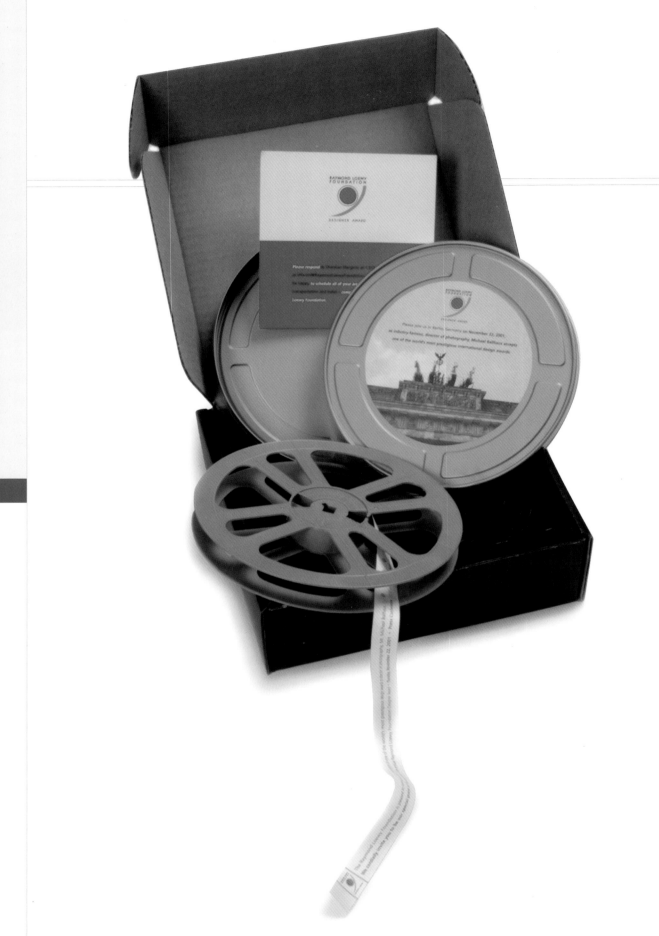

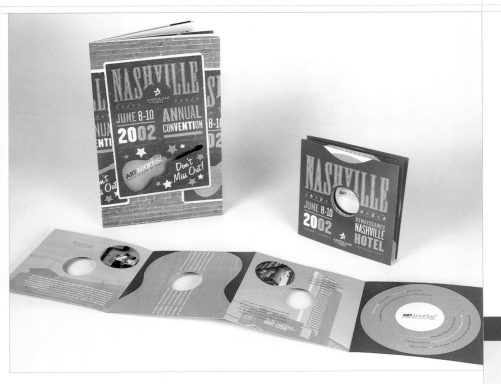

NASAA DETROIT CONFERENCE: DRIVING NEW AGENDA ◄

[STUDIO] Fuszion Collaborative
[ART DIRECTOR] John Foster
[DESIGNERS] Bryan Keever, John Foster
[ILLUSTRATOR] John Foster
[CLIENT] National Assembly of State Arts Agencies
[PAPER] PhoeniXmotion, Finch Fine
[COLORS] 4/4, process (folder and cover); 2/2, match (interior)
[SIZE] 9" × 12" (23 × 30 cm) (folder); 6" × 10" (15 × 25 cm) (brochure)
[TYPE] Clarendon, DIN Engschrift, Gill Sans, Minion, News Gothic
[SPECIAL TYPE TECHNIQUE] Header copy is formed using a font reconstructed from Xeroxes of old type-spec books
[SPECIAL PRODUCTION TECHNIQUE] Custom dyes for the folder pockets; shorter bind-in registration form
[SPECIAL COST-CUTTING TECHNIQUES] Brochure cover and the folder were printed at the same time to save ink charges, and the interior pages were designed as two-color solutions.

"The conference materials were inspired by Detroit's rich history and exciting future," art director John Foster says. *"We paid particular interest to the music and automotive industries. We incorporated old 'doo-wap' groups and early makes/models with techno references and concept cars. The conference also highlighted the unique connection Detroit has with neighboring Windsor, Canada. We achieved an overall artistic and unique feel rather than an Adobe Photoshop collage by incorporating old lithographic textures from some of my failed college projects."*

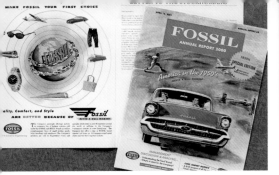

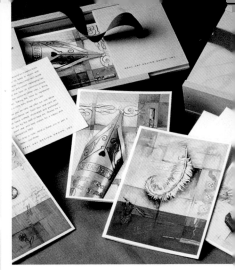

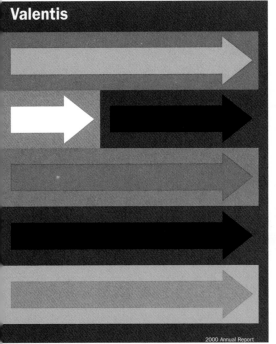

Valentis

2000 Annual Report

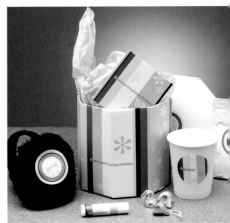

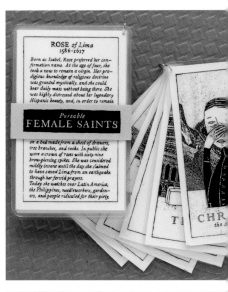

THIS CD HAS MILLIONS OF SONGS

VE GOT IT
RAPPED

B12

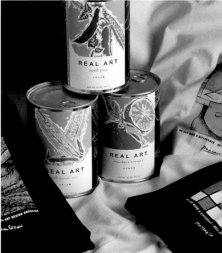

REAL ART

BUSINESS COLLATERAL

Business collateral such as annual reports and press kits are like cough medicine—everyone knows they need it, but they sure hate to take it. Business collateral like self-promotions are more like candy—everyone wants it, but the sheer choices and sparkling colors of the candy store can be overwhelming. Designers have the gift of making even cough medicine taste good, and of choosing the best arrangement of candies for candy dish. In this section, designers organize the bulky information of annual reports into tasty treats, and give a little sweetness to other projects from identity systems to self-promotion mailings.

BSA GRAND CANYON COUNCIL 2001 ANNUAL REPORT ▼ ►

[STUDIO] Catapult Strategic Design
[ART DIRECTOR/DESIGNER] Spencer Walters
[PHOTOGRAPHER] Doug Redig/Redig Photography
[CLIENT] Boy Scouts of America, Grand Canyon Council
[PAPER] Boyd Converting Buckskin White 90# Cover (flag); Hammermill Via Smooth Natural 100# Cover (book cover); Hammermill Via Smooth Natural 80# Text (text)
[COLORS] 4, process plus 2 match
[SIZE] 35 " × 22" (89 × 56 cm) (flag, flat), 16" × 11" (41 × 28 cm) (flag, folded); 14 " × 14" (35 × 35 cm) (book, flat); 7 " × 14" (18 × 35 cm) (book, folded)
[PRINT RUN] 1,250
[COST PER UNIT] $18
[TYPE] Rosewood Fill (headings), Bell Gothic (body copy)
[SPECIAL PRODUCTION TECHNIQUES] Registered emboss on both flag and book (stars); spine sewn bindery for book; 45-degree custom-angled book trim.
[SPECIAL FOLDS/FEATURES] Customized progressive box score die for folding of flag; each book was inserted and then hand folded inside the flag; custom-sized, black rubber gasket enclosures to hold the piece together

"Many years ago, when I was but a little lad, I was a Scout," says designer Spencer Walters. *"I remember the Pinewood Derby, helping old ladies across the street, and of course, learning how to honor our country's greatest symbol, the flag of the United States of America. I remember learning how to salute it, how to raise it, how to carry it (yes, there is a proper way) and how to fold it. These childhood experiences are what ultimately led to this adulthood inspiration."*

★ ON MY HONOR ★

Grand Canyon Council Boy Scouts of America
2001 ANNUAL REPORT

ON MY HONOR

I WILL DO MY BEST TO DO MY DUTY TO GOD AND MY COUNTRY

AND TO OBEY THE SCOUT LAW; TO HELP OTHER PEOPLE AT ALL TIMES; TO KEEP MYSELF PHYSICALLY STRONG, MENTALLY AWAKE, AND MORALLY STRAIGHT.

THE X FACTOR ▶

[STUDIO] Equus Design Consultants Pte Ltd
[ART DIRECTOR] Andrew Thomas
[DESIGNERS] Chung Chi Ying, Gan Mong Teng
[ILLUSTRATOR] Michael Lui
[CLIENT] Craft Print International Ltd
[PAPER] 100 gsm Munken BWM
[COLORS] 4, process plus 2 match
[PRINT RUN] 3,500 copies
[TYPE] Century Schoolbook (main book text), Univers and
 Gill Sans (for some of the tip-ins)
[SPECIAL FOLDS/FEATURES] Incorporation of various tip
 ins including a letter, a docket, a flipper book and a cal-
 endar into the printed report using hand finishing,
 French folding, and special die cuts on several pages;
 book style hard case with thread-sewn binding, with a
 dust jacket and endpapers.

"The boss of Craft Print is Charlie Chan, the same name as the 1930s Hollywood B-movie detective," says art director Andrew Thomas. *"Charlie Chan, the fictional character, is a Chinese sleuth based out of Hawaii with a practical and very Asian approach to problem solving, and a fondness for Chinese proverbs. Charlie Chan of Craft Print really identifies with this character, seeing himself as a problem solver and solutions provider, not simply a printer. He also is rather fond of peppering his conversation with salty old Chinese proverbs. So the personal affinity and identification was already there."*

Our challenge is convincing the client to accept our most creative concept proposals. The trick is not to sell the creative concept at all, but the rationale behind it, on logical grounds. Clients are not generally creative and do not know how to assess creative work, but they do know their own businesses and can understand a logical argument.

ANDREW THOMAS

SILICON VALLEY BANK 2000 ANNUAL REPORT ◄

[STUDIO] Cahan & Associates
[ART DIRECTOR] Bill Cahan
[DESIGNER] Michael Braley
[PHOTOGRAPHERS] Jock McDonald, Graham MacIndoe
[CLIENT] Silicon Valley Bank
[CLIENT'S PRODUCT/SERVICE] Investment banking
[PAPER] Utopia Two
[SIZE] 6½" × 11" (17 × 28cm)
[TYPE] Helvetica Neue

"This annual report was designed to resemble a Rolodex, symbolizing the bank's extensive, mutually profitable relationships with entrepreneurs, investors and service providers," explains art director Bill Cahan. "The theme of the report is stated in its first few pages: 'Ideas don't build companies; people do.' The bank wanted to focus on client relationships. To me, the best way to illustrate this concept was to use the metaphor of the Rolodex. I was inspired by my own Rolodex as it acts as a secondary personal sketchbook; most of the cards in the annual report are modeled after cards in my real Rolodex. I had always wanted to incorporate my own doodles and sketches into an annual, and this was the perfect opportunity."

ENTERTAINMENT WEEKLY
MEDIA KIT ▲

[STUDIO] Platinum Design, Inc.
[ART DIRECTOR] Vickie Peslak
[DESIGNER] Kelly Hogg
[PHOTOGRAPHER] Eric Tucker
[CLIENT] *Entertainment Weekly*/Time Warner·
[CLIENT'S PRODUCT/SERVICE] Magazine publishing
[PAPER] Uncoated

[COLORS] 3, match
[SIZE] 9⅝" × 11¾" (24 × 30 cm) (folded)
[PRINT RUN] 7,500
[COST PER UNIT] $10.00
[TYPE] Fratiger
[SPECIAL PRODUCTION TECHNIQUE] Embossed tag
line on book cover and front of kit
[SPECIAL FOLDS/FEATURES] Folder fits in a filing
cabinet and has easy-to-locate functional tab
[SPECIAL COST-CUTTING TECHNIQUE] Two-color
inserts are easy to update and reproduce

"Our inspiration for this project was the magazine's tag line: 'The buzz. The biz. The best in entertainment,'" says art director Vickie Peslak.

DEL MONTE 2000 ANNUAL REPORT ◄ ▼

[STUDIO] Howry Design Associates
[ART DIRECTOR] Jill Howry
[DESIGNER] Todd Richards
[ILLUSTRATOR] Shinichi Imanaka/Photonica
[PHOTOGRAPHER] Stuart Schwartz
[CLIENT] Del Monte Foods Company
[PAPER] Monadnock Dulcet Smooth 100lb (cover); Monadnock Dulcet Smooth 100lb, Champion Carnival Summer Vellum 70lb (text)
[COLORS] 5, process plus 4 match and varnish
[SIZE] 7" × 9¼" (18 × 25 cm) 78 pages
[PRINT RUN] 15,000
[COST PER UNIT] $4.53
[TYPE] Bembo, Helvetica Neue
[SPECIAL FOLDS/FEATURES] Recipe cards were interleaved between each consumer case study

"Our objective was to design a concept based on their corporate tag line, 'Inspiring Great Meals at Home and On the Go'," says designer Todd Richards. *"We did not want to bore the reader with a book full of lifestyle portraits of people in their kitchens and around the dining table. The wacky illustrations existed and fit well with the warm and fuzzy consumer approach we were looking for, as well as looking different."*

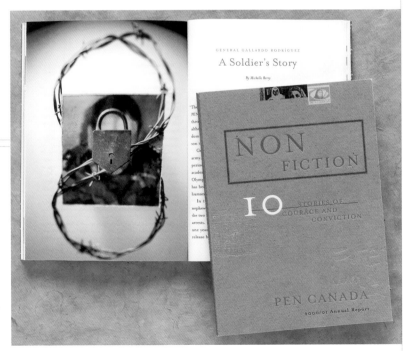

PEN CANADA ANNUAL REPORT ◄

[STUDIO] Soapbox Design Communications
[ART DIRECTORS] Gary Beelik, Jim Ryce
[DESIGNER] Jim Ryce
[ILLUSTRATOR] Paul Dallas
[PHOTOGRAPHER] James Reid
[CLIENT] PEN Canada
[CLIENT'S PRODUCT/SERVICE] Human Rights
[PAPER] Strathmore 80lb Text, Bright White 100lb Spexel Cover Limited Edition Art Paper
[SIZE] 5" × 7" (13 × 18 cm)
[PRINT RUN] 2,500
[COST PER UNIT] $2.50 each
[TYPE] Mrs Eaves (heads, decks and body); Trade Gothic (secondary text)
[SPECIAL PRODUCTION TECHNIQUES] The cover was printed in four process colors, and we scanned a piece of cardboard for the cover background image. The type and graphic images were blind debossed to give the look of letterpress printing.
[INSPIRATION/CONCEPT] "The stories and lives of the people who have been put in prison for their beliefs," says art director Gary Beelik.

RELIANCE STEEL & ALUMINUM CO 2000 ANNUAL REPORT ▶

[STUDIO] Louey/Rubino Design Group Inc.
[ART DIRECTORS] Robert Louey, Karen Dacus
[DESIGNER] Robert Louey
[PHOTOGRAPHER] Eric Tucker
[CLIENT] Reliance Steel & Aluminum Co
[CLIENT'S PRODUCT/SERVICE] Metals Processing
[PAPER] 100# Starwhite (cover), 100# McCoy Matte (text)
[COLORS] 8/8, match and process plus varnish
[SIZE] 7½" × 10" (19 × 25 cm)
[PRINT RUN] 10,000
[TYPE] Janson, Univers condensed
[SPECIAL PRODUCTION TECHNIQUES] Embossing and special match fluorescent and metallic inks
[SPECIAL FOLDS/FEATURES] Gatefolds
[INSPIRATION/CONCEPT] "Scientific diagrams, charts," says art director Robert Louey, "and The Periodic Table of Elements."

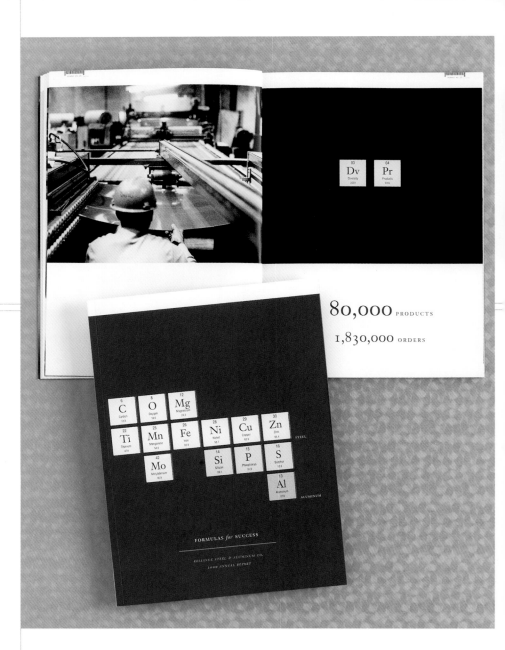

Annual reports are the most important informational communications tools public companies produce in a given year. They contain a large quantity of data, yet must be simple, straightforward and must engage the reader with a compelling story of the company's vision for the future. We find that the key to producing a successful annual is to work directly with only high level company representatives and to focus on an intelligent story.

ROBERT LOUEY

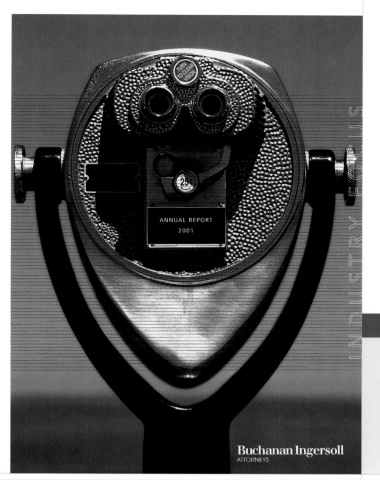

BUCHANAN INGERSOLL
ANNUAL REPORT ◀ ▼

[STUDIO] Greenfield/Belser
[ART DIRECTOR] Burkey Belser
[DESIGNERS] Charlyne Fabi, Liza Corbett
[CLIENT] Buchanan Ingersoll
[CLIENT'S PRODUCT/SERVICE] Law firm
[PAPER] 80 lb. McCoy Gloss cover
[COLORS] 4, process and match plus spot dull varnish and
gloss varnish
[SIZE] 8½" × 11" (22 × 28 cm)
[PRINT RUN] 20,000
[TYPE] Bodoni Heavy, AntiqueOlive Light, Bulmer MT

"By balancing strong images and lean text, the page design focuses on the law firm's clients rather than the firm itself," says art director Burkey Belser. "'Slice-of-life' photographs portray events in the lives of clients—not the usual office shots—to convey that Buchanan Ingersoll understands each client's business. The box-and-arrow device neatly connects pictures and words and summarizes the connection."

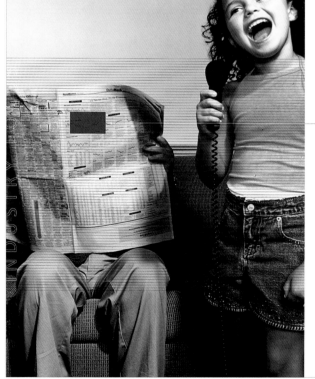

Buchanan Ingersoll in 2001

Industry Presence

Buchanan Ingersoll works with many of the world's largest and fastest-growing companies. We focus on the industries that are, or will likely be, most significant to our clients—allowing us to address their legal and business needs quickly and effectively.

WE REPRESENTED FINANCIAL INSTITUTIONS IN APPROXIMATELY 300 TRANSACTIONS VALUED AT MORE THAN $20 BILLION.

:: President George W. Bush nominated Buchanan Ingersoll attorneys Joy Flowers Conti and Arthur Schwab for two of only three U.S. District Court judgeships in the Western District of Pennsylvania. Their nominations are pending Senate confirmation.

:: For the second time in five years, James Kennedy was named "Best Healthcare Attorney" by the *Florida Medical Business* newspaper.

:: In 2001 Thomas VanKirk, former chairman of the board of the Pittsburgh Downtown Partnership, chaired the search committee to secure a new executive director for the economic development partnership.

:: Mark Neuberger, head of the firm's South Florida labor group, developed a five-step plan for how businesses should deal with the rising concerns of workplace security following September 11.

:: Buchanan Ingersoll's dedication to its communities is evident in the pro bono work we performed in 2001. The firm recorded more than 16,000 hours of pro bono legal activity for organizations such as the Disabilities Law Project, The Dollar Energy Fund and KidsVoice, the child advocacy project that served as the basis for the drama series *The Guardian*.

BIOMEDICAL AND PHARMACEUTICALS
Buchanan Ingersoll has one of the broadest biomedical and food and drug practices in the United States. Under the leadership of Edward Allera, Ronald Schuler and Robert Pinco, the revenues of this group increased by more than 20 percent in 2001. Our 30 attorneys serve nearly 300 life science clients worldwide—from companies that help map the human genome to those that treat cancer. In the wake of September 11, many of our biotechnology clients are playing a leading role in the war on bioterrorism.

Through our Miami office and our government relations professionals, the firm represented American Media, Inc., whose Florida headquarters was contaminated with anthrax. The firm's efforts to obtain federal relief for the cleanup costs included discussions with key Cabinet agencies such as the Office of Homeland Security and the Environmental Protection Agency. We also advised American Media on some unique insurance claim issues to assist with the significant cleanup costs.

In 2001, our work also included:

:: More than 20 licensing transactions for Cellomics with commercial entities and research institutions.

:: Technology transfer and co-development transactions for Sequel Genetics, Inc., Pharmactinium, Inc., Clairus Technologies, Inc., GeneScan Europe and others.

:: Bioterrorism lobbying before Congress and the Executive Branch regarding funding and policy for detection, treatment and vaccination initiatives on behalf of Celsis, CyGene, Inc., Gradipore, Inc. and others.

:: Serving as legal counsel to the BSE Coalition, an international organization of leading pharmaceutical companies concerned about the possible spread of Mad Cow Disease into the United States, we assisted the group in protecting the ability of the pharmaceutical industry to use pharmaceutical grade gelatin in their products. We have also been actively involved in assessing the regulatory issues and in maintaining a dialogue with the Food and Drug Administration and other federal agencies that impact those products.

:: Developing a proposal for a venture capital fund to provide federal seed money for anti-bioterrorism research. The proposal was selected as "Idea of the Week" by Washington's Democratic Leadership Council.

CORPORATE FINANCE AND TECHNOLOGY
Led by Carl Cohen and Thomas Thompson, our more than 80 corporate finance attorneys have played roles in hundreds of corporate and business transactions—including mergers, acquisitions, joint ventures, SEC registrations, and debt and equity financings—that totaled nearly $7 billion in 2001.

Representative corporate finance transactions of 2001:

:: The firm represented a telecommunications client in cable system acquisitions and swaps with an aggregate value of over $2.5 billion. We also represented the company in various securities offerings.

:: On behalf of our client Pitt-Des Moines, Inc., an American Stock Exchange-listed

Buchanan Ingersoll :: 2001 Annual Report 05

QWEST 2001 ANNUAL REPORT ▼

[STUDIO] Cahan & Associates
[ART DIRECTOR] Bill Cahan
[DESIGNER] Bob Dinetz
[PHOTOGRAPHER] Daniel Stier
[CLIENT] Qwest Communications

[CLIENT'S PRODUCT/SERVICE] Broadband and telecommunications
[PAPER] Opus Dull
[PRINT RUN] 280,000
[TYPE] Futura

"Qwest is both a global broadband company and a 14-state phone company," explains art director Bill Cahan. "To show this dichotomy and reflect the range of products available to customers, we showed people's images twice, with quotes indicating the two Qwest products they use. The message continued with company facts grouped in unlikely pairs, such as: 'A local phone company linking customers in 25 countries.'"

Qwest is my communications company.

Qwest 2001 **Annual Report**

"Qwest is my broadband company and my long-distance company."

2 · Qwest 2001

Qwest 2001 · 3

Qwest operates the world's largest fiber optic broadband network.

"Qwest is my Web hosting company and my wireless company."

285

IRI INFOPRO BROCHURE AND CARRIER ▶ ▼

[STUDIO] Maddock Douglas
[ART DIRECTOR/DESIGNER] Maddock Douglas
[CLIENT] IRI (Information Resources)
[CLIENT'S PRODUCT/SERVICE] Web-based applicaton that
 gives consumer package goods analysts access to up-to-
 the-minute IRA data over the Internet
[PAPER] 100 lb. Lustro Dull cover (folder), 80 lb. Lustro Dull
 Cover (brochure)
[COLORS] 4, process plus 1 PMS and overall aqueous coating
[SIZE] 8½" × 11" (22 × 28 cm)
[PRINT RUN] 20,000
[TYPE] Gill Sans
[SPECIAL FEATURES] Four-page fold-out spread, spot gloss
 varnish, perfect binding

*"We wanted to creatively connect the consumer goods
packaging industry with consumer buying habits," says
art director Maddock Douglas. "The idea of looking clos-
er was represented by the detail snapshots of con-
sumers making decisions while shopping."*

InfoPro Features
- Web accessible
- Open, industry-standard architecture
- Microsoft® Windows-user interface
- Business intelligence layer
- Creation of personal custom aggregates
- Measure creation "on-the-fly"
- Ability to merge scripts and lists
- Concurrent ranking reports
- Drill down capabilities in charts
- Ability to toggle "on-the-fly" between views – reports, graphs, and charts
- Automated ability to publish reports & custom aggregates globally
- Dynamic spreadsheet links to live data
- Static and dynamic export to PowerPoint
- Global report repository
- Customizable tool bar
- No data refresh

We Listened

A team of dedicated IRI professionals worked closely with our customers to determine the next generation of data access, reporting and mining tools. The resulting feedback became the foundation of InfoPro's design, and was instrumental in creating the value of this powerful tool.

Familiar Microsoft® Windows environment

InfoPro was designed to be as easy to use as a Web browser. To simplify use, many standard Windows conventions have been incorporated into the tool. Additionally, users can export data, reports, charts and graphs to Excel or PowerPoint. The result is a truely user-friendly interface.

More efficient distribution and updating of organization-wide reports

InfoPro has been designed to allow users to save queries, reports and selections to either a local or shared repository. These reports can be saved in a variety of formats, including Excel, PowerPoint, HTML and InfoPro native. InfoPro reports can be saved in a static or dynamic mode where live connections back to the database are maintained for drill-down analysis. Updated dynamic reports can be accomplished with one click.

9:25 am
Chicago, IL
Based on critical data accessed via the Web,
CEO makes split-second decision to approve
new in-store promotion.

1:14 pm
Cincinnati, OH
Company analysts share data across
business units revealing opportunity to
regain market share on
the East Coast.

Executives Will:
- Quickly access critical data via a user-friendly, Windows-like interface on the Web
- Utilize automatically updated pre-populated top line reports and KPI's that are customized for their specific business needs
- Get immediate answers by drilling down within reports, no need to go back to source
- Focus on the business

12:05 pm
Milano, Italia

9:48 am
New York City, NY

2:42 pm
Atlanta, GA

Web-accessible

Immediate

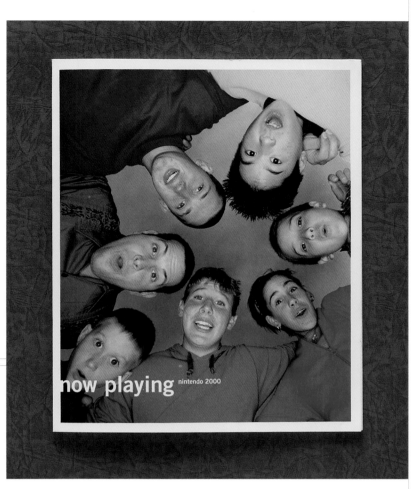

NOW PLAYING: NINTENDO
2000 ANNUAL REPORT ◄

[STUDIO] Leimer Cross
[ART DIRECTOR] Kerry Leimer
[DESIGNERS] Kerry Leimer, Marianne Li
[PHOTOGRAPHERS] Mika (locations), Michael Indresano (products)
[CLIENT] Nintendo Co., Ltd.
[CLIENT'S PRODUCT/SERVICE] Video games
[PAPER] Utopia and Monadnock
[COLORS] 12/12 (cover and narrative); 6/6 (financials), match and process
[SIZE] 9¼" × 11⅛" (23 × 28 cm)
[PRINT RUN] 20,000
[TYPE] Grotesque Black, Garamond No. 3
[SPECIAL PRODUCTION TECHNIQUES] Multiple dry trap and touch-plate passes
[SPECIAL COST-CUTTING TECHNIQUES] "Nintendo's budget for this report was not restrictive," says art director Kerry Leimer.
[INSPIRATION/CONCEPT] Competitive environment

When you're just getting started, an awareness of the work of other designers is imperative. It will help you begin to recognize what works and why, and it will begin to help you shape your own comprehension and approach to creative work.
KERRY LEIMER

287

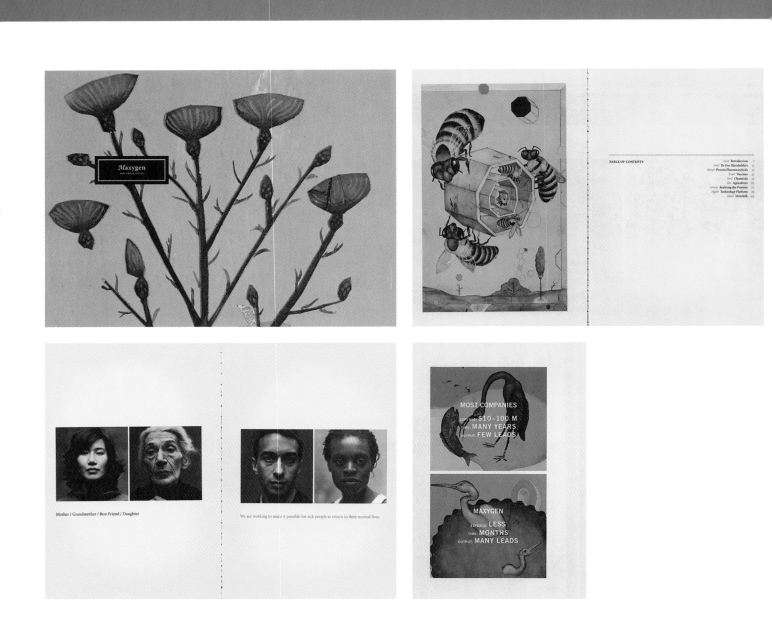

MAXYGEN 2000
ANNUAL REPORT ▲

[STUDIO] Cahan & Associates
[ART DIRECTOR] Bill Cahan
[DESIGNER] Gary Williams
[PHOTOGRAPHERS] Ann Giordano, Esther Henderson,
 Ray Manley, Robert Markow, John Sann
[ILLUSTRATOR] Jason Holley
[CLIENT] Maxygen
[CLIENT'S PRODUCT/SERVICE] Biotech/molecular
 breeding
[PAPER] Vision
[SIZE] 7" × 10" (18 × 25 cm)
[PRINT RUN] 20,000
[TYPE] Minion, Trade Gothic

"Maxygen wanted to focus on their products this year," says art director Bill Cahan. *"My first thought was to create a book/journal that felt like something found in the 19th century, a scientific journal of sorts. Visually, the theme of the report rested on the idea of nature as a metaphor. The size and scope of the book emphasized the credibility of Maxygen as the leader in its industry."*

Wear your game face every day.

LISA KLIMAN

GIRL SCOUTS ANNUAL REPORT ▼

[STUDIO] Liquid Agency, Inc.
[ART DIRECTOR] Lisa Kliman
[DESIGNER] Jennifer Larsen
[PHOTOSHOP SPECIALIST] Jeff Gardner
[PHOTOGRAPHER] Mark Leet Photography
[CLIENT] Girl Scouts of Santa Clara County
[CLIENT'S PRODUCT/SERVICE] Provides girls and young women with life skills that help them reach their full potential.
[PAPER] StarWhite Vicksbur
[COLORS] 8 (4-color process plus 4 match)
[SIZE] 9" × 7" (23 × 18 cm) (annual); 28½" × 26" (72 × 66 cm) (poster/envelope wrapper)
[PRINT RUN] 14,000
[TYPE] GS MIX
[SPECIAL COST-CUTTING TECHNIQUES] Donated materials and services

"Many potential donors, and potential members maintain the misconception that the Girl Scouts is simply about selling cookies and going camping," says art director Lisa Kliman. "The concept behind this piece was to do away with the old, restricting perceptions and to inform about the impressive, contemporary realities of Girl Scouting."

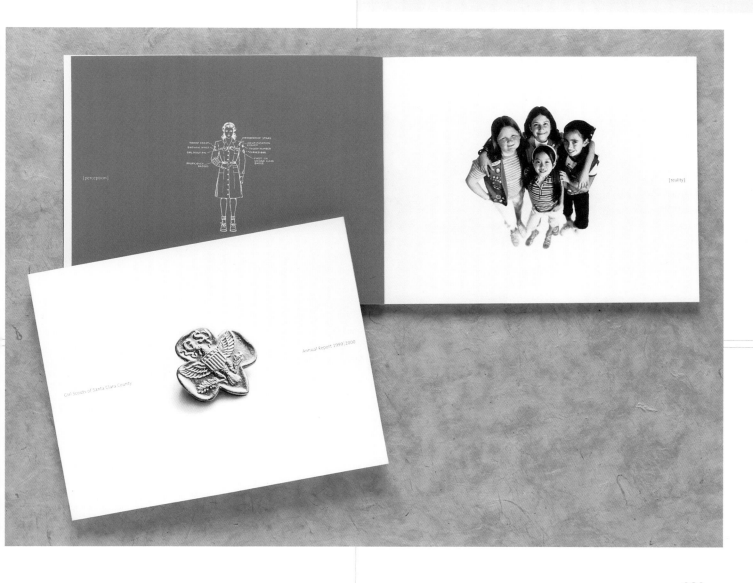

DMA MARKETING KIT ▼

[STUDIO] Platinum Design Inc.
[ART DIRECTOR] Mike Joyce
[DESIGNER] Andrew Taray
[ILLUSTRATOR] Andrew Taray
[CLIENT] Dimensional Media Associates
[CLIENT'S PRODUCT/SERVICE] 3-D holograms
[PAPER] Acetate, 130 lb. Mohawk Inkwell cover, 100 lb. Mohawk Inkwell text, 80 lb. Mohawk Navajo Inkwell cover (brochure)
[COLORS] 5, process plus metallic
[SIZE] 9" × 12" (23 × 30 cm)
[PRINT RUN] 3,000
[TYPE] Eurostile
[SPECIAL PRODUCTION TECHNIQUE] Die cut, color acetate overlays, wire binding of internal brochure

"Our inspiration for this kit was 3-D space and illusion," art director Mike Joyce says.

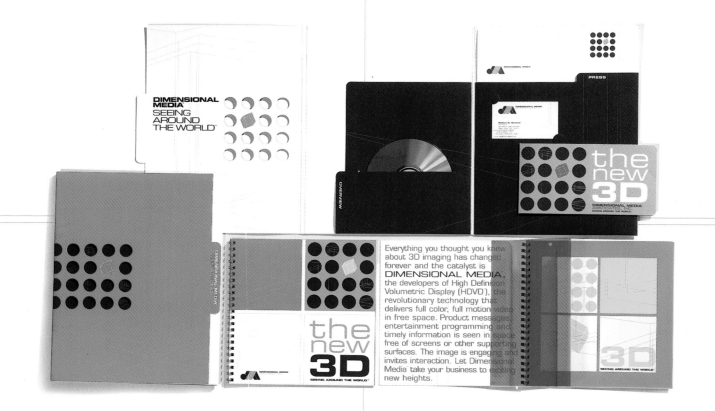

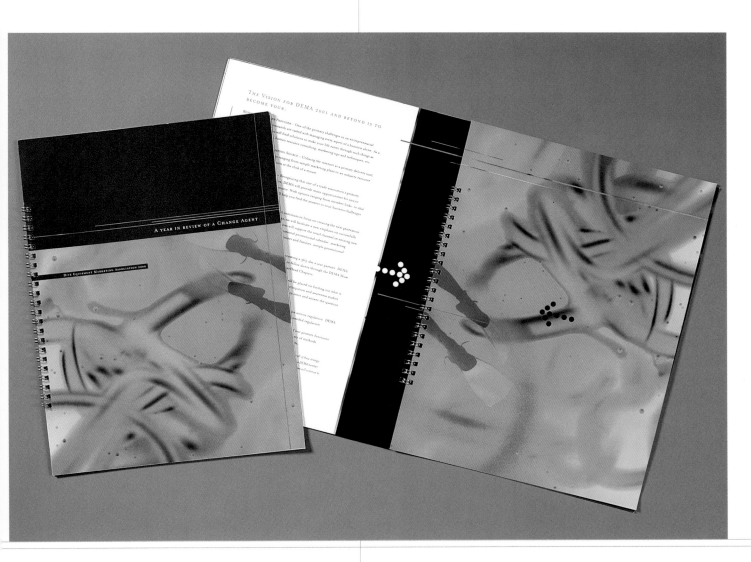

DEMA ANNUAL REPORT ▲

[STUDIO] Morris Creative
[ART DIRECTOR/DESIGNER] Steven Morris
[CLIENT] DEMA (Dive Equipment Marketing Association)
[PAPER] StarWhite Vicksburg
[COLORS] 4, process
[PRINT RUN] 5,000
[TYPE] Mrs Eaves

"We wanted to capture the spirit and energy of diving without showing traditional dive images,"
explains art director Steven Morris. "We also wanted to convey the spirit of the DEMA brand
through the progressive use of typography grounded in a traditional foundation."

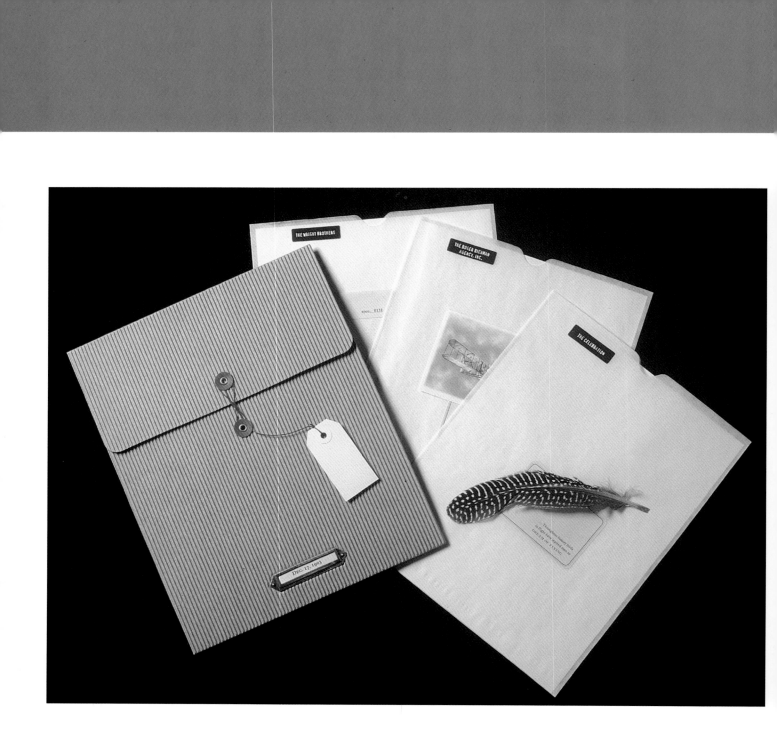

THE WRIGHT BROTHERS
100TH ANNIVERSARY
PRESS KIT ▶

[STUDIO] 30sixty design, inc.
[ART DIRECTOR] David Fuscellaro
[DESIGNER] Duy Nguyen
[CLIENT] The Roger Richman Agency
[CLIENT'S PRODUCT/SERVICE] Licensing agency
[PAPER] E-flute, Glassine Envelopes
[SIZE] 9" × 12" (23 × 30 cm)
[COST PER UNIT] $44
[TYPE] Confidential, Caslon
[SPECIAL PRODUCTION TECHNIQUES] Each press kit
 was hand assembled
[SPECIAL FOLDS/FEATURES] Use of a variety of mate-
 rials including cloth, metaland feathers

"The inspiration for the piece was, of course, the tremendous accomplishment of the Wright Brothers," says art director David Fuscellaro. "The concept for this press kit was for it to feel archival, as if it was a piece of history."

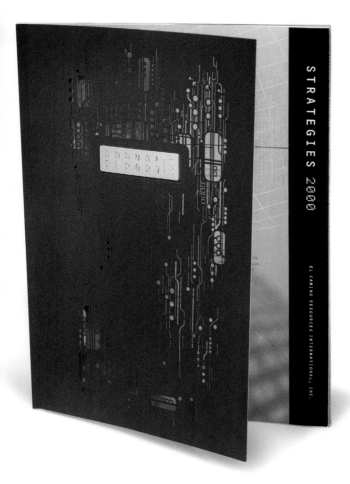

EL CAMINO RESOURCES INTERNATIONAL, INC. ANNUAL REPORT ◄

[STUDIO] [i]e design
[ART DIRECTOR] Marcie Carson
[DESIGNER] Cya Nelson
[CLIENT] El Camino Resources International, Inc.
[CLIENT'S PRODUCT/SERVICE] Computer mainframe reseller, lessor; information technology solution provider and electronic commerce developer
[PAPER] Mohawk Options (cover); CTI Glama Opaline (interior); Strathmore Elements, Grid (financials)
[COLORS] 4, process plus black
[SIZE] 11¾" × 9" (30 × 23 cm), 38 pages plus cover
[PRINT RUN] 6,000 (English); 2,500 (Spanish); 1,000 (Portuguese)
[COST PER UNIT] $18.25
[TYPE] Courier (body copy); OCRB (subheads, folios); Bubbledot ICG (heads)
[SPECIAL PRODUCTION TECHNIQUES] "Four-color process was printed full-coverage on vellum, which is more difficult than it appears," says art director Marcie Carson. All type was printed in black, the fifth color. "This way English, Spanish and Portuguese versions of the text could be done in three separate print runs."
[SPECIAL FOLDS/FEATURES] Laser-cut circuit board pattern and the embossed metal plate tip in on the cover. For the French-folded pages, the design was printed on only one side of the sheet, and the outer edge was folded; the inner edge was perfect bound.
[SPECIAL COST-CUTTING TECHNIQUES] Numerous CD-ROM stock photographs were collaged with illustrations done by the studio to create "custom" computer imagery. This way the money allocated for the photography budget could be put toward printing.

"We wanted to visually depict the inner workings of a computer—its thoughts, communication and movement," says art director Marcie Carson. "This concept led to the circuit board pattern that was laser cut into the cover; it invites the reader inside the workings of the annual. We decided to print the computer-driven design on French-folded vellum sheets so the layout was constantly changing and moving, much like a computer."

CONSOLIDATED PAPER PROMO ▼

[STUDIO] Cahan & Associates
[ART DIRECTOR] Bill Cahan
[DESIGNERS] Bob Dinetz, Mark Giglio, Kevin Roberson
[PHOTOGRAPHERS] Bill Dinetz, Graham MacIndoe, Mark Giglio, Robert Schlatter, Ken Probst, Steve McCurry, Wade Goddard, Paul Chesley, Richard Nowitz, David Turnley, Glen Allison, Peter Brown

[ILLUSTRATORS/COPYWRITERS] Bod Dinetz, Mark Giglio, Kevin Roberson, Lars Tunbjork
[CLIENT] StoraEnse/Consolidated Papers
[CLIENT'S PRODUCT/SERVICE] Paper manufacturer
[PAPER] Reflections Silk
[SIZE] 3½" × 4½" (9 × 11 cm)
[TYPE] Helvetica

"Photographs, illustrations and diagrams make straightforward and unexpected observations about the nature of public companies and their yearly financial publication, the annual report," says art director Bill Cahan. "Some of the topics addressed are deadlines, financial disclosure, earnings, branding, shareholders, expediency, seduction, artifice and the corporate ladder. Each chapter employs its own visual style, ranging from loose Polaroid photography to hard-edge illustration. Preceding each chapter is an introductory spread that includes a running table of contents and a coded symbol. A legend in the back of the book explains each chapter idea with a statement and corresponding thumbnail. The small size is meant to make this book a keepsake for designers and a fun giveaway for merchants."

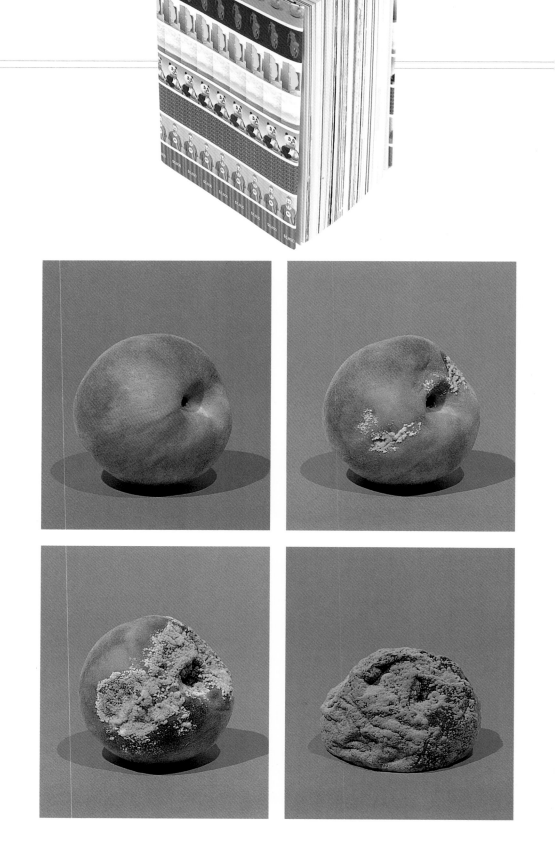

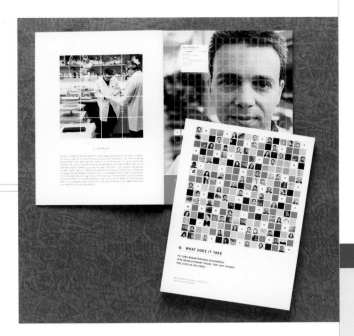

REGENERON ANNUAL REPORT ◄

[STUDIO] Ideas on Purpose
[ART DIRECTORS] Darren Namaye, Michelle Marks
[DESIGNER] Darren Namaye
[PHOTOGRAPHER] Horacio Salinas
[CLIENT] Regeneron Pharmaceuticals
[CLIENT'S PRODUCT/SERVICE] Biopharmaceutical company that discovers, develops and intends to commercialize medicines for the treatment of serious medical conditions
[PAPER] Ikono Matte (front section); Champion Carnival Summer (financials)
[COLORS] 4-color process plus 2 match colors in front and 1 match color in the financials
[SIZE] 7¼" × 9¾" (18 × 25 cm)
[PRINT RUN] 24,000
[TYPE] Trade Gothic

"Regeneron wanted to feature people and somehow communicate the idea that it was a fully integrated biotech company," says art director Michelle Marks. "So, to get across the idea that Regeneron 'has what it takes,' we featured people from different disciplines within the organization. We used a Scrabble metaphor to get across the idea that all these pieces are interconnected and work together."

SUPERGEN ANNUAL REPORT ◄ ▼

[STUDIO] Alterpop
[ART DIRECTOR] Dorothy Remington
[DESIGNER] Christopher Simmons
[PHOTOGRAPHY] Client-supplied photos
[CLIENT] SuperGen, Inc.
[CLIENT'S PRODUCT/SERVICE] Biopharmaceutical company that specializes in oncology
[PAPER] 65# Sundance Smooth Cover, Ultra White
[COLORS] 5
[SIZE] 8¼" × 10¾" (21 × 27 cm)
[PRINT RUN] 30,000
[COST PER UNIT] $2.16
[TYPE] Mrs Eaves, Interstate
[SPECIAL PRODUCTION TECHNIQUE] Litho printing

"Oncological research is a long-term undertaking," says designer Christopher Simmons. "As such, results don't often coincide with the end of the fiscal year. With no new breakthroughs, drug approvals or revenue boosts to report, we made the focus the clinicians who are using SuperGen's products. A series of five interviews addresses a different aspect of each client's work. The interviewees are all prominent clinicians in their respective fields; their voices are an endorsement of the important work that SuperGen is pursuing."

FOSSIL ANNUAL REPORT 2000 ▶

[STUDIO] Fossil
[ART DIRECTORS] Tim Hale, Stephen Zhang
[DESIGNERS] Lana McFatridge
[ILLUSTRATORS] Ellen Tanner, Eric Cash, Stephen Zhang, David Eden, Brad Bollinger, Marty Christiansen, Dominique Pierron, Olivia Turner, Sara Carpeaux, Jun Park, Dru McCabe, Brandon Webster, Greg Wolverton, Lana McFatridge, Scott Boyd, Albert Hernandez, Charles Spearman, Rick Miranda, Jon Arvizu, Robbie Wilson
[PHOTOGRAPHERS] David McCormick, Russ Aman
[PAPER] Mead Escanaba
[COLORS] 7, process and match
[SIZE] 10½" × 13½" (27 × 34 cm)
[PRINT RUN] 10,000
[COST PER UNIT] About $5
[TYPE] Berkeley
[SPECIAL TYPE TECHNIQUES] Designer Lana McFatridge says "much of the type in the graphics was hand rendered, scanned in and incorporated into the 'ads' with various Photoshop techniques like blurring the edges and adding noise."
[SPECIAL PRODUCTION TECHNIQUES] "We used a tint varnish over the whole piece to give the feeling of an aged publication," says designer Lana McFatridge.
[INSPIRATION/CONCEPT] Popular 1950s magazines

CYGNUS INC. ANNUAL REPORT ▶

[STUDIO] Howry Design Associates
[ART DIRECTOR] Jill Howry
[DESIGNER] Ty Whittington
[PHOTOGRAPHER] Dwight Eschliman
[CLIENT] Cygnus, Inc.
[CLIENT'S PRODUCT/SERVICE] Glucose Watch Biographer
[PAPER] Beckett 80# Expression
[COLORS] 3, match
[SIZE] 7" × 9½" (18 × 24 cm)
[PRINT RUN] 28,000
[TYPE] Trade Gothic
[SPECIAL FOLDS/FEATURES] Belly Band used to bind report and 10K.

"The Glucose Watch Biographer is designed to help people with diabetes measure their blood sugar frequently and noninvasively through the convenience of a device worn like a wristwatch," says designer Ty Whittington. "The information supplied by the Glucose Watch has the potential to improve lives by giving automatic information about blood sugar levels, which up until now have only been obtained by finger stick blood monitoring. The annual report highlights other inventions throughout history that have helped man navigate through potentially dangerous territories."

VALENTIS 2000 ANNUAL REPORT ◄ ▼

[STUDIO] Cahan & Associates
[ART DIRECTOR] Bill Cahan
[DESIGNER] Sharrie Brooks
[CLIENT] Valentis
[CLIENT'S PRODUCT/SERVICE] Biotechnology
[PAPER] Cougar opaque vellum
[SIZE] 5½" × 7" (14 × 18 cm)
[PRINT RUN] 7,000
[TYPE] Franklin Gothic

"Valentis is a biotechnology company developing a broad technology platform consisting of several in vivo, nonviral gene delivery systems," explains art director Bill Cahan. "The small format of the book was continued from the previous year and, due to budget restraints, worked well. The use of color and geometric forms help illustrate the company's message."

A Year of Progress

Over the past year, we have transformed Valentis from a combination of three companies rich in intellectual property and technologies to a well-integrated company focused on the development of products. We now have a diversified pipeline of products targeting large markets in pre-clinical and clinical development. Our challenge going forward is to ensure the expeditious development of our products with the greatest potential shareholder value by carefully managing our financial and technical resources. ■■■■ Through our mergers, we have assembled what we believe is the broadest array of delivery technologies and intellectual property for the delivery of biopharmaceuticals. Biopharmaceuticals are protein-based products, in contrast to traditional pharmaceuticals which are chemical-based. We strongly believe biopharmaceuticals will be the growth area in therapeutics for many years to come as the field is being driven by the success of genomics research, the largest biological mission in our lifetime. ■■■■ The more near-term products coming from genomics research should continue to be proteins, antibodies and gene medicines, and their success will provide Valentis with a steady stream

of potential products to which we can apply our delivery technologies. The focus on delivery technologies enables us to create both novel therapeutics and improved versions of currently marketed therapies, creating a nicely diversified portfolio. ■■■■ Our technologies for the delivery of gene medicines involve the use of lipid or polymer delivery systems and proprietary expression systems. Our most advanced products are gene medicines in the oncology area and, through a collaboration with Roche, we are developing a series of cancer immunotherapeutics. These are gene medicines injected directly into tumors to turn on the patient's immune system for a systemic immune response both to the primary tumor as well as to the sites where the tumor has spread. ■■■■ Following these products into clinical trials will be a systemically administered immunotherapeutic. With this product, our strategy is to localize the production of a known efficacious protein to the site where it is needed and to spare the rest of the body from its commonly associated adverse effects. ■■■■ In the cardiovascular area, we are focusing on gene medicines that stimulate angiogenesis, or new blood vessel formation.

4

5

Cancer Gene Medicines

IL-2	Phase IIa
IFN-α	Phase IIa
IL-12	Phase IIa
IL-2+chemotherapy	Phase IIb
IL-12 + IFN-α	Phase IIa
IL-2 + Superantigen B	Phase IIa
IV IL-2	IND
BRCA-1	Preclinical
Anti-angiogenesis genes	Preclinical

THE GEORGE GUND FOUNDATION
ANNUAL REPORT ▼

[STUDIO] Nesnadny + Schwartz
[ART DIRECTOR] Mark Schwartz
[DESIGNER] Michelle Moehler
[PHOTOGRAPHER] Douglas Lucak
[CLIENT] The George Gund Foundation
[CLIENT'S PRODUCT/SERVICE] Private, nonprofit institution
[PAPER] Sappi Lustro Dull, 100#T; French Parchtone, white, 60#T and 80#C
[COLORS] 6/6, 3 match plus 2 blacks and gloss spot varnish (coated); 4/4, match (uncoated)
[SIZE] 8 × 8" (20 × 20 cm)
[PRINT RUN] 3,500
[TYPE] Bickham Script, Kepler
[SPECIAL PRODUCTION TECHNIQUES] Tritones (a "special mix" gray and two blacks)
[SPECIAL FEATURES] Peek-a-boo window, double die-cut window, gatefold

Throughout my career, I have worked on projects with strict guidelines and projects where the sky seems to be the limit. In all honesty, I find the challenge of having to work within certain parameters to be the most rewarding. Pushing yourself to find a super-creative, costeffective solution can be extremely gratifying. Those are the pieces you cherish in the long ru

MICHELLE MOEHLER

"The unusual colors found in Douglas Lucak's hand-toned prints inspired the palette of four match colors in the book. The undulating quality of the skies in the photographs lead me to the Parchtone paper which makes up half of the book. The 3⅜" (9 cm) images (reproduced at actual size) inspired the small format. To me, the small size of the book reflects the jewel-like quality of the photographs."

FOGDOG SPORTS 1999 ANNUAL REPORT ◄

[STUDIO] Cahan & Associates
[ART DIRECTOR] Bill Cahan
[DESIGNER] Todd Simmons
[PHOTOGRAPHER] Todd Hido
[CLIENT] Fogdog Sports
[CLIENT'S PRODUCT/SERVICE] Online sporting-goods
[PAPER] Appleton Utopia 2 matte
[SIZE] 6" × 7½" (15 × 19 cm)
[TYPE] Helvetica Neue 55

"The approach for this piece, the first annual report/marketing tool for Fogdog Sports, was to evoke a unique understanding of the everyday online shopper/sport enthusiast," explains art director Bill Cahan. "When it comes to traditional sports graphics, there tends to be a strong use of gelled-out, motion-rich photography and typography. Also, images of professional athletes are often used to convey a 'Be Like Mike' message. It was the strict intention of this piece not to do that. Instead, we took studio portraits of everyday people, then French-folded the portraits to form interesting juxtapositions between a person's working life and his or her dedicated playtime (or alterego). For these individuals, sports don't necessarily equal life, only perhaps the better half of it. The typographic formatting came out of a desire to keep the overall look of the piece semi-technical, a constant characteristic of any sporting enthusiast's vernacular."

RIAA 2000 ANNUAL
REPORT ▶

[STUDIO] Ashby Design
[ART DIRECTOR/DESIGNER] Neal Ashby
[PHOTOGRAPHER] Mike Northrup
[ILLUSTRATOR] John Moore
[CLIENT] Recording Industry Association of America (RIAA)
[CLIENT'S PRODUCT/SERVICE] Trade association for the
 record industry
[PAPER] Potlatch McCoy
[COLORS] 6, process and match
[SIZE] 10" x 10" (25 x 25cm)
[PRINT RUN] 5,000
[COST PER UNIT] $8
[TYPE] Avant Garde
[SPECIAL PRODUCTION TECHNIQUE] Addition of fluores-
 cents to inks
[SPECIAL FOLDS/FEATURES] Back panel folds to hold CD
[SPECIAL COST-CUTTING TECHNIQUE] Using digital pho-
 tography and interns and students as models

"The RIAA wanted to be proactive in laying down its
position that music does matter to people, it has value,
it isn't something that should be taken for granted and
that the organization plans to protect it," art director
Neal Ashby says. "The report needed to reinforce the
message that the American record industry is working
hard to provide a legitimate online environment for the
digital distribution of music. The CD-ROM, showing digi-
tal links to thousands of music web sites (other than
pirating web sites like Napster), seemed a dynamic way
to prove the client's point."

AR.2000 MUSIC MATTERS ANNUAL REPORT Recording Industry Association of America

THIS CD HAS MILLIONS OF SONGS

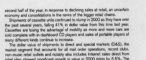

KEEPING TIME MANUFACTURER'S UNIT SHIPMENTS AND DOLLAR VALUE

Despite a very strong first half of the year, the market for recorded music in the United States declined sharply in the last six months of 2000. However, the appetite for music remains strong as the mainstay of the recording industry, the full-length compact disc, continued to grow in dollar value. While shipments of full-length CDs increased 3.1% in dollar value over last year, manufacturers saw their bottom line drop nearly 7% in unit shipments, while the dollar value of those units declined 1.8% from $14.6 billion in '99 to $14.3 billion last year.

This decrease is largely attributed to new options provided by the Internet, which drove changes in consumer purchasing habits. This was most visible in a notable reduction in shipments of CD singles, which fell 38.8% in 2000. This one-year decrease in CD singles shipments was preceded by a 200% growth between 1995 and 1997 and flat growth in 1998 and 1999. Free access online seems to have had a dramatic effect on the singles markets as well as the sluggish growth in CD shipments. Added to that, retailers began tightening their inventories and purchasing more conservatively in the second half of the year, in response to declining sales at retail, an uncertain economy and consolidations in the ranks of the bigger retail chains.

Shipments of cassette units continued to slump in 2000 as they have over the past several years, falling 41% in dollar value from this time last year. Cassettes are losing the advantage of mobility as more and more cars are sold complete with in-dashboard CD players and sales of portable players of many different kinds continue to increase.

The dollar value of shipments to direct and special markets (D&S), the market segment that accounts for all mail order operations, record clubs, non-music retail outlets and notably also includes Internet sales direct from label sites showed significant growth in value in 2000 rising by 5.5%. The D&S market makes up 27% of the marketplace.

Music video shipments continued to drop this past year from 19.8 million units in 1999 to 18.2 million in 2000. However, it is important to note a sizeable growth of 35.2% in DVD music video unit shipments during the same period indicating how popular the format has become with consumers.

	1991	1992	1993	1994	1995	1996	1997	1998	1999	2000	%CHANGE 1999-2000	
CD	333.3	407.5	495.4	662.1	722.9	778.9	753.1	847.0	938.9	942.5	0.4%	Units Shipped
	$4,337.7	$5,326.5	$6,511.4	$8,464.5	$9,377.4	$9,934.7	$9,915.1	$11,416.0	$12,816.3	$13,214.5	3.1%	(Dollar Value)
CD SINGLE	5.7	7.3	7.8	9.3	21.5	43.2	66.7	56.0	55.9	34.2	-38.8%	Calculated at suggested list price
	20.1	45.1	45.8	56.1	110.9	184.1	272.7	213.2	222.4	142.7	-35.9%	
CASSETTE	360.1	366.4	339.5	345.4	272.6	225.3	172.6	158.5	123.6	76.0	-38.5%	
	3,019.6	3,116.3	2,915.8	2,976.4	2,303.6	1,905.3	1,522.7	1,419.9	1,061.6	626.0	-41.0%	
CASSETTE SINGLE	69.0	84.6	85.6	81.1	70.7	59.9	42.2	26.4	14.2	1.3	-91.0%	
	230.4	298.8	298.5	274.9	236.3	195.3	133.5	94.4	48.0	4.6	-90.3%	
VINYL LP/EP	4.8	2.3	1.2	1.9	2.2	2.9	2.7	3.4	2.9	2.2	-24.6%	
	29.4	13.5	10.6	17.8	25.1	36.8	33.3	34.0	31.8	27.7	-12.7%	
VINYL SINGLE	22.0	19.8	15.1	11.7	10.2	10.1	7.5	5.4	5.3	4.8	-8.1%	
	63.9	66.4	51.3	47.2	46.7	47.5	35.6	25.7	27.9	26.3	-5.4%	
MUSIC VIDEO	6.1	7.6	11.0	11.2	12.6	16.9	18.6	27.2	19.8	18.2	-8.0%	
	118.1	157.4	213.3	231.1	220.3	236.1	323.9	508.0	376.7	381.9	-35.2%	
*DVD MUSIC VIDEO	na	na	na	na	na	na	na	0.5	2.5	3.5	35.2%	
	na	na	na	na	na	na	na	12.2	66.3	80.3	21.1%	
TOTAL UNITS	801.0	895.5	955.6	1,122.7	1,112.7	1,137.2	1,063.4	1,124.2	1,160.6	1,079.3	-7.0%	
TOTAL VALUE	$7,834.2	$9,024.0	$10,046.6	$12,068.0	$12,320.3	$12,533.8	$12,236.8	$13,723.5	$14,584.5	$14,323.0	-1.8%	

*While broken out for the chart, DVD Music Video Product is included in the Music Video totals.

Numbers compiled quarterly by PricewaterhouseCoopers LLP, represent data from companies that distribute approximately 84% of the pre-recorded music in the United States. To calculate unit shipments and dollar values for the remainder of the market, PricewaterhouseCoopers LLP utilizes retail sales data from SoundScan to estimate shipments by non-reporting companies. Dollar value is calculated at suggested list price.

LINEAR 2000 ANNUAL
REPORT ▲

[STUDIO] Cahan & Associates
[ART DIRECTOR] Bill Cahan
[DESIGNER] Todd Simmons
[PHOTOGRAPHER] Todd Hido
[ILLUSTRATOR] Todd Simmons
[CLIENT] Linear Technology Corporation
[CLIENT'S PRODUCT/SERVICE] Semiconductor chip
 manufacturer
[PAPER] Kromkote, Utopia 2 Dull
[SIZE] 4¼" × 6½" (11 × 16 cm)
[PRINT RUN] 93,000
[TYPE] Berthold Akzidenz Grotesk

"This piece, designed to be PDA-size, is divided into two 132-page books, Digital and Linear, to increase Linear's image on Wall Street as being one of the 'sexy' digital companies, not just another one of the analog or 'linear' ones," says art director Bill Cahan. "The Digital book has only ASCII code streaming through it, making it completely undecipherable. The Linear book opens with the caption 'Digital means nothing without linear.' From there, the reader gets a complete understanding of Linear's business and its relevance in making the digital world possible."

THE PROGRESSIVE CORPORATION ANNUAL REPORT ◄ ▼

[STUDIO] Nesnady + Schwartz
[ART DIRECTORS] Joyce Nesnadny, Mark Schwartz
[DESIGNERS] Joyce Nesnadny, Michelle Moehler
[ILLUSTRATOR] Greg Colson
[CLIENT] The Progressive Corporation
[CLIENT'S PRODUCT/SERVICE] Insurance
[PAPER] French Smart White 80# text and 110# cover, and Sappi Lustro Dull 100# Cover
[COLORS] 4, process plus 1 match (cover); 4, process plus 3 tinted varnishes and gloss spot
 varnish (coated paper); 6, match plus black (uncoated paper)
[SIZE] 8½" × 11" (22 × 28 cm)
[PRINT RUN] 60,000
[TYPE] Trade Gothic, Trade Gothic Light, Trade Gothic Bold Two
[SPECIAL PRODUCTION TECHNIQUES] Blind de-boss on uncoated paper (cover)
[SPECIAL FOLDS/FEATURES] Mix of coated and uncoated paper throughout
[SPECIAL COST-CUTTING TECHNIQUES] Using press imposition (different colors on different
 forms) to extend the number of colors available to us

"Our inspiration was the timeline sketches of the history of the automobile as it relates to
the Progressive Corporation, the auto insurance industry and their cyclical nature," say
the art directors. "The direction commemorates Peter B. Lewis's final year as the CEO of
a company he nurtured for 36 years."

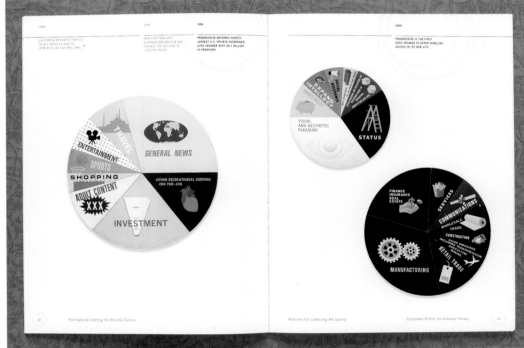

Ask yourself "Does it communicate? Is the idea clear? Have I considered the big picture and the small details?"
NESNADY + SCHWARTZ

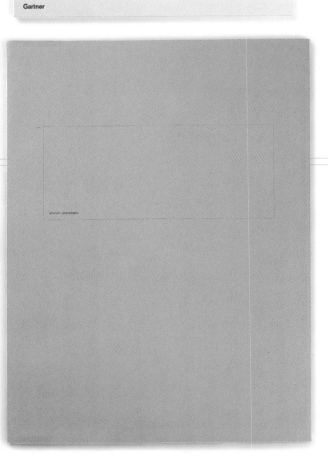

While companies look for ways to cut
expenditures in response to economic downturn,
the majority of our client relationships remain intact.
In most cases, they strengthen.

Gartner

GARTNER ANNUAL REPORTS
2000 AND 2001 ▲ ▶

[STUDIO] Cahan & Associates
[ART DIRECTOR] Bill Cahan
[DESIGNERS] Kevin Roberson (2000), Bob Dinetz (2001)
[PHOTOGRAPHERS] Lars Tunbjork, Steven Ahlgren, Catherine Ledner (2000), Frank Schwere (2001)
[ILLUSTRATOR] Steve Hussey (2000)
[CLIENT] Gartner
[CLIENT'S PRODUCT/SERVICE] Technology research and consulting
[PAPER] Utopia 2 Matte
[PRINT RUN] 45,000 (2000)
[TYPE] Corporate (2000); Akzidenz Grotesk (2001)

*"In the 2000 report, design details such as codified head-
lines, silhouetted line drawings and highlighted text
support the notion that Gartner acts as an organization's
secret weapon," art director Bill Cahan explains. "In the
2001 report, to convey the importance of Gartner's work,
unsuspecting business people are identified by indicat-
ing the information they may be lacking soon. After a
critical decision was made, the idea of repurposing
research among departments is conveyed through the
use of translucent pages. The pages explain the five
components that make up Gartner's company."*

IMAGE INFO MARKETING KIT ▼

[STUDIO] Platinum Design Inc.
[ART DIRECTOR] Mike Joyce
[DESIGNERS] Mike Joyce, Andrew Taray
[CLIENT] Image Info
[CLIENT'S PRODUCT/SERVICE] Fashion business software
[PAPER] Utopia
[COLORS] 5, process, plus metallic
[SIZE] 9" × 12" (23 × 30 cm)
[TYPE] Akzidenz Grotesk
[SPECIAL PRODUCTION TECHNIQUE] Side-stitching on brochure simulates fashion stitching

"The idea behind this is fashion blending with technology," art director/designer Mike
Joyce says.

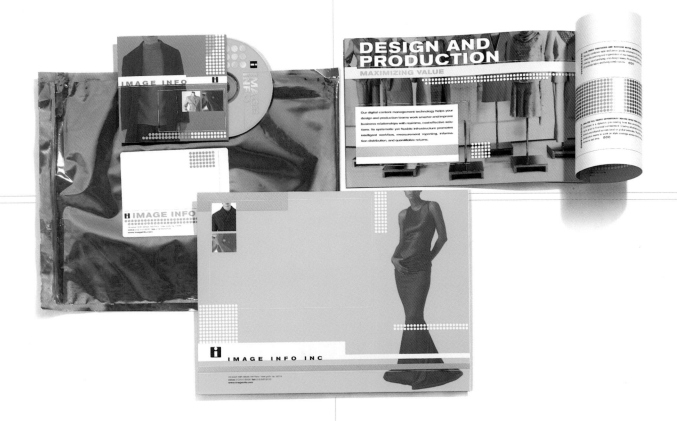

DELTA MARKETING KIT ▼

[STUDIO] Platinum Design, Inc.
[ART DIRECTOR] Vickie Peslak
[DESIGNER] Bazil Findlay
[CLIENT] Modem Media
[CLIENT'S PRODUCT/SERVICE] Strategic marketing
[PAPER] 18 pt. Carolina
[COLORS] 4 plus coating over 7 plus coating, PMS
[SIZE] 9¾" × 12"
[PRINT RUN] 1,000
[SPECIAL PRODUCTION TECHNIQUE] Die cut
[SPECIAL FEATURES] Housing simulates a briefcase for the business traveler

"The concept that inspired us is the idea of flying a paper airplane," art director
Vickie Peslak says.

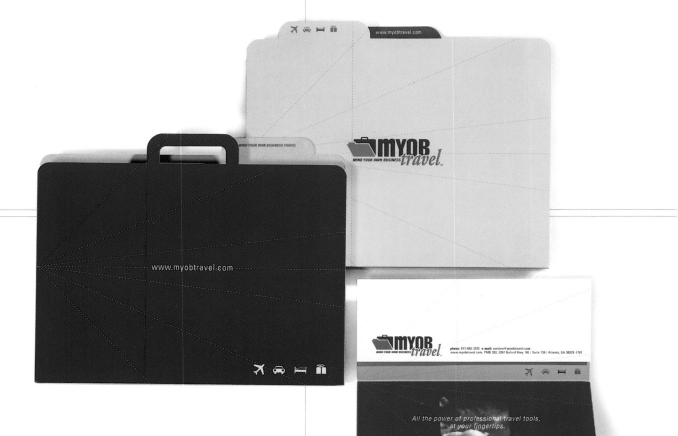

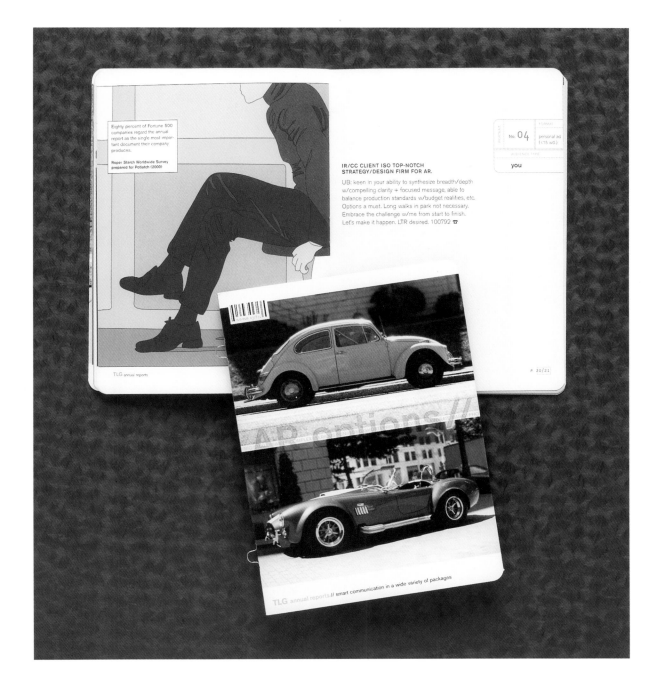

AR OPTIONS ▲

[STUDIO] Leonhardt Fitch
[ART DIRECTOR] Ray Ueno, Steve Watson
[DESIGNER] Ben Graham
[ILLUSTRATOR] Ben Graham
[PHOTOGRAPHER] Lesley Feldman
[PAPER] Fox River, Starwhite Vicksburg
[COLOR] 7/7, offset print
[SIZE] 5" × 6¾" (13 × 17 cm) (finished), 10" × 6¾" (25 × 17 cm) (text flat), 14⅞" × 6¾" (38 × 17 cm) (cover flat)
[PRINT RUN] 2000
[COST PER UNIT] Collaboration with GAC/Allied
[SPECIAL PRODUCTION TECHNIQUES] Debossing on front cover with translucent pearl foil stamp, metallic silver used sparingly throughout book
[SPECIAL FOLDS/FEATURES] Gatefold front cover to conceal foil deboss; rounded corners; loop-stitch binding; booklet mailed out in a translucent metallic envelope

"This piece was part of a campaign to promote our company's annual report and investor relations capabilities," says designer Ben Graham. *"We wanted to educate and inspire clients and potential clients with examples of alternative form factors for annual reports and investor communications. In the current economic climate, many companies are looking for intelligent, cost-effective solutions for their communications. The goal of the piece was to show our audiences that there are many solutions to this problem and that cost-effective doesn't have to mean cheap or uninteresting."*

WEIL GOTSHAL & MANGES ▶

[STUDIO] Greenfield/Belser
[ART DIRECTOR] Burkey Belser
[DESIGNERS] Burkey Belser, Liza Corbett
[CLIENT] Weil Gotshal & Manges
[CLIENT'S PRODUCT/SERVICE] Law firm
[PAPER] 120# McCoy Silk Cover, 100# McCoy Silk Text
[COLORS] 2 PMS, spot gloss varnish, spot dull varnish (cover); 4-color plus spot gloss varnish plus spot dull varnish (interior)
[SIZE] 9" × 12" (23 × 30 cm), 52 pages
[PRINT RUN] 20,000

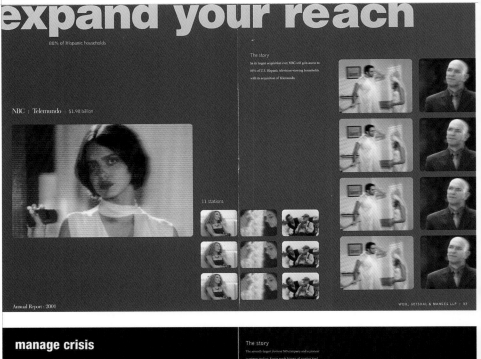

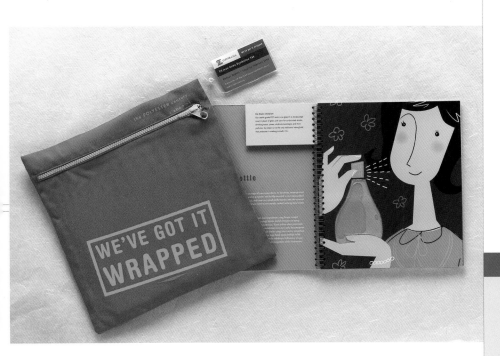

P.T. INDO-RAMA SYNTHETICS
TBK ANNUAL REPORT ◄

[STUDIO] Equus Design Consultants Pte Ltd
[ART DIRECTOR] Andrew Thomas
[DESIGNER] Paul Van Der Veer
[ILLUSTRATOR] Stanley Lau
[PHOTOGRAPHER] Artli, Artli Studio, Jakarta
[CLIENT] P.T. Indo-Rama Synthetics Tbk
[CLIENT'S PRODUCT/SERVICE] Polyester yarns/textiles
[PAPER] Wood-free
[COLORS] 4/4, process
[SIZE] 8½" × 10" (22 × 25 cm)
[PRINT RUN] 1,000 copies
[TYPE] Scala, Scala Sans
[SPECIAL FOLDS/FEATURES] Textiles and clear plastic
 incorporated into report using hand finishing, hand
 sewing, French folding, special die cuts.

*"The theme of the annual report was 'We've Got It
Wrapped,' referring to the strength of Indo-Rama's posi-
tion in the worldwide polyester industry," says art direc-
tor Andrew Thomas. "We therefore wrapped the report
in a bag made from Indorama's polyester (hence the
title), and illustrated the text in a retro sixties cartoon
style reminiscent of Paul Rand. This enabled us to incor-
porate Indorama's fabrics in the images, so readers of
the report could literally feel the quality."*

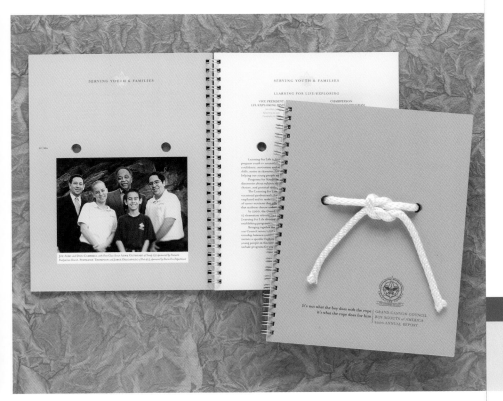

BSA GRAND CANYON
ANNUAL REPORT ◄

[STUDIO] Catapult Strategic Design
[ART DIRECTOR] Peter Jones
[DESIGNER] Peter Jones
[ILLUSTRATOR] Randy Heil/Cheney, Nieman, Munson & Son
[PHOTOGRAPHER] Doug Redig, Redig Photography
[CLIENT] Boy Scouts of America, Grand Canyon Council
[PAPER] Neenah Classic Crest Duplex 120# Cover, Nekoosa
 Solution Super Smooth Carrera White and Cream 80#
 Cover
[COLORS] 3, PMS
[SIZE] 9" × 7" (23 × 18 cm)
[PRINT RUN] 1,500
[COST PER UNIT] $17.33. Design and layout production
 fees donated pro bono. Photography, materials, bindery
 and printing donated or charged at lower costs.
[TYPE] Mrs Eaves
[SPECIAL PRODUCTION TECHNIQUES] Tying square knots
 through each annual report
[SPECIAL FOLDS/FEATURES] Silver Wire-O binding, rope
 tie, two drilled holes

*This annual report is based on the theme, "It's not
what the boy does with the rope, it's what the rope
does for him."*

ZOO ATLANTA ANNUAL REPORT ▶ ▼

[STUDIO] Vista
[ART DIRECTOR] Stephen Beshara
[DESIGNER] Stephen Beshara, Jason Sauer
[ILLUSTRATORS] Various
[PHOTOGRAPHER] Kevin Garratt
[CLIENT] Zoo Atlanta
[CLIENT'S PRODUCT/SERVICE] Entertainment, wildlife preservation
[PAPER] Neenah paper (several stocks)
[COLORS] 8, process and match plus hexachrome spots
[SIZE] 7" × 9" (18 × 23 cm)
[PRINT RUN] 18,000
[COST PER UNIT] Unknown (subsidized by four partners: Vista, Neenah Paper, Dickson's and Williamson Printing)
[TYPE] Granjon
[SPECIAL PRODUCTION TECHNIQUES] Process printing on foil stamp; die cut punched through entire book
[INSPIRATION/CONCEPT] A "look book" — a form of children's book repurposed for adults and children

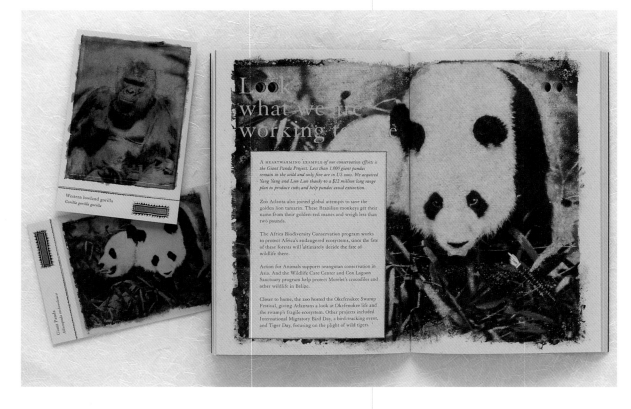

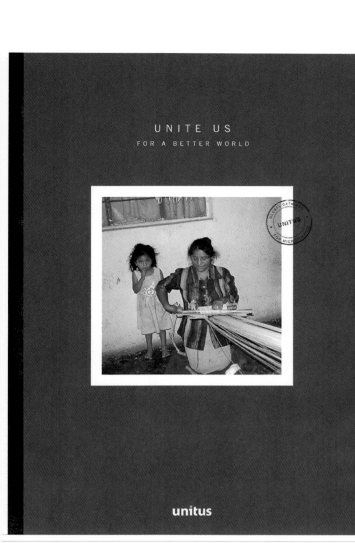

UNITE US

FOR A BETTER WORLD

unitus

UNITUS DONOR BROCHURE ◄ ▼

[STUDIO] Belyea
[ART DIRECTOR] Patricia Belyea
[DESIGNER] Ron Lars Hansen
[PHOTOGRAPHER] Mesha Davis
[CLIENT] Unitus
[CLIENT'S PRODUCT/SERVICE] Relief of poverty in developing countries
[TYPE] Trade Gothic, Clarendon, Courier
[SPECIAL TYPE TECHNIQUE] The messages on the first pages of the book are important, but the copy is not set in big, bold type. Instead, the few lines of type are small and pristine with lots of space around them to create a focal point.

"The goal of this brochure is to raise money for the organization in $50,000 social investment units from individual donors," art director Patricia Belyea says. "The design speaks to both types of potential donors for Unitus: those who are completely unfamiliar with the organization and those who know about it. The front of the book, with large photos and short copy, tells the story of Unitus quickly and with emotion to the uninitiated. The back is full of in-depth copy, graphs and charts to give detailed information about Unitus to those ready to invest in the organization."

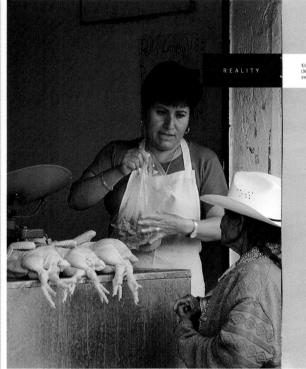

REALITY

Unitus has invented a new way of accelerating the growth of selected microfinance institutions (MFIs) which give these loans. Our unique approach rapidly increases the number of people receiving microcredit loans.

The Unitus Social Investment Fund provides the means for achieving these results.

NEOFORMA 2001
ANNUAL REPORT ▶

[STUDIO] Cahan & Associates
[ART DIRECTOR] Bill Cahan
[DESIGNER] Sharrie Brooks
[PHOTOGRAPHERS] Todd Hido, John Dolan, Holger thoss
[CLIENT] Neoforma Inc.
[CLIENT'S PRODUCT/SERVICE] Health care supplier
[PAPER] Utopia 2 Matte
[SIZE] 8" × 10¼" (20 × 26 cm)
[PRINT RUN] 20,000
[TYPE] Folio Light, Folio Medium

"Neoforma builds and operates private, customized Internet market places for leading health care trading partners, helping them maximize their existing technologies and optimize their supply-chain relationships to enable them to increase revenue and reduce costs," art director Bill Cahan explains. *"The annual report focuses on the value that Neoforma brings to its customers through the use of statistics, diagrams and customer quotes."*

Neoforma

2001 Annual Report

34,890,768 patients

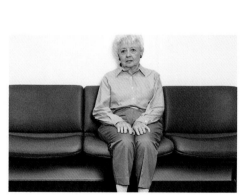

36,468,200,000 case files

983,628 hospital beds

4,058,814 births

"Neoforma has been extremely
proactive and responsive.
The implementation was
quick and easy, and we are now
connected to over 200
of our hospital customers."

Rob Kuehnle, Senior E-Business Systems Analyst, Abbott Laboratories

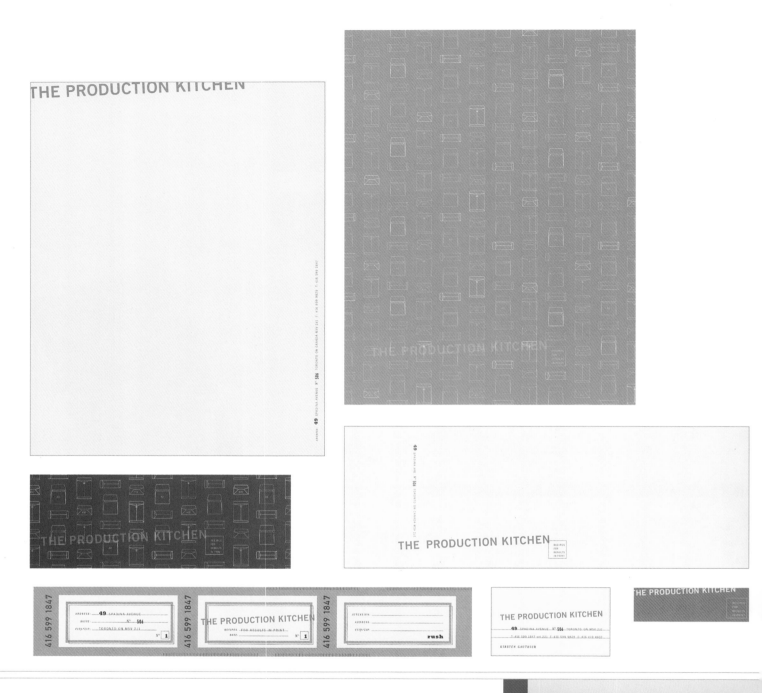

THE PRODUCTION
KITCHEN ▲

[STUDIO] Blok Design
[ART DIRECTOR] Vanessa Eckstein
[DESIGNERS] Vanessa Eckstein, Frances Chen,
 Stephanie Yung
[CLIENT] The Production Kitchen
[CLIENT'S PRODUCT/SERVICE] Print production
 company
[PAPER] Strathmore Renewal Calm
[COLORS] 4, match
[PRINT RUN] 3,000–5,000

"Spare graphics and complex linear patterns were combined to express both the nature of the business and the passion this company has for the print production process itself," says art director Vanessa Eckstein. "A certain playfulness runs throughout the graphics as well as in the slanted text which consistently appears and disappears depending on the application. Colors enhance the dynamic aspect of the system as they flow from element to element, reinforcing the impactful yet clear presentation of the company."

X DESIGN COMPANY ◀

[STUDIO] X Design Company
[ART DIRECTOR/DESIGNER] Alex Valderrama

"Bold graphics, hot design and simple and bold colors were used for strength and flair,"
says designer Alex Valderrama. "We are very happy with the outcome."

RED CANOE
IDENTITY SYSTEM ▶

[STUDIO] Red Canoe
[ART DIRECTOR/COPYWRITER] Deb Koch
[DESIGNER] Caroline Kavanagh
[PHOTOGRAPHER] Caroline Kavanagh
[CLIENT] self
[PAPER] Fox River, Starwhite, Tiara, Smooth and Evergreen, Kraft
[COLORS] 3 match colors
[PRINT RUN] 2,500 (initial); 30,000 (later reprinted by Fox River Paper Co. for a company promotion)
[TYPE] Clarendon, Officina
[SPECIAL PRODUCTION TECHNIQUE] The three match colors (warm red, 121u and 1595u) produced pure, solid printing results.
[SPECIAL COST-CUTTING TECHNIQUE] "Never waste space on a press sheet!" art director Deb Koch says. They also used wire binding, and made multifunctional labels instead of having envelopes printed.

"The strategy for Red Canoe branding begins with the business name itself. Hearing it evokes a universal visual that embodies the character of the firm. It suggests fun and relaxation, and brings to mind rivers, cabins, adventures—a nostalgic American postcard," art director Deb Koch says. "Red Canoe's reality is a classic escape fantasy. Work and play interplay. Committed to a shared passion to do 'only work we love with people we enjoy,' we journey, we paddle. Deadlines can be interrupted by deadly snakes, but that's another part of the Red Canoe story."

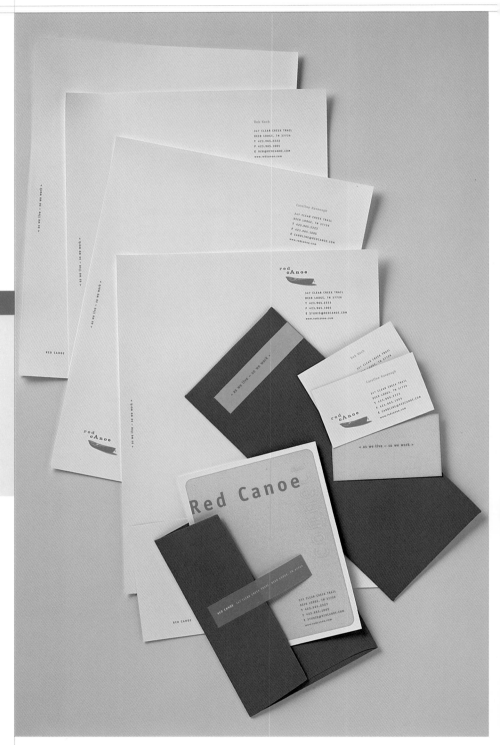

ERIC BREITENBACH
IDENTITY SYSTEM ◄

[STUDIO] Fry Hammond Barr
[CREATIVE DIRECTOR] Tim Fisher
[DESIGNER] Sean Brunson
[CLIENT] Eric Breitenbach
[CLIENT'S PRODUCT/SERVICE] Photography
[COLORS] 1, match
[TYPE] Univers Condensed
[SPECIAL COST-CUTTING TECHNIQUE] Kept design to one
color ink; also used a colored paper stock

*"The inspiration behind this design concept was film
packaging," designer Sean Brunson says.*

908765-1

01 01 908765-1

ERIC BREITENBACH FILM+PHOTOGRAPHY TEL. 407.322.3148 ERICBREITENBACH.COM ERIC BREITENBACH
 FAX 407.322.4487 1505 S. PALMETTO AVE. SANFORD, FL 32771

908765-1

01 01

ERIC BREITENBACH FILM+PHOTOGRAPHY E

TEL. 407.322.3148 ERICBREITENBACH.COM
FAX 407.322.4487 1505 S. PALMETTO AVE. SANFORD, FL 32771

FLOURISH ▶

[STUDIO] flourish
[DESIGNER] Jing Lauengco, Christopher Ferranti, Henry Frey
[PAPER] Utopia One, Blue White Matte, 100# Text (letter-head); Utopia One, Blue White Matte, 80# Cover Gilclear, White, Medium (business cards); Gilclear, White, Medium (envelope); Embossed, Silver Foil, Pressure Sensitive Adhesive Backed Seal
[COLORS] 3, match plus silver foil, tinted varnish
[PRINT RUN] 2,000–5,000
[COST PER UNIT] $.02–$.20
[TYPE] Frutiger
[SPECIAL PRODUCTION TECHNIQUES] Manual assembly of business card sleeves; tinted varnish overprinting on the silver foil of the pressure sensitive seal

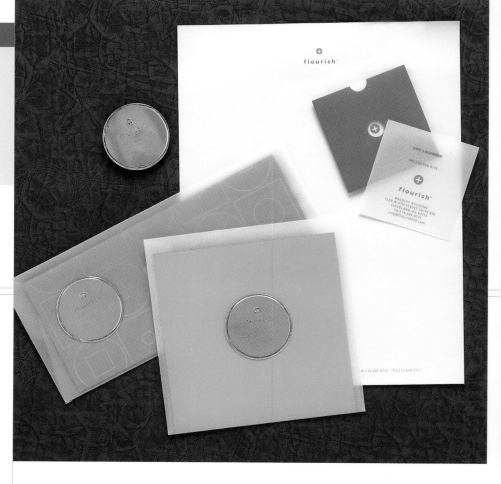

"We chose flourish *as the name for our company partly because of the action the word implies; in addition to being a graphic element, the verb* flourish *alludes to something emerging, constantly redefining itself," say designers Jing Lauengco and Christopher Ferranti. "In concepting our own identity, it was our desire that all materials embody the essence of our forward yet classic contemporary approach to the business of design."*

Unrealistic timelines can be a challenging hurdle when trying to generate effective design. We try to communicate with our clients and help them understand the added value of initial research, exploring multiple directions, thoughtful rounds of revisions. When that fails, we work until midnight to meet deadlines.

JING LAUENGCO,
CHRISTOPHER FERRANTI

[STUDIO] Fry Hammond Barr
[DESIGNER] Sean Brunson
[CLIENT] Contemporary Wood Concepts
[CLIENT'S PRODUCT/SERVICE] Custom woodworking
[PAPER] French Parchtone
[COLORS] 1, match

[TYPE] Trade Gothic
[SPECIAL FEATURES] "The entire identity is handmade,"
designer Sean Brunson explains. "We printed one-
color stickers and the client placed these onto letter-
head, envelope and business cards."

"We tried to match and reflect the client's hands-on approach to his craft in our design," designer Sean Brunson says.

MOO IDENTITY ▶

[STUDIO] Williams and House
[ART DIRECTOR] Pam Williams
[DESIGNER] Rich Hollant, CO:LAB
[CLIENT] Moo
[CLIENT'S PRODUCT/SERVICE] women's boutique

The goal was "to create an identity system for a chic, high-end fashion boutique for women. This store, slated to open in 2003, appeals to the confident woman; one who has her own sense of style, as well as a sense of humor. At Moo, she'll find great style basics, as well as unique accessories," explains the staff of Williams and House. "One of the design challenges was to create a flexible core system to be built, over time, to feature the textile designs featured in the store. Initial work includes mix and match hangtags, business cards and gift certificates called 'moola,' as well as necessary stationery and envelopes."

KELHAM MACLEAN STATIONERY ◄

[STUDIO] Templin Brink Design
[ART DIRECTOR] Gaby Brink
[DESIGNER] Gaby Brink
[CALLIGRAPHER] Elvis Swift
[CLIENT] Kelham MacLean Winery
[PAPER] Cranes
[COLORS] 3, match
[SIZE] 8½" × 11" (22 × 28 cm)
[TYPE] Bodoni, Trade Gothic, Clarendon, hand lettering
[SPECIAL PRODUCTION TECHNIQUES] The letterhead features two horizontal pin perfora-
 tions (an inexpensive tactile detail) and the business cards have a printed, faded edge.

*"Kelham MacLean is a new winery that makes high-end handcrafted wines," says art
director Gaby Brink. "They wanted their identity to reflect this level of quality, while
helping them look established from the beginning. We created a typographic lockup
that draws inspiration from old turn-of-the-nineteenth-century French typography. The
hand-lettered 'logotype' speaks to the partnership between the wine grower and the
wine maker."*

TOM & JOHN: A COLLABORATIVE
ID SYSTEM ◄

[STUDIO] Tom & John: A Design Collaborative
[ART DIRECTORS/DESIGNERS] Tom Sieu and John
[PHOTOGRAPHERS] Tom Sieu and John
[PAPER] Starwhite Vicksburg, uncoated 100 lb. text (letterhead); Starwhite Vicksburg, uncoat-
 ed 130 lb. cover (business card)
[COLORS] 4-color process, 1 match
[SIZE] 8½" × 11" (22 × 28 cm) (letterhead); 3" × 1¾" (8 × 4 cm) (business card)
[PRINT RUN] 2,000 sheets (letterhead); 1,500 (business cards)
[TYPE] Helvetica, all weights
[SPECIAL COST-CUTTING TECHNIQUES] Die-cut colon (two dots) on letterhead and busi-
 ness cards represent the process of defining and the process of collaboration.

*Art director Tom Sieu says the back of the letterhead is an assembly of found objects and
images, reflecting daily influences and inspirations we are surrounded by. "The business
cards also become personal extensions of each individual designer as a way to personal-
ize each card."*

OSSMS CORPORATE IDENTITY ▼

[STUDIO] Renee Rech Design
[ART DIRECTOR/DESIGNER] Renee Rech
[CLIENT] Orthopedic Surgery and Sports Medicine Specialists
[CLIENT'S PRODUCT/SERVICE] Orthopedic Surgery
[PAPER] Neenah Classic Crest
[COLORS] 6, process and 2 match plus varnish
[PRINT RUN] 10,000 of each
[SPECIAL PRODUCTION TECHNIQUES] All pieces were designed to be interchangeable for
 multiple uses.
[SPECIAL COST-CUTTING TECHNIQUES] Four different labels were printed for versatility,
 allowing for many different looks and uses.

*"We wanted to create an identity that was classic, contemporary and tactile," says art
director Renee Rech. "We used X-rays as both an inspiration and an art form to cre-
ate a warm departure from the cold and sterile feel of most medical environments."*

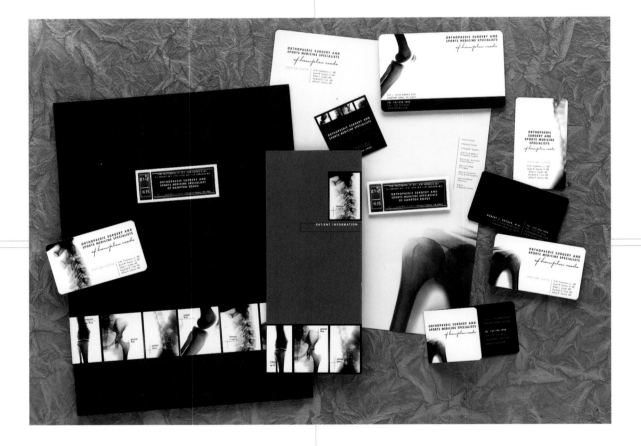

BLACKSTONE STATIONERY & FOLDER ▼

[STUDIO] Templin Brink Design
[ART DIRECTOR] Joel Templin
[DESIGNERS] Joel Templin, Kris Delaney, Paul Howalt (logo)
[CLIENT] Blackstone Technology Group
[CLIENT'S PRODUCT/SERVICE] Systems integration and application development expertise and services to the financial services, energy, and telecommunications industries
[PAPER] Futura Matte Coated Stock
[COLORS] 4, match
[PRINT RUN] 5,000
[TYPE] Trade Gothic, Alpin Gothic
[SPECIAL PRODUCTION TECHNIQUES] Metallic inks on a matte coated sheet
[SPECIAL FOLDS/FEATURES] A metal clip on the folder allows people to tip in a cover letter as a separate piece.
[SPECIAL COST-CUTTING TECHNIQUES] "We overprinted some of the colors to achieve additional colors at no added cost."
[INSPIRATION/CONCEPT] Old school office forms with a modern twist

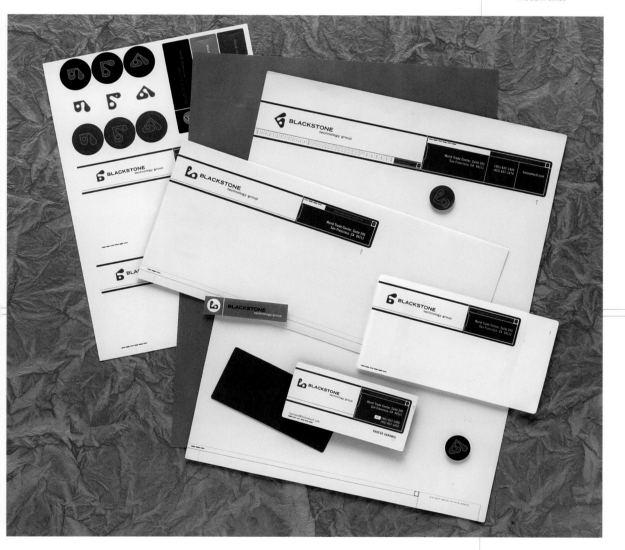

FAVER IDENTITY ▼

[STUDIO] Mirko Ilic
[ART DIRECTOR] Mirko Ilic
[DESIGNERS] Mirko Ilic, Heath Hinegardner,
 Kristina Duewell
[CLIENT] Faver
[CLIENT'S PRODUCT/SERVICE] Veterinary research
[PAPER] Crane
[COLORS] 3, spot

"For an organization that sponsors noninvasive veterinary research, this needed to be a fresh, light and open identity not specific to any particular animal but referencing animals in general," art director Mirko Ilic says.

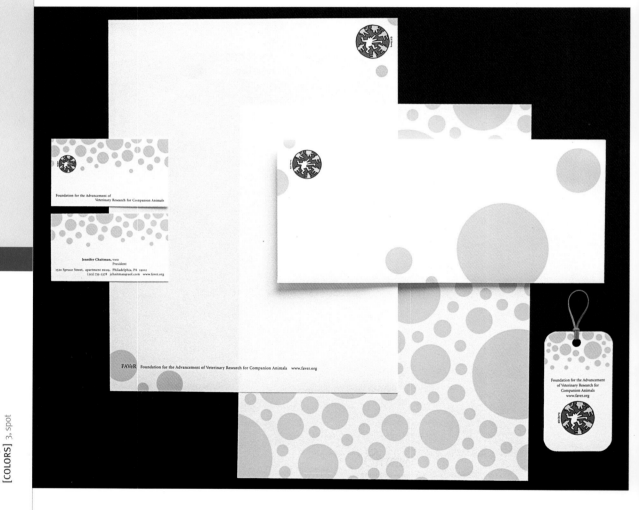

GREG HERR STATIONERY ▼

[STUDIO] Stone & Ward
[ART DIRECTORS] Bill Jennings, Takako Yagai
[DESIGNER] Larry Stone
[PHOTOGRAPHER] In-house
[CLIENT] Greg Herr, Haberdasher
[CLIENT'S PRODUCT/SERVICE] menswear
[PAPER] Hammermill, Environment
[NUMBER OF COLORS] 4-color process
[PRINT RUN] 250
[TYPE] Granjon
[SPECIAL FOLDS/FEATURES] The paper is die cut and folded to reflect the collar of a man's shirt.
[SPECIAL COST-CUTTING TECHNIQUES] To assure that each and every collar is crisp when received by a potential customer or client, each piece of stationery is folded by hand prior to being handed out or mailed.

"Our client offers all kinds of quality menswear and the use of a collar and tie from a traditional dress shirt provides instant identity to the client's type of business," says designer Larry Stone. "To reinforce that image, a crisp, white paper stock, along with a variety of colorful ties from the client's own closet, were chosen."

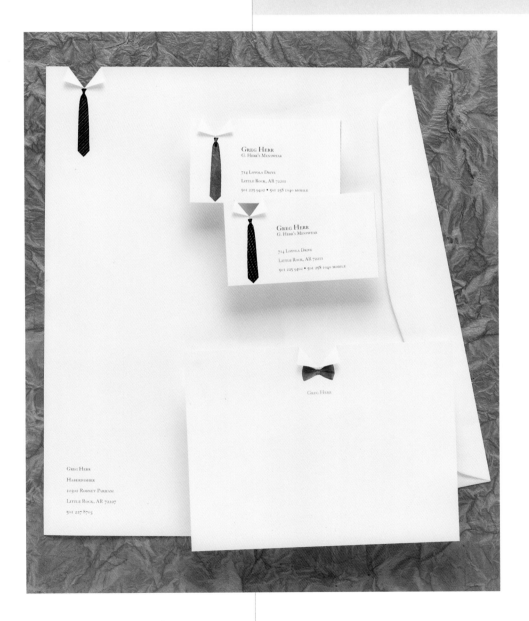

BEN VAN HOOK
STATIONERY ▶

[STUDIO] Fry Hammond Barr
[CREATIVE DIRECTOR] Tim Fisher
[ART DIRECTOR/DESIGNER] Sean Brunson
[CLIENT] Ben Van Hook
[CLIENT'S PRODUCT/SERVICE] Photography
[PAPER] Fox River
[COLORS] 3, match
[PRINT RUN] 1,500
[TYPE] Trade Gothic, Letter Gothic

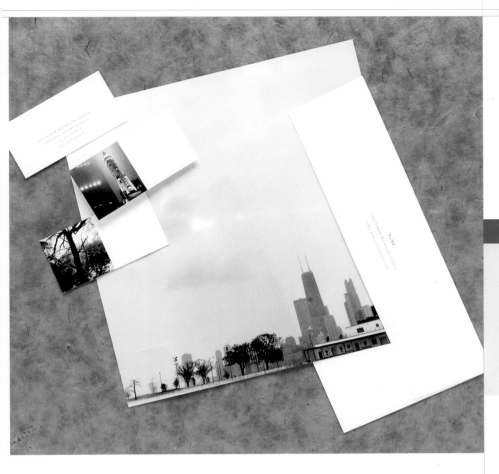

NOMI STATIONERY ◄

[STUDIO] Louey/Rubino Design Group Inc.
[ART DIRECTOR] Robert Louey
[DESIGNERS] Robert Louey, Alex Chao
[PHOTOGRAPHERS] Various
[CLIENT] Park Hyatt Hotel Chicago
[CLIENT'S PRODUCT/SERVICE] Hospitality
[PAPER] Mohawk Superfine
[COLORS] 2, match
[SIZE] 8" × 8" (20 × 20 cm)
[PRINT RUN] 10,000
[TYPE] Bodoni Book
[SPECIAL PRODUCTION TECHNIQUES] duotone printing,
 debossed logo

While the inspiration behind this piece was simply "Chicago," art director Robert Louey says, "Creating an identity which embodies the spirit of a great property is always an exciting experience for us. The foundation of this piece is its use of great photography. With that body of work as the main visual element, the supporting elements had to be sophisticated yet understated. Also, the tactile use of exquisite paper greatly enhances the overall impression of the system."

Be very aware of production techniques. Build strong alliances with high quality printers and paper representatives. Work with visionary photographers and illustrators and allow them to do their best work for you. Gain support from your client by building trust. They will become your biggest advocate when they are clear about the goals.
ROBERT LOUEY

INDIGO MARKETING ▶

[STUDIO] Indigo Marketing
[ART DIRECTOR/DESIGNER] Justin Hattingh
[PAPER] Superwove
[COLORS] 2, process
[PRINT RUN] 2,000
[SPECIAL PRODUCTION TECHNIQUE] Die cut

"The company was going into its tenth year and we decided to change the logo and identity," says designer Justin Hattingh. "The company was started in the year of the dragon, so we knew what the logo would be, but colors were not yet certain. The circles are used to represent scales of a dragon, movement, and red for passion, something each employee feels about their job at the company."

BEDLAM FILMS ▶

[STUDIO] Blok Design
[ART DIRECTOR] Vanessa Eckstein
[DESIGNER] Stephanie Yung
[CLIENT] Bedlam Films
[CLIENT'S PRODUCT/SERVICE] Film production company
[PAPER] Strathmore
[COLORS] 2, match
[PRINT RUN] 3,000–5,000
[SPECIAL PRODUCTION TECHNIQUE] Special slanted envelope

"A bold and unusual combination of colors gives this identity a unique personality," says art director Vanessa Eckstein. "Both balance and surprise, contrast and simple white space are the elements used to reflect a different point of view. Color is as fundamental to this system as the edges of the paper, which always appear slanted. Bedlam Films had to feel confident, modern yet simple and strong."

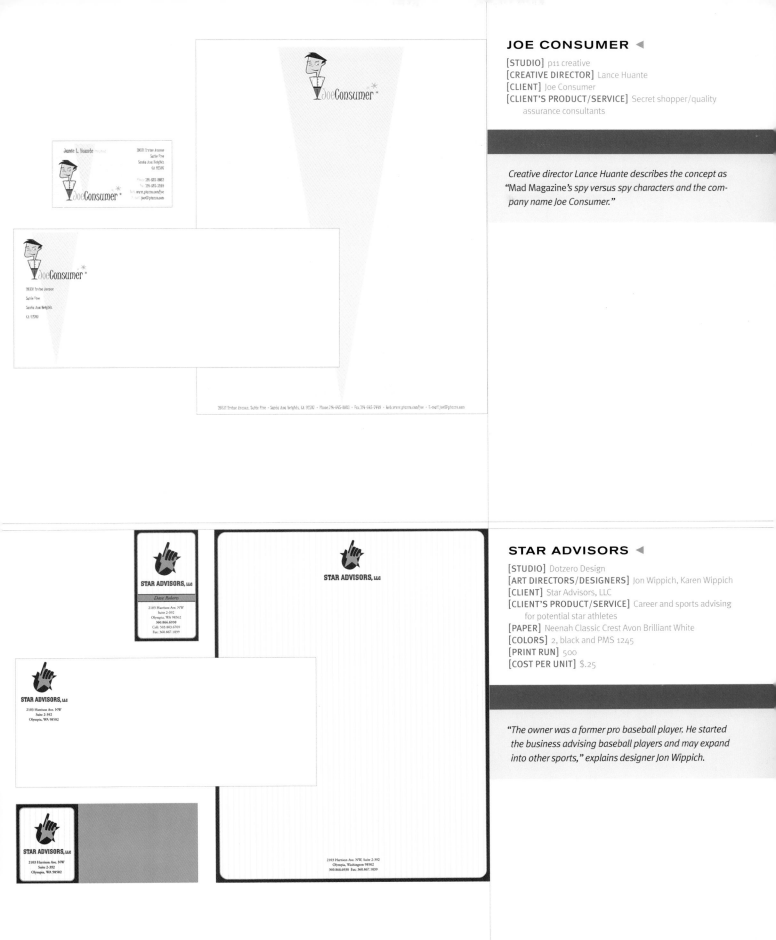

JOE CONSUMER ◄

[STUDIO] p11 creative
[CREATIVE DIRECTOR] Lance Huante
[CLIENT] Joe Consumer
[CLIENT'S PRODUCT/SERVICE] Secret shopper/quality
 assurance consultants

Creative director Lance Huante describes the concept as "Mad Magazine's spy versus spy characters and the company name Joe Consumer."

STAR ADVISORS ◄

[STUDIO] Dotzero Design
[ART DIRECTORS/DESIGNERS] Jon Wippich, Karen Wippich
[CLIENT] Star Advisors, LLC
[CLIENT'S PRODUCT/SERVICE] Career and sports advising
 for potential star athletes
[PAPER] Neenah Classic Crest Avon Brilliant White
[COLORS] 2, black and PMS 1245
[PRINT RUN] 500
[COST PER UNIT] $.25

"The owner was a former pro baseball player. He started the business advising baseball players and may expand into other sports," explains designer Jon Wippich.

329

BLOK DESIGN ▲

[STUDIO] Blok Design
[ART DIRECTOR/DESIGNER] Vanessa Eckstein
[CLIENT] Self
[PAPER] Strathmore
[COLORS] 4, match
[PRINT RUN] 3,000–5,000

"There is no harder job, at least for us, than to design your own identity," says designer Vanessa Eckstein. "We wanted something simple yet bold which would express not only our sensibility but our motivations. Through the logo we tried to imply dialogue, one which invited not only one language but many. We expressed our personality through words like revolt or ignite which appear randomly throughout our stationery, yet the information is clear as colors flow in and out of the system."

BARBEE CURRAN
ELEVATOR

BARBEE CURRAN
ELEVATOR

MAUREEN H. BARBEE

BARBEE CURRAN ELEVATOR COMPANY INC.
5701 WICOMICO AVENUE, ROCKVILLE, MD 20852
P: 301.468.0470 F: 301.468.2238

BARBEE CURRAN ELEVATOR COMPANY INC. 5701 WICOMICO AVENUE, ROCKVILLE, MD 20852
P: 301.468.0470 F: 301.468.2238

◄((((BARBEE CURRAN ELEVATOR COMPANY INC.

5701 WICOMICO AVENUE
ROCKVILLE, MD 20852

BARBEE CURRAN ELEVATOR
COMPANY INC. ◄

[STUDIO] Fuszion Collaborative
[ART DIRECTOR/DESIGNER] John Foster
[CLIENT] Barbee Curran Elevator Company Inc.

"Barbee Curran Elevator Company had undergone a
change in ownership as a new generation of family had
taken over the business," says art director John Foster.
"In order to reflect this change and to bring their collater-
al in line with their capabilities, they decided to redesign
their logo for the first time in over 40 years. Most eleva-
tor companies are using logos that are a century old,
those that simply state the company name, or are full of
elevator cliches (up and down arrows). Barbee Curran
wanted to reflect the unique nature of a family-run busi-
ness with the family members' personality intact. They
also wanted to reflect that they are in sync with new
industry technologies while not losing sight of the
mechanical nature of the business. After sorting through
numerous options reflective of the elevator business,
the company decided to move in a direction truly unique
to them. Using the 'bee' portion of Barbee, the family
had long collected bee-related items. The fast and cun-
ning insect also serves to reflect the speed, smarts and
teamwork that the company brings to its clients. The
complete stationery system uses simple graphic ele-
ments to relate to aspects of the business. A masculine
color palette uses dotted lines reminiscent of blue prints
which double as elevator shafts on the letterhead to
allow simple shapes to form moving elevator cars as
well as to mark the fold lines on the sheet."

MEDIABOLIC ID SYSTEM ▶

[STUDIO] Tom & John: A Design Collaborative
[ART DIRECTORS/DESIGNERS] Tom & John
[PHOTOGRAPHERS] Tom & John
[CLIENT] Mediabolic
[CLIENT'S PRODUCT/SERVICE] Home entertainment network provider
[PAPER] Glama Translucent (letterhead) Ikono Dull Satin, 80 lb. text (second sheet); SpringHill CS1, 130 lb. cover (business card); Glama Translucent (envelope)
[COLORS] 3, match
[TYPE] Eurostile (modified); Univers
[SPECIAL PRODUCTION TECHNIQUES] Metallic ink printed on translucent envelopes and letterhead
[SPECIAL COST-CUTTING TECHNIQUES] Radius corner business cards

Tom says the logo/visual language stems from the original roots of the company name, Mediabolic. "The M logo is composed of cells as the building blocks for digital media," he says. "The M sits within the shape of a TV screen to suggest entertainment. The materials used for letterhead and envelope, such as translucency, suggest media going beyond physical boundaries and it references a sense of futurism given the advancement of such technology."

D-CODE STATIONERY ▶

[STUDIO] Spencer Francey Peters
[ART DIRECTOR/DESIGNER] Barry Quinn
[PHOTOGRAPHER] Stacey Brandford
[CLIENT] D-code
[CLIENT'S PRODUCT/SERVICE] Consulting firm that helps clients understand how their products, services, policies relate to the eighteen to thirty-five-year-old population.
[PAPER] Domtar Weeds
[COLORS] 4-color process plus 1 match
[TYPE] Interstate, Nobel
[SPECIAL COST-CUTTING TECHNIQUES] The back of the letterhead is also the backs of the business cards. Heavier stock was run using the same film, then cut after the other sides were printed.

"The logo was inspired by keys and totem poles," says art director Barry Quinn. "We liked the idea that it might be interpreted as unlocking or expressing. The stationery was inspired by children's slide puzzles. You just get fragments of an image but as you slide the pieces around, you get a clearer idea of what the image is. That's sort of what D-code does. It's very easy for them to explain what they do for clients once they hand out the business card. Each card had a phrase from someone in their network."

ALTERPOP STATIONERY SYSTEM ▼

[STUDIO] Alterpop
[DESIGNERS] Doug Akagi, Dorothy Remington, Christo-
pher Simmons, Kimberly Powell, Jennifer Andreoni
[PAPER] Crates 28# Writing (letterhead, envelope) 130#
Coronado Bright White Vellum Cover
(business cards)
[COLORS] 2

[SIZE] Various
[PRINT RUN] 2,000 (letterhead and envelopes); 500
(business cards)
[COST PER UNIT] $.80 (letterhead); $1.11 (envelopes),
$.68 (business cards)
[TYPE] Futura, Mrs Eaves
[SPECIAL PRODUCTION TECHNIQUE] letterpress printing

"The letterhead and envelope are carefully designed to work in tandem—the letterhead folds accordion-style to allow the recipient's address to appear through the die-cut window on the front of the envelope (the tag line "design in the future tense" indicates the exact point of fold). The envelope was custom designed (the result of weeks of patient prototyping with the printer) with a custom-perforation that is strong enough to withstand mailing yet weak enough to be easily broken when the letter is pulled," says designer Christopher Simmons.

Alterpop ☀

design in the future tense ™

☀ Alterpop

1001 mariposa street /no.304
san francisco, ca 94107
415.558.1515
www.alterpop.com

1001 mariposa street no. 304 san francisco, ca 94107 p. 415 558 1515 f. 415 558 8422 www.alterpop.com

Alterpop design in the future tense ™

☀

Clare Warmke
HOW Design Books
4700 E. Galbraith Rd.
Cincinnati, OH 45236

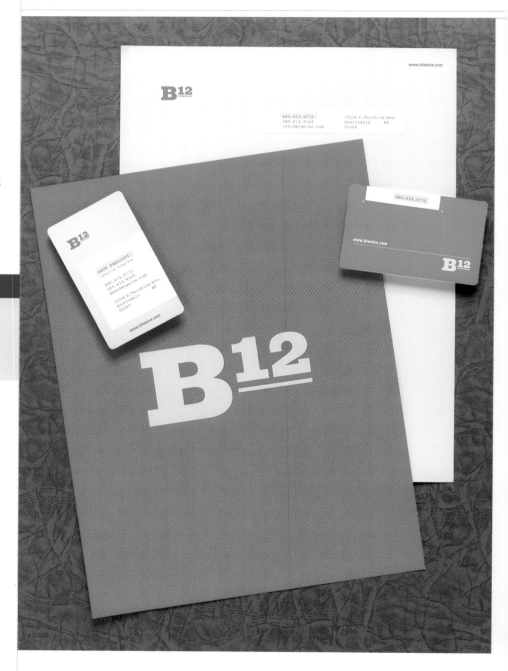

Keep track of current design styles but don't base your portfolio on style alone. A design based on concept will last longer than any specific trend.

DAVE PRESCOTT

B12 STATIONERY ▶

[STUDIO] B12
[ART DIRECTOR/DESIGNER] Dave Prescott
[CLIENT] self
[PAPER] Starliner Label Stock, Fox River Starwhite, Yupo Translucent
[COLORS] 4-color process (labels); 2/2 spot color
[TYPE] Courier, Berthold Akzidenz, Egiziano
[SPECIAL TYPE TECHNIQUES] Courier type simulates a pharmacy-printed label
[SPECIAL PRODUCTION TECHNIQUES] Applied labels to the business cards, letterhead and envelope simulate the look of a medical prescription bottle
[SPECIAL FOLDS/FEATURES] Label wraps around the back side of the business card, back side can used as a horizontal card in a Rolodex even though the front of the card is formatted vertically
[SPECIAL COST-CUTTING TECHNIQUES] System can be updated easily by reprinting only the labels, which contain primary address and contact info.

The inspiration was vitamin B12. "One of the benefits of vitamin B12 is enhanced memory," says art director Dave Prescott. "Our creative interpretation increases brand awareness therefore making brands more memorable."

MERGE DESIGN COLLATERAL ▼

[STUDIO] Merge
[ART DIRECTORS] Michael Taylor, Ash Arnett
[DESIGNERS] Ali Harper, Rebecca Klein, Ash Arnett
[ILLUSTRATORS] Various
[PHOTOGRAPHERS] Various
[PAPER] French
[COLORS] 1, match (letterhead), 2, match (folder), 4-color process stickers (match and process)
[COST PER UNIT] $2.00
[TYPE] Univers
[SPECIAL PRODUCTION TECHNIQUES] Stickers that customize each piece
[SPECIAL FOLDS/FEATURES] Die cut folder holds letterhead, postcard, business card and proposal attachment
[SPECIAL COST-CUTTING TECHNIQUES] Use of one color on letterhead, use of stickers to enhance message and effect
[INSPIRATION/CONCEPT] Multi disciplinary approach

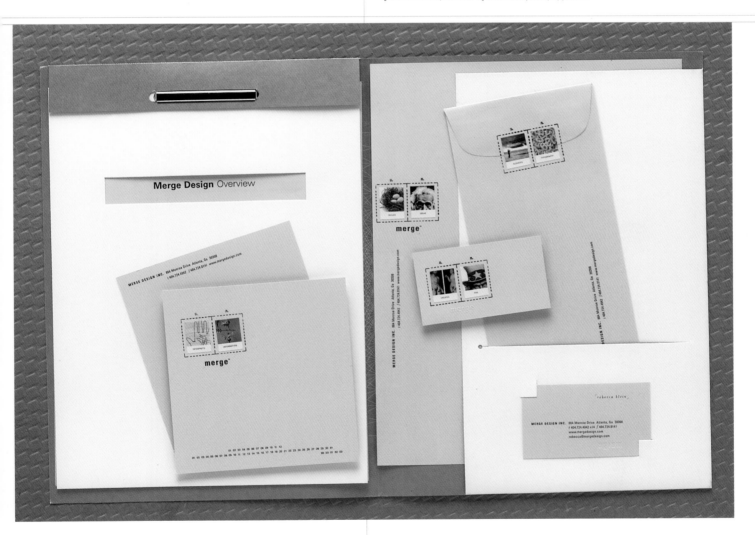

ZIP POTS LOGO & STATIONERY ▶

[STUDIO] THR3E Design
[ART DIRECTOR] Mike Nelson
[ILLUSTRATOR] Mike Nelson
[CLIENT] Zip Pots
[CLIENT'S PRODUCT/SERVICE] A new type of planter for
the landscape industry
[PAPER] Construction Orange by French Paper
[COLORS] 1, match
[TYPE] New Courier Bold, Tarzana Narrow
[SPECIAL TYPE TECHNIQUES] Perforated strip down all
the stationery elements (inspired by the special feature
zipper like perforation down two sides of the pot itself)
[SPECIAL PRODUCTION TECHNIQUES] Controlled depth of
stationery perforation to prevent tearing

*"The client wanted a logo that captured the user's excite-
ment of the experience when 'unzipping' the pot and
pulling out the plant or tree with ease," says art director
Mike Nelson. "We had to create a logo that worked well
as a stamp in the mold of the pot and would translate
well in one color. We wanted to keep the overall look
and feel fairly simple and utilitarian to match most of
what you see in that industry. This satisfied the limited
budget we had to work with as well."*

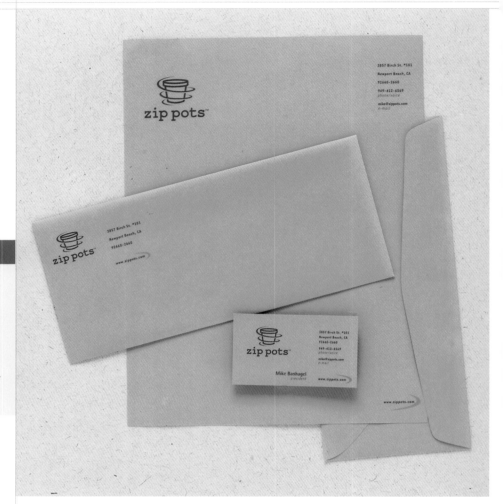

Surround yourself with
like-minded, creative people
and get involved with a
design community. Live and
breathe design daily to an
obnoxious level that causes
you to mentally redesign every
storefront/sign/logo you see as
you walk down the street.
(Oh, and command+shift+3
whenever possible.)

MIKE NELSON

336

GEORGE FULTON IDENTITY SYSTEM ◄

[STUDIO] Townsend Design Co.
[ART DIRECTOR/DESIGNER] Barry Townsend
[PHOTOGRAPHER] George Fulton
[CLIENT] George Fulton Photo Imagery
[PAPER] French Durotone
[COLORS] 3, match
[SIZE] Various
[PRINT RUN] 5,000
[TYPE] Trade Gothic
[SPECIAL TYPE TECHNIQUES] Logo is an abstract illustration of a large format camera using the letters in Fulton
[SPECIAL COST-CUTTING TECHNIQUES] Traded out cost of printing with the printer; paper donated by the mill in exchange for samples to be used for paper promotional purposes

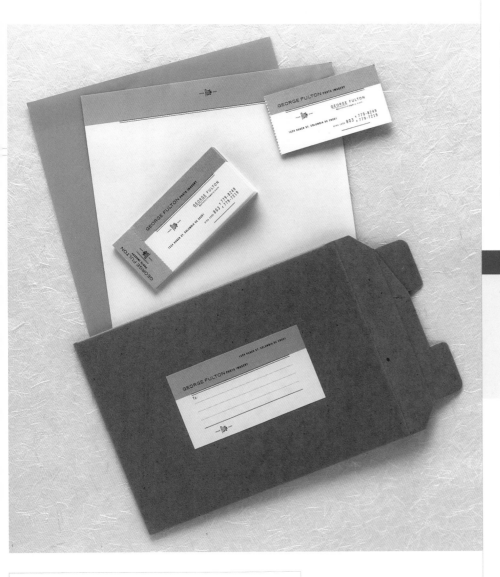

"The challenge was to design an identity system for George that reflected his style but didn't actually use any photography," explains art director Barry Townsend, "so that the identity wouldn't be dated as his style evolved. George's studio provided much of the inspiration for the design, including an antique 8" × 10" (20 × 25 cm) camera that influenced the logo."

PARADOX STATIONERY SYSTEM ◄

[STUDIO] Alterpop
[DESIGNER] Christopher Simmons
[ILLUSTRATOR] Christopher Simmons
[CLIENT] Paradox Media
[CLIENT'S PRODUCT/SERVICE] Event production/artist promotion and representation
[PAPER] Fox River Select 88# Cover, Arctic White, Wove
[COLORS] Primarily 1 color (2 colors on letterhead)
[PRINT RUN] 1,000 (letterhead, envelopes); 500 (business cards, each of four names)
[COST PER UNIT] $.65 (letterhead); $.33 (envelope); $.15 (business cards)
[TYPE] Interstate

The logo is the classic paradox, "Which came first, the chicken or the egg?" designer Christopher Simmons explains. "The Paradox Media business system is an interesting example of a creative solution on a very limited budget. The clients had limited funds, pressing need and knew they would be moving in the near future. The design is basically a system of one-color stickers. By constructing the system this way, any variable information (names, addresses, and so on) can be quickly and inexpensively printed without reprinting the entire system."

337

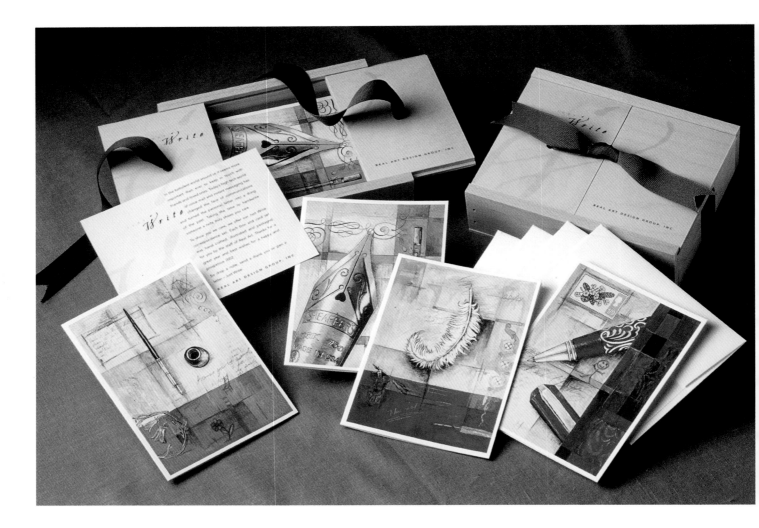

JUST WRITE—
CHRISTMAS 2001 ▲

[STUDIO] Real Art Design Group, Inc.
[ART DIRECTOR] Chris Wire
[DESIGNERS] Rachel Botting, Mark Kargl
[ILLUSTRATOR] Rachel Botting
[CLIENT] Self
[PAPER] Strathmore Writing Ultimate White Wove 88#
 Cover (cards)
[COLORS] 4, process plus varnish

[SIZE] 4¼" × 5⅝" (11 × 14 cm) folded (cards); 6½" ×
 5¼" × 1⅞" (16 × 13 × 5 cm) (boxes)
[PRINT RUN] 325 sets of 12 cards
[COST PER UNIT] $1.09 (card and envelope)
[TYPE] Aquiline, Avenir, Futura
[SPECIAL COST-CUTTING TECHNIQUES] All in-house
 creation except for card printing, wooden boxes
 created by owner Chris Wire and office manager
 Jain Watson, label and vellum insert printed in-
 house, packaging and mailing done by Real Art
 employees

The designers say that the inspiration was "keep-ing in touch. Today's high-tech world of voice mail and instant messaging has changed the face of communications and turned the personal letter into a thing of the past. We wanted to remind people of the care that goes into writing a note by hand."

"A SAMPLING,"
TCHEREVKOFF STUDIO
SELF-PROMOTION ▼

[STUDIO] Tcherevkoff Studio Ltd.
[ART DIRECTOR] Michel Tcherevkoff
[DESIGNER] Howard Huang
[PHOTOGRAPHER] Michel Tcherevkoff
[CLIENT] Bed, Bath & Beyond (featured)
[PAPER] Epson Photo Quality Inject Card, vellum
[COLORS] 6, process
[SIZE] 4⅛" × 6" (10 cm × 15 cm)
[PRINT RUN] 500
[COST PER UNIT] $7–8
[TYPE] Helvetica
[SPECIAL PRODUCTION TECHNIQUES] In-house production with Epson Stylus Photo Ex and HP LaserWriter 5MP
[SPECIAL FEATURES] A handmade die cut in the glossy green protective card provides a glimpse of the bright yellow corrugated paper inside. The piece was mailed in a transparent plastic envelope. Bright images showcase the designs, while corrugated covers and vellum fly-leaves add elegance.

This piece was created "to have a mini portfolio to show my mother in France what I was doing!" says art director Michel Tcherevkoff. "Also to highlight one of my current advertising campaigns."

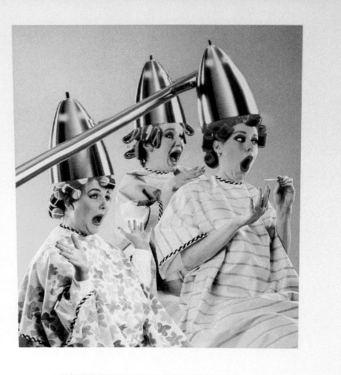

three headed lamp

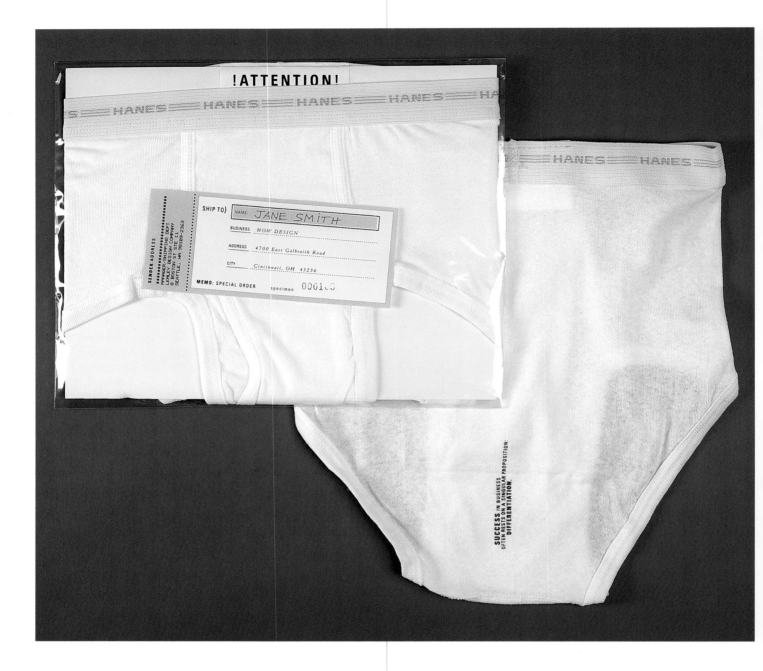

WEB SITE RELAUNCH ANNOUNCEMENT ▲

[STUDIO] Lemley Design Company
[ART DIRECTOR] David Lemley
[DESIGNERS] David Lemley, Yuri Shvets, Matthew Loyd
[PAPER] Tag board and Hane's underwear briefs
[COLORS] 2, match (paper); 1, match (underwear)
[PRINT RUN] 200
[TYPE] Univers, Bembo Italic

Art director David Lemley wanted to "grab attention and drive traffic to our new web site—which we think is 'tight and white.'"

DIGITAL SOUP TRAVELING PORTFOLIO ◀

[STUDIO] Digital Soup
[ART DIRECTOR] Pash
[DESIGNERS] Pash, Roy Dequina
[COLORS] 4, process
[SIZE] 9" × 8" × 5" (23 × 20 × 13 cm) (box)
[PRINT RUN] 6 boxes, approximately 200 inside "plates"
[COST PER UNIT] About $400 (for one complete box with 24 "plates")
[SPECIAL TYPE TECHNIQUES] "Recreating the vintage luggage labels turned out to be an absolute blast (for example, Manhattan, New York became Manhattan Clam Chowder), but we faced type challenges," explains art director Pash. "With such a wide variety of eclectic and vintage typefaces used, many fell outside our own font collection and had to be recreated by hand."
[SPECIAL PRODUCTION TECHNIQUES] "The leather boxes are made in Italy; we found someone in Los Angeles who could import 6 of them for us. The labels are simply printed on a high-resolution color laser printer, then slightly distressed before attaching. The plates on the inside are LiteJet prints mounted onto pressboard that we cut down to size and sanded, then mounted felt pads on the back of each to protect the faces."
[SPECIAL FOLDS/FEATURES] A custom cut and stitched leather band is used to lift the plates out of and back into the box.
[SPECIAL COST-CUTTING TECHNIQUES] "Two words: Home Depot," says Pash.

Art director Pash says the inspiration for this pieces was "a vintage suitcase my wife and I own which sits in our living room for decoration. One evening while admiring it and marveling at all the places it had been, I thought that if this suitcase could talk, what stories it could tell! About that time I was contemplating overhauling the Digital Soup portfolio, and as the days wore on, I kept thinking about that suitcase and what a respectable tool for carrying a message or conveying information it could be. I finally grabbed it and brought it with me to the office, and when I pitched the idea to others, everyone loved it and imaginations started running."

10 YEARS HARD LABOR ▶

[STUDIO] Lloyds Graphic Design and Communication
[ART DIRECTOR/DESIGNER] Alexander Lloyd
[ILLUSTRATOR/PHOTOGRAPHER] Alexander Lloyd
[PAPER] Matte board, around 220 gsm
[COLORS] 4, process
[SIZE] 4¾" × 6¾" (12 × 17cm)
[PRINT RUN] 600
[TYPE] Helvetica, Bell Gothic
[SPECIAL COST-CUTTING TECHNIQUE] Collected and
 bound in-house

*"Our business was celebrating 10 years in operation," art
director Alexander Lloyd says.*

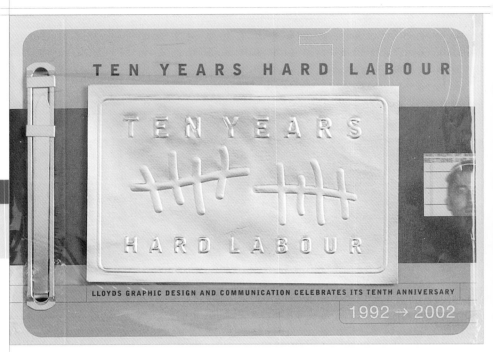

WHAT'S A KARAGEORGE? ◄

[STUDIO] Schulte Design
[ART DIRECTOR/DESIGNER] Paul Schulte
[PHOTOGRAPHER] Jim Karageorge
[CLIENT] Karageorge Studio
[CLIENT'S PRODUCT/SERVICE] Photography, studio and
 location
[COLORS] 6/6, 4-color process plus 2 PMS on 2 sides
[TYPE] Tarzana Narrow, Tarzana Wide
[SPECIAL PRODUCTION TECHNIQUES] Blind emboss,
 vacuum mold

*"For years Jim Karageorge had saved some of his favorite
misspellings of his last name from pieces of mail he
received,"* says art director Paul Schulte. *"He had them
up on his studio door. They were hysterical. Samples
included Jim Karagego; Carol George; George Kara; and
Jim, Lara and George. The promo was a way to capitalize
on name recognition. Flash cards were used because
they teach children a word through its association with
an image. Since he is a photographer who uses a lot of
artificial light (flash), it's a play on words that creates
an association between the photographer's name and
his images. It also capitalizes on his unusual name in a
playful way."*

Q COASTERS ◄

[STUDIO] Q LTD
[ART DIRECTOR/DESIGNER] Mike McGowan
[ILLUSTRATOR] Mike McGowan
[COPYWRITERS] Don Hammond, Mike McGowan
[CLIENT] self
[PAPER] McCoy Silk 80# Cover, Gil Clear Envelopes, 16 pt.
 blotter paper
[COLORS] 4, process, plus PMS 877
[SIZE] 4¾" × 4¾" (12 × 12cm)
[PRINT RUN] 25,000
[COST PER UNIT] $3.75
[TYPE] Trade Gothic, Futura
[SPECIAL TYPE TECHNIQUES] Reversing 8 pt. type out of 4-
 color process trap on blotter paper
[SPECIAL FOLDS/FEATURES] Black ink on translucent
 stock
[SPECIAL COST-CUTTING TECHNIQUES] All handwork
 done internally
[INSPIRATION/CONCEPT] Irish bar coasters

OUT OF THIS WORLD COLLECTORS CARD SERIES ▼ ▶

[STUDIO] Fuszion Collaborative
[ART DIRECTORS] Richard Lee Heffner, John Foster
[DESIGNER] John Foster
[COLORS] 4/0, process (cards); 2/0, match (envelopes and belly bands)
[SIZE] 4½" × 6½" (11 × 16cm)
[PRINT RUN] 1,000
[SPECIAL TYPE TECHNIQUE] Various era-specific type was used and manipulated for cover.
[SPECIAL PRODUCTION TECHNIQUE] Some overprinting to create an aged appearance.
[SPECIAL FEATURES] Custom-converted envelopes, a double-hit of match white and a single hit of metallic on the envelope and belly band
[SPECIAL COST-CUTTING TECHNIQUE] All work done on this piece in exchange for use as promos

"Originally intended as a reply card to job applicants, the initial design concepts had pulp science-fiction covers and were lifted from a rejected concept from a project for the Buffy the Vampire Slayer television show," explains designer John Foster. "That piece grew into a full collectors card series as we gathered era-specific illustrations and clip art, building to the final five cards. In the finished design, everything is given an aged look as if the covers had been in someone's garage for 50 years."

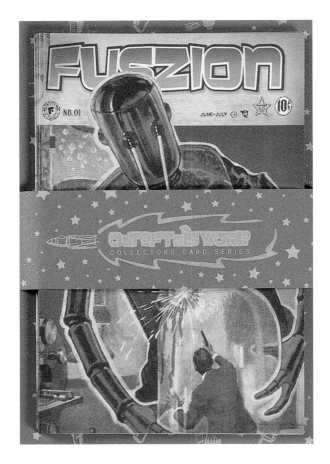

344

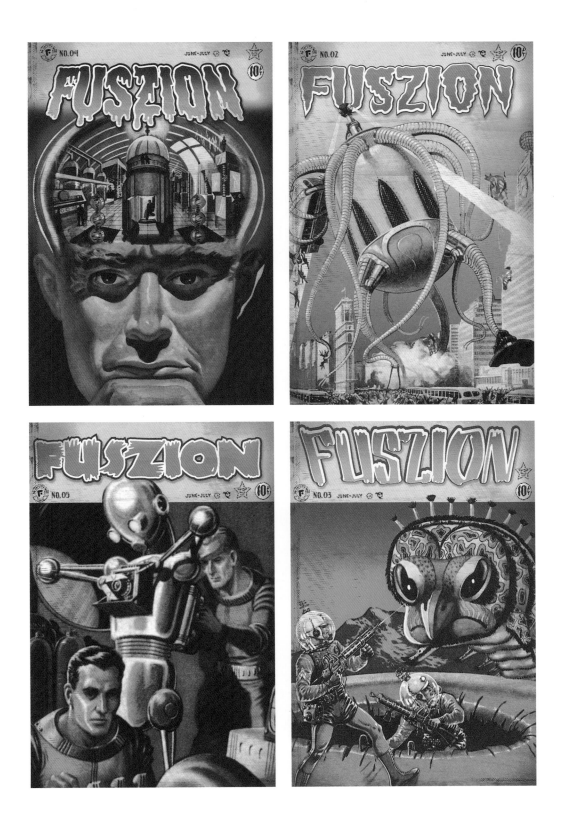

HOW TO DAYDREAM ▶

[STUDIO] Morris Creative
[ART DIRECTOR] Steven Morris
[DESIGNER] Tom Davie
[ILLUSTRATOR] Tom Davie
[PHOTOGRAPHER] Tom Davie
[CLIENT] self
[PAPER] Potlatch McCoy, Wasau
[COLORS] 4, process plus one color on uncoated stock
[SIZE] 4" × 6" (10 × 15cm)
[PRINT RUN] 2,000
[TYPE] Snell Roundhand, Bell Gothic family
[SPECIAL TYPE TECHNIQUES] A mixture of set typography with hand-drawn type made the piece more personal.
[SPECIAL FOLDS/FEATURES] Wire-O binding, double-thick (folded back) one-color pages.
[INSPIRATION/CONCEPT] "Daydreaming at work," says art director Steven Morris.

WE'RE SCREWED ▶

[STUDIO] Essex Two
[ART DIRECTORS] Nancy Essex, Joseph Essex
[DESIGNERS] Nancy Essex, Joseph Essex, John Knowles
[CLIENT] Mark Joseph Photography
[CLIENT'S PRODUCT/SERVICE] Photography
[COLORS] 2, process
[SIZE] Approximately 8½" × 11" (22 × 28cm)
[TYPE] Helvetica Ultra Compressed (headline); Helvetica Neue Condensed Light (body)

"We felt there was a need to acknowledge the growing frustrations good photographers have with clients, agencies, representatives—even their own trade publications—who want to categorize who they are by what they shoot," says art director Joseph Essex. "While many good photographers have demonstrated a special ability to work in particular areas, for some associates, it tends to negate the fact that they are first, last and always communicators."

We're Screwed

We are photographers. No matter how great our work is, if you are looking for a location shooter and we choose to show a series of product shots here, we're screwed. If a formal corporate portrait is your need and we display the best mixed media, electronic, isolated focus, digital collage, we're screwed. Even if the client wants a three-year-old girl holding a tan beagle puppy and our three-year-old girl is holding a tan cat, some people may not be able to make the leap. They may not be able to recognize our ability to capture a moment, set a mood or make a point visually. • On this page we can only show so many images before they become a mosaic of colors. At that reduced size it is almost impossible to demonstrate our experience, expertise and our passion for communication. • We thought if we tried to show you everything we've done and could do, you would just turn the page, and we would be screwing ourselves. So close this book, go to your computer, laptop or Web device and visit our site. • Our portfolio of images is arranged by areas of interest illustrating over 40 years of combined experience photographing the world and everything in it. The difference in seeing a few images here and our portfolio on our website is the same as the difference between being screwed and making love. **JOSEPH BENDER**
www.josephandbender.com

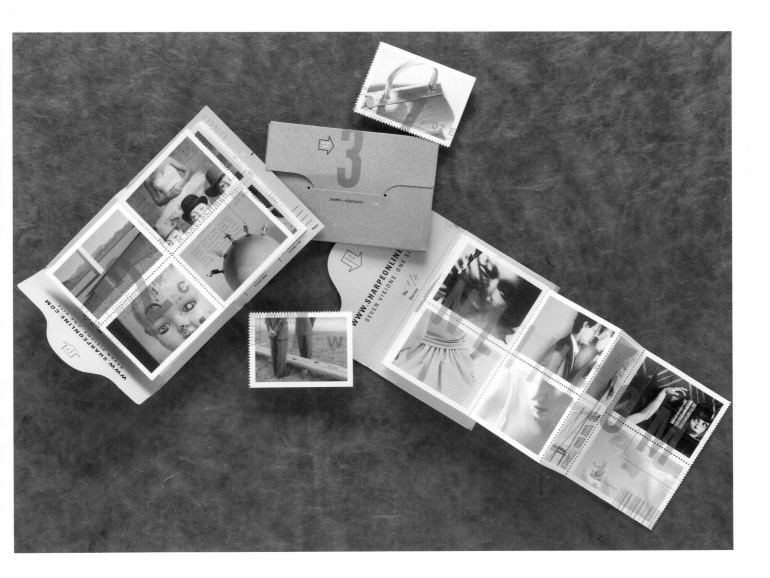

SHARPE + ASSOCIATES
PROMOTION ▲

[STUDIO] Templin Brink Design
[ART DIRECTORS] Joel Templin, Gaby Brink
[DESIGNER] Joel Templin
[PHOTOGRAPHERS] Neal Brown, Ann Cutting, Hugh
 Kretschmer, Lise Metzger, Jamey Stillings, Eric Tucker,
 Everard Williams
[CLIENT] Sharpe + Associates
[CLIENT'S PRODUCT/SERVICE] Rep agency for photogra-
 phers

[COLORS] 9, 4-color process plus 5 match colors
[TYPE] Trade Gothic, Garamond, Alpin Gothic
[SPECIAL PRODUCTION TECHNIQUES] Overprinting a
 contaminated metallic spot varnish for added depth and
 interest
[SPECIAL COST-CUTTING TECHNIQUES] Promotion
 designed in such a way to gang all four on one press
 sheet, saving on both printing and die-cutting costs

*"The initial inspiration came from an old sou-
venir that I found while traveling in Italy," says
art director Joel Templin, who adds that the
piece was designed to highlight the work of the
seven photographers represented by Sharpe +
Associates and to drive traffic to the agency's
web site. "The concept for the piece was '7
visions/1 site,'" he says.*

BND DESIGN LIBRARY ▶

[STUDIO] Brad Norr Design (BND)
[ART DIRECTOR] Brad D. Norr
[DESIGNERS] Daniel Anderson, Andrew Bessler, Michael White, Brad D. Norr
[ILLUSTRATORS] BND
[PHOTOGRAPHERS] Various
[TYPE] Disturbance (FoneFonts) for body copy, Blackoak, Univers Condensed, Clarendon
[SPECIAL COST-CUTTING TECHNIQUES] Piece produced totally in-house, using desktop color printer for work pages, laser printer for copy pages
[SPECIAL PRODUCTION TECHNIQUES] Book covers feature rolled edges like actual hardcover books and are Wire-O bound. Slipcase has a tag with the recipient's name laser printed.

"We wanted to come up with a way to showcase our work, one that was easy to update, so new work could be shown without re-creating the whole piece," says art director Brad D. Norr. "I was influenced by small keepsake gift books, and the idea of small books for each area of design expertise, for example, logos and brochures, was born. We needed to house the books in something, so the custom slipcase, and thus the library idea, followed. It was functional yet gave the impression of an object of value that wouldn't get tossed aside."

HOLIDAY WARM-UP KIT ◄

[STUDIO] SJI Associates
[ART DIRECTOR] Jill Vinitsky
[DESIGNERS] Rick Bacher, Karen Lemcke, Marie Coons
[COLORS] 4, match plus matte laminate
[TYPE] Rotis Sans Serif, various fonts for "snowflake" asterisks
[SPECIAL COST-CUTTING TECHNIQUES] Entire job printed in the same Pantone colors. Box and cards printed on one sheet, labels on another.

"Each year we create a holiday gift to amuse our clients and ourselves," says art director Jill Vinitsky. *"This year, thoughts of ice skating, playing in the snow and getting really cold inspired our 'Holiday Warm-Up Kit.' It includes everything you'd need to get a little toasty with the exception of Peppermint Schnapps! The influence of 1960s Schrafft's holiday candy boxes and a clean, wintery color palette combine to create stylish packaging to evoke our memories of cozy winters in New York City."*

KILMER AND KILMER CAPABILITIES BROCHURE ▲

[STUDIO] Kilmer & Kilmer Brand Consultants
[ART DIRECTOR] Richard Kilmer
[DESIGNER] Randall Marshall
[PHOTOGRAPHERS] Michael Barley, Richard Kilmer
[PAPER] Black art board, LOE Gloss, French Speckletone
[COLORS] 4, process plus 1 PMS
[TYPE] Janson Text, Janson Text Italic, Univers Black, Univers Ultra Compressed
[SPECIAL PRODUCTION TECHNIQUES] Wire-O binding, blind embossing on cover, letterpressed type treatments, cover and tab dividers with an anodized metal circle with the company's logo and graphics

Designer Randall Marshall says the firm wanted "to create a piece that would be cost-effective to produce, memorable when received and informative to a wide variety of potential clients. We wanted to show samples of our work, interchangeable at a moments notice, and of course, be timeless."

349

SPUR PROMO ▼

[STUDIO] Spur
[ART DIRECTOR/DESIGNER] David Plunkert
[PHOTOGRAPHER] Geoff Graham
[PAPER] Kimdura Buckskin, McCoy Satin
[COLORS] 7 (4-color process, 2 match, flood aqueous coat)
[SIZE] 6" × 9" (15 × 23cm)
[PRINT RUN] Less than 5,000
[TYPE] Akzidenz Grotesk
[SPECIAL PRODUCTION TECHNIQUES] Pigment-foiled type, full-color cover tip-on
[SPECIAL FOLDS/FEATURES] Die cuts, foils
[SPECIAL COST-CUTTING TECHNIQUES] Cover tip-on and collation done in-house

"The inspiration of this piece," says art director David Plunkert, "was the need to find more design work. We designed the piece simply but with fine materials and production values in an effort to prove to clients that there might be something to that approach."

When designing for ourselves we try to push beyond what's appropriate (we attempt to do that for clients, too, but for ourselves we really turn up the dial) without being funky for funky's sake.
DAVE PLUNKERT

GONE CANOEING ◀

[STUDIO] Red Canoe
[ART DIRECTOR] Deb Koch
[DESIGNER] Caroline Kavanagh
[PAPER] Fox River, Evergreen, Kraft, Starwhite Tiara, smooth
 and Epson ink-jet matte
[SIZE] 7" × 5" × 4" (18 × 13 × 120cm) (overall package)
[PRINT RUN] 150
[TYPE] Frutiger, Base 9
[SPECIAL COST-CUTTING TECHNIQUE] The wrapping
 paper was created from digital photographs and scans of
 the toy along with existing Red Canoe identity elements
 and was printed in-house via ink-jet printer.

*"This was a self-promotion announcement sent to exist-
ing clients, vendors and freelancers to advise them that
the Canoeists would be out of the 'cabin' for five days
attending a design conference," art director Deb Koch
explains. "This 'forgive us' piece included designed
wrapping paper and a reproduction (circa 1940s) vin-
tage plastic toy, in the firm's colors—a station wagon
with a canoe on top."*

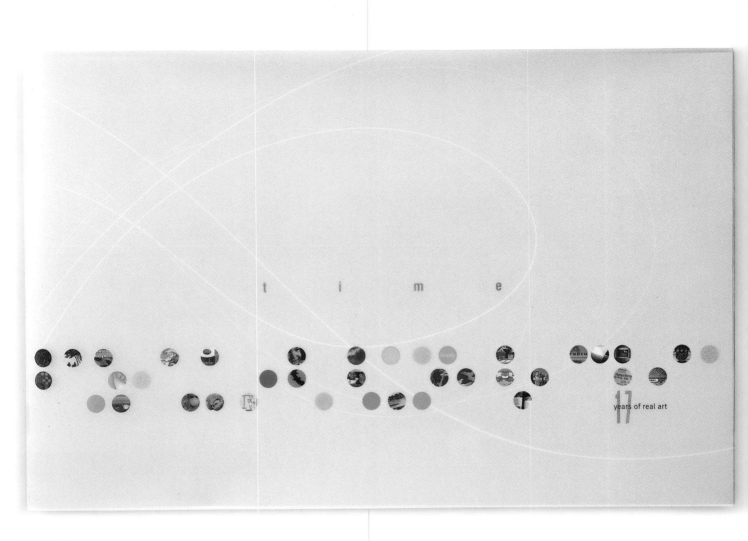

t i m e

17 years of real art

TIME ▲ ▶

[STUDIO] Real Art Design Group, Inc.
[ART DIRECTOR] Chris Wire
[DESIGNERS] Rachel Botting, Mark Kargl
[PHOTOGRAPHERS] Rachel Botting, Ann Crowley, Dotty Crowley, Tom Crowley, Jack Holtel, John Lloyd, David Miller, Rose Pero, Crystal Rhodes, Kate Rohrer, Emma Shorr, Victor Spisak, Jerald Watercutter
[CLIENT] Self
[PAPER] Gilbert Clearfold 30# medium white (cover); Strobe Silk 80# cover (interior)
[COLORS] 4, process with offset lithography plus spot PMS 8001 and spot UV (cover); 4, process with offset lithography plus spot UV (interior)
[SIZE] 11¾" × 7¾" (30 × 19cm)
[PRINT RUN] 1,000
[TYPE] Courier, Courier New, OCRA, Rotis Sans Serif, Rotis Semi Sans, Soup Bone Seven, Trixie
[SPECIAL COST-CUTTING TECHNIQUES] Printing was supplied by Brown and Kroger Printing Company, photography was donated by employees and friends of Real Art

"The Brown and Kroger Printing Company requested a promotional piece that highlights the printing techniques of a new press. Consequently, this was an opportunity for Real Art to create a self-promo piece in celebration of our 17th anniversary," explain the designers.

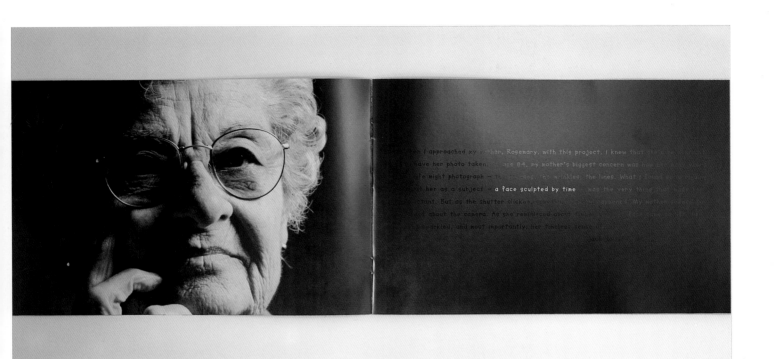

When I approached my mother, Rosemary, with this project, I knew that she might not have her photo taken. ... see 84, my mother's biggest concern was how she would life might photograph — the and wrinkles, the lines. What I found her as a subject — **a face sculpted by time** — was the very thing that tant. But as the shutter clicks about the camera. As she reminisced about and most importantly, her timeless sense of

PORTABLE FEMALE SAINTS ▶

[STUDIO] Christiane Grauert
[ART DIRECTOR/DESIGNER] Christiane Grauert
[ILLUSTRATOR] Christiane Grauert
[COLORS] one (black)
[TYPE] hand-lettering based on Caslon typeface
[SPECIAL TYPE TECHNIQUES] Text on each card was first
 set on the computer, then redrawn by hand to give it a
 quality similar to that of the illustration.
[SPECIAL PRODUCTION TECHNIQUES] Each card is lami-
 nated to give it an almost everlasting, portable quality.

*"The final product grew out of a collaborative fine art
project with sculptor Margaret McGee,"* says designer
Christiane Grauert. *"Five wooden busts of female saints
were accompanied by laminated cards in the tradition of
prayer cards for the audience to take. Unlike traditional
prayer cards, the back doesn't have religious text but
rather a humorous summary of lesser known facts about
each saint's life."* Because of the positive response gen-
erated by the cards, Grauert now uses them as a self-
promotion mailer for her illustration work.

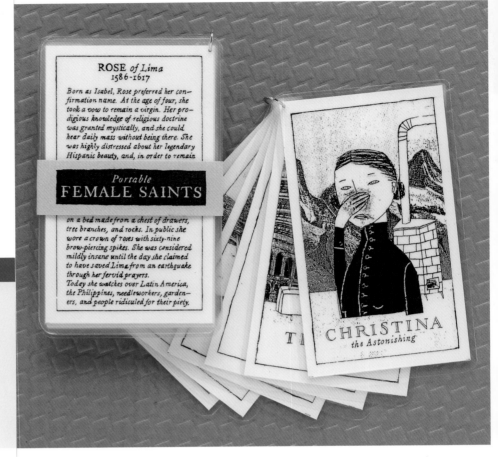

MESSAGE NIGHT-LIGHT ▶

[STUDIO] Paprika Communications
[ART DIRECTOR] Louis Gagnon
[DESIGNERS] Louis Gagnon, Francis Turgeon
[ILLUSTRATORS] Paprika Communications
[CLIENT] Paprika and Litho Acme
[COLORS] 4, process
[TYPE] Rockwell (box); Rockwell, Clarendon, Egyptian
 extended, Trade Gothic Condensed (night-light visuals)
[SPECIAL PRODUCTION TECHNIQUES] 4-color process on
 coated paper with matte lamination on paperboard

*"We like to offer our clients a printed keepsake for the
Christmas holidays, one that highlights our talent and
creativity,"* says art director Louis Gagnon. *"The piece
also illustrated the printer's expertise and the quality
they can deliver. Of course, the idea we look for should
be strikingly attractive. But it must also be something
our clients will enjoy looking at year-round. Basically,
this is the same idea as the calendars that have long
been a tradition for printing firms."*

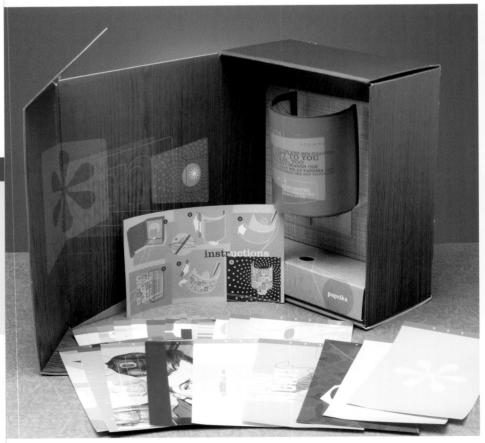

THE SLIDE BOX ▲

[STUDIO] Joel Nakamura
[ART DIRECTOR/DESIGNER] Joel Nakamura
[ILLUSTRATOR] Joel Nakamura
[PHOTOGRAPHER] Art Works
[INSPIRATION/CONCEPT] Self-promotion of
 new work for illustration and gallery work

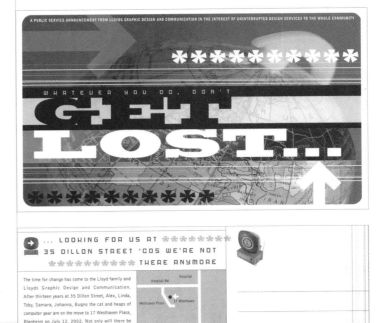

GET LOST ▶

[STUDIO] Lloyds Graphic Design and Communication
[ART DIRECTOR/DESIGNER] Alexander Lloyd
[ILLUSTRATOR/PHOTOGRAPHER] Alexander Lloyd
[PAPER] Matte, uncoated, 400 gsm
[COLORS] 1, match (PMS 222)
[SIZE] 4" × 7¼" (10 × 18cm)
[PRINT RUN] 500
[COST PER UNIT] $.40
[TYPE] Astronaut, Bell Gothic, Blackoak
[SPECIAL COST-CUTTING TECHNIQUE] Photo of globe was taken in-house with digital camera

"After thirteen years living and working from home, the time came for the family to move to a larger premises and to have a separate studio on the new property," art director Alexander Lloyd explains.

RIGHT/LEFT BRAIN JOURNAL ▶

[STUDIO] Miriello Grafico
[ART DIRECTORS] Ron Miriello, Michelle Aranda
[DESIGNERS] Chris Keeney, Maureen Wood, Liz Bernal, Lisa Stenz, Maximo Escobedo, Michelle Aranda
[SPECIAL TYPE TECHNIQUES] Heavy blind-embossed cover laminated on the back from the project make-ready sheets
[SPECIAL COST-CUTTING TECHNIQUES] Interior pages run on one master sheet, exterior box used an existing die strike from a previous piece

"Each year we step back as a studio and create a piece that we would love to receive ourselves for our friends and clients," say the designers at Miriello Grafico. *"This piece was based on the funky way creativity works between the left and right brains, the balance and tension necessary to navigate successfully between both halves of the whole. That balance and tension was the premise of this Right/Left Brain Journal. Opening the journal from one side shows left-brain thinking and from the opposite side, right-brain thinking."*

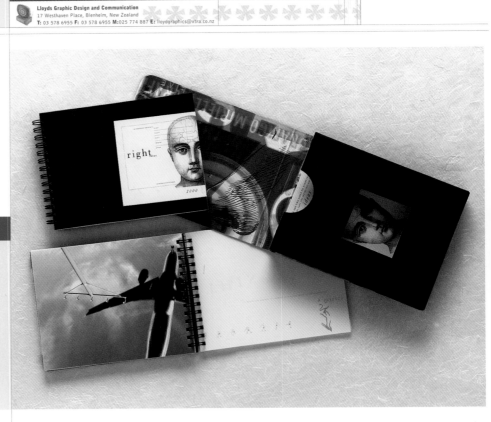

MIRIELLO GRAFICO SELF-PROMO ◄

[STUDIO] Miriello Grafico
[ART DIRECTORS] Ron Miriello, Michelle Aranda
[DESIGNERS] Chris Keeney, Maureen Wood, Liz Bernal, Lisa Stenz, Maximo Escobedo, Michelle Aranda
[PAPER] Chipboard exterior, Fasson Label Stock
[COLORS] 4/0, process (label); 1/0, match (cards)
[SPECIAL TYPE TECHNIQUES] Exterior boxes were die cut and folded but not printed. Instead, Miriello Grafico used a 4-color label as a box closure. Cards were letterpress printed in one color and each received a hand tipped-on postage stamp.

"Once a year our firm creates a piece for our friends and clients," say the designers at Miriello Grafico. "Always fascinated by repurposing old great design, we based this collection of blank writing cards (10 per box) around a collection of old postage stamps we found at a garage sale. $5.00 for hundreds of incredible intaglio stamps by designer greats from around the world. We used the stamps as the accent to the letterpress printed one color backgrounds we created. It was all about inspiring people to write and reach out non-digitally- once again."

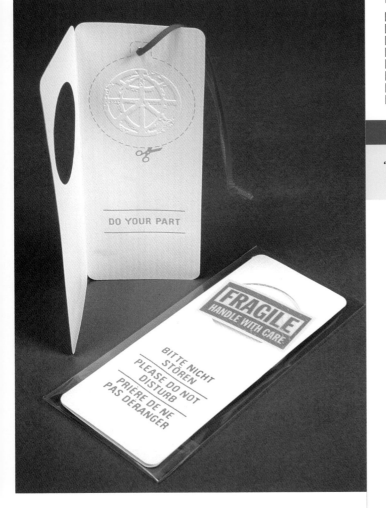

LDC HOLIDAY GREETING ◄

[STUDIO] Lemley Design Company
[ART DIRECTOR] David Lemley
[DESIGNERS] David Lemley, Yuri Shvets
[PAPER] Classic Column
[COLORS] 2, match plus engraving, blind emboss and die-cut
[SIZE] 2¾" × 7" (7 × 18cm)
[PRINT RUN] 250
[TYPE] Univers, found type

"Our holiday greeting is strictly a goodwill gesture," says art director David Lemley. "In light of the times (2001), we wanted to be somber but empowering."

MOWERS PHOTOGRAPHY SELF-PROMO
PRAYER CARDS ▼

[STUDIO] Initio
[CREATIVE DIRECTOR] Scott Sample
[DESIGNER] Sean Lien
[PHOTOGRAPHER] John Mowers
[CLIENT] Mowers Photography
[PAPER] 24 pt. White Great Lakes c25 (prayer cards); French Parchtone 80# cover (holder)
[PRINT RUN] 3,000
[COST PER UNIT] $2.42
[TYPE] Janson Text (body copy); Bembo, Trade Gothic (address information)
[SPECIAL PRODUCTION TECHNIQUES] Die-cut holder, rounded edges, aqueous coating

"How many times have you looked in your inbox to find yet another photographer's promo piece that features—surprise! surprise!—a photo taken by said photographer," asks designer Sean Lien. *"It seems as if the people who make their living from advertising have forgotten the first rule of advertising: Tell people what makes you unique. With that in mind, Initio sought a way to differentiate Mowers studio by actually telling art directors why Mowers is 'the answer to their prayers.' Then we put it into a special enough format (prayer cards) that would encourage art directors and print buyers to hang on to it."*

Clients come to you because you have the ability to come up with creative solutions. Although they say they want to stand out from the competition, they often feel uncomfortable doing something unexpected. Convincing them to break away from the norm often is difficult. The way you face this challenge is by explaining why you did what you did, how it accomplishes the goals of the project, and why it will make their company, brand or product stand out.

SEAN LIEN

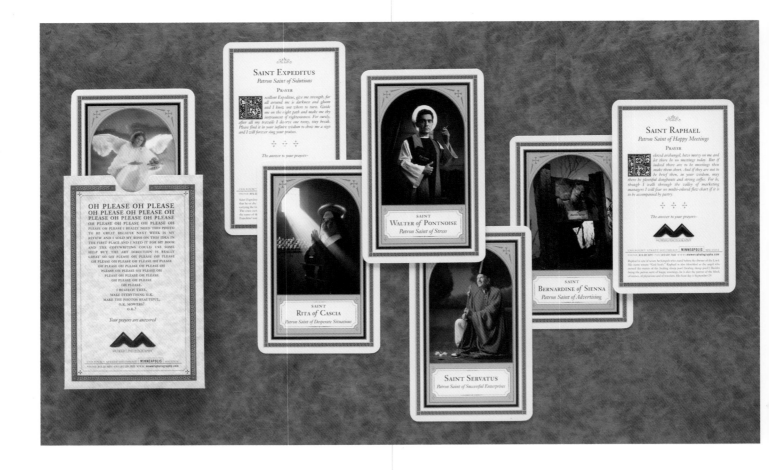

CANNED GOODS ▼

[STUDIO] Real Art Design Group, Inc.
[ART DIRECTOR] Chris Wire
[DESIGNER] Rachel Botting
[PAPER] Utopia 2 blue-white matte 70# text (label); Curious Popset cryogen white 89# cover (hang tag)
[COLORS] 4, process plus varnish
[SIZE] 5½" × 4" (14 × 10cm) (cans); 5¼" × 12¾" (13 × 32cm) (labels)
[PRINT RUN] 350
[COST PER UNIT] $3.70 (labels and tags)
[TYPE] Arial, Avenir, Futura, SignsMT
[SPECIAL PRODUCTION TECHNIQUES] Cans were stuffed, labeled and sealed by Real Art employees using a hand-cranked can-sealer
[SPECIAL COST-CUTTING TECHNIQUES] Hang tags were gang printed with the yearly Christmas card. Illustrations for can labels were done by a staff member.

"In the spirit of the holiday season, many people make contributions to food banks. Along with our own charitable donation to America's Second Harvest, giving away T-shirts in fruit and vegetable cans was Real Art's way to remind people to make their own donation," say the designers.

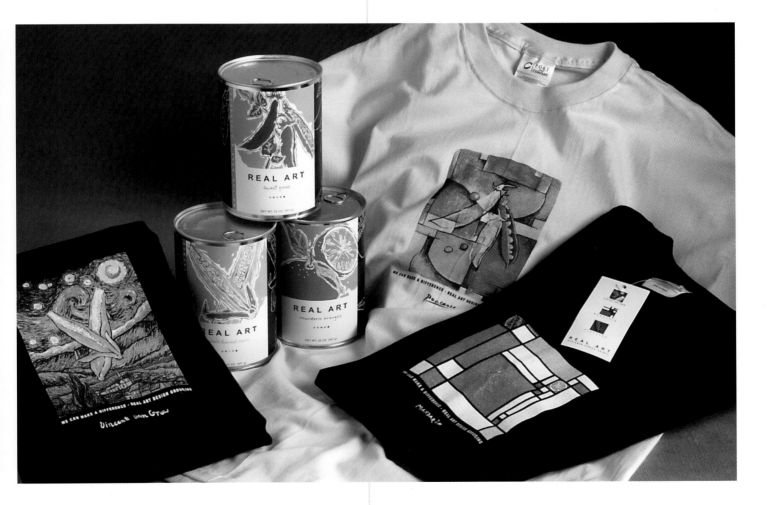

AUTOBIOGRAPHY: A GRAPHIC DESIGNER'S RESUME ▶

[STUDIO] A Day In May Design
[ART DIRECTOR/DESIGNER] Eve Billig
[ILLUSTRATOR] Eve Billig
[COLORS] 1, match
[TYPE] Mrs Eaves
[SPECIAL PRODUCTION TECHNIQUES] Letterpress printing for cover and dividers; laser-printed interior pages (French-folded); all hand assembled (stapled and glued to cover)
[SPECIAL FOLDS/FEATURES] Cover and dividers scored to allow for easy bend, interior pages French-folded for heft
[SPECIAL COST-CUTTING TECHNIQUES] One-color printing on duplex stock, different color stock for dividers, laser-printed interior pages, hand assembly

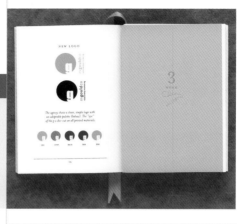

"My inspiration was simply coming back from a two month sabbatical spent away from the computer screen," says art director Eve Billig, "I wanted to create something intimate and tactile that would force the audience to pull away from the digital realm. A book was the perfect tool on all levels, a reminder of the almost forgotten joy of reading on paper, a reference to the craft of classical book printing and a perfect vehicle/metaphor for a resume."

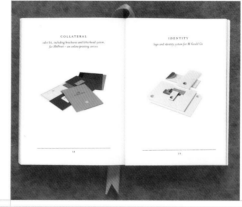

The biggest challenge in design is to never forget your message. It is easy to make things pretty but difficult to actually do it for a reason. I try to stay as simple as possible and eliminate any urge towards the frivolous. I always try to ask 'why?'

EVE BILLIG

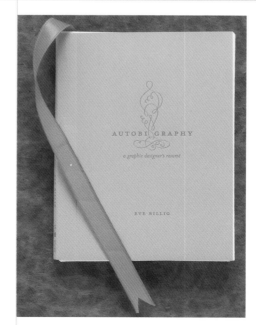

STIMULI ▲

[STUDIO] Pacifico Integrated Marketing Communications

[CREATIVE DIRECTOR] Boyd Tveit

[ART DIRECTOR] Phillip Mowery

[ILLUSTRATORS] Boyd Tveit, Phillip Mowery

[PAPER] 120# Centura dull cover, 30# Reich Translucent

[COLORS] 4, process plus spot varnish, aqueous varnish, silver match

[SIZE] 4" × 12¾" (10 × 32cm), 20 pages plus three slip sheets

[PRINT RUN] 2,500

[COST PER UNIT] Approximately $2.50

[TYPE] Univers

[SPECIAL FOLDS/FEATURES] Front and back covers are wrapped with a translucent sheet and a metal plate with a stamped monkey head was affixed to the brochure using Chicago screws. The screws allow pages to be added or removed as necessary.

The inspiration, according to art director Phillip Mowery, was "response mechanisms and information context. A moth is attracted to a flame in a similar manner as we would like to have our client's customer react to our client's message. Drawn in and mesmerized— though without the fiery death in the end."

A Day in May Design (pg. 360)
www.adayinmay.com

Alfred A. Knopf, Inc. (see Random House)

Alterpop (pgs. 257, 295, 333, 337)
www.alterpop.com

American Airlines Publishing (pg. 99)
www.spiritmag.com

Ames Design (pgs. 34, 43, 51, 140, 150, 159)
barry@speakeasy.net

Amoeba Corp. (pg. 139)
www.amoebacorp.com

And Partners (pg. 180)
www.andpartnersny.com

Appetite Engineers (pg. 36)
www.appetiteengineers.com

Archer/Malmo (pg. 224)
www.archermalmo.com

Archrival (pg. 227)
www.archrival.com

Arnika (pgs. 14–15, 262)
www.arnikans.com

Art Chantry Design Co. (pg. 247)
www.artchantry.com

Ashby Design (pg. 300–301)
www.ashbyandassociates.com

Atlantic Records (pg. 139)
www.atlanticrecords.com

Axiom Creative Group (pg. 193)
www.axiomcg.com

B12 (pg. 334)
www.btwelve.com

Backbone Design (see Scott Sugiuchi)

BAD Studio (pg. 19)
www.badgraphics.com

Baer Design Group (pg. 178)
www.baerdesign.com

Base Art Co. (pg. 92)
www.baseartco.com

BC Design (pg. 31)
www.bcgraphicdesign.com

Belyea (pgs. 182, 207, 311)
www.belyea.com

BIRD Design (pg. 49)
www.birddesign.com

Blok Design (pgs. 314, 328, 330)
blokdesign@earthlink.net

Bozell (see also CPS Group)
www.bozell.com

Brad Norr Design (pg. 348)
www.bradnorrdesign.com

Bradbury Branding & Design (pg. 235)
www.bradburydesign.com

Brainstorm, Inc. (pg. 270)
www.brainstormdesign.com

Burning Bush (see Zepponi Design)

Cahan & Associates (pgs. 83, 204, 254, 279,
284–285, 288, 294, 297, 299, 302, 304, 312)
www.cahanassociates.com

Carlson Marketing Group (pg. 171)
www.carlson.com

Catapult Strategic Design (pgs. 276–277, 309)
www.catapultu.com

Champion Graphics (pg. 12)
www.championdontstop.com

Chantry/Sheehan (see Art Chantry Design Co.)

Chris Rooney Studio (see Y+R 2.1)

Christine Grauert (pg. 354)
c_grauert@hotmail.com

Chronicle Books (pgs. 77, 80–81, 94, 95, 100,
106–107, 108, 114, 117, 127, 129, 132–133)
www.chroniclebooks.com

C.I.A., Creative Intelligence Agency (pg. 162)
kurt@ciastudio.com

Close Design (pg. 83)
luclose@hotmail.com

CO:LAB (pg. 181)
www.colabin.com

Cognition Design (pg. 105)
www.cognitiondesign.com

COMA (pg. 126)
coma@aya.yale.edu

CPS Group (pgs. 22–23, 37, 60–61)
www.cpsgroup.com

Curiousity, Inc. (pg. 112)
info@curiousity.co.jp

Cyclone Design (pg. 59)
www.cyclone-design.com

Dahlia Digital (pg. 148)
www.dahliadigital.com

Decker Art Services (pg. 242)
Julied@alaskalife.net

Dennard, Lacey & Associates (pg. 45)
www.dennardlacey.com

Design Guys (pg. 267)
www.designguys.com

Design:MW (pgs. 215, 266)
www.designmw.com

Digital Soup (pg. 341)
www.digitalsoup.com

DiMassimo Brand Advertising (pg. 65)
www.dimassimo.com

Direct Design Studio (pg. 263)
www.directdesign.ru

Dotzero Design (pg. 329)
www.dotzerodesign.com

Douglas Joseph Partners (pg. 237)
www.djpartners.com

Drew Souza Studio (pg. 176)
studiodrew@aol.com

Duncan|Channon (pgs. 144, 201)
www.duncanchannon.com

EAI (pg. 188)
www.eai-atl.com

Lloyds Graphic Design & Communication
(pgs. 33, 342, 356)
lloydgraphics@xtra.co.nz

Louey/Rubino Design Group, Inc. (pgs. 172,
237, 282, 327)
www.louryrubino.com

Louviere & Vanessa (pg. 32)
zeroagogo@aol.com

M.O.D. (formerly Y Design)
mod.nyc@verizon.net

Maddock Douglas (pg. 286)
www.maddockdouglas.com

Mark Andresen Illustration (pg. 235)
andresenm@aol.com

McMurry Publishing, Inc. (pg. 116)
www.mcmurry.com

Merge (pg. 335)
www.mergeagency.com

MetaDesign (pg. 192)
www.metadesign.com

Miriello Grafico (pgs. 356, 357)
www.miriellografico.com

Mirko Ilic Corp. (pgs. 29, 54, 131, 174–175, 218, 324)
www.mirkoilic.com

MOD/Michael Osborne Design (pg. 208)
www.modsf.com

Modern Dog Communications (pg. 246)
www.moderndog.com

Molloy & Son Box Company/Elvis Swift Library
(pg. 108)
elvis@joaniebrep.com

Morla Design (pg. 13)
www.morladesign.com

Morris Creative (pgs. 168, 190, 216, 256, 291, 346)
www.thinkfeelwork.com

Motive Design Research (pg. 271)
www.altmotive.com

Motoko Hada (pg. 223)
moto524ra@earthlink.net

Nesnadny + Schwartz (pgs. 197, 298, 303)
www.nsideas.com

Nina Pavicsits (pg. 240)
ninilein@hotmail.com

Oliver, Russell & Associates (pg. 62)
www.oh-zone.com

OMB Design and Visual Communication (pg. 73)
www.oscarmarine.com

p11creative (pgs. 46, 329)
www.p11.com

Pacifico Integrated Marketing Communications
(pgs. 170, 361)
www.pacifico.com

Paper Plane Studio (pg. 167)
www.paperplanestudio.com

Paprika Communications (pg. 354)
www.paprika.com

Penguin Publishing (pgs. 84, 110, 113, 118)
www.penguinputnam.com

Pentagram Design (pgs. 17, 234, 243)
www.pentagram.com

Permsak Suwannatat (pg. 63)
permsak_mail@yahoo.com

Peterson & Company (pg. 105)
www.peterson.com

Philip Fass (pgs. 24–25)
fass@uni.edu

Piper Design Co. (pg. 269)
www.piperdesignco.com

Planet Design Company (see Planet Propaganda)

Planet Propaganda (pgs. 64, 67, 230)
www.planetpropaganda.co

Platinum Design, Inc. (pgs. 40, 67, 72, 79, 86,
98, 104, 123, 125, 130, 173, 228, 260, 280,
290, 305, 306)
www.platinum-design.com

Plazm Media (pgs. 119, 157)
www.plazm.com

Prototype 21 (see Terratag)

Pylon (pgs. 103, 128)
www.pylondesign.ca

Q Ltd. (pg. 343)
www.qltd.com

Ralfinoe Creations (pg. 27)
www.ralfinoe.com

Random House (pgs. 101, 102, 124)
www.randomhouse.com

Real Art Design Group, Inc. (pgs. 338,
352–353, 359)
www.realartusa.com

Red Canoe (pgs. 238, 316, 351)
www.redcanoe.com

Renee Rech Design, Inc. (pg. 322)
www.reneerechdesign.com

Ringling School Design Center (pg. 205)
jmumford@rsad.edu

RVC Design (pg. 248)
rdevicq@earthlink.net

Ryan Slone (pg. 31)
ryanbslone@hotmail.com

Sagmeister Inc. (pgs. 70, 96–97, 115, 194–195)
www.sagmeister.com

Saint Hieronymus Press (pg. 93)
dlg@webbnet.com

Schulte Design (pg. 343)
www.schultedesignsf.com

Scott Sugiuchi (formerly Backbone Design)
(pg. 158)
scottsugi@hotmail.com

Setezeroum Design (pg. 191)
www.setezeroum.com

Sibley Peteet Design (pgs. 16, 236)
www.spddallas.com

Signal (pg. 250)
www.signaldesign.com

SJI Associates (pg. 349)
www.sjiassociates.com

P. 12 © Geoff McFetridge/Champion Graphics 1999

P. 13 © 2002 Morla Design, Inc.

P. 14–15 © Design: Arnika

P. 16 © 1999 Brent McMahan/Sibley Peteet Design

P. 17 (top) © Abraham Morales; (bottom) © 2000 Pentagram Design

P. 18 © John Foster/Fuszion Collaborative

P. 19 © Client: Innovations, Design: BAD Studio

P. 20 (top) © Client: OpenCola, Design: Spencer Francey Peters; (bottom) © 2002 Stoltze Design

P. 21 © 2002 Amilus Inc.

P. 22–23 © Design: CPS

P. 24–25 © 2000 Philip Fass

P. 26 © 2002 Kuhlmann Leavitt, Inc.

P. 27 © 2002 Ralfinoe Creations

P. 28 © Client: Valencia Community College, Design: Fry Hammond Barr

P. 29 © 2002 Mirko Ilic Corp.

P. 30 © 2001, Texas Department of Health

P. 31 (left) © Client: Nordsrom, Design: BC Design; (right) © Ryan Slone

P. 32 © 2001 the american™ dream

P. 33 © 2002 Lloyds Graphic Design & Communication

P. 34 © Design: Ames Bros. Inc.

P. 35 © Edward ODowd

P. 36 © Design: Martin Venezky/Appetite Engineers

P. 37 © Design: CPS

P. 38–39 © Client: Valencia Community College, Design: Fry Hammond Barr

P. 40 (top) © 2002 Art Directors Club NY; (bottom) © 2000 David Lemley

P. 41 © 2002 Thirst

P. 42 © Steven Cerio illustration

P. 43 © Design: Ames Bros. Inc.

P. 44 © Client: AIDS ARMS, Design: Group Baronet

P. 45 © 2000 Dennard, Lacey & Associates

P. 46 © Design: p11creative

P. 47 © 2002 Thirstype.com

P. 48 © Design: Felix Sockwell

P. 49 (left) © Client: Winston-Salem Symphony, Design: Henderson Bromstead Art Co.; (right) © BIRD Design

P. 50 © Client: The Orlando Sentinel, Design: Fry Hammond Barr

P. 51 © Design: Ames Bros. Inc.

P. 52 © 2002 Art Real

P. 53 © 2002 Fuszion Collaborative

P. 54 © 2002 Mirko Ilic Corp.

P. 55 © Client: Fong & Fong Printers and Lithographers, Design: Howry Design Associates

P. 56–57 © Client: Hard Rock Live, Design: Fry Hammond Barr

P. 58 © Design: Fuszion Collaborative

P. 59 © Design: Cyclone Design

P. 60–61 © Design: CPS

P. 62 © 2000 Oliver, Russell & Associates

P. 63 (top) © Design: Permsak Suwannatat

P. 63 (bottom) © Client: AIGA, Design: Werner Design Werks, Inc.

P. 64 (top) © Design: Planet Propaganda/Aesthetic Apparatus; (bottom) © 1999 Lemley Design Company

P. 65 © Client: Crunch Fitness; Design: DiMassimo Brand Advertising

P. 66 © 2002 Sussner Design Company

P. 67 (top) © 2002 Art Directors Club NY; (bottom) © Design: Planet Propaganda

P. 70 © Sagmeister, Inc.

P. 71 © 2001 Hillside

P. 72 © Clarkson Potter

P. 73 (top) © Design: Willoughby Design Group; (bottom) © Design: OMB Design and Visual Communication

P. 74 © F&W Publications

P. 75 © John Fulbrook III/Little Brown and Co.

P. 76 © Grant Design Collaborative/360 Magazine

P. 77 Copyright © Chronicle Books LLC. All rights reserved. Reprinted with permissions from http://www.chroniclebooks.com.

P. 78 © 2002 ESPN, The Magazine

P. 79 © 2001 Platinum Design, Inc./Space.com

P. 80–81 Copyright © 2002 Chronicle Books LLC. All rights reserved. Reprinted with permission from http://www.chroniclebooks.com.

P. 82 © Client: Evan Dion photography inc.; Design: Teikna Design inc.

P. 83 (top) Design: Close Design; (bottom) © Design: Cahan & Associates

P. 84 © Design: Martin Ogolter/Y Design

P. 85 © F&W Publications

P. 86 © 2001 Brown fipl Williamson/Hearst Custom Publishing

P. 87 © Client: Rizzoli Publishing, Design: Werner Design Werks, Inc.

P. 88 © Publirevistas S.A./Dallas Symphony

P. 89–91 © F&W Publications

P. 92 © (top) 2002 Base Art Co.; © (bottom) 2000 Golf Magazine Properties

P. 93 © Design: David Lance Goines/Saint Hieronymus Press

P. 94–95 Copyright © Chronicle Books LLC. All rights reserved. Reprinted with permissions from http://www.chroniclebooks.com.

P. 96–97 © Sagmeister inc.

P. 98 © 2001 New York Magazine

P. 99 (top) © American Airlines Publishing/Southwest Airlines; (bottom) © 2001 Amilus Inc.

P. 100 Copyright © 2002 Chronicle Books LLC. All rights reserved. Reprinted with permission from http://www.chroniclebooks.com.

P. 101 Jacket Design © John Gall

P. 102 Jacket/Cover Design © Archie Ferguson

P. 103 © Client: Random House Canada, Design: Pylon Design Inc.

P. 104 © Lynne Berentson

P. 105 (top) © Design: Peterson & Co.; (bottom) © Design: Cognition Design

P. 106–107 Copyright © Chronicle Books LLC. All rights reserved. Reprinted with permission from http://www.chroniclebooks.com.

P. 108 (left) © Design: Molloy & Son Box Company/Elvis Swift Library; (right) Copyright © Chronicle Books LLC. All rights reserved. Reprinted with permission from http://www.chroniclebooks.com.

P. 109 © 2000 Walker Art Center

P. 110 © Penguin Putnam Inc.

P. 111 © F&W Publications

P. 112 © 2000 Curiosity

P. 113 © Martin Ogolter/Y Design

P. 114 Copyright © 2002 Chronicle Books LLC. All rights reserved. Reprinted with permissions from http://www.chroniclebooks.com.

P. 115 © 2002 Sagmeister inc./Amilus, Inc.

P. 116 © McMurry Publishing, Inc.

P. 117 Copyright © 2002 Chronicle Books LLC. All rights reserved. Reprinted with permissions from http://www.chroniclebooks.com.

P. 118 © Design: Gail Belenson, formerly of Penguin Putnam Inc.

P. 119 © Design: Plazm Media

P. 120–121 © Design: FL@33

P. 122 © Graphic Havoc

P. 123 © 2000 Daimler Chrysler

P. 124 (top) Jacket/Cover Design © Archie Ferguson; (bottom) © Rodrigo Corral—Farrar Straus Giroux

P. 125 © 1999 Bomb Magazine

Inc.; (bottom) 2002 Fraser Papers Inc.
P. 238 © Design: Red Canoe
P. 239 © 2002 John Foster
P. 240 (top) © Nina Pavicsits; (bottom) © Design: Williams and House
P. 241 © Studio 106
P. 242 © Copyright 2001 by Julie Decker
P. 243 (top) © Design: Pentagram Design; (bottom) © Webby Awards
P. 244 © Client: Dallas Society of Visual Communications, Design: GroupBaronet
P. 245 © Tyler Blik Design
P. 246 © Design: Modern Dog
P. 247 © Art Chantry & Jamie Sheehan/ACDC
P. 248 (top) © Design: RVC Design; (bottom) © Design: Turner Duckworth
P. 249 © 2000 Group 55 Marketing
P. 250 © Signal
P. 251 © Liska + Associates
P. 252 © Design: Greenfield/Belser
P. 253 © Design: Williams and House
P. 254 © Design: Cahan & Associates
P. 255 © karlssonwilker inc.
P. 256 © 2001 Morris Creative
P. 257 (top) © Ferguson & Katzman Photography; (bottom) © Alterpop
P. 258 © Client: Salem College, Design: Henderson Bromstead Art Co.
P. 259 © Client: Mac Papers, Design: Fry Hammond Barr
P. 260 © Platinum Design, Inc.
P. 261 (top) © Wood Design; (bottom) © Design Firm: Hornall Anderson Design Works, Inc. Client: Leatherman Tool Group, Inc.
P. 262 © Design: Arnika
P. 263 2000 Direct Design
P. 264 © 2002 Fuszion Collaborative
P. 265 © Kraft&Werk
P. 266 (top) © 2002 Spur Design LLC; (bottom) © Buttenpapierfabrik Gmund/ Design: MW
P. 267 © Design Guys
P. 268 © 2002 Fuszion Collaborative
P. 269 © Piper Design Co.
P. 270 © Brainstorm, Inc.
P. 271 © 2001 Motive Design Research LLC
P. 272 © Design: Williams and House
P. 273 © 2002 Fuszion Collaborative
P. 276–277 © Design: Catapult Strategic Design
P. 278 © Equus Design Consultants Pte Ltd
P. 279 © Design: Cahan & Associates
P. 280 © Platinum Design, Inc.
P. 281 (top) © Client: Del Monte Foods, Design:

Howry Design Associates; (bottom) © 2002 Soapbox Design
P. 282 © Louey/Rubino Design Group Inc.
P. 283 © Design: Greenfield/Belser
P. 284–285 © Design: Cahan & Associates
P. 286 © Maddock Douglas
P. 287 © Nintendo Co., Ltd.
P. 288 © Design: Cahan & Associates
P. 289 © Client: Girl Scouts of Santa Clara County; Design: Liquid Agency, Inc.
P. 290 © 1999 DMA
P. 291 © 2001 Morris Creative
P. 292 © 30sixty design, inc.
P. 293 © [i]e design, Los Angeles
P. 294 © Design: Cahan & Associates
P. 295 (top) © 2001 Ideas on Purpose, LLC; (bottom) © SuperGen, Inc./Alterpop
P. 296 (top) © Fossil; (bottom) © Client: Cyngus, Inc., Design: Howry Design Associates
P. 297 © Design: Cahan & Associates
P. 298 © 2002 The George Gund Foundation
P. 299 © Design: Cahan & Associates
P. 300–301 © RIAA 2000
P. 302 © Design: Cahan & Associates
P. 303 © 2002 the Progressive Corporation
P. 304 © Design: Cahan & Associates
P. 305 © Platinum Design, Inc.
P. 306 © 2000 Modern Media
P. 307 © Leonhardt: Fitch
P. 308 © Design: Greenfield/Belser
P. 309 (top) © Equus Design Consultants Pte Ltd; (bottom) © Design by Catapult Strategic Design
P. 310 © Zoo Atlanta/Design by Vista
P. 311 © 2002 Belyea
P. 312–313 © Design: Cahan & Associates
P. 314 © Blok Design
P. 315 © X Design Company
P. 316 © Red Canoe
P. 317 © Client: Eric Breitenbach, Design: Fry Hammond Barr
P. 318 © 2002 flourish, Inc. All rights Reserved
P. 319 © Client: Contemporary Wood Concepts, Design: Fry Hammond Barr
P. 320 © Design: Williams and House
P. 321 (top) © Client: Kelham MacLean Winery, Design: Templin Brink Design LLC; (bottom) © 2002 Tom & John: A Design Collaborative
P. 322 © 2000 Renee Rech Design
P. 323 © 2002 Templin Brink Design LLC
P. 324 © 2002 Mirko Ilic Corp.
P. 325 © Greg Herr/Design by Stone & Ward

P. 326 © Fry Hammond Barr
P. 327 © Louey/Rubino Design Group Inc.
P. 328 (top) © Indigo Marketing; (bottom) © Blok Design
P. 329 (top) © Design: p11creative; (bottom) © Dotzero Design
P. 330 © Blok Design
P. 331 © Fuszion Collaborative
P. 332 (top) © Tom & John: A Design Collaborative; (bottom) © Client: D-Code, Design: Spencer Francey Peters
P. 333 © Alterpop
P. 334 © B12
P. 335 © Merge
P. 336 © Design by THR3E Design
P. 337 (top) © 2002 Townsend Design Co.; (bottom) © Paradox Media/Alterpop
P. 338 © Real Art Design Group, Inc.
P. 339 © Tcherevkoff Studio
P. 340 © 2002 Lemley Design Company
P. 341 © Digital Soup
P. 342 © 2002 Lloyds Graphic Design & Communication
P. 343 (top) © 2001 Jim Karageorge; (bottom) © 2002 Q LTD
P. 344–345 © 2002 Fuszion Collaborative
P. 346 (top) © 2001 Morris Creative; (bottom) © Client: Mark Joseph Photography, Art director: Joseph and Nancy Essex, Design: Jospeh and Nancy Essex, Writers: Joseph Essex, John Knowles, Office: Essex Two/Chicago
P. 347 © Client: Sharpe + Associates, Design: Templin Brink Design LLC
P. 348 © Brad Norr Design
P. 349 (top) © SJI Associates; (bottom) © Kilmer & Kilmer Brand Consultants
P. 350 © 2002 Spur Design LLC
P. 351 © Red Canoe
P. 352–353 © 2000 Image Info
P. 354 (top) © Christiane Grauert; (bottom) © Design: Paprika Communications
P. 355 © Joel Nakamura
P. 356 (top) © 2002 Lloyds Graphic Design & Communication; (bottom) © Miriello Grafico
P. 357 (top) © Miriello Grafico; (bottom) © 2001 Lemley Design Company
P. 358 © Design: Initio
P. 359 © Real Art Design Group, Inc.
P. 360 © A Day in May Design
P. 361 © Pacifico Integrated Marketing Communications